ART HISTORY: A STUDY GUIDE

Janet Fuller Masters

Joyce McKeon Smith

PRENTICE-HALL, INC., Englewood Cliffs, New Jersey 07632

Library of Congress Cataloging in Publication Data
MASTERS, JANET FULLER.
 Art history.

 Bibliography:
 1. Art—History—Outlines, syllabi, etc. I. Smith,
Joyce McKeon. II. Title.
N5305.M32 709 81-19989
ISBN 0-13-047324-3 AACR2

N5305
.M32

Manufacturing buyer: Harry P. Baisley
Editorial production and supervision
 by Frank Hubert
Cover design by Photo Plus Art,
 Celine A. Brandes

Printed in the United States of America
10 9 8 7 6 5 4 3 2 1

ISBN 0-13-047324-3

Prentice-Hall International, Inc., *London*
Prentice-Hall of Australia Pty. Limited, *Sydney*
Prentice-Hall of Canada, Ltd., *Toronto*
Prentice-Hall of India Private Limited, *New Delhi*
Prentice-Hall of Japan, Inc., *Tokyo*
Prentice-Hall of Southeast Asia Pte. Ltd., *Singapore*
Whitehall Books Limited, *Wellington, New Zealand*

Contents

Preface

The contents of this study guide correspond to the major cultural styles of western art from the prehistoric eras to the twentieth century. It is the objective of this study guide to provide a consistent pattern for study and an overview of information found in the three major textbooks in this field: H.W. Janson, *History of Art*, Second Edition; Frederick Hartt, *Art: A History of Painting, Sculpture, and Architecture;* and de la Croix and Tansey, *Gardner's Art through the Ages*, Seventh Edition. Consult the Cross-Indexes on the inside front and back covers for convenience in locating parallel information in the study guide and each of these textbooks.

The format of this book was developed to provide a framework for comprehensive study. Each chapter begins with a summary of the major topics to be discussed and concludes with a list of basic terms. For concise definitions of these terms, consult the textbook glossaries or the dictionaries of art listed in the bibliography. Illustrations of the art works cited as examples in each chapter can be found in the major textbooks. A code letter and figure number in italics following each example identifies its location according to the following system: *G = Gardner's Art through the Ages; H =* Hartt, *Art: A History of Painting, Sculpture, Architecture;* and *J =* Janson, *History of Art*. Figures, black and white illustrations, and plans are listed in numerical order, followed by colorplates of that example (abbreviated *cpl*).

<div align="right">

Janet Fuller Masters

Joyce McKeon Smith

</div>

ACKNOWLEDGMENTS

The authors wish to thank Sally Fauske and Myra Taylor for their assistance, and Sarah Wasley-Smith for her illustrations.

ILLUSTRATION CREDITS

The following illustrations were taken or adapted from James Smith Pierce, *From Abacus to Zeus: A Handbook of Art History,* 2nd ed., © 1977: Fig. I-2, Fig. I-3, Fig. 2-2b, Fig. 5-3d, Fig. 5-3e, Fig. 6-3, Fig. 7-2a, Fig. 11-1, and Fig. 13-1. Reprinted by permission of Prentice-Hall, Inc., Englewood Cliffs, N.J.

The following illustrations were taken or adapted from H. W. Janson, *History of Art,* 2nd ed., 1977: Fig. 2-1b, Fig. 2-1c, Fig. 5-1, Fig. 5-2, and Fig. 10-1. Reprinted by permission of Harry N. Abrams, Inc., New York.

The following illustrations were taken or adapted from Frederick Hartt, *Art: A History of Painting, Sculpture, Architecture* (Vol. I), 1976: Fig. 2-1a, Fig. 2-2a, Fig. 3-1, Fig. 7-1b, c, d, e, and Fig. 9-1b. Reprinted by permission of Harry N. Abrams, Inc., New York.

The following illustrations were drawn by Sarah Wasley-Smith: Fig. I-1, Fig. 1-1, Fig. 2-1d, Fig. 6-1, and Fig. 6-2.

Introduction to Art

SUMMARY

I. What is art?

 A. Art is visual or spatial communication.

 B. Art communicates ideas and attitudes.

 C. Art reflects the values of its cultural environment.

II. What are the purposes of art?

 A. Historically, some of the main purposes include:

 1. Immortality and prestige.

 2. Propaganda and instruction.

 3. Enjoyment and entertainment.

 B. Purposes vary with the culture, the era, the patron, and the artist.

III. What are the forms of art?

 A. The three major art forms are

 1. Architecture

 2. Painting

 3. Sculpture

 B. Other arts often termed minor include forms such as ceramics, metalsmithing, mosaics, weaving, stained glass, and the like.

IV. What are the basic elements of art?

 A. Subject matter (or building type) tells "what it is about."

 B. Media (or materials) define what the work is made of.

 C. Techniques (or construction methods) refer to the manner in which the materials are used.

 D. Design and composition principles dictate the combination of colors, shapes, textures, etc.

V. What is style?

 A. Style is the combination of various basic elements into a recognizable type or character.

 B. Style is categorized by

 1. Time period or era.

 2. Geographic location.

 3. Artistic group or "school."

 4. Individual artists.

Before tracing the history of western art, it is necessary to consider certain basic questions: (1) What is art? (2) What are the purposes of art? (3) What are the forms of art? (4) What are the basic elements of art? and (5) What is style? What follows is only an abbreviated treatment of these complex questions.

I. WHAT IS ART?

A dictionary may define art as "the production or expression of that which is beautiful." This definition is too vague to be useful. For our purposes: **ART IS VISUAL OR SPATIAL COMMUNICATION.** Art attempts to communicate ideas and attitudes. Because ideas and reactions to them change with each period and culture, it is understandable that art changes.

Every work of art expresses the ideas and attitudes of the society or individual who produced it. This does not mean that every expression will be beautiful or pleasant. It does not guarantee quality of workmanship. It certainly does not mean that everyone who looks at the work will like it. But, if it is successful, the object will in some small way speak to us. We can appreciate an art object for its communication value even if we do not like it. But, we cannot appreciate what we do not understand.

To evaluate a work of art properly, we must deal with it in the context of the society which produced it. Otherwise, we judge it with our own values. While our value system and ideas are useful in relating to contemporary works, our values often hinder our reading of the past.

II. WHAT ARE THE PURPOSES OF ART?

There have been many purposes for art in the history of mankind. One major purpose has been to secure immortality and prestige. The artist can immortalize his subjects and gain prestige for himself. The patron or society which supports the artist can also look for prestige or immortality through art. Art is often a kind of visual propaganda or instruction: an expression of moral and philosophical values for the purpose of perpetuating these values. Art may also have propaganda value by presenting a "public image" to viewers. Art works may also be made for enjoyment and entertainment. There is enjoyment in the act of creation, just as there is in viewing, experiencing, or owning works of art. Usually, art is created for a combination of purposes and reasons.

III. WHAT ARE THE FORMS OF ART?

ART FORMS are the broadest classifications for art objects. There are three **MAJOR ARTS**: architecture, painting, and sculpture.

ARCHITECTURE is a three-dimensional art form concerned primarily with enclosing space on a human scale or larger. We experience architecture both from within the enclosed space and from the outside.

PAINTING is a two-dimensional art form consisting of colored powders, pastes, or liquids applied to various types of surfaces. Western artists, however, have frequently attempted to create the illusion of depth in their works. Thus, although paintings and related media have only length and width, we often perceive the images in the paintings as being three-dimensional.

SCULPTURE is a three-dimensional art form concerned primarily with the mass or volume of the work in relation to the space around it. Historically, sculptors have emphasized surface texture and lighting effects to enhance the massiveness of the images and works created.

There are many other art forms which have generally been regarded as less important than architecture, painting, and sculpture. The so-called **MINOR ARTS** include art forms which are normally classified as "crafts," unless elevated to a higher status by their design excellence, expression, or symbolic value. Pottery, weaving, metalsmithing, stained glass, and mosaic are a few examples of the minor arts. The relative importance of various art forms differs from era to era and region to region.

IV. WHAT ARE THE BASIC ELEMENTS OF ART?

The most important **ELEMENTS OF ART** include: subject matter, media, techniques, and principles of design.

SUBJECT MATTER is one of the first things we try to identify when we look at a work of art. In fact, the usual first question asks what the work is about, or what its subject is.

A. In **ARCHITECTURE**, the subject is the function of the building. Historically, the major building types have been religious, memorial, residential, civic, and commercial. Religious and memorial structures appear to be the oldest surviving types.

B. In the "visual arts" such as **PAINTING** and **SCULPTURE**, subject matter has traditionally referred to the particular faces, places, incidents, or objects which the artist has used as his or her inspiration. Certain categories of subjects have repeatedly interested western artists. Religious themes, historical events, and mythology have been most widely used as sources of subjects. Other popular subject categories include portraiture, landscape and seascape, still-life and **genre** (the everyday activities of ordinary people). Within each category there are many potential themes.

MEDIA are the various materials which an artist can use to give substance to his or her ideas and subjects. Each art form has its own media. In fact, the artist's choice of materials strongly affects the visual and tactile qualities of his finished work.

A. **ARCHITECTURE** has relied on several materials including mud-and-thatch, sun-dried brick, fired brick, wood, stone, concrete, iron, steel, and glass. Before the invention of concrete, stone and fired brick were the most permanent materials and were regarded as the most prestigious media for construction. Generally, the most valuable materials were used for the most important structures.

B. **PAINTING** includes many media, but all consist of a binding agent mixed with powdered pigment (color). It is the difference in binding agent that results in different types of paint. The most important painting media in the history of western art are:

1. Acrylic—pigment in acrylic polymer resin.
2. Encaustic—pigment mixed with beeswax and resin.
3. Fresco—pigment suspended in water and applied to a lime-plastered surface.
4. Oils—pigment suspended in linseed or walnut oil.
5. Pastel—pigment bound with grease, oil, or water.
6. Tempera—an emulsion of pigment, egg yolk, and water.
7. Watercolor—pigment suspended in gum arabic or glue.

Various drawing and printmaking media could be added to this list because of similar structure and applications.

C. **SCULPTURE** has utilized various media. The physical properties of these materials have strongly affected the technique or methods used by sculptors. Non-pliable materials, such as wood, bone, ivory, and stone, are usually worked in some manner of carving. Usually, the sculptor will model or cast work made of "plastic" (pliable) media such as, clay, wax, and molten metal.

TECHNIQUES are the methods, manners, and skills used in the creation of art works.

A. **ARCHITECTURAL** techniques are also called construction methods. Historically, two essential construction principles or techniques developed. One based on the post-and-lintel concept, the other based on the arch.

1. **The post-and-lintel** or **trabeated system** of construction developed first and is still the most common method of building. It relies on the use of vertical posts (or walls) to support horizontal lintels (beams). Unfortunately, the weight of the lintels and the roof can overstress the structure, limiting design possibilities. (See Figure I-1.)
2. **The arch** or **arcuated system** of construction was developed to overcome the strength limitation of stone used in the post-and-lintel system. The true arch is a curved support in which the blocks of stone or brick framing the opening are wedge-shaped. Use of the arch rather than the lintel reduces stress by transferring the gravitational load on the building down the sides of the arch

a. The Elements

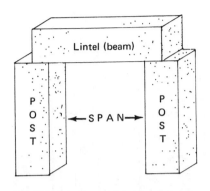

b. The Stresses and Weaknesses

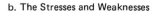

FIGURE I-1 Post-and-lintel construction.

to the foundation. The use of wedge-shaped blocks locks the arch tightly to-gether when load is applied. (See Figure I-2.) The arch principle also offers alternatives in ceiling and roof design. Various types of vaults and domes are possible because of the basic concept of a curved superstructure connected to vertical walls or posts.

3. **The corbeled arch** is a unique variation of the arch concept and is often con-sidered transitional between the simpler post-and-lintel and the more complex true arch. The corbeled arch consists of flat stones laid so that each succes-sively higher row, or "course," extends farther into the opening being spanned. (See Figure I-3.) Like the true arch, corbeling can also be used for vaults and domes.

B. **PAINTING** techniques refer to the methods used to apply the paint. A painter's technique or "handling" is influenced by the characteristics of his or her materials and tools. For instance, a brush can be used to produce various effects from fluid "washes" to thick "impasto" depending on the qualities of the paint, but a palette knife is not appropriate for transparent wash effects regardless of the ma-terial or the surface.

Handling or technique varies between two extremes: either the artist's strokes and tool marks are barely visible, or the texture of the paint and the movements of the artist's tools across the surface can be easily traced.

C. **SCULPTURE** techniques include carving, modeling, casting, and assem-blage.

1. **Carving** is a "subtractive" method, meaning that the artist creates a work by subtracting or removing what he or she does not want to remain in the fin-ished object. The artist uses non-pliable materials and cutting tools such as knives and chisels to rough out the form. He or she may then use more precise tools to refine the work, and may conclude by working abrasives over the sur-face to smooth out the tool marks.

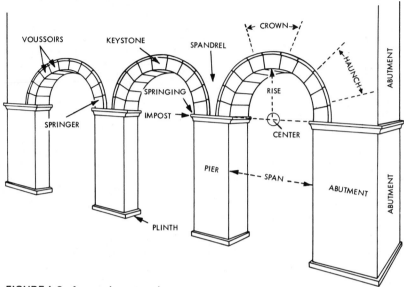

FIGURE I-2 Arcuated construction.

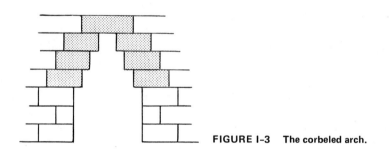

FIGURE I-3 The corbeled arch.

2. **Modeling** involves working with soft or pliable materials. The artist may build up a form or may cut away material. In this way, modeled sculpture can be either "additive" or "subtractive." Usually, it will be a combination of both. For instance, a clay form may be built up by adding to the overall mass, and the details may be produced by subtracting from the surface.

3. **Casting** developed as an accompaniment to modeling in an effort to overcome the fragile nature of modeling materials. All castings consist of a hardening liquid (traditionally, molten metal) poured into a mold. Once hardened and removed from the mold, the casting becomes the sculpture. The modeled image with which the artist started his or her casting process serves only as the basis for the mold. The cast form is the finished work.

4. **Assemblage** involves the construction of a work from separate pieces that are joined together in some way. Welded steel sculptures and works composed of "found objects" are among the best examples of the assemblage technique.

DESIGN PRINCIPLES also concern the artist. For convenience, we will group the different elements into two categories: realization of form and composition.

A. **REALIZATION OF FORM** includes the use of color, shape, lighting, texture, size and scale, and an approach to form.

1. **Color** is basic to everything we see and helps us to define or distinguish forms. Hue refers to the names of the colors—red, blue, green, etc. Saturation refers to the brightness or dullness of a hue. Value refers to the lightness or darkness of a color on a scale of white to gray.
An artist may select from the primary colors (red, yellow, blue), the secondary (orange, green, violet), or the tertiary colors (combinations of adjacent primary and secondary colors). His or her color scheme may rely on warm colors such as red and orange, or on cool colors such as blue and green. The artist may use a high-key color scale in which all the colors are bright, or a low-key palette in which all the colors are muted or dulled. In combining colors, the artist may use analogous colors (colors which are adjacent on a color chart, such as red, orange, yellow), or complementary colors (colors which are opposite each other on a color chart, such as red-green, orange-blue, and yellow-violet).
2. **Shape** also defines form. Usually, lines and silhouettes are used to create shapes. In many cases, the kinds of shapes an artist uses in a work help us to describe his or her style. The use of predominantly angular shapes generally reflects a geometric approach, while a preference for rounded, fluid shapes is referred to as curvilinear or organic.
3. **Lighting** can also be used to define form, and is especially useful in two-dimensional works where highlighting and shading suggest three-dimensional forms.
4. **Texture** or surface treatment ranges from the very smooth to extremely rough. In architecture and sculpture, the artist conveys texture directly because he or she is working with three-dimensional materials. In painting, the texture of images is often implied through the use of line, color, lighting, and brushwork.
5. **Size and scale** are also important design considerations. Size refers to the actual, measurable dimensions of a work or image. Scale refers to the psychological impression of size given by the work and may not correspond at all to the physical size. Our impression of scale in any work of art is partially based on the size of the background in relation to the forms created by the artist. Scale can be perceived miniature if we experience the images as less than life-size or monumental if they seem larger than life.
6. **Approach to form** can be divided into three broad categories: representational, abstract, and non-representational. If the artist takes his or her subjects from nature and tries to approximate the natural appearance of those subjects, we can consider the resulting works to be representational. How closely an image resembles the natural form determines whether we describe the image as naturalistic, realistic, or idealized. Abstract art includes works in which the original inspiration is from nature, but in which the artist does not try to imitate the object's natural appearance. Finally, the artist can use forms which

are not inspired by an object found in the natural world. This approach is called non-representational.

B. COMPOSITION refers to the arrangement of the parts or formal elements of a work and includes figure-ground relationships, pattern and rhythm, and balance.

1. **Figure-ground relationships** are also called positive and negative space relationships. We usually think of a building or free-standing sculpture as a positive figure set against a background space. In the same way we think of identifiable images in a two-dimensional work as the figures set off against the background.
2. **Pattern and rhythm** refer to the repetition of similar elements such as shapes, lines, colors, in such a way that we recognize a particular order and sequence of images. Pattern identifies the repeated element. Rhythm identifies the interval or sequence between the repeated elements.
3. **Balance** is the establishment of equilibrium in the combination of compositional or formal elements. Our sense of balance in a work of art can be static or dynamic, symmetrical or asymmetrical. The artist can also choose to combine his elements in a startling way intended to convey lack of balance or harmony.

V. WHAT IS STYLE?

Style may be called the characteristic way of giving expression to an idea or emotion. In art, it is the cumulative result of choices made by the artist in regard to the purpose, the art form, the materials, techniques, and the elements of design. It is the unique combination of these characteristics that defines a style. Regional, cultural, historical, individual, and group (school) styles are the most commonly discussed. Style changes are the result of many factors affecting cultures and artists. Geography, economics, politics, religion, and time are among the most obvious influences.

VOCABULARY

acrylic	media	rhythm
analagous colors	miniature	saturation
complementary colors	minor arts	style
hue	monumental	tactile
major arts	primary colors	value

1. Prehistoric Art

SUMMARY

I. Paleolithic Period (Old Stone Age) c. 35,000–8000 B.C.

Architecture: None.

Painting: Found in caves. Subjects: animals, signs, some human beings. Purpose assumed to be religious-magical.

Sculpture: Reliefs and engravings on cave walls and small objects. Subjects: animals and people. Free-standing sculpture from caves and graves. Female fertility figures were most frequent.

Style features: Naturalism, selective observation, twisted perspective, superpositioning.

II. Mesolithic Period (Middle Stone Age) c. 8000–3000 B.C.

Architecture: None.

Painting: Rock-shelter paintings of people in action. Animals seldom seen without people.

Sculpture: Some low-reliefs and engravings; same subjects as painting; of secondary importance.

Style features: Abstraction, silhouette images, figures in settings, figures in action.

III. Neolithic Period (New Stone Age) c. 7000–1500 B.C.

Architecture: Near East: cities of mud-brick. Northern Europe: megalithic stone monuments.

Painting: Religious wall paintings found in the Near East. Designs were also painted on hand-built pottery in the Near East and Europe.

Sculpture: Small "earth goddess" figures and reliefs and engravings of bulls, gods, and geometric and curvilinear designs were important.

Style features: Megalithic architecture: monumental and sculptural; Near Eastern architecture: modest, built on a human scale. Pottery and painting were abstract or naturalistic. Sculpture was similar to that of the Paleolithic Period.

The prehistoric development of the human race is broadly divided into three major phases called "stone ages," because early human beings made their tools and weapons from stone and bone.

I. PALEOLITHIC PERIOD (OLD STONE AGE)
c. 35,000–8000 B.C.

A. ARCHITECTURE

There is evidence that people lived in the entrances of natural caves or in open-air camps, but no architecture has survived.

B. PAINTING

Paleolithic paintings have been found in caves throughout Europe, but the principal concentration is in south-central France and northern Spain. The paintings date from 15,000 to 10,000 B.C.

PURPOSES: We know very little about the world's oldest art as the paintings and sculptures were only recently rediscovered. We assume that the paintings are not mere "doodles," but that they were made for various magic or religious purposes.

SUBJECT MATTER

1. Most important were large, hunted animals.
2. Some smaller (fish, birds, etc.) and "monsters."
3. Occasional images of male human beings as **shaman** or priests.
4. Lines, signs, and dots intermixed with other markings.

MEDIA AND TECHNIQUES

1. Natural materials such as red ochre and manganese oxide were ground into powders and blown through hollow tubes or mixed with grease or water and applied with "brushes" made of moss or matted hair.
2. Earth tones and black have survived.
3. Skill varied with location, but is generally of high quality.

DESIGN: The following terms characterize Paleolithic painting:

1. **Naturalism:** Shapes and colors defined forms which closely resembled their natural sources.

2. **Selective observation**: The artist showed only the essential elements of a form.
3. **Twisted perspective**: Images were shown with various viewpoints combined.
4. **Figures without settings**: Images appeared to "float" without ground lines or suggested landscapes.
5. **Mixed species groupings**: Many paintings showed different kinds of animals grouped together, including animals which were natural enemies.
6. **Superpositioning**: Images often overlapped each other, perhaps to suggest a group in depth or due to overpainting.

LOCATION, SIZE, AND SCALE

1. Paintings were made on walls, floors, and ceilings of caves, in hidden or remote chambers and passages.
2. Figures were generally one-fourth life-size or larger.
3. Scale was monumental due to bold outlines, simplified forms, and naturalistic, powerful images.

EXAMPLES (all dated 15,000–10,000 B.C.)

1. Altamira, Spain: *Bison.* (*H cpl 2*)
2. Lascaux, France: *Hall of the Bulls*, life-size animals. (*G 1-1; H 6; J 12, J cpl 1*)
3. Lascaux, France: *Chinese Horse*, 50 in. long. (*G 1-5*)
4. Lascaux, France: *Well Scene (Wounded Bison)*, 5 ft. high. (*G 1-7, H 7*)
5. Niaux, France: *Bison with Superposed Arrows*, 4 ft. long. (*G 1-6*)
6. Pech-Merle, France: *Spotted Horses with Negative Hand Imprints*, 11 ft. 2 in. long. (*G 1-4*)
7. Trois Frères, France: *The Sorcerer*, 2 ft. high. (*G 1-8*)

C. SCULPTURE

The oldest Paleolithic art works discovered so far are sculptures, dating as far back as 30,000 B.C.

1. Free-standing Sculpture

PURPOSES AND SUBJECT MATTER: The carved objects are thought to have been magico-religious.

1. Fertility figures: images of human female figures.
2. Animals.

MEDIA AND TECHNIQUES: Carving was done in stone, bone, ivory, and horn.

DESIGN

1. **Selective observation**, particularly in "Venus figures."
2. Traces of color remain.
3. **Naturalism** was stronger in images of animals than of human beings.

LOCATION, SIZE, AND SCALE

1. Images of animals have been found throughout Europe.
2. Female figures have been found mainly in Central Europe in women's graves or in firepits.
3. Works were small in size, but monumental in scale.

EXAMPLES

1. *Venus of Willendorf,* 30,000–20,000 B.C., stone, about 4 in. high. (*G 1-12, H 1, J 16*)
2. *Venus of Lespugne,* 20,000–18,000 B.C., ivory, about 6 in. high. (*H 2, H cpl 1*)
3. *Bison with Turned Head,* 15,000–10,000 B.C., reindeer horn, about 4 in. high. (*G 1-10, H 4, J 17*)

2. Relief Sculpture

PURPOSES AND SUBJECT MATTER: Magico-religious.

1. Human images.
2. Animals.

MEDIA AND TECHNIQUES: Carving was done in the stone or clay of cave walls, and on small stones and bones.

DESIGN

1. More naturalism was expressed in animal than in human forms.
2. Ground lines were implied in wall carvings; figures were right-side up.
3. Mixed species and superpositioning were used in engravings.

LOCATION, SIZE, AND SCALE

1. Carved stones and bones have been found throughout Europe.
2. Cave carvings have been found primarily in France and Spain.
3. Size of portable carvings is small. Size of cave carvings ranges from small to life-size.

EXAMPLES (*all date from 15,000–10,000 B.C.*)

1. Le Tuc d'Audobert, France: *Two Bison,* clay, 24 in. long. (*H 8*)
2. Cap Blanc, France: *Relief Horse,* 7 in. long. (*G 1–11*)
3. La Madeleine, France: *Reclining Woman,* life-size. (*H 9, J 14*)

II. MESOLITHIC PERIOD (MIDDLE STONE AGE)
c. 8000–3000 B.C.

A. ARCHITECTURE

Human beings no longer lived in caves. There are traces of open-air camps, such as firepits, domestic debris, and bones.

B. PAINTING

Mesolithic paintings have been found all around the Mediterranean coasts of Spain, Africa, Italy, and Sicily, but not in caves. They appear mostly on open-air rock surfaces.

PURPOSES: Magico-religious.

SUBJECT MATTER

1. People are the most frequent subjects with both sexes shown in scenes of war, hunting, dancing, and genre.
2. Small animals are shown in scenes with people, not always as the victims of hunts.

MEDIA AND TECHNIQUES

1. Natural pigments were ground up and mixed with water, egg white, or blood, and applied with brushes.
2. Preference was for solid red or black images; there was very little blending of colors.
3. Skill was generally not as high as in the Paleolithic Period.

DESIGN: Some of the major differences from Paleolithic art are:

1. **Abstraction** replaced naturalism. Figures were simplified and elongated into sinuous forms.
2. **Action and movement** replaced static poses.

3. **Narrative groupings** replaced isolated images.
4. Flat, **silhouette images** were created, instead of modulated color within outlines.

LOCATION, SIZE, AND SCALE

1. Eastern Spain is the best known region, with over sixty sites.
2. Daylight art: Paintings were done on exposed rock surfaces.
3. Drastic reduction in size: Most are less than 12 inches high. Scale is also miniature.

EXAMPLES (both date from 8000–3000 B.C.)

1. El Cerro Felio, Spain: *Hunting Scene. (H 10)*
2. Gasulla Gorge, Spain: *Marching Warriors,* about 9 in. long. (*G 1-13*)

C. SCULPTURE

Mesolithic sculpture consisted primarily of rock-engravings located around the Mediterranean coastline.

PURPOSES AND SUBJECT MATTER: Magico-religious with scenes of people and animals.

MEDIA AND TECHNIQUES: Engraving on rock-shelters was the most typical.

DESIGN: See Mesolithic Painting: Abstraction, sketchy forms, action, and movement are most characteristic.

LOCATION, SIZE, AND SCALE: Found throughout the Mediterranean region on open-air rock surfaces, the images are small in size and scale.

EXAMPLE

Addaura, Sicily: *Ritual Dance,* c. 10,000 B.C., figures 10 in. high. (*H 11, J 13*)

III. NEOLITHIC PERIOD (NEW STONE AGE)
c. 7000–1500 B.C.

A. ARCHITECTURE

There were two distinct regional styles: Near Eastern and European.

1. Near Eastern

The oldest architectural remains date from 8000–6000 B.C.

BUILDING TYPES

1. **Houses** in permanent villages were either unattached oval or rectangular structures or attached rectangular clusters.
2. **Shrines** to the earth-goddess or the sun-god were based on rectangular house designs, but more richly decorated.
3. **Fortifications** made their first appearance in the Neolithic Period.

MEDIA AND TECHNIQUES

1. Materials consisted of stone foundations, mud-brick walls, thatch, timber, or mud-brick roofs.
2. Post-and-lintel construction was dominant with occasional use of the corbeled arch.

DESIGN

1. Oval house and city plans were used mostly in Mesopotamia; rectangular plans were preferred in Anatolia (Turkey).
2. Structures were blockish, low, with blank walls and few windows.
3. Exterior decoration is uncertain; interior decoration included plaster and stone reliefs and dry fresco paintings.

EXAMPLES: The best-known sites include Jericho, Çatal Hüyük, Alaca Hüyük, and Hacilar. All date from c. 8000–6000 B.C. (*G 2-1, 2, 3, 4; H 12, 14, 16, 17; J 20, 21, 22*)

2. European

The general term for Neolithic architecture in Europe is **Megalithic** ("big stone") because enormous stones were used for the structures, which appeared first on Mediterranean islands such as Malta around 4000 B.C., and then spread to Spain and Portugal around 3000 B.C. The tradition reached France around 2800 B.C., and finally, Britain and Scandinavia around 2500 B.C.

BUILDING TYPES

1. Religious: Temples and shrines.
2. Memorial: Tombs and grave markers.

MEDIA AND TECHNIQUES

1. Gigantic blocks of rough-hewn stone, such as limestone, were used.
2. Wood and thatch probably preceded the use of stone; no structures survive.

3. Post-and-lintel construction was dominant.
4. Occasional use was made of the corbeled arch, vault, and dome.

DESIGN (See Figure 1-1.): The main types of structures include:

1. **Menhir**: A vertical stone or group of stones in parallel rows; probably a shrine; usually 10 to 20 ft. high.
2. **Dolmen**: Two or more vertical stones topped by a flat "capstone," usually 10 to 20 ft. high.
3. **Cromlech** (henge): A circular grouping of upright stones or dolmen; probably a temple for sun-worship; possibly also for astronomic calculations. Usually 10 to 20 ft. high and 25 to 100 ft. in diameter.
4. **Trefoil temple**: Mediterranean sites only; a clover-leaf shaped temple with corbeled domes, usually 30 to 40 ft. in diameter per section and 10 to 15 ft. high.
5. **Tomb**: Various plans developed including the single-chamber tomb based on the dolmen.
6. **Trilithon**: A specialized type of dolmen.

EXAMPLES

1. Carnac, France, menhirs and dolmen, c. 1500 B.C. (*J 28*)
2. Stonehenge, England, cromlech, c. 2000 B.C. (*G 1-14, 15; H 22, 23; J 29, 30*)
3. Tarxien, Malta, trefoil temples, c. 3000 B.C. (*H 20*)

FIGURE 1-1 Megalithic architecture.

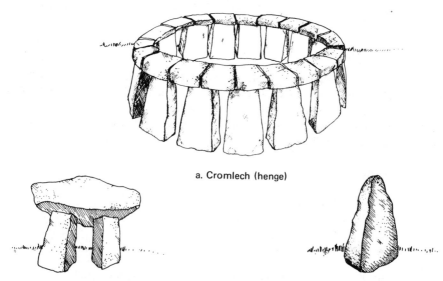

a. Cromlech (henge)

b. Dolmen

c. Menhir

4. Maes Howe, Orkney Islands (north of Scotland), single-chamber tomb, c. 2800 B.C. (*H 21*)

B. PAINTING

SUBJECT MATTER

1. Pottery from both regions was decorated with elements associated with agriculture (sun, water, grain, livestock) or with geometric or spiral designs.
2. Wall paintings, found only in the Near East, are generally religious. Occasionally, geometric patterns, hunting scenes, and genre scenes appear. Most unusual is the *Landscape with Volcano,* Çatal Hüyük, considered to be the first landscape painting of an actual place.

MEDIA AND TECHNIQUES

1. **Pottery**: Decorations were applied to handbuilt pottery either with paint, or by carving or embossing. Glazing had not yet developed.
2. **Wall Painting**: Dry fresco was applied with brushes to plastered walls. Technique was generally skillful.

DESIGN

1. Continuation of Mesolithic interest in groups of figures in action.
2. Forms usually flat, silhouette abstractions in a single color. Few attempts at depth, texture, or volume.

LOCATION, SIZE, AND SCALE

1. Pottery was portable; found throughout both regions. It was generally 3 in. to 24 in. high, with miniature decorations.
2. Wall painting has been found only in the Near East. Compositions generally covered entire walls, yet their scale was often miniature.

EXAMPLES

1. Çatal Hüyük, Anatolia: *Landscape with Volcano,* c. 6150 B.C. (*G 2-8, H 18, J 25*)
2. Çatal Hüyük, Anatolia: *Deer Hunt,* Level III, 5750 B.C. (*G 2-6, 7; J 22, J cpl 2*)

C. SCULPTURE

Sculpture was the least outstanding of the major arts in the Neolithic Era. Found only in the Near East are a few free-standing pieces representing the earth goddess.

In Anatolian shrines, relief carvings represent the earth-goddess or the bull symbol of the sun-god.

Found in both the Near East and Europe are designs of spirals, vines, and geometric patterns, in relief or engraved.

EXAMPLES

1. Çatal Hüyük, Anatolia: *Goddess Giving Birth,* c. 6200 B.C., baked clay, 8 in. high. (*H 15, J 24*)
2. Çatal Hüyük, Anatolia: *Seated Goddess,* c. 5900 B.C., painted baked clay, 4 in. high. (*G 2-5*)
3. Tarxien, Malta: Entrance slab of Temple, low relief designs, late third millennium, B.C., limestone. (*H 20*)

VOCABULARY

corbeled arch	genre	selective observation
cromlech	lintel	superpositioning
dolmen	megalithic	trefoil temple
dry fresco	menhir	trilithon
engraving	relief	twisted perspective
fertility figure		

2. Egyptian Art

SUMMARY

Egyptian art was very static; traditions were established early and were maintained for 3000 years.

Architecture: Tombs were most important. Three types: mastaba, pyramid, and rock-cut. Temples were also important. Architecture was married to painting and relief sculpture.

Painting: Tomb and temple decoration were most extensive. Style was rigid and formal with conventions controlled by tradition. Dry fresco on flat walls and over relief were most typical. Manuscript illustration was done on papyrus scrolls.

Sculpture: Relief: low relief and sunken relief were generally painted. Free-standing: enthroned rulers, standing rulers or officials, seated scribes, reserve ("ka") statues and heads, effigy figures, and deities were the most significant subjects.

CHRONOLOGICAL SURVEY

Pre-Dynastic Period c. 3500–3000 B.C.: Mounds were built over graves. There were some wall paintings and pottery.

Early Dynastic Period c. 3100–2670 B.C.: Mastaba tombs and small ceremonial objects were most typical. Stylistic conventions were established.

Old Kingdom 2670–2160 B.C.: The earliest monumental structures, paintings and sculptures date from this era. Pyramid-type tomb was developed.

First Intermediate Period 2135–2040 B.C.: Due to internal chaos, art was not very important.

Middle Kingdom 2040–1650 B.C.: Rock-cut tombs and mortuary temples were introduced.

Second Intermediate Period 1715–1550 B.C.: Due to invasions, art was unimportant.

New Kingdom 1550–1070 B.C.: Tombs and temples were colossal in size and scale. Painting and sculpture remained traditional.

Amarna Phase of the New Kingdom 1370–1350 B.C.: This was the only "deviant" era in Egyptian art and culture: style became soft, fluid, and sensuous.

Late Period 1070–333 B.C., Ptolemaic Period 333–30 B.C., and **Roman Domination 30 B.C.—A.D. 480**: Foreign rule of Egypt ended the cultural independence of Egyptian art.

A. ARCHITECTURE

We know a great deal about ancient Egyptian architecture because the Egyptians used stone for their most important structures. The surviving examples illustrate a very conservative history of building, with forms and details derived ultimately from domestic structures built of perishable materials.

BUILDING TYPES

1. **Tombs** were the most impressive and important structures.
 a. After the original oblong mounds, the following three types developed:
 (1) The mastaba.
 (2) The pyramid.
 (3) The rock-cut tomb.
 b. Each type developed first for pharaohs (kings) then became suitable for the nobility and upper classes.
2. **Temples** were also important throughout Egyptian history. The two types, mortuary and cult temples, relied on similar designs and plans.

MEDIA AND TECHNIQUES

1. Perishable materials such as mud-brick, palm trunks, and papyrus were used for domestic structures, and even palaces.
2. Wood, costly to import from Lebanon, was not widely used.
3. Stone (limestone, sandstone, and granite) was used exclusively for tombs and temples.
4. Post-and-lintel construction employed massive walls, piers and columns.
5. Arches and vaults were used occasionally for doorways and passageways.
6. Craftsmanship was precise. Mathematical measurements were based on the invention of geometry.

NOTE: One area of considerable invention in Egyptian architecture involved the use of **piers** and **columns**. The Egyptians were probably the first people to use these elements structurally as well as decoratively. Their use of these supports profoundly influenced the development of Aegean, Greek, and Persian architecture, which in turn affected the development of later western architecture. In addition to free-standing vertical supports, the Egyptians used "slices" of columns and piers as **engaged columns** and **pilasters** attached to walls to articulate these surfaces and to provide a geometric rhythm.

1. Tombs

Although the appearance of tombs changed in the course of their history, the basic symbolism was maintained. The interior decoration and furnishings of the

tombs complemented the architectural settings, and have provided us with a rather complete view of Egyptian life.

DESIGN: Tomb design progressed from simple subterranean graves to elaborate monumental complexes of buildings.

1. The **oblong mound** over a subterranean grave was used in the Pre-Dynastic Period. The body was mummified and surrounded with grave goods.
2. The **mastaba** (meaning "bench" in Arabic) tomb:
 a. Originated in the Early Dynastic Period.
 b. Was a rectangular brick structure with sloping sides. (See Figure 2-1a.)
 c. The components of a mastaba tomb are:
 (1) A burial chamber below ground.
 (2) A light shaft from the grave through the roof.
 (3) A small offertory chapel attached to the mastaba.
 (4) A serdab chamber for "reserve statues" (resting places for the "ka" or soul).
 d. Exterior decoration consisted of vertical grooves and niches which were usually painted.
 e. Interior decoration consisted of wall-painting, reliefs, and free-standing sculptures:
3. **Pyramid tombs** and related structures
 a. Originated in the Old Kingdom with the Step-Pyramid of Zoser, Third Dynasty.
 (1) Intermediate between a mastaba and a true pyramid.
 (2) The first monumental stone structure in Egypt.
 (3) It is a 204-foot stack of six mastabas of diminishing size. (See Figure 2-1b.)
 b. Great Pyramids at Giza, Fourth Dynasty.
 (1) Among the first true pyramid tombs; the biggest and best of all the Egyptian pyramids.
 (2) A true pyramid has a square base and four triangular sides coming to a point at the top.
 (3) The body is buried in a sealed chamber inside the pyramid or below ground. (See Figure 2-1c.)
 c. Pyramid exteriors were finished with smooth facing-stones; often highly-polished limestone.
 d. Interiors were lavishly decorated with painting and sculpture.
 e. Included within the tomb compound were storehouses, chapels, and living quarters for priests.
4. **Rock-cut tombs**
 a. Were introduced in the Middle Kingdom because pyramid tombs proved to be too expensive, and were attacked by grave robbers.

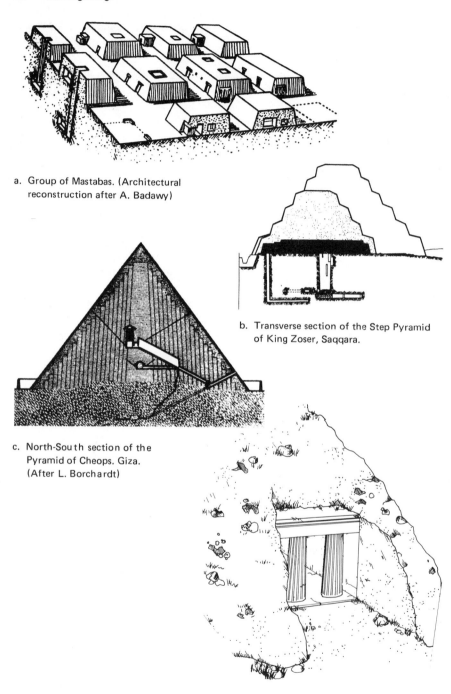

a. Group of Mastabas. (Architectural reconstruction after A. Badawy)

b. Transverse section of the Step Pyramid of King Zoser, Saqqara.

c. North-South section of the Pyramid of Cheops. Giza. (After L. Borchardt)

d. Entrance to a rock-cut tomb.

FIGURE 2-1 Egyptian tomb architecture.

b. Replaced pyramid tombs for royal burials.
c. Were carved out of the "living rock" of mountainsides. (See Figure 2-1d.)
d. "Reserve columns" supported the entrance and roof, and provided the only exterior decoration.
e. Interiors were decorated with painting, reliefs, etc.

EXAMPLES
OLD KINGDOM

1. Step Pyramid of Zoser, Saggara, c. 2750 B.C., 204 ft. high. (*G 3-6; H 50, 52, 53, 54; J 53, 54, 55, 56*)
2. Pyramids of Khufu (Cheops), Khafre (Chephren), and Menkure (Mycerinus), Giza, c. 2570–2500 B.C., originally 484, 471, and 218 ft. high. (*G 3-7, 8, 9; H 58, 59, 60; J 57, 58, 59*)

MIDDLE KINGDOM

Rock-cut tombs at Beni Hasan, c. 1800 B.C., 30 ft. high. (*G 3-16, 17, 18*)

2. Temples

DESIGN

1. The **Mortuary (funerary) temple** for funeral rites of pharaohs
 a. Began as an offering room attached to the east side of a mastaba.
 b. Later became a separate building within the sacred tomb precinct.
 c. Was isolated from the rock-cut tomb and became a dominant structure in the Middle and New Kingdoms. (See Figure 2-2a.)
 d. A typical mortuary temple was a complex structure with.
 (1) A statue-lined avenue leading to the temple.
 (2) Elaborate gardens in the fore-court.
 (3) Ground-level storage space supported by piers.
 (4) A ramp leading to the first terrace.
 (5) A first-terrace hypostyle hall or peristyle hall.
 (**Hypostyle hall**: a large rectangular room with a flat stone roof, supported by a "forest" of interior columns.)
 (**Peristyle hall**: an open, rectangular court surrounded by covered colonnades on all four sides.)
 (6) A ramp to the second terrace.
 (7) A second terrace (main level) with a pier-supported portico and open court in the center.
 (Some had small pyramids built on this level.)

(8) A private chapel and rock-cut tomb behind the mortuary temple.

(9) Decoration that included paintings, reliefs and sculptures.

2. The **Cult temple**, dedicated to a particular deity

 a. Began as a simple room or niche dedicated to a local god or household deity.

 b. Later evolved into a complex of many rooms, dedicated to national gods.

 c. The best-preserved and largest examples date from the New Kingdom and the Late Period.

 d. Space was mathematically arranged and standardized.

 A typical temple:

 (1) Was surrounded by an enclosure wall.

 (2) Had Pylons flanking the entrance. (These were towers with trapezoidal sides and were the tallest structures in the temple.)

 (3) Had a court leading from the pylons to a peristyle hall.

 (4) Had a hypostyle hall, lower and less open than the peristyle hall which it followed.

 (5) Had a sanctuary as its final space, enclosed by four windowless walls, a single door, and a low ceiling. (See Figure 2-2b.)

 e. Use of columns and piers was innovative and dramatic.

 f. Decoration included paintings, reliefs, and sculptures.

EXAMPLES

OLD KINGDOM

Valley Temple of Chephren, Giza, c. 2530 B.C. (*G 3-10, H 61*)

MIDDLE KINGDOM

Mortuary Temple of Mentuhotep III, Deir-el-Bahari, 2065 B.C. (*H 71*)

NEW KINGDOM

1. Mortuary Temple of Queen Hatshepsut, Deir-el-Bahari, c. 1500 B.C. (*G 3-21; H 74, 75; J 69, 70*)

2. Temple of Amon, Karnak, built over several centuries, c. 1300 B.C. (*G 3-26, 3-27; H 79*)

3. Temple of Amon-Mut-Khonsu, Luxor, c. 1300 B.C. (*G 3-28; H 77, 78; J 71, 72*)

4. Temple of Ramesses II, Abu Simbel, c. 1257 B.C., colossi approximately 60 ft. high. (*G 3-22, 23*)

PTOLEMAIC

Temple of Horus, Edfu, third to first century B.C. (*G 3-25, H 76*)

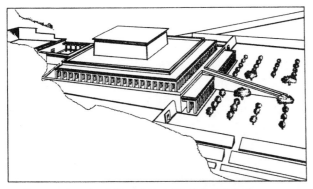

a. Funerary temple of Mentuhotep III. Deir-el-Bahari.
 (Architectural reconstruction after Dieter Arnold)

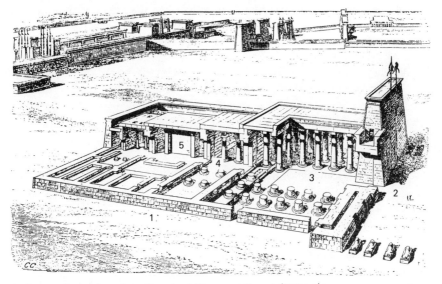

b. Perspective section of the Temple of Khonsu at Karnak (Chipiez):
 (1) enclosure wall (2) pylons (3) peristyle hall
 (4) hypostyle hall (5) sanctuary

FIGURE 2-2 Egyptian temple architecture.

B. PAINTING

It is important to remember that all of the arts formed a unified system in ancient Egypt. A building was incomplete without painting and sculpture, just as painting and sculpture were conceived against architectural settings.

PURPOSES: Paintings were created to complement the temples and the tombs. Every detail of human existence was represented on the walls, floors, and

ceilings to ensure the well-being of the pharaohs and nobles in the after-life, and to glorify the gods.

SUBJECT MATTER: Egyptian paintings expressed the major religious concepts and related everyday human existence to religion. Subjects were depicted in standardized forms.

Most of the subjects originated in the Early Dynastic Period and continued until the time of the Roman Empire.

1. **Tomb paintings** featured
 a. Scenes of the deceased making religious offerings.
 b. Funeral banquets.
 c. Boat journeys to the Netherworld.
 d. Scenes of the deceased being introduced to the after-life by protective gods.
 e. **Genre** scenes. (Scenes of everyday life were carefully detailed in tomb decorations.)
2. **Temple paintings** featured
 a. Offerings to the gods by the rulers.
 b. Mythological stories (life cycles of the gods, etc.).
 c. Rulers in symbolic poses:
 (1) Battle hero.
 (2) Protector of Egypt.
 (3) Descendant of the sun-god, Amon-Re.

MEDIA AND TECHNIQUES

1. **Dry fresco.** Pigment was applied to lime-plastered wall surfaces after the plaster had dried. Paint dried to a dull finish.
2. Relief carvings were frequently covered with dry fresco.
3. **Illuminated manuscripts** were painted on papyrus scrolls.
4. Technique was generally linear and work was very detailed.
5. Skill was excellent in the Old Kingdom and declined in later periods.

DESIGN

1. Colors were bright and intense.
2. Figures were outlined in black and filled in with color.
3. No color modulation or shading of figures was done.
4. Style was standardized in the Early Dynastic Period and maintained, except in the Amarna Phase of the New Kingdom.
5. Twisted perspective was used for people; poses were rigid.

6. A more naturalistic approach was used for animals and plants.
7. Hierarchic scaling was used to indicate social rank of figures.
8. Landscape was schematized in a manner similar to a road map.
9. Figures were often represented in registers rather than in naturalistic space.

LOCATION, SIZE, AND SCALE

1. Tombs and temples
 a. Walls, floors, and ceilings were decorated with paintings.
 b. Illuminated manuscripts were found in tombs and temples.
2. Domestic structures (houses and palaces) are assumed to have been painted.
3. Size varied with location and era, with New Kingdom works generally being the largest.
4. Scale is considered monumental.

EXAMPLES
WALL PAINTING
PREDYNASTIC

Men, Boats, and Animals, Hierakonpolis, before 3000 B.C., painted plaster. (*G 3-1, H 45, J 48*)

OLD KINGDOM

1. *Geese of Medum,* c. 2600 B.C., dry fresco, 18 in. high. (*G 3-15, H cpl 6*)
2. *Birds in Flight,* Tomb of Neferirkara, c. 2400 B.C., dry fresco. (*H 69*)

MIDDLE KINGDOM

Feeding the Oryxes, Tomb of Khnumhotep, c. 1900 B.C., dry fresco. (*G 3-19, J 68*)

NEW KINGDOM

1. *Banquet Scene* and *Nebamun Hunting Birds,* Tomb of Nebamun, c. 1400 B.C., dry fresco, 32 by 38 in. (*G 3-30, 3-32; H 80, H cpl 8*)
2. *The Daughters of Akhenaten,* c. 1360 B.C., dry fresco, 12 by 16 in. (*J cpl 4*)

ILLUMINATED MANUSCRIPT

Last Judgment Before Osiris, Books of the Dead, painted papyrus. (*H 87*)

C. SCULPTURE

1. Reliefs and Engravings

SUBJECT MATTER: Same as painting. Many subjects originated on cosmetic palettes of slate, made in the Early Dynastic Period, and were used throughout the history of ancient Egypt, except during the Amarna Phase of the New Kingdom.

MEDIA AND TECHNIQUES

1. Carved slate, limestone, sandstone, granite, schist, and wood were used.
2. Two techniques
 a. Relief carving: the background was cut away to reveal the image.
 b. Engraved carving: Images were cut into the background. (This is sometimes called sunken relief.)
3. Carving was geometric, linear, and precise.
4. Forms generally had flattened front surfaces.
5. Carvings were often covered with a thin coating of stucco or plaster and painted in dry fresco.

DESIGN, LOCATION, SIZE, AND SCALE: See Painting.

EXAMPLES
EARLY DYNASTIC

Narmer Palette, c. 3200 B.C., slate, 25 in. high. (*G 3-2; H 47, 48; J 49, 50*)

OLD KINGDOM

1. *Mycerinus Between Two Goddesses,* from the Valley Temple of Mycerinus, Giza, c. 2570 B.C. schist, 38 in. high. (*H 63*)
2. *Panel of Hesira,* c. 2750 B.C., wood, 45 in. high. (*G 3-3, 4; H 57; J 51*)
3. *Cattle Crossing a River,* Tomb of Ti, 2400 B.C., limestone. (*H 68, J 66*)
4. *Hippopotamus Hunt,* Tomb of Ti, c. 2400 B.C., painted limestone, 48 in. high. (*G 3-14, H cpl 5, J 65*)

NEW KINGDOM

1. *Blind Harper,* Tomb of Patenemhab, 1552–1306 B.C. (*H 81*)
2. *Brother of the Deceased,* Tomb of Ramose, 1375 B.C. (*J 74*)
3. *Workmen Carrying a Beam,* Tomb of Horemheb, 1325 B.C. (*J 77*)

PTOLEMAIC

Carving on pylon of Temple of Horus at Edfu, sunken relief, 237–212 B.C. (*G 3-25*)

2. Free-standing Sculpture

SUBJECT MATTER

1. Human figures:
 a. Enthroned ruler or rulers.
 b. Standing ruler, official or deity.
 c. Seated scribe.
 d. Reserve heads and reserve statues.
 e. Effigy figures.
2. Animal guardian statues: cats, lions, hawks, rams, etc.

MEDIA AND TECHNIQUES

1. Materials were the same as relief. Diorite and obsidian were also used.
2. Free-standing pieces often had unnecessary material remaining between torso and limbs of figures, giving the works a relief-like appearance.

DESIGN

1. **Enthroned rulers** were generally very rigid, formal, and frontal in posture and expression. These works were often the official portraits of the rulers and were made with the best materials and craftsmanship.
2. **Standing figures** were also rigid, formal, and frontal. Many are shown with the left foot forward as if the figure were walking, but the weight is balanced on both legs as if the figure were standing still.
3. **Seated scribe** images always showed the scribe (writer) seated on the floor with legs crossed, papyrus scroll across his lap, hand poised to write, eyes up and alert as if waiting for dictation.
4. **Reserve heads** and statues were generally careful portraits of particular individuals; intended as "body" for the soul in after-life should anything happen to the mummified body.
5. **Effigy figures** were generally small, toy-like works, constructed in groups to depict daily activities. They were part of the grave goods found in tombs.
6. **Guardian statues** were generally large and imposing. In groups, they were used to line avenues leading to tombs, temples, and palaces. Sometimes they stood alone. *The Sphinx at Giza* is the most colossal example of a guardian statue.

LOCATION, SIZE, AND SCALE

1. Free-standing figures were put inside tombs as well as displayed outdoors.
2. It is assumed that sculptures also decorated homes and gardens.
3. Size was generally life-size and larger. Images of the pharaohs were especially large in the New Kingdom to convey power and status.
4. Scale was monumental.

EXAMPLES
OLD KINGDOM

1. *King Zoser Seated,* c. 2750 B.C., limestone, 55 in. high. (*H 55*)
2. *The Great Spinx at Giza,* c. 2530 B.C., limestone, 65 ft. by 240 ft. (*H 62, J 60*)
3. *Chephren Seated,* c. 2530 B.C., diorite, 66 in. high. (*G 3-11, H cpl 4, J 61*)
4. *Prince Rahotep and Wife Nofret,* c. 2600 B.C., painted limestone, 47 in. high. (*H 64, J cpl 3*)
5. *Bust of Ankhaf,* c. 2550 B.C., limestone, 22 in. high. (*H 65, J 63*)
6. *Kaaper (Sheikh-el-Beled),* c. 2400 B.C., wood, 43 in. high. (*G 3-13, H 66*)
7. *Seated Scribe,* c. 2400 B.C., limestone, 21 in. high. (*H 67, J 64*)

MIDDLE KINGDOM

1. *Princess Sennuwy,* c. 1950 B.C., granite, 68 in. high. (*H 73*)
2. *Head of Sesostris III,* c. 1850 B.C., granite. (*G 3-20, H 72, J 67*)

NEW KINGDOM

Colossal statues of Ramesses II, Abu Simbel, 1275 B.C., sandstone. (*G 3-22*)

D. MINOR ARTS

The Egyptians were excellent metalsmiths and jewelers. They produced many fine hammered gold reliefs inlaid with precious stones, carved onyx, and quartz. Among the best-known works are the many pieces found in the tomb of Tutankhamen. The Egyptians also produced handmade glass objects of great value.

EXAMPLES
NEW KINGDOM

1. *Coffin covers of King Tutankhamen,* c. 1360 B.C., gold, wood with gold-leaf, lapis lazuli, and semiprecious stones, approximately 73 in. high. (*H cpl 10, J cpl 5*)

2. *Throne of Tutankhamen,* c. 1360 B.C., wood, gold, faience, silver, glass paste, semiprecious stones, 41 in. high. (*H 85*)

THE AMARNA PHASE OF THE NEW KINGDOM

During the Amarna Phase of the New Kingdom, the art of Egypt had a totally different quality. The changes are most easily seen in the surviving reliefs and free-standing sculptures from this era. It has been difficult to study the architecture as most of it was viciously destroyed by Akhenaten's successors.

The style of the Amarna era can be described by the following:

1. Curvilinear and sensual (often described as "feminine") where traditional forms were geometric and angular (often called "masculine.")
2. Round forms suggestive of movement and life replaced stiff and flat figures.
3. Naturalistic effects, which had been confined to images of plants and animals, now extended to images of people, including the pharaoh and his family.

EXAMPLES

1. *Akhenaten,* pillar statue, c. 1375 B.C., sandstone, 13 ft. high. (*G 3-33, H 83*)
2. *Akhenaten and His Family Sacrificing to Aten,* c. 1360 B.C., limestone relief. (*H 84*)
3. *Bust of Nefertiti,* c. 1365 B.C., limestone, 20 in. high. (*G 3-34, H cpl 9, J 76*)
4. *King Smenkhkare and Meritaten,* relief, c. 1360 B.C., limestone, 69 in. high. (*G 3-35*)

VOCABULARY		
capital	"ka"	pylon
column	mastaba	pyramid
cosmetic palette	peristyle hall	reserve column
engaged column	pharaoh	reserve statue
frieze	pier	rock-cut tomb
hypostyle hall	pilaster	serdab

③. Ancient Near Eastern Art

SUMMARY

Architecture: Temples most important; their form was established in the Protohistoric Period and maintained until the Persian Era. Palaces were developed by the Assyrians and Persians.

Painting: Not a vital form in the Near East.

Sculpture: Free-standing: Small figures of animals and worshippers, life-size images of rulers and deities, and gigantic partially free-standing guardian figures. Relief: Scenes of worship, hunting, and tribute on stelae, walls, and decorative objects; carved or inlaid.

CHRONOLOGICAL SURVEY

Protohistoric 4000–3000 B.C.: Basics of religion, culture, and art established. Cylinder seals, some pottery. Rudiments of fortifications, houses, temples.

Sumerian 3500–2500 B.C.: Temples and religious sculptures of worshippers most characteristic. Unique tomb goods. Sculptural conventions established.

Akkadian 2350–2180 B.C.: Adopted Sumerian language and cultural traditions. Known for metalwork. Temples followed Sumerian models.

Neo-Sumerian 2125–2025 B.C.: Cities of Telloh-Lagash and Ur. Known for rebuilt temples and free-standing figures of rulers. Introduced the temple form to North Mesopotamia and Iran.

Babylonian 1900–1750 B.C.: Emphasis on relief sculpture and mud-brick. Some free-standing and relief sculpture in stone. Buildings larger.

Hittite 1600–1150 B.C.: Known for cyclopean walls and colossal guardian animals.

Assyrian 1000–612 B.C.: Palaces and temples competed for importance. Major subjects for relief sculpture were lion hunts and battles. Lamassu guardian figures (bull-men) were partially free-standing.

Neo-Babylonian 612–539 B.C.: Emphasis on large mud-brick religious and civic buildings decorated with brightly colored glazed brick reliefs.

Achaemenid Persian 539–330 B.C.: Best known for palace-cities such as Susa and Persepolis, decorated with relief carvings of tribute scenes. Beginning use of columns for construction. This period is also known for metalwork by nomad craftsmen.

A. ARCHITECTURE

The Near East did not possess an abundant supply of building stone or timber. Mud-brick was used extensively and since it is not especially durable, our knowledge of ancient architecture in this region is inadequate.

BUILDING TYPES

1. Temples were the most important structures except during the Assyrian and Persian eras. The Persians built no temples because they worshipped the sun-god outdoors.
2. Palaces were the most important structures during the Assyrian and Persian periods.
3. Civic structures included fortifications and city gates.

1. Temples

Before 1000 B.C., the time of the Assyrian Empire, the most important structure in any city-state was the temple, which often served as an administrative as well as a religious center.

MEDIA AND TECHNIQUES

1. Mud-brick and fired brick over foundations of rubble were the most common building materials. Ziggurats were built of solid mud-brick with a facing of baked brick laid in bitumen (tar). Chopped straw gave strength to mud-brick.
2. Wood was scarce and was used only for reinforcement and doorjambs.
3. Post-and-lintel principles of construction were used.

DESIGN

1. Temple architecture consisted of a stepped, mud-brick platform, called a "ziggurat" supporting a rectangular temple, called a "shakhuru" on top.
 a. The **ziggurat** served to elevate the temple above the common ground, closer to heaven. It had a square base whose corners were oriented to the four points of the compass.
 b. The **shakhuru** (which means "waiting room") contained an image hall, storage rooms, and living quarters flanking a corridor. (See Figure 3–1.)
2. Walls were blockish, massive, windowless, and sloped inward.
3. Wall surfaces had vertical grooves, and niches for sculpture.
4. Paint was used extensively on both interiors and exteriors.
5. Glazed tiles and clay cones were attached to walls for colorful decoration in geometric patterns.

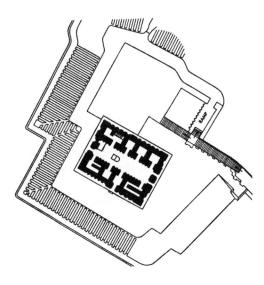

Figure 3-1
Plan of the White Temple
on its Zuggurat. (After
H. Frankfort)

LOCATION, SIZE, AND SCALE

1. Temples were built throughout the Near East.
2. Structures averaged 60 ft. in height:
 a. ziggurat: 40 to 50 ft. high, one or more stages.
 b. shakhuru: 10 to 25 ft. high, one story.

EXAMPLES

1. (Sumerian) White Temple and Ziggurat, Uruk, c. 3000 B.C. (*H 88, 89; J 79, 80, 81*)
2. (Neo-Sumerian) Ur-Nammu's Temple and Ziggurat, Ur, c. 2100 B.C. (*G 2-9, 10; H 90; J 82*)

2. Civic Structures

BUILDING TYPES

1. **City walls** enclosed and defended city-states:
 a. Plans for cities and walls were irregular rectangles.
 b. Walls were blockish, massive, often 10 ft. thick and 40 ft. high.
 c. Mud-brick was the most commonly used material.
 d. The Hittites introduced **cyclopean** stone walls.
 (The name refers to stones so large that later people thought they had been assembled by a mythological race of giants, the Cyclops.) No mortar was used.

2. **Gateways** into cities were decorated and emphasized in the following ways:
 a. Mud-brick and glazed brick were used for arches and vaults.
 b. Glazed brick was used for relief decorations.
 c. Stone guardians were introduced by the Hittites and continued by the Assyrians and Persians.

EXAMPLES

1. (Hittite) City wall, Boghazköy, Turkey, 1400 B.C. (*G 2-22, H 103, J 91*)
2. (Hittite) Lion Gate, Boghazköy, 1400 B.C., lions 7 ft. high. (*G 2-22, H 103, J 91*)
3. (Neo-Babylonian) Ishtar Gate, Babylon, c. 575 B.C., glazed brick, 47 ft. high. (*G 2-30, 31; H 112; J cpl 7*)

3. Palaces

The earliest known palace, c. 2600 B.C., looked like a temple. It was raised on a platform, enclosed by a protective wall, and had the same floor plan as a temple. It was not until 1000 B.C. that palaces became important in their own right, under the Assyrian Empire.

MEDIA AND TECHNIQUES

1. Mud-brick was used for most parts of Assyrian palaces, and for the walls of Persian palaces.
2. Stone was used by the Assyrians for important walls and entrances. Persians used stone for platforms, gates, stairs, columns, and doorjambs.
3. Wood was used by the Persians for small columns and roofs.
4. Post-and-lintel construction was dominant.
5. Arches and barrel vaults were used for some Assyrian entrances.

DESIGN

1. **Assyrian palaces**
 a. Interconnecting chambers, not detached buildings.
 b. Rectangular rooms arranged around central courtyards.
 c. Emphasis on horizontal elements, massive forms.
 d. Structures elevated and surrounded by mud-brick walls.
2. **Persian palaces**
 a. Separate buildings spread out over site; open plans.
 b. Square rooms and buildings.
 c. Emphasis on vertical elements, light, open forms.
 d. Elevated like Assyrian palaces, enclosed by mud-brick walls.

 e. Use of the column:
 (1) Not used structurally in the Near East before the Persian Empire.
 (2) Resulted from contact with Egypt, Crete, and Greece.
 (3) Unique forms developed by the Persians.

EXAMPLES

1. (Assyrian) Palace of Sargon II, Khorasbad, Iraq, 742-706 B.C., 150,000 sq. ft., elevated 40 ft. above the city. (*G 2-23, 24; H 104, 105, 106; J 92, 93*)
2. (Persian) Audience Halls and Palaces of Darius and Xerxes, Persepolis, Iran, c. 500 B.C., 400 by 400 ft., 60 ft. high, built on a 40 ft. terrace. (*G 2-32, 33, 35; H 113, 115; J 100*)

B. PAINTING

Very little painting from the Ancient Near East has survived. There is an abundance of painted **pottery** from the Protohistoric Period, but pottery from later times is strictly utilitarian. The few fragments of **wall painting** that have been found generally depict gods and goddesses, scenes of war, hunting, and rituals.

C. SCULPTURE

Many of the sculptural forms, conventions, and stylizations were established in the Protohistoric and Sumerian periods and continued unbroken until contact was made with the Greeks in the sixth century B.C.

PURPOSES AND SUBJECT MATTER: Most of the sculptures involved the search for immortality and prestige. Propaganda was also important. The gods and their worshippers were immortalized in carved and cast images; rulers and dynasties were commemorated in scenes of military victory, receipt of tribute, and sacred rituals. Human laws and decrees were impressed into clay tablets or chiseled into stone boundary stelae (**kudurru**).

1. Figures include gods and goddesses, rulers, heroes (such as Gilgamesh), worshippers, sacred animals, and guardian creatures.
2. Narrative scenes include mythological rituals and events, offerings and tribute (both religious and political), and combat (both military and ritual).

MEDIA AND TECHNIQUES

1. Carved reliefs and free-standing works in ivory, bone, alabaster, brick, limestone, diorite, basalt, and granite.

2. Inlay of lapis-lazuli, mother-of-pearl, ebony, carnelian.
3. Cast and hammered bronze, silver, gold, and alloys for reliefs and free-standing pieces.
4. Modeled clay and brick for reliefs and free-standing work.
5. Emphasis on linear detailing regardless of the physical size or the materials.
6. Workmanship of metalwork generally superior to stone pieces, with the exception of Assyrian and Persian stone reliefs, which were excellent.

DESIGN: Throughout history, Near Eastern sculpture emphasized:

1. **Static figures**: Poses did not suggest movement; repeated poses, costumes, and faces gave the effect of static figures.
2. **Twisted perspective**: This was used in relief sculpture until the Persian Dynasty. (Fairly accurate perspective and proportions were used in free-standing work.)
3. **Figures in settings**: Figures were usually in groups or scenes with some form of setting to imply landscapes or architectural interiors. When lines of figures were longer than the surfaces of sculptures, the figures were spread over several "registers" or parallel ground-lines.
4. **Hierarchic scale**: Figures were scaled in size to reveal their social rank or class.
5. **Conventionalization**: All approaches to form are conventions (practices established by consent or general usage). However, when a culture puts more emphasis on maintenance of traditions than on artistic originality or invention, its approach to form is called "conventionalization." The Near East maintained certain conventions throughout its history. Most of them pertained to representations of **people and gods**:
 a. Continuous eyebrows shaped like curved "v's."
 b. Wide, staring eyes intended to reveal pure thoughts.
 c. Tight spiral curls for hair and beard.
 Nature was also conventionalized.
 a. Wavy and zig-zag lines meant rivers, water.
 b. Rows of semicircles meant mountain tops.
 c. Circles with radiating lines were sun and stars.
 d. Leaves and flowers stood for whole trees and plants.

LOCATION, SIZE, AND SCALE: Sculptures of various types have been found throughout the Near East.

1. **Free-standing sculpture**:
 a. Intended for temples and palaces.
 b. Varied in size from small objects less than 12 inches high to colossal figures of people and animals larger than life-size.
 Note: The guardian lions (Hittite) are not entirely free-standing, and guardian lamassu (Assyrian) are a combination of relief and free-standing sculpture.

2. **Relief sculpture:**
 a. Used as decorations for walls of temples, palaces, and gates.
 b. Most reliefs were over life-size, and monumental in scale.

EXAMPLES

FREE-STANDING SCULPTURE

1. (Sumerian) Ceremonial objects from Royal Tombs at Ur, c. 2600 B.C., various materials and sizes. (*G 2-14, 15, 16; H 94, 95, cpl 11; J 85, cpl 6*)
2. (Sumerian) Statues from Abu Temple, Tell Asmar, c. 2600 B.C., marble, to 30 in. high. (*G 2-12, 13; H 93; J 84*)
3. (Akkadian) *Head of a Ruler,* c. 2300 B.C., cast bronze, 15 in. high. (*G 2-18, H 97, J 86*)
4. (Neo-Sumerian) *Gudea* figures, c. 2150 B.C., diorite, various sizes. (*G 2-20; H 99, 100; J 88, 89*)
5. (Hittite) *Lion Gate,* Boghazköy, c. 1400 B.C., 7 ft. high. (*G 2-22, H 103, J 91*)

RELIEF SCULPTURE

1. (Sumerian) Alabaster vase from Uruk, c. 3350 B.C., 36 in. high. (*H 91*)
2. (Akkadian) *Stele of Naram-Sin,* c. 2300 B.C., sandstone, 78 in. high. (*G 2-19, H 98, J 87*)
3. (Babylonian) *Stele of Hammurabi,* c. 1760 B.C., basalt, 84 in. high, (relief portion 28 in. high). (*G 2-21, H 102, J 90*)
4. (Assyrian) Reliefs from Nimrud, c. 850 B.C., and Nineveh, c. 650 B.C., limestone and alabaster, various sizes. (*G 2-26, 27, 28, 29; H 108, 109, 110, 111; J 94, 95, 96*)
5. (Assyrian) Lamassu guardians, Khorsabad, c. 720 B.C., limestone, c. 14 ft. high. (*G 2-25, H 106, J 93*)
6. (Persian) Reliefs from Persepolis, c. 490 B.C., limestone. (*G 2-32, 34, 35, 36; H 114; J 100, 101, 102*)

VOCABULARY

bas-relief	cyclopean construction	lamassu
city-state	Gilgamesh	votive
conventionalization	hierarchic scale	ziggurat
cuneiform	kudurru	

4. Aegean Art

SUMMARY

I. Cycladic or Early Minoan Period c. 2800–1550 B.C.

Art of the Cyclades Islands, also called Pre-Palace Period.

Architecture: Some "Neolithic" tombs in Megalithic style, before 2500 B.C.
Painting: None.
Pottery: Hand-built stoneware variously decorated.
Sculpture: Free-standing, portable sculptures in alabaster and marble, most less than half life-size. "Fiddle" and "plank" female "fertility" figures; some male musician sculptures in "tubular" style.

II. Minoan Period c. 2000–1400 B.C.

Art of Crete during the Middle and Late Minoan periods, also called Old and New Palace periods.

Architecture: The palace was the most important building type. Knossos is the most famous example. Open plans and organic arrangement of space, especially for hilltop sites. No fortifications, tombs, or temples of any significance.
Painting: Wall painting very important in palace decoration. Buon fresco used in bright, free, fluid, lively scenes.
Sculpture: Free-standing, portable sculptures, usually small and made of precious materials such as gold, faience and steatite. Also vases and cups of steatite and gold, decorated with "bull jumping" and harvest scenes.

III. Mycenaean Period c. 1500–1100 B.C.

Art of the Greek mainland before the arrival of the Greeks, also called the Late Helladic period.

Architecture: Fortified citadels, such as Tiryns and Mycenae. Also grave circles, beehive (tholos) tombs built in the cyclopean manner. Corbeled arch and vault used.
Minor Arts: Metalsmithing and pottery were more important than painting or sculpture. Repoussé technique highly developed.

The term "Aegean art" includes three distinct cultures: Cycladic, Minoan, and Mycenaean. Because of extensive trade contacts, cultural similarities, and successive development, these cultures are discussed together. All three served as part of the cultural foundation of the Greek civilization.

I. CYCLADIC ART: c. 2800–1550 B.C.

The Neolithic culture of the islands of the Aegean Sea, including the Cycladic Islands and Crete, is called "Cycladic." This New Stone Age culture had no written language and has left few traces of its existence.

A. ARCHITECTURE

Very little architecture from this era has been found. The few remaining works are stone tombs built in the Megalithic style.

B. PAINTING

Current knowledge indicates that painting was unimportant in this era.

C. POTTERY

The earliest Cycladic ceramics were hand-built, thick-walled jugs and cups. The shapes were irregular and rather squat. Although unpainted, they were decorated with embossed or stamped linear and geometric patterns.

The later ceramic works were also hand-built, but had thinner walls and more elongated shapes. By 2000 B.C., the pottery was painted with designs in black **engobe** (liquid clay, or "slip") and decorations progressed from geometric to curvilinear, and finally to naturalistic. From 2000 to 1550 B.C., the pottery was influenced by the developing culture of the Minoans.

D. SCULPTURE

The most striking Cycladic art works—and the most numerous—are the small sculptures of human figures.

PURPOSE: Religious. Most have been found in tombs and graves.

SUBJECT MATTER: All of the statuettes are human figures.

1. Nude female figures (possibly earth-goddesses or fertility figures) are most common.
2. Male figures include
 a. Seated lyre players.
 b. Standing flute players.
 c. Non-musicians (extremely rare).

MEDIA AND TECHNIQUES

1. Figures were carved of alabaster, marble, and gypsum.
2. Forms were shaped by cutting, chiseling, and gouging.
3. Surfaces were smoothed and polished with powdered abrasives.
4. Red paint originally decorated most of the figures.

DESIGN

1. Approach to form depended on the subject:
 a. Female figures are either "plank idols" or "fiddle idols" because of flat, rigid shapes and inactive poses.
 b. Male figures are tubular in form—more rounded; usually in active poses.
2. All statuettes were complete figures; no parts were omitted.
3. Details have been simplified and streamlined.
4. Unnecessary stone was removed, increasing the openness of forms. [Compare an Egyptian seated figure with a male Cycladic seated figure. The Cycladic piece is more open.]

LOCATION, SIZE, AND SCALE

1. Most surviving pieces were found in tombs and graves.
2. Sculptures are generally 8 to 30 inches tall.
3. Scale is considered monumental.

EXAMPLES

1. *Female Idol,* from Amorgos, c. 2500 B.C., marble, 30 in. high. (*H 118, H 109*)
2. *Female Idol,* from Syros, c. 2500 B.C., marble, 9 in. high. (*G 4-1*)
3. *Lyre Player,* from Keros, c. 2500 B.C., marble, 9 in. high. (*G 4-2, H 119*)

II. MINOAN ART: c. 2000–1400 B.C.

"Minoan" is the name of the culture of the island of Crete from c. 2000 to 1400 B.C.

A. ARCHITECTURE

BUILDING TYPES

1. **Palaces** were the most important Minoan structures.
2. Religious structures were rare, although **shrines** were often erected in natural caves or groves, and in palaces.

MEDIA AND TECHNIQUES

1. Stone was used for massive walls, foundations, and roofs.
2. Timber was used for columns, doorjambs, and beams.
3. Post-and-lintel construction was used exclusively.

DESIGN

1. Palace plans were irregular, asymmetrical.
2. Rooms were constructed on various levels around rectangular courtyards and open terraces.
3. Palaces sprawled over hillside sites without fortifications.
4. Open courtyards, terraces, light shafts, and windows provided light, open interiors, and casual structures.
5. The Minoan column was tapered downward (smaller at the bottom).
6. The Minoan capital was cushion shaped.
7. Bright, intense colors—red, blue, yellow—covered all surfaces.

LOCATION, SIZE, AND SCALE

1. Palaces were located at coastal sites including Kato Zakro, Knossos, Mallia, and Phaistos.
2. Palaces frequently occupied one to two acres and had 100 to 200 rooms; many were three stories high.
3. Scale was human, not colossal, because of the emphasis on
 a. Horizontal elements and comfortable proportions.
 b. Open plans and light, airy rooms.
 c. Lively, expressive painted decorations.

EXAMPLE

Palace at Knossos, c. 1600–1400 B.C. (*G 4-5, 6, 7, 8, 9; H 122, 123, 124; J 108, 110*)

B. PAINTING

Painting and architecture formed a unified whole. The combination of the two was most important.

PURPOSES: Religious and decorative.

SUBJECT MATTER

1. People in action scenes, such as bull-jumping, processionals, ceremonials, and dancing.
2. Landscapes and seascapes.
3. Nature, such as birds, animals, and flowers.
4. Motifs assumed to be symbolic, since they are repeated everywhere: a single Minoan column, snakes, axes, and bulls.

MEDIA AND TECHNIQUES

1. True fresco (**buon fresco**) was used on wet-plaster wall surfaces. Since the pigment is absorbed into the plaster as it dries, this method is much more permanent than dry fresco.
2. Drawing and painting were very skillful.

DESIGN

1. Colors were very bright and intense; not always natural.
2. Forms were created with black outlines; color was filled in.
3. Males were colored red, females yellow.
4. Anatomy was fairly accurate except for eyes in profile.
5. Poses were fluid, never stiff.
6. Minoan painting was generally curvilinear, joyous in mood.

LOCATION, SIZE, AND SCALE

1. Paintings were placed on both interior and exterior walls of palaces.
2. The size was generally large, covering entire walls.
3. The scale was generally monumental.

EXAMPLES

1. *Toreador Fresco* (*Bull Dance*), Knossos, c. 1500 B.C., 32 in. high. (*G 4-11, H 125, J cpl 9*)
2. *La Parisienne,* Knossos, c. 1500 B.C., 10 in. high. (*G 4-12*)
3. *Dolphins,* Queen's Megaron, Knossos, c. 1500 B.C. (*G 4-9, H 129, J 110*)
4. *Cat Stalking Pheasant,* Hagia Triada, c. 1600 B.C., 21 in. high. (*J 113*)
5. *Landscape from Thera,* before 1500 B.C. (*H cpl 12*)

C. POTTERY

SUBJECT MATTER

1. Marine life.
2. Plant forms.

MEDIA AND TECHNIQUES

1. The potter's wheel was introduced around 2000 B.C.
2. Clay body was usually buff or reddish, and fine-grained.
3. Work is called "eggshell ware" because of thin walls.
4. No glazes were used; decoration was applied with engobe.

DESIGN: All pieces had elegant, elongated shapes. There were three styles:

1. **Kamares ware**, c. 2000–1600 B.C. The decorations
 a. Were abstracted from nature.
 b. Were curvilinear and dynamic.
 c. Covered the entire surface.
 d. Appeared as white-on-black.
 e. Had occasional details of red and yellow.
2. **Marine Style**, c. 2000–1600 B.C. The decorations
 a. Featured naturalistic recognizable sea life.
 b. Covered the entire container.
 c. Appeared as black-on-white.
3. **Palace Style**, c. 1500–1400 B.C. The decorations
 a. Featured stiffened, formalized subjects from nature.
 b. Covered the entire container.
 c. Emphasized lines appearing as black-on-white.

EXAMPLES

1. *Beaked Kamares Jug,* from Phaistos, c. 1800 B.C., 10 in. high. (*G 4-4, H 120*)
2. *Octapus Jar,* from Gournia, c. 1600 B.C., 8 in. high. (*G 4-13. H 121, J 112*)
3. *Three-handled Jar with Papyrus Decorations,* c. 1500 B.C., 53 in. high. (*G 4-14*).

D. SCULPTURE

PURPOSES AND SUBJECT MATTER: Since most examples were found in sacred places, their purpose is assumed to be religious. Subjects included:

1. Snake Goddesses or priestesses.
2. Human figures, especially acrobats and bull-jumpers.
3. Bulls and bull-heads. Bull-heads were used as rhytons (drinking cups).

MEDIA AND TECHNIQUES

1. Media included: terracotta (often painted), **faience** (glazed earthenware), ivory (often combined with gold), hammered gold, and steatite (a soft carving stone).
2. Pieces were modeled, carved, or hammered, depending on the material.
3. The quality of workmanship was excellent.

DESIGN

1. Curvilinear and dynamic forms were preferred.
2. Pieces emphasized expressive movement and joy.
3. Details were often carved or painted onto forms.

LOCATION, SIZE, AND SCALE

1. Most sculptures were found in shrines, groves, and caves.
2. Most objects are portable; very small in size.
3. The scale varies from piece to piece.

EXAMPLES

1. *Snake Goddess,* Knossos, c. 1600 B.C., faience, 14 in. high. (*G 4-17, H 128, J 11*)
2. *Harvester Vase,* c. 1500 B.C., steatite, 11 in. high. (*G 4-15, 16; H 129; J 114*)

3. *Bull Rhyton,* c. 1500 B.C., steatite, 8 in. high without horns. (*H 130*)
4. *Ivory Bull-Jumper or Acrobat,* Knossos, c. 1500 B.C., bronze, 6 in. high. (*illustrated elsewhere*)

III. MYCENAEAN ART: c. 1500-1100 B.C.

The term "Mycenaean" refers to the culture of mainland Greece from c. 1500-1100 B.C., and is named for the city, Mycenae, which yielded the first archaeological traces of this culture.

A. ARCHITECTURE

BUILDING TYPES

1. Fortified citadels or strongholds.
2. Palaces within citadels.
3. Tombs: grave circles with shaft graves (1600–1400 B.C.) and tholos tombs (1400–1100 B.C.).

MEDIA AND TECHNIQUES

1. Citadels were fortified with cyclopean stone walls.
2. Palaces were built of sun-dried mud-brick, with true fresco decorations on the walls.
3. Tombs were built of stone.
4. The corbeled arch, vault, and dome of stone were used for passageways within citadels (vault), gateways into citadels (arch), and tholos-type tomb construction (dome).
5. No mortar was used in stone construction.

DESIGN

1. **Citadels** were irregular rectangular clusters of buildings with entrance gates framed with trilithons and corbeled arches.
2. **Palaces** included various rectangular rooms:
 a. The **megaron** was the most important.
 (1) Used as an audience hall or shrine, it was
 (2) Rectangular, and enclosed on three sides.
 (3) Two columns framed the porch in front.
 (4) Four columns inside held up the roof and surrounded the circular hearth in the center.

(5) The megaron is considered to be the source of the Greek temple.
 b. True-fresco wall and floor paintings complemented the architecture in all the palace rooms.
3. **Tombs**
 a. The grave circle was an early development. A stone wall encircled the grave compound, and shaft graves were dug within the circle.
 b. The tholos tomb was the most advanced form, with a corbeled, beehive-shaped dome.

EXAMPLES

1. Citadel of Tiryns (enclosing wall, passage, megaron), c. 1400-1200 B.C. (*G 4-18, 19, 20; H 113*)
2. Grave Circle at Mycenae, c. 1600-1400 B.C. (*illustrated elsewhere*)
3. Lion Gate at Mycenae (trilithon gate with corbeled arch), c. 1300 B.C., 9 ft. 6 in. high. (*G 4-21, H 132, J 120*)
4. Treasury of Atreus, Mycenae (tholos), c. 1300 B.C., 43 ft. high, 48 ft. wide. (*G 4-22, 23; H 133; J 115, 116*)

B. PAINTING

Very little has survived. What does exist consists of true fresco paintings in a style quite similar to Minoan, but the subject matter is very different (*see H 138*). Soldiers and armored females are most common. Facial details and costumes are also different.

C. POTTERY

The best preserved example of Mycenaean pottery is the so-called *Warrior Vase*, c. 1200 B.C. (*G 4-27*). The shape and color scheme are similar to Minoan works, but the subject is quite different: warriors instead of nature. The style is closer to Minoan fresco painting.

D. SCULPTURE

Very little Mycenaean sculpture survived.

1. **Monumental sculpture**: The Lion Gate relief at Mycenae is the only surviving example of large stone sculpture. Although its meaning is uncertain, homage or devotion is assumed. The relief fits into a triangular opening above the gate. (*G 4-21, H 132, J 120*)

2. **Portable sculpture**: The best example is the *Three Deities* ivory carving (*H 137; J 122, 123*). Its relationship to Near Eastern sculpture is unclear, and its meaning and purpose are disputed.

E. MINOR ARTS

Like the Minoans, the Mycenaeans seem to have been more interested in various minor art forms than in sculpture. As metalsmiths, they produced exquisite objects of **repoussé** goldwork (hammered sheets of gold and gold alloys, shaped and engraved into various forms), which were used as grave goods.

1. Several **death masks** from Mycenae were found attached to mummies. These masks convey sensitivity to individual details. The existence of these masks and the knowledge of mummification support claims of direct contact with Egyptian customs. (*G 4-25, H 134*)
2. The **vaphio cups** were found in grave circles and tholoi. The gold sheets were hammered into reliefs and joined with rivets. Since the subject matter, bull-catching, is of Minoan origin, their fabrication by Minoan or Mycenaean craftsmen is disputed. (*G 4-26; H 136; J 118, 119*)
3. Other grave goods include weapons such as the *Bronze Dagger*, from Mycenae. (*G 4-24, H 135*)

VOCABULARY

buon fresco	grave circle	rhyton
citadel	marine decoration	shaft grave
engobe	megaron	terracotta
faience	repoussé	tholos (tholoi)

5. Greek Art

SUMMARY

Architecture: The temple was the most innovative structure. Other important buildings included the stoa, theater, and tholos. Architecture was based on the use of columns and orders: Doric, Ionic, and Corinthian. Sculpture (often painted) complemented structural design.

Painting: Wall painting was important, but little has survived.

Pottery: Pottery decoration was a major art form until the Classical Period. Four major types developed: Geometric, black-figure, red-figure, and white-ground. Early geometric designs gave way to narrative-figural scenes illustrating Greek mythology and daily life.

Sculpture: Free-standing and architectural reliefs of gods, goddesses, and heroes were most typical with figures represented as types rather than individuals. Early sculpture was stiff and frontal. Archaic and Classical styles developed complete understanding of anatomy and idealized the figure. Hellenistic works stressed dramatic realism and represented un-idealized human beings.

CHRONOLOGICAL SUMMARY

Geometric Period 900–600 B.C.: Pottery had all-over patterns. Sculpture included small bronze and marble animals and human figures.

Archaic Period 650–480 B.C.: Earliest surviving temples were built in the Doric order with squat proportions. Pottery decoration progressed to naturalistic representations on black-figure and red-figure ware. Sculpture progressed from stiff figures to natural, rounded forms. Bronze and marble works were often life-size.

Classical Period 480–323 B.C.: The "Golden Age" of Greek culture and art. Both Doric and Ionic temples were constructed. Pottery declined as an art form; white-ground ware was the last major style. Sculpture idealized the human form. Art reflected the general intellectualism and self-confidence of the era.

Hellenistic Period 323–30 B.C.: Non-religious (secular) architecture became more important than before. Buildings were much larger than earlier structures. Ionic and Corinthian orders were most frequently used. Pottery was insignificant. Sculpture emphasized dramatic realism and emotion rather than Classical repose and idealism.

A. ARCHITECTURE

The most famous buildings of ancient Greece are the temples. Various non-religious buildings also developed although elaborate tombs and palaces were unimportant. Private houses remained extremely modest even in the Hellenistic Period. Although the structural systems used by the Romans and later western cultures surpassed the post-and-lintel system, the decorative language developed by the Greeks continued to influence architectural design for many centuries.

BUILDING TYPES

1. **Rectangular temples** dedicated to various humanized gods.
2. **Civic structures**
 a. **Agora**: An open square in the center of each city, used as a market place and meeting area.
 b. **Stoa**: A long rectangular structure containing shops, walled at the back, covered with a shed roof, and fronted with a portico or colonnade. It usually adjoined the agora.
 c. **Theater**: A semi-circular entertainment center with concentric rows of banked seats and a circular stage area in the center. Not roofed.
 d. **Tholos**: A circular monument, tomb, or temple, probably based on the Mycenaean tholos tomb.

MEDIA AND TECHNIQUES

1. Earliest structures had mud-brick foundations and walls, and timber columns, beams and roofs.
2. During the Archaic Period, marble and limestone began to replace these perishable materials, but the decorative surface treatments developed in wood were retained.
3. Timber beams and clay tiles were usually used for roofing. In the best Classical and Hellenistic buildings, marble was used for roofing.
4. **Post-and-lintel** principles of construction as realized in columns and entablatures were extensively developed.
5. **Ashlar construction** was typical. Blocks of stone with smooth surfaces and square edges were laid in even horizontal courses. Mortar was not used. Iron and bronze rods or dowels connected sections of columns assembled from drum-shaped segments.
6. Color was added to the temples and other buildings. Red, blue, and yellow were most commonly used on the cornices, pediments, and friezes.

DESIGN

1. Buildings were "sculptural" structures whose exteriors were more important than the interiors.

2. Structural and decorative elements developed from the column-based architecture of Egypt, Crete, and Mycenae.
3. The human body was the basis of proportion and scale in Greek architecture.
4. Greek religious and philosophical values were reflected in the mathematical precision, geometric clarity, and symmetry of the buildings.

1. Temples

BASIC ELEMENTS (See Figure 5-1): All Greek temples included:

1. **A base,** or building platform consisting of:
 a. A stereobate (two to four steps at the lower level).
 b. A stylobate (top step), which supported the columns.
2. **Columns,** tapering upward, supporting the roof, and including:
 a. A base (except the Doric order).
 b. A shaft, vertically fluted.

FIGURE 5-1 The Doric and Ionic Orders. (after Grinnell)

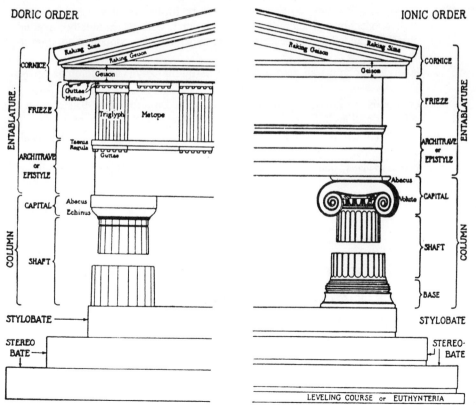

 c. A capital.

 d. Entasis (a swelling in the center to suggest organic response to the weight of the roof).

3. **An entablature**, consisting of:

 a. An architrave, resting directly on the capitals.

 b. A frieze.

 c. A cornice.

4. **A roof**, which was pitched. The two open ends were framed by raking cornices and defined the pediment (triangular space).

5. **A cella** (naos), or inner chamber, built for the image of the deity, and enclosed on at least two sides. A cella was usually open at the east end, and framed by a porch.

PLANS (See Figure 5-2): Greek temples were not intended for indoor public worship. They were built primarily for statues of gods and the offerings made to them. The Mycenaean megaron is the probable source. Types of plans include:

1. **In Antis**: Cella side walls are extended to form a front porch (**pronaos**), with two columns enclosed between the porch walls. Occasionally a second porch was added at the back (**opisthodomos**) and also contained columns in antis.

2. **Prostyle**: Columns all across the front. Amphiprostyle had columns across the back also.

3. **Peripteros**: Columns all around the building. Dipteros plans had a double colonnade all around.

4. **Tholos**: A circular temple built with a single or double ring of columns all around.

5. In most plans, one or two rows of two-story columns stood in the cella to support the ridge of the roof.

FIGURE 5-2 Ground plan of a typical Greek temple. (after Grinnell)

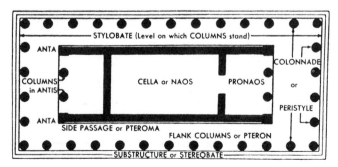

ARCHITECTURAL ORDERS (See Figure 5-1)

1. **Doric** was developed on the Greek mainland and also was used in western Greek colonies. It was the heaviest, stockiest, simplest order, and was considered to be "masculine."
 a. The Doric column had:
 (1) No base. The shaft rested directly on the stylobate.
 (2) Proportions of: height = six times diameter at the widest point.
 (3) Twenty vertical flutes.
 (4) A capital with a cushion-shaped echinus and a square abacus.
 b. The Doric entablature contained a frieze made of
 (1) **Triglyphs** (triple-grooved blocks imitating wooden beam-ends).
 (2) **Metopes** (rectangular stone slabs carved with mythological subjects and usually painted).
2. **Ionic** was developed in Asia Minor and had spread to the mainland by the fifth century. It was used throughout Greece after the Archaic Period. A slender, delicate, ornate order, it was considered "feminine," and was preferred in mature temple architecture.
 a. The Ionic column had:
 (1) A curved base.
 (2) Proportions of: height = nine times diameter.
 (3) Twenty-four vertical flutes.
 (4) A capital with a decorated echinus, double volute, and curved abacus.
 b. The Ionic entablature consisted of a three-sectioned architrave with a continuous, decorated frieze.
3. **Corinthian** developed as a decorative variant of Ionic. The major difference is the capital which contains an echinus of rising tiers of acanthus leaves, vertical volutes, and a thin abacus.

NOTE: It is not unusual to find two, or even three orders used in the same temple.

CHRONOLOGICAL SURVEY

1. **Geometric Period**: Buildings were constructed of timber and mud-brick. Only small, terracotta models of temples survive.
2. **Archaic Period**: Doric order was preferred. Buildings were heavy, massive, made of limestone and marble.
3. **Early Classical Period**: This era is considered the peak of purity and clarity of design. Doric and Ionic were used equally, Corinthian was introduced, but not widely used.
4. **Late Classical** and **Hellenistic Periods**: The preference was for larger, slender buildings. Most were constructed in Asia Minor. Ionic and Corinthian orders were used most frequently.

2. Civic Structures

Every city-state had an agora, stoa, theater, stadium, and assembly hall. Some had commemorative monuments in the form of **tholoi** near the agora. The regular arrangement and geometrical planning of each structure were as important as the integration of all structures within a rational plan. The rectangular "grid" city plan, with streets intersecting at right angles, was developed in the Hellenistic era.

LOCATION, SIZE, AND SCALE

1. The hilltop, or acropolis, was preferred for temples. Civic structures and other buildings were situated according to function in the town below the acropolis.
2. Size steadily increased. Heights of 20 feet were typical for Archaic, 40 to 60 feet for Classical, and larger for Hellenistic temples. Civic structures were not as large as temples, but followed the same size increase.
3. Scale was human, at least through the Classical Period. Structures were scaled to make people feel comfortable and equal to their surroundings rather than awed by their comparative insignificance, as in Egyptian architecture.

EXAMPLES
GEOMETRIC PERIOD

Model of a Temple, from the Heraion near Argos, mid-eighth century B.C., terracotta, c. 14. in. long. (*H 139*)

ARCHAIC PERIOD

1. Temple of Artemis, Corfu, c. 580 B.C. (Doric). (*H 155, J 139*)
2. Temple of Apollo, Corinth, c. 540 B.C. (Doric). (*illustrated elsewhere*)
3. Basilica (Temple of Hera I), Paestum, Italy, 530 B.C. (Doric). (*G 5-22, 23; J 154; J 147, 148*)
4. Temple of Aphaia, Aegina, c. 500 B.C. (Doric). (*G 5-20, H 159, 160*)

CLASSICAL PERIOD

1. Temple of Hera II (Poseidon), Paestum, Italy, c. 480 B.C. (Doric). (*G 5-25; H 178, 179; J 147, 149, 150, 151*)
2. Temple of Zeus, Olympia, c. 470-450 B.C. (Doric). (*illustrated elsewhere*)
3. Parthenon, Acropolis, Athens, 447-432 B.C. (Doric with Ionic frieze). (*G 5-38, 39, 40, 41; H 185, 186, 187, 188, map 9, 192; J 152, 153, 154*)
4. Propylaea, Acropolis, Athens, 437-432 B.C. (Doric with interior Ionic columns). (*G 5-39, 47; H 153, 185, 186, map 9, 196, 197; J 154, 155, 156, 157*)
5. Temple of Athena Nike, Acropolis, Athens, 427-424 B.C. (Ionic). (*G 5-39, 48; H 185, 186, map 9, 198; J 154, 157*)

6. Erechtheum, Acropolis, Athens, 421-406 B.C. (Ionic). (*G 5-39, 49, 50, 51; H 185, 196, map 9, 200, 201; J 154, J 160*)
7. Temple of Apollo, Bassae, c. 447 B.C. (all three orders). (*H 204, cpl 17*)
8. Agora and Stoa of Athens, fifth century B.C. (*illustrated elsewhere*)
9. Agora and Stoa of Assos, Turkey, fourth century B.C. (*H 219*)
10. Theater of Epidauros, c. 350 B.C. (*G 5-77, 78; H cpl 18; J 162, 163*)
11. Choragic Monument (tholos) of Lysicrates, Athens, 334 B.C. (Corinthian). (*G 5-64, H 209, J 161*)
12. Tholos of Epidauros, c. 360 B.C. (Ionic and Corinthian). (*G 5-63, H 208*)
13. Temple of Athena Polias, Priene, c. 350-334 B.C. (Ionic). (*G 5-79*)
14. Temple of Artemis, Ephesos, after 356 B.C. (Ionic). (*illustrated elsewhere*)
15. Temple of Apollo, Didyma, c. 330 B.C. (Ionic). (*G 5-76; H 222, 223*)

HELLENISTIC PERIOD

1. Temple of Olympian Zeus, Athens, 174-110 B.C. (Ionic). (*H 224*)
2. Altar of Zeus, Pergamon, c. 175 B.C. (*G 5-67; H 218; J 188, 189*)
3. Mausoleum at Halicarnassus, c. 353 B.C. (*H 210, J 178*)

B. PAINTING

Until the recent discovery in Paestum, Italy of a series of frescoes from a Greek tomb dated around 470 B.C. (*H 184, cpl 16*), scholars have had to rely on ancient literary descriptions of Greek wall paintings and speculate about their artistic development. It now appears that painting in true fresco presented naturalistic figures and scenes, and progressed from forms defined by heavy outline and flat color to increasingly illusionistic images.

Etruscan and Roman painting are clearly dependent upon Greek prototypes. (The entire Greco-Roman painting tradition is treated in Chapter Six.)

C. POTTERY

The production and decoration of pottery appeared as an art form during the Geometric Period and became increasingly important in the Archaic and early Classical Periods. By the "Golden Age of Pericles" (450-400 B.C.) however, vase painting had become merely a commercial enterprise centered in the cities of Athens and Corinth.

FORMS AND SUBJECT MATTER: There were numerous shapes of Greek pottery and even more subjects which decorated them. Only a brief summary is offered here.

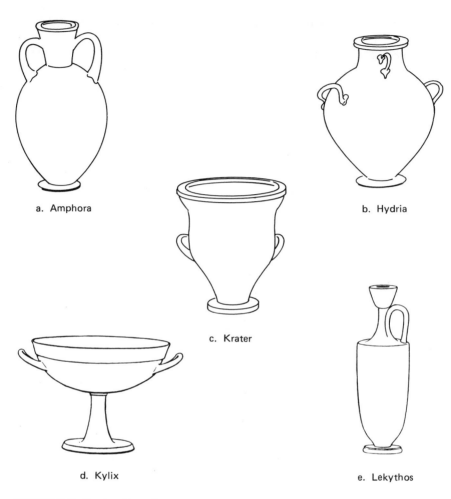

FIGURE 5-3 Greek pottery shapes.

1. **Major pottery shapes** (See Figure 5-3):
 a. **Amphora:** A storage jar with egg-shaped body, a foot, and two handles attached at neck and shoulder.
 b. **Hydria:** A water jar with two horizontal handles and one vertical handle.
 c. **Krater:** A wide-mouth bowl with two vertical handles, for mixing wine and water.
 d. **Kylix:** A shallow bowl, or wine cup, with two handles, a stem, and a foot.
 e. **Lekythos:** A tall vase with a narrow neck, flared mouth, and single handle, for oil or perfume.

MEDIA AND TECHNIQUES

1. Fine-grained red clay was preferred. The artists of Athens had an abundance of it, while their rivals at Corinth only had clay that fired to a less attractive greenish yellow, or buff.
2. Vessels were hand-made by coiling in the Geometric Period; wheel thrown in the Archaic and Classic Periods.
3. Proper shapes were attained by using templates.
4. The **engobe** used for decoration had the same composition as the clay of the container, but was finer grained. Its final color, red or black, depended on its thickness, and on the timing of the reduction-firing process.
5. Technique was very skillful, even in the early Geometric Period.

CHRONOLOGICAL SURVEY

1. **Geometric Period** 850-700 B.C.
 a. Large (up to six feet high) amphorae and kraters were used as grave markers.
 b. Decorations included
 (1) Crowded, small, geometric designs in black over the entire surface.
 (2) Funeral scenes.
 (3) Battle scenes.
 c. Human figures were reduced to wedges and other geometric shapes.
2. **Orientalizing Phase** 700-600 B.C.
 a. Named for the "Oriental" beasts and figures borrowed from Near Eastern and Egyptian sources.
 b. Animals and figures appeared in outline or silhouette over the entire container.
 c. Figures were loosely arranged, not in bands or registers.
 d. Proto-Attic and Proto-Corinthian ware were developed.
3. **Archaic Period** 650-480 B.C.
 a. **Black-figure ware**
 (1) Developed in Corinth around 580 B.C.
 (2) Figures were in black against red or buff of container.
 (3) Designs were refined; figures realistic.
 (4) Details were incised with a sharp point.
 (5) Other details were painted on in white or red-purple after firing.
 b. **Red-figure ware**
 (1) Appeared around 530 B.C.
 (2) Figures were reserved in red, background painted black.
 (3) Details were painted on with a brush.

 (4) Figures were arranged to suggest groups in depth.

 (5) Poses showed the contrapposto current in sculpture.

 c. The late Archaic Period was the peak of artistic development in pottery.

4. **Classical Period** 480–323 B.C.

 a. **White-ground ware**

 (1) Was used for funerary gifts.

 (2) Was painted with impermanent color after firing.

 (3) Naturalistic forms were shown in convincingly illusionistic space.

 b. Pottery painting declined during this period.

LOCATION, SIZE, AND SCALE

1. Most surviving pottery has been found in graves and tombs, especially in Italy at Etruscan sites. This does not mean, however, that painted vases were intended only as grave goods.

2. Size varied from six inches to six feet. Mature Attic ware ranged from 20 to 50 inches in height.

3. Scale of the decoration was extremely miniature in the Geometric Period, monumental in the Archaic and Classic Periods.

EXAMPLES
GEOMETRIC

1. *Dipylon Amphora,* Athens, c. 750 B.C., 60 in. high. (*G 5-2, H 140*)
2. *Dipylon Krater,* Athens, c. 750 B.C., 42 in. high. (*G 5-3, J 125*)

ORIENTALIZING

1. *Amphora with Odysseus Blinding Polyphemos,* Athens, c. 650 B.C., 56 in. high. (*G 5-4, H 142, J 126*)
2. *Chigi Vase,* Corinth, c. 650 B.C., 10 in. high. (*H 143*)
3. *Owl Perfume Jar,* Corinth, c. 650 B.C., 10 in. high. (*J 127*)

ARCHAIC
BLACK-FIGURE

1. Kleitas and Ergotimos, *François Vase* (krater), found at Chiusi, Italy, c. 570 B.C., 26 in. high. (*G 5-6, H 164*)
2. Exekias, *Dionysos in a Sailboat,* interior of kylix found at Vulci, Italy, c. 540 B.C., 12 in. diameter. (*G 5-7, H 166, J 129*)

RED-FIGURE

1. Andokides Painter, *Herakles and Apollo Struggling for the Tripod,* amphora, c. 525 B.C., 23 in. high. (*G 5-8*)
2. Euphronios, *Herakles Strangling Antaios,* krater, c. 510 B.C., 19 in. high. (*G 5-9*)
3. Euphronios, *Sarpedon Carried off the Battlefield,* krater, c. 515 B.C., 19 in. high. (*H cpl 14*)
4. Euthymides, *Revelers,* amphora, c. 510 B.C., 24 in. high. (*G 5-10*)
5. Kleopharades Painter, *Dionysos Between Maenads,* amphora, c. 500–490 B.C., 22 in. high. (*H 167, H cpl 15*)
6. Brygos Painter, *Revelling,* skyphos, c. 490 B.C., 8 in. high. (*G 5-11, H 169*)

CLASSICAL

RED-FIGURE

1. Niobid Painter, *Argonaut Krater,* c. 450 B.C., 21 in. high. (*G 5-55, H 183*)
2. Phiale Painter, *Hermes Presenting Dionysos to Papposilenos,* krater, c. 440 B.C., 14 in. high. (*G 5-56*)

WHITE-GROUND

1. Achilles Painter, *The Deceased Woman as a Muse of Mt. Helikon,* lekythos, c. 430 B.C., 15 in. high. (*H 207*)
2. Achilles Painter, *Maid and Mistress,* lekythos, c. 430 B.C., 16 in. high. (*J cpl 13*)

D. SCULPTURE

PURPOSES: Early Greek sculpture was used primarily as temple decorations or as religious-commemorative works in other settings.

During the Classical and Hellenistic Periods, as personal wealth increased, sculpture became more secular (worldly), and adorned private and civic structures as well as temples.

Because of the later wholesale destruction of Greek sculpture, much that remains today consists of Roman copies of Greek originals.

DESIGN: Greek contributions to western sculpture include:

1. **Sculpture in the round:** natural and convincing, finished on all sides, and relief-sculpture so well rounded that it looks almost free-standing.
2. **Open spaces in figures,** such as between the body and the arms, revealed by the removal of unnecessary material.
3. **Nude figures.**

4. **Contrapposto,** or counterpositioning. This is most easily recognized in the weight-shift poses of the late Archaic and Early Classical kouroi.

1. Geometric Period

FORMS AND SUBJECT MATTER

1. Animals.
2. Warriors.

MEDIA: Bronze, terracotta, ivory.

DESIGN: Abstracted shapes related to vase painting.

SIZE: Under 12 inches high.

2. Orientalizing Phase

FORMS AND SUBJECT MATTER

1. Horses.
2. Warriors.
3. Gods and Goddesses.
4. Exotic beasts (Near Eastern influence).
5. Introduction of kouros and kore figures.

MEDIA: Bronze, terracotta, ivory, limestone.

DESIGN: Influenced by Egypt and the Near East.

1. Stiff, frontal figures; awkward body proportions.
2. Large, staring eyes with heavy eyebrows.
3. Wide mouths.
4. Mop-like hair in four braids to shoulder; tight curls across forehead.

SIZE: Larger than Geometric, but less than life-size.

3. Archaic Period

FORMS AND SUBJECT MATTER

1. Kouros and kore figures.
2. Architectural sculpture.
3. Grave stelae.

MEDIA AND TECHNIQUES

1. Marble and limestone were used for relief sculpture and free-standing images. The stone was worked with iron chisels, smoothed with powdered abrasives, and polished with wax.
2. Paint and gold were frequently added.

DESIGN

1. **Kouros** (nude male) and **kore** (clothed female) **figures** were used as grave markers and votive images for temples. They represented people, not gods. The development and refinement of these figures were the major contributions of the Archaic Period to Greek sculpture.
 a. **Early Archaic** figures (650–580 B.C.)
 (1) Stiff and frontal poses, similar to Egyptian models.
 (2) Mop-like hair.
 (3) Large protruding staring eyes.
 (4) Very pronounced "Archaic smile."
 (5) Male figures
 (a) Stood with left foot forward, weight balanced on both feet, all muscles in tension.
 (b) Held arms stiffly at sides, fists clenched.
 (c) Had anatomical details indicated by incised lines.
 (6) Female figures
 (a) Stood with feet together.
 (b) Held arms at sides or one across chest.
 (c) Had anatomy completely hidden beneath full-length costume with no folds or decoration.
 b. **Late Archaic** figures (580–480 B.C.)
 (1) More natural poses, with arms in a variety of positions.
 (2) Hair arranged in distinct curls or braids.
 (3) More natural faces: features modeled, smiles less exaggerated, eyes no longer protruding.
 (4) Male figures
 (a) Stood with right foot forward sometimes.
 (b) Had anatomical details indicated by modeling.
 (c) Introduced **contrapposto** at the end of the Archaic Period.
 (5) Female figures
 (a) Had anatomy suggested under fitted costume with folds and decoration imitating actual current fashions.
 (b) Commonly were painted.

2. **Architectural sculpture** for temple decoration developed parallel to free-standing sculpture.
 a. **Pedimental groupings** included:
 (1) Free-standing figures attached to the triangular slab with iron bars.
 (2) Very high relief carvings.
 (a) Symmetry was most important, as the design was adjusted to fit the triangular space.
 (b) Early Archaic pediment groups were inconsistently scaled and proportioned to fit into the pedimental space. Late Archaic figures fit into the space by changes in posture, not proportion.
 b. **Friezes** reflected the same stylistic developments as the pedimental sculptures, growing increasingly naturalistic, and even beginning to represent figures overlapping each other and receding into space.
 c. **Caryatids**, female figures serving as architectural supports, were used occasionally.
3. **Grave stelae**, vertical stone slabs, four to six feet high, were used as grave markers. The front surfaces were carved in high relief with images of the deceased or mythological figures. The stylistic development followed the historical progression toward fully rounded figures with convincing proportions and poses.

4. Classical Period

Sculpture of this period is divided into three styles: Transitional, Early Classical, and Late Classical.

a. Transitional (480–450 B.C.)

FORMS AND SUBJECT MATTER

1. Free-standing
 a. Athletes.
 b. Gods and goddesses.
2. Relief sculpture
 a. Mythology.
 b. Battle scenes.

MEDIA AND TECHNIQUES

1. Continued use of marble.
2. Introduction of life-size, hollow-cast bronzes. Individual pieces were fastened together with tongue-and-groove seams, disguised by hammering, and finished by chasing (tooling to remove marks).

DESIGN

1. **Free-standing figures** displayed:
 a. Controlled, restrained poses.
 b. Fully developed contrapposto.
 c. Short, wavy hair, ending in curls at the face.
 d. Female anatomy revealed by "wet drapery" which hung in vertical, parallel folds.
2. **Architectural sculpture** paralleled the styles of free-standing works. The contrast between the violent subject matter of most pedimental groups and the calm, restrained facial expressions is remarkable.

ARTISTS

1. Myron, known for development of new poses in athletic figures.
2. Polykleitos, known for his famous canon of proportions (body = six and one-half heads high), and for his development of balance between tensed and relaxed muscles.

b. *Early Classical (450–400 B.C.)*

This period is considered to be the peak of Classical development.

FORMS AND SUBJECT MATTER

1. **Free-standing sculpture** was eclipsed by architectural sculpture during this period.
2. **Architectural sculpture** included
 a. Caryatid figures.
 b. Pedimental sculpture, nearly free-standing, representing gods and goddesses.
 c. Relief sculpture depicting mythology and ceremonial processions.
3. **Grave stelae** depicted the deceased.

MEDIA AND TECHNIQUES

1. Marble prevailed.
2. **Chryselephantine**, a combination of ivory and gold, was used for a few large, free-standing works, such as the famous Athena Parthenos by Phidias, but nothing survives.
3. Craftsmanship was excellent. The technical virtuosity of the Greek Classical Period set the standard for subsequent Roman, Renaissance, and Neo-Classical sculptors.

DESIGN

1. **Free-standing figures** displayed
 a. More relaxed poses; new gracefulness and ease.
 b. Drapery folds implying movement, and helping to convey the emotions of the subject.
 c. The female partial nude for the first time.
2. **Architectural sculpture** was produced in great quantities for the decoration of the Acropolis. It followed the developments seen in free-standing sculpture.
3. **Grave stelae** relief carvings increased in sensitivity.

ARTIST: Phidias, famous as a sculptor and director of the Acropolis decorations.

c. *Late Classical (400–323 B.C.)*

This period is often referred to as "Fourth Century."

DESIGN

1. **Free-standing figures** showed
 a. Even more relaxed poses than those seen previously.
 b. More expressive faces.
 c. The totally nude female figure for the first time.
2. **Architectural sculpture** showed increased action and emotion.

ARTISTS

1. Skopas, whose work was known for intense action, anxious expressions, deep-set eyes, deeply-carved details.
2. Praxiteles, known for his new canon of proportions (body = seven and one-half heads high), the softness and grace of his figures which had swaying S-curve postures.
3. Lysippus, known for extending his figures into space, and for proposing an even taller, more slender canon of proportions. For his subject matter, he returned to the athletic themes of the Transitional Period.

5. Hellenistic Period

FORMS AND SUBJECT MATTER

1. **Free-standing sculpture** introduced new subjects:
 a. Erotic subjects (satyrs and nymphs).

 b. Emotional subjects: sentimental, grotesque, tragic.

 c. Portraits of famous individuals.

2. **Architectural sculpture** spread from traditional locations on entablatures and pediments to column bases and pedestals.

DESIGN

1. Conservative sculptors imitated the styles of earlier Greek art. Gods and goddesses in the Praxitelian manner were especially popular.

2. "Progressive" sculptors introduced

 a. Twisting, turning, energetic movement in very high relief.

 b. Deep undercutting to produce rich shadows.

 c. Windblown drapery.

 d. Windblown hairstyles.

 e. Faces expressing anxiety, even despair.

EXAMPLES
GEOMETRIC PERIOD, 900-700 B.C. (All examples are eighth century B.C.)

1. *Deer Nursing a Fawn,* Thebes, bronze, 3 in. high. (*H 141*)

2. *Warrior from the Acropolis,* Athens, bronze, 8 in. high. (*G 5-12*)

ORIENTALIZING PHASE, c. 700-600 B.C.

1. *Mantiklos Apollo,* c. 680 B.C., bronze, 8 in. high. (*G 5-13*)

2. *Artemis of Nikandre,* c. 660 B.C., limestone, half life-size. (*illustrated elsewhere*)

ARCHAIC PERIOD 650-480 B.C.
EARLY ARCHAIC

1. *Kouros of Sounion,* c. 600 B.C., marble, 10 ft. high. (*H 145*)

2. *Lady of Auxerre* (kore), c. 650-625 B.C., limestone, 24 in. high. (*H 144, J 131*)

3. *Standing Youth* (kouros), c. 600 B.C., marble, 6 ft. high. (*J 132)*

LATER ARCHAIC: Free-standing

1. *Kouros of Tenea,* c. 570 B.C., marble, 5 ft. high. (*G 5-15*)

2. *Calf-Bearer,* c. 570 B.C., marble, 66 in. high. (*H 147, J 134*)

3. *Kouros of Anavysos,* c. 525 B.C., marble, 76 in. high. (*G 5-16, H 146, J 133*)

4. *Hera of Samos,* c. 565 B.C., marble, 76 in. high. (*G 5-14, H 149, J 136*)

5. *Peplos Kore,* c. 530 B.C., marble, 48 in. high. (*G 5-17, H 150, J 137*)

6. *La Delicata,* c. 525 B.C., marble, 36 in. high. (*H cpl 13*)
7. *Kore* from Chios, c. 510 B.C., marble, 22 in. high. (*G 5-18, J cpl 12*)

LATER ARCHAIC: Architectural

1. *Gorgon Medusa,* west pediment, Temple of Artemis at Corfu, c. 600 B.C., limestone, 9 ft. high. (*G 5-29; H 155, 156; J 138, 139*)
2. *Battle of the Gods and the Giants,* north frieze, Siphnian Treasury, Delphi, c. 530 B.C., marble, 26 in. high. (*G 5-28; H 157, 158; J 140, 141*)
3. *Caryatids* (reconstructed), facade of the Siphnian Treasury, Delphi, c. 530 B.C. (*G 5-27, H 157, J 141*)
4. *Oriental Archer,* west pediment, Temple of Aphaia, Aegina, c. 510 B.C., marble, 4 in. high. (*H 161*)
5. *Herakles,* east pediment, Temple of Aphaia, Aegina, c. 490 B.C., marble, 31 in. high. (*G 5-30, 32; H 162; J 143*)
6. *Dying Warrior,* east pediment, Temple of Aphaia, Aegina, c. 490 B.C., marble, 72 in. long. (*G 5-30, 31; H 163; J 144*)

LATER ARCHAIC GRAVE STELE

Stele of Aristion, c. 525 B.C., limestone, 96 in. high without base. (*H 148*)

CLASSICAL PERIOD 480–323 B.C.
TRANSITIONAL PERIOD 480–450 B.C.
FREE-STANDING

1. *Kritios Boy,* c. 480 B.C., marble, 3 ft. high. (*G 5-19, H 171, J 164*)
2. *Charioteer of Delphi,* c. 470, bronze, 6 ft. high. (*G 5-33, H 170, J 166*)
3. *Zeus of Artemision,* c. 460 B.C., bronze, 7 ft. high. (*H 173, J 169*)
4. Myron, *Discobolos,* (Discus Thrower), c. 450 B.C. Roman copy of a bronze original, life-size. (*G 5-34, H 174, J 170*)
5. Polykleitos, *Doryphoros,* (Spear-bearer), 450 B.C. Various Roman copies of bronze original, life-size. (*G 5-54; H 175, 176; J 165*)

RELIEF SCULPTURE

1. *Birth of Aphrodite, Ludovisi Throne,* early fifth century B.C., marble, 56 in. wide. (*H 177*)
2. *Battle of the Lapiths and the Centaurs,* west pediment, Temple of Zeus at Olympia, c. 470 B.C., marble, Apollo, 10 ft. high. (*G 5-35, 36, 37; H 80, 81; J 167, 168*)
3. *Labors of Herakles,* metope frieze, Temple of Zeus at Olympia, c. 470 B.C., 63 in. high. (*H 182*)

EARLY CLASSICAL PERIOD 450-400 B.C.

FREE-STANDING

Dying Niobid, c. 450-440 B.C., marble, 59 in. high. (*J 171*)

ARCHITECTURAL

1. *Caryatid figures,* Porch of the Maidens, Erechtheum, Athens, 421-405 B.C., over life-size. (*G 5-51, H 201, J 160*)
2. *Dionysos,* east pediment of the Parthenon, 438-432 B.C., marble, over life-size. (*G 5-42, H 190, J 172*)
3. *Three Goddesses,* east pediment of the Parthenon, 438-432 B.C., marble, over life-size. (*G 5-43, H 189, J 173*)

ARCHITECTURAL RELIEF

1. *Metopes,* Parthenon, 438-432 B.C., marble, 56 in. high. (*G 5-44, H 191*)
2. *Panathenaic Procession,* Parthenon frieze, 438-432 B.C., marble, about 4 ft. high, 550 ft. long. (*G 5-45, 46; H 192, 193, 194; J 174*)
3. *Nike (Victory) (Un)tying her Sandal,* Temple of Athena Nike, Athens, c. 410 B.C., marble, 42 in. high. (*G 5-53, H 199, J 175*)

GRAVE STELE

Stele of Hegeso, c. 410 B.C., marble, 59 in. high. (*G 5-52, H 203, J 176*)

LATE CLASSICAL PERIOD 400-323 B.C.

FREE-STANDING

1. Bryaxis (?), *Mausolus,* from Halicarnassus, c. 353 B.C., marble, 9 ft. 10 in. high. (*G 5-61, H 211, J 180*)
2. Scopas, *Head,* from the Temple of Athena Alea, Tegea, c. 350-340 B.C., marble. (*G 5-60, H 213*)
3. Praxiteles, *Hermes and Dionysos,* c. 330-320 B.C., marble, 85 in. high. (*G 5-57, 58; H 215; J 183*)
4. Praxiteles, *Aphrodite of Knidos,* c. 350 B.C., Roman marble copy of marble original. (*H 214, J 182*)
5. *Youth of Antikythera,* c. 340 B.C., bronze, 77 in. high. (*H cpl 19*)
6. Lysippos, *Apoxyomenos* (Scraper) c. 330 B.C., Roman marble copy of bronze original, 81 in. high. (*G 5-62, H 216, J 185*)
7. *Apollo Belevedere,* fourth or first century B.C., Roman copy, marble, over 7 ft. high. (*J 184*)

RELIEF

Skopas (?), *Battle of the Greeks and the Amazons,* frieze, from the Mausoleum at Halicarnassus, c. 350 B.C., 35 in. high. (*H 212, J 179*)

HELLENISTIC PERIOD 323-30 B.C.
FREE-STANDING

1. *Demosthenes,* c. 280 B.C., Roman marble copy of bronze original, 80 in. high. (*H 226*)
2. *Satyr, (The Barberini Faun)* c. 220 B.C., Roman marble copy, over life-size. (*H 228, J 186*)
3. *Nike of Samothrace,* c. 200 B.C., marble, 96 in. high. (*G 5-65, H 231, J 191*)
4. *Venus de Milo (Aphrodite of Melos),* c. 200 B.C., marble, 82 in. high. (*G 5-72*)
5. *Portrait of Alexander,* second century B.C., marble, 16 in. high. (*H 225*)
6. *Old Market Woman,* second century B.C., marble, 42 in. high. (*G 5-73*)
7. *Aphrodite of Cyrene,* first century B.C., marble, life-size. (*G 5-59, H 229*)
8. *Seated Boxer,* first century B.C., bronze, 50 in. high. (*G 5-75, H 227*)
9. Hagesandros, Polydoros, and Athenodoros, *Laocoön and his Sons,* first century A.D., marble 96 in. high. (*G 5-69, H 234, J 192*)
10. Hagesandros, Polydoros, and Athenodoros, *Head of Odysseus,* late second century B.C., marble, life-size. (*G 5-71, H 235*)
11. *Suicidal Gaul and Dying Gaul,* from Pergamon, c. 230-220 B.C., marble, life-size. (*G 5-66, H 232*)

RELIEF

Battle of the Gods and the Giants, Altar of Zeus (and Athena), Pergamon, c. 181-159 B.C., marble, over life-size. (*G 5-68; H 218, 233; J 189, 190*)

VOCABULARY

abacus	Doric	Ionic	peripteral plan
agora	echinus	kore	stoa
architrave	entablature	kouros	stylobate
cella	entasis	metope	triglyph
contrapposto	fret/meander	architectural order	weight-shift
Corinthian	frieze	pediment	

6. Etruscan and Roman Art

SUMMARY

I. Etruscan Art c. 750–200 B.C.

Architecture: Temples are known for modified Greek plan with a podium, axial-alignment, low-pitched roof, triple-cellae, and portico. Tombs are the best preserved Etruscan structures and include rock-cut and tumulus types.

Painting: Tomb wall paintings were very colorful. Movement and action were more pronounced than in Greek prototypes. The subject matter became increasingly morbid as the culture declined.

Pottery: Greek wares were imported as well as imitated. Bucchero ware was native to Etruria.

Sculpture: Free-standing bronze and terracotta figures were made for temples and tombs. Terracotta reliefs, cremation urns, and sarcophagi were also important. Style combined Etruscan interest in energetic realism with superficial imitation of Archaic and Classical Greek forms and styles.

Minor arts: Etruscan artists were noted metalsmiths and jewelers.

II. Roman Art Republic c. 509–27 B.C., Empire 27 B.C.–A.D. 476

Architecture: Temples were based on Greco-Etruscan types. Houses, apartments, baths, amphitheaters, basilicas, bridges, aqueducts, and city-planning were also important. Known for their innovations in structural engineering, the Romans created large, complex structures. The discovery of concrete and the development of arcuated construction are notable contributions. Articulation was influenced by Greek decorative language.

Painting: Illusionistic wall painting developed in four styles: incrustation, architectural, ornate, and intricate. Panel paintings were produced in tempera and encaustic.

Sculpture: Roman artists were known for portraits which emphasized extreme realism, reliefs which depicted civic and military events, statues of their rulers, and sarcophagi. They also made copies and adaptations of Greek originals.

Minor arts: Mosaic paving in intricate geometric patterns and illusionistic scenes were very important. Cameos, metal jewelry, and coins were also produced.

I. ETRUSCAN ART c. 750-200 B.C.

Traditionally, it has been assumed that the Etruscans came to Italy between 1100 and 800 B.C. and settled in the north-central region, an area now called Tuscany. Their original homeland is not known although Etruscan culture reflected the combination of native elements and borrowings from the Greeks and peoples of Asia Minor.

A. ARCHITECTURE

Very little of the Etruscans' architecture has survived because their cities were taken over by the Romans and have been rebuilt several times since. However, their temples and cities can be studied through Roman examples derived from Etruscan sources. Only Etruscan tombs have survived for direct study.

BUILDING TYPES

1. Tombs of two basic types.
2. Temples based on Greek models.
3. Houses.
4. City gates and fortifications.

MEDIA AND TECHNIQUES

1. Mud-brick was used for house and temple walls.
2. Timber was used for roofing and reinforcement of walls.
3. Stone was used for tombs and temples.
4. Terracotta tiles were used for roofing.
5. Post-and-lintel construction dominated temples and houses.
6. Corbeled arch and true arch construction in stone was used for city gates and tombs.

DESIGN

1. **Tombs** (Several hundred have been excavated).
 a. Two basic types have been found:
 (1) **Tumulus mounds** of earth and masonry in northern Etruria.
 (2) **Rock-cut tombs** in southern Etruria.
 b. All have rectangular interiors decorated with reliefs, paintings, pottery, furniture, and sculpture in imitation of house decoration.
2. **Temples** (None still exist; study based on Roman forms). Plan and elevation were modifications of Doric Greek prototypes (See Figure 6-1):

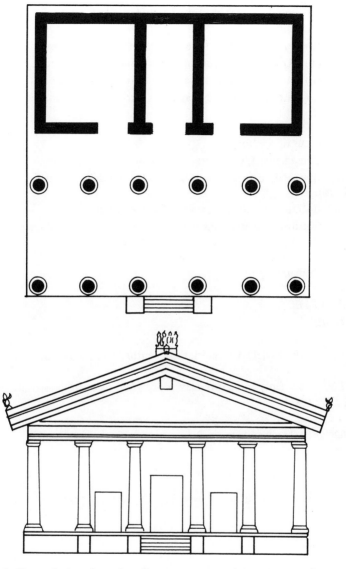

FIGURE 6-1 Plan and elevation of an Etruscan temple. (after Vitruvius)

a. Square temple on high base (podium).
b. Axial alignment, north-south orientation, entrance at south end.
c. Three-part cella, which occupied half of the plan.
d. Column-supported porch (portico), which occupied the other half.
e. Free-standing Tuscan columns on portico only. (Tuscan is a variant of Greek Doric which has a base, and is not fluted.)

 f. Low pitched gabled roof with wide overhang; no pedimental or frieze sculpture.

 g. Roof decorated with terracotta reliefs and sculptures:

 (1) **Antefixae**: ornamental tiles along the edge of roof.

 (2) **Acroteria**: sculptures on the corners or ridge of the roof.

3. **Houses** (Present knowledge based on Etruscan tomb interiors and Roman houses).

 a. The **atrium** (an open court with a roofed perimeter) was the central focus of the house.

 b. Rectangular rooms were arranged around the atrium.

4. **City gates and fortifications** (These were developed as defenses against the Romans).

 a. Entrances to cities were arched and vaulted.

 b. Construction methods were learned from Greek colonists, and decorative treatment imitated Greek architecture.

 c. Etruscan knowledge of the true arch and vault strongly influenced later Roman usage.

EXAMPLES

TOMBS

Tomb of the Reliefs, Cerveteri, third century B.C. (*G 6-2, 3; H 244; J 203*)

TEMPLES: Only miniature clay models and reconstructions survive. (*G 6-1, H 237, J 204*)

HOUSES: None survive.

CITY GATES

Porta Marzia and Porta Augusta, Perugia, second century B.C. (*H 238, J 209*)

B. PAINTING

Only tomb paintings have survived. Etruscan wall painting borrowed many stylistic features from Greek wall painting, but was more than mere imitation.

PURPOSES: Religious and funerary.

SUBJECT MATTER

1. Genre.
2. Dancing and banquet scenes.

3. Hunting, fishing, and sports.
4. Duplication of domestic interior decoration.
5. Demons and symbols of death.

MEDIA AND TECHNIQUES (Varied with location)

1. Tempera on dry stone walls.
2. Dry fresco and true fresco on plaster-prepared walls.
3. Generally, outlines were incised in stone surfaces, then color was applied.
4. Colors were bright, intense.

DESIGN

1. Happy, energetic figures appeared in the paintings made before 470 B.C.
2. Morbid subjects, somber colors, and sad faces characterized the final phase of the Etruscan Period.
3. Shapes were defined by heavy, unmodulated black outlines.
4. Forms were filled in with flat color.
 Note: At the end of the Etruscan era, shading appeared in imitation of Hellenistic painting.

EXAMPLES

1. *Dancing Woman and Lyre Player,* Tomb of Triclinium, Tarquinia, fifth century B.C. (*H 243*)
2. *Hunting and Fishing Scene,* Tomb of Hunting and Fishing, Tarquinia, c. 500 B.C. (*H cpl 25, J 201*)
3. *Revelers,* Tomb of the Leopards, Tarquinia, c. 470 B.C. (*G 6-4*)
4. *Woman of the Velcha Family,* Tomb of Orcus (Hades) Tarquinia, c. 470 B.C. (*G 6-5*)

C. POTTERY

There were two distinct developments in Etruscan ceramics:

1. **Greek-style pottery**
 a. Etruscans imported Greek vases from Corinth and Athens. (The bulk of the extant Archaic and Classical Greek vases are from Etruscan tombs.)
 b. Etruscan potters imitated both black-figure and red-figure wares, attempting to duplicate both subject and style.
2. **Buccero pottery**, native to Etruria, consisted of thin-walled pieces without decoration and thick-walled pieces with stamped and modeled reliefs.

D. SCULPTURE

Although dependent upon Greek art for subjects and compositions, Etruscan sculpture emphasized realism more than idealism, and Etruscan figures were more animated than their Greek prototypes.

PURPOSES AND SUBJECT MATTER

1. **Temple sculptures** were mostly free-standing figures (acroteria) from Greek mythology.
2. **Funerary articles** included
 a. **Portraits** of the deceased in bronze and terracotta.
 b. **Canopic urns** for cremation ashes.
 c. **Sarcophagi** (terracotta and stone coffins).
 d. **Mirrors and cistae** with scenes from Greek mythology.
3. **Miscellaneous figure sculptures** represented deities and people.

MEDIA AND TECHNIQUES

1. Terracotta was used for reliefs, free-standing figures, canopic urns, and sarcophagi.
2. Bronze was used for hollow-cast statues and solid statuettes, mirrors, urns, cistae. The lost-wax process was used for both solid and hollow castings.
3. Limestone was used occasionally for sarcophagi and figures.
4. Marble was NOT used.
5. Modeling techniques and media were preferred over carving.
6. Carving and incising were used only for details.
7. Paint was usually applied to terracotta and limestone.

DESIGN

1. Imitation of Greek sculpture from Archaic and Classical Periods lagged twenty-five years behind Greek styles. Similarities included
 a. Subjects.
 b. Postures and proportions.
 c. Costumes and accessories.
 d. Facial types and hair styles.
2. Etruscan figures usually showed more animation than Greek prototypes.
3. Bodies were unarticulated or inaccurately represented; heads were often too small.
4. Faces progressed from Archaic masks to extremely realistic features.
5. Detailing was usually very precise and sophisticated.

LOCATION, SIZE, AND SCALE

1. Most sculptures were found in temples and tombs.
2. Size ranged from very small bronze figurines to life-size terracotta and hollow bronze castings.
3. Scale was generally monumental.

EXAMPLES

1. *Capitoline She-Wolf,* c. 500 B.C., bronze, 33 in. high. (*G 6-10, H 241, J 206*)
2. *Portrait Bust of Lucius Junius Brutus,* third century, B.C., bronze, 13 in. high. (*H 242*)
3. *Apollo of Veii,* c. 510 B.C., terracotta, 70 in. high. (*G 6-8, H cpl 24, J 205*)
4. *Canopic Urn from Chiusi,* seventh century B.C., bronze and terracotta, 33 in. high. (*G 6-6, H 239, J 199*)
5. *Married Couple Sarcophagus,* c. 520 B.C., terracotta, 79 in. long. (*G 6-7, H 240, J 200*)
6. *The Chimera,* from Arezzo, fifth-fourth century B.C., bronze, 32 in. high. (*G 6-11*)

E. MINOR ARTS

The Etruscans were considered superb metalsmiths not only in the production of solid and hollow-cast sculptures, but also in the production of gold jewelry. Many of the pins and pendants reflect contact with the Near East and Egypt in the subjects and forms represented.

II. ROMAN ART c. 509 B.C.-A.D. 476

With the Expulsion of the Etruscan Kings in 509 B.C., the Romans began a gradual development and consolidation of power that would eventually make Rome the center of the world's largest empire.

A. ARCHITECTURE

1. Republican Period c. 509–27 B.C.

BUILDING TYPES: Most of the building types used by the Romans were introduced during the Republican Period and developed under the Empire. The two major building types begun in the Republican Period which did NOT change much during the Empire were

1. Temples.
2. Houses.

MEDIA AND TECHNIQUES

1. Travertine limestone and tufa were used for foundations and facings of buildings.
2. Concrete was invented/discovered and used for walls, vaults, and domes. (Concrete has been called "synthetic stone.")
3. The use of the arch and vault in combination with concrete led to vast increases in the strength and size of structures.

DESIGN

1. **Axial alignment,** or symmetry, was typical of all Roman buildings and city planning.
2. **Temples** used both rectangular and circular plans, combining Etruscan and Greek prototypes with new Roman innovations.
 a. **Etruscan elements**
 (1) Emphasis on facade; shallow porches and cellae.
 (2) Podium, steps, and blank sides, which emphasized axial alignment.
 (3) Triple cellae for triad of gods of Etruscan-Greek origin.
 (4) Deep overhanging cornices; no pedimental sculpture.
 b. **Greek elements**
 (1) Basics of rectangular and tholos plans.
 (2) Use of three Greek orders for exterior decoration.
 (3) Engaged columns and pilasters in imitation of Greek peripteral temples.
 c. **New Roman elements**
 (1) Concrete cores faced with veneers of brick or stone.
 (2) Use of vaulted or domed ceilings.
 (3) Inscriptions on the pediments.
 (4) Garland and bucrania frieze decoration in stucco.
 (5) Temples generally situated in the center of cities.
3. **Houses**
 a. The basic form originated with the Etruscans.
 (1) Corridor from street entrance to central atrium.
 (2) **Atrium** flanked by rectangular sleeping and living rooms.
 b. Refinements were developed by the Romans.
 (1) **Tablinium** (reception hall) opposite the entrance side of the atrium.

(2) **Peristyle court** surrounded the garden on the far side of the tablinium; other rooms radiated from the sides of the peristyle court.

EXAMPLES

TEMPLES

1. Temple of Fortuna Virilis, Rome, second century B.C. (*G 6-16, H 247, J 210*)
2. Temple of Fortuna Primigenia, Palestrina, second century B.C. (*G 6-18, 19, 20; H 249, 250; J 213, 214, 215*)
3. Temple of the Sibyl, Tivoli, first century B.C. (*G 6-17; H 248; J 211, 212*)
4. Maison Carée, Nîmes, France, 19 B.C. (*H 260*)

HOUSES

1. House of the Silver Wedding, Pompeii, first century A.D. (*G 6-25, H 251, J 230*)
2. House of Pansa, Pompeii, second century B.C. (*G 6-24*)

2. The Empire Period 27 B.C.-A.D. 476

Public, non-religious structures were the most innovative during the Empire Period. Houses and temples continued along fairly traditional lines.

BUILDING TYPES

1. Apartment houses (insulae).
2. Bridges and aqueducts.
3. Amphitheaters and theaters.
4. Baths (thermae).
5. Basilicae (government centers).
6. Triumphal arches.

MEDIA AND TECHNIQUES: See Republican Period architecture for a general discussion.

1. Marble was used in addition to travertine and tufa as facing for buildings with concrete cores.
2. Structures became larger in all dimensions as Roman arch and vault technology increased.

DESIGN: See Republican Period architecture for a general discussion.

1. Roman architecture concentrated on the creation and organization of interior space.
2. The **orders of architecture** were expanded from three to five to include
 a. **Tuscan:** Greek Doric with a base added to the column; shorter unfluted shaft.
 b. **Composite:** Ionic and Corinthian combined. (See Figure 6-2).
 NOTE: The Roman Doric column had a base and a fluted shaft.

FIGURE 6-2 Roman architectural orders. From left to right: Tuscan, Doric, Ionic, Corinthian, Composite.

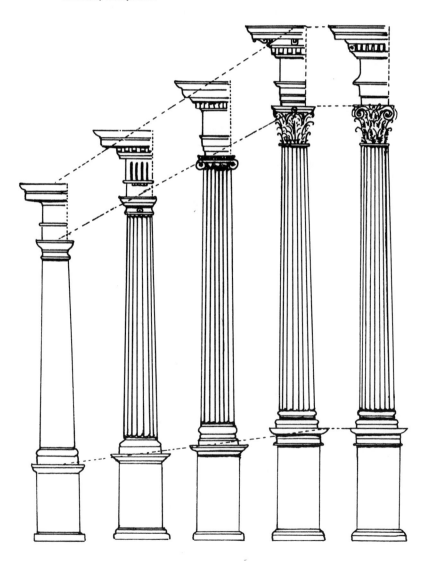

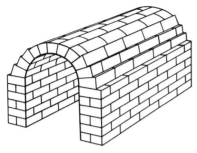

a. Barrel vault

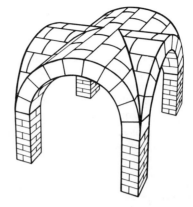

b. Groin vault seen from above

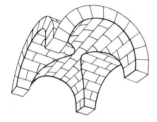

c. Groin vault seen from below

FIGURE 6-3 Roman vaults.

3. **Roman orders with arches** (embracing) were used decoratively before A.D. 125, and structurally with supporting arches after that date.

4. **Barrel vaults** were used to roof rectangular spaces. (See Figure 6-3a) **Groin vaults** (the right-angle intersection of two barrel vaults) were used over square or rectangular spaces where light and circulation of traffic were needed. Stress in the barrel vaults was carried down the sides of the vaults; stress in the groin vaults was carried down the four supporting piers at the corners. (See Figure 6-3b and 6-3c)

5. **Domes** of cast concrete covered circular structures. Coffering (a network of ribs) was used to reinforce the shell of the dome and lessen the weight.

6. **Rustication** (the use of stones with roughened surfaces and indented joints) was popular for emphasis of the utilitarian nature of some structures. This was typical of aqueducts and gateways.

7. **Apartment houses** (insulae) were four- to six-story, blockish structures for urban housing of the lower classes.

8. **Bridges and aqueducts** relied on arch-and-concrete construction to span large openings of great height. Repetition and modulation of arch sizes enhanced the aesthetic quality.

9. **Amphitheaters** consisted of two "Greek" theaters combined to produce elliptical structures in multiple stories. **Theaters** (semi-circular) were also built. Both types were free-standing structures made possible by the use of barrel and groin vaults. Exteriors were decorated with the Roman orders in superimposed sequence: Tuscan, Roman Doric, Ionic, Corinthian, and Composite.

10. **Baths** (thermae) were constructed as recreation centers equipped with baths, swimming pools, exercise rooms, and libraries. Barrel and groin vaults, buttressed by thick massive walls, enclosed large open spaces.

11. **Basilicae** were administrative centers, court houses, and halls of records. They were rectangular structures with a central nave and two side aisles. Colonnades separated the naves from the aisles. Semi-circular niches called "apses" enclosed both ends of the building.

12. **Triumphal arches** were commemorative structures which used the language and technology of architecture. Triumphal arches were built with either one or three openings and surface decoration in the Roman orders.

EXAMPLES

ORDERS WITH ARCHES

1. The Colosseum, Rome, A.D. 72-80 (embracing). (*G 6-44, 45; H 266, 267; J 218, 219, 220*)

2. Peristyle Court, Palace of Diocletian, Split, A.D. 293 (supporting). (*G 6-73, 74; H 305; J 235*)

COFFERED DOME

The Pantheon, Rome, rebuilt A.D. 118-125. (*G 6-48, 49, 50; H 283, 284, 285; J 221, 222, 223, 224*)

AQUEDUCT

Pont du Gard, Nimes, France, late first century B.C. (*G 6-42, H 264, J 217*)

AMPHITHEATER

The Colosseum (Flavian Amphitheater), Rome, A.D. 72-80. (*G 6-44, 45; H 266, 267; J 218, 219, 220*)

THEATER

Theater, Sabratha, Libya, late second century A.D. (*H 291*)

BATHS

Baths of Caracalla, Rome, A.D. 211-217. (*G 6-52, 53; H 298, 299*)

BASILICAE

1. Basilica Ulpia, Rome, A.D. 98-117. (*G 6-47, H 276*)

2. Basilica of Maxentius and Constantine, Rome, A.D. 306-313. (*G 6-76, 77; H 306, 307; J 225, 226, 227*)

TRIUMPHAL ARCHES

1. Arch of Titus, Rome, c. A.D. 81. (*G 6-58, H cpl 30*)
2. Arch of Trajan, Benevento, c. A.D. 114-117. (*H 280*)
3. Arch of Constantine, Rome, A.D. 312-315. (*G 6-80, H 301, J 256*)

CITY PLANNING: The Romans devoted major efforts to the construction of new cities and the rebuilding of old ones. Cities were laid out around a civic center or **forum** (derived from the Greek **agora**), which included the bath, basilica, amphitheater, and major temples. (*G 6-22, 23, 43, 46; H 261, 290; J 216*) The two main streets ran north-south, and east-west, dividing the city into four equal quadrants which were subdivided into blocks by alleys and narrow streets. Roman use of the rectangular grid reflects the continued use of Greek concepts in city planning.

B. PAINTING

Roman painting included wall paintings, which decorated public buildings and houses, and panel paintings, which decorated houses. Wall painting was more important and innovative. Its illusionistic effects established the foundations of later western painting.

PURPOSES AND SUBJECT MATTER

1. Religious and subject matter.
2. Secular (non-religious, decorative).
 a. Landscapes, real and imaginery.
 b. Cityscapes (architectural views).
 c. Genre scenes (everyday life).
 d. Still-life.

MEDIA AND TECHNIQUES

1. True fresco on wet plastered wall surfaces was prevalent.
2. Tempera on wood panels was used for small portable pictures.
3. Encaustic on wood panels was also used for small pictures and for the mummy-portraits made in Egypt under Roman rule.

DESIGN

1. **Wall painting:** There were at least four phases of development of fresco painting during the Republic and Early Empire. The styles have been named after the city of Pompeii.
 a. **First Pompeiian Style (Incrustation)** c. 150-40 B.C.
 (1) Imitation of marble inlay, painted and modeled on stucco panels.

 (2) This style coexisted with other styles as decoration for the lower sections of walls.

 b. **Second Pompeiian Style (Architectural)** 100–44 B.C.

 (1) Architectural elements painted very illusionistically: columns, entablatures, balconies painted with scenes between them, like views through windows.

 (2) Herringbone perspective (multiple viewpoints combined in the same scene).

 (3) **Chiaroscuro** (shading and modulation of color).

 (4) Sculptural, three-dimensional objects and figures.

 c. **Third Pompeiian Style (Ornate)** 20 B.C.–A.D. 60

 (1) Architectural fantasies that could not exist in real life.

 (2) Figural scenes reduced in size and arranged like framed pictures hung on walls.

 d. **Fourth Pompeiian Style (Intricate)** A.D. 60–80

 (1) Elements from the three previous styles combined.

 (2) Aerial views often included in the architectural settings.

 e. **Design characteristics** contributing to Roman illusionism:

 (1) Shading of forms from light to dark (chiaroscuro).

 (2) Modulation of color within forms.

 (3) Diminution of size from foreground to background.

 (4) Foreshortening of forms and figures.

 (5) Directed lighting (forms cast shadows).

 (6) **Atmospheric perspective** (forms become indistinct and bluish toward the horizon).

 (7) **Herringbone perspective** (multiple viewpoints and vanishing points).

2. **Panel painting:** Wooden panels were painted in both tempera and encaustic. Encaustic employed colored beeswax resins fused into a cohesive surface by the application of heat. The most famous examples of encaustic painting are the mummy-cover portraits made in Egypt under Roman domination. The style is considered very direct in recording realistic images, and very expressive in capturing psychological traits.

EXAMPLES

INCRUSTATION

Wall painting from a Samnite House, Herculaneum, second century B.C. (*G 6-26*)

ARCHITECTURAL

1. *Architectural View,* Villa at Boscoreale, late first century B.C. (*G 6-27, H cpl 27, J 260*)

2. *Events from the Odyssey,* Villa from Esquiline Hill, Rome, 30 B.C. (*G 6-29, H 252, J cpl 17*)
3. *Dionysiac Mystery Cult Initiation,* Villa of the Mysteries, Pompeii, first century B.C. (*G 6-28, H 253, J 263, cpl 19*)
4. *Garden Room,* House of Livia, Prima Porta, late first century B.C. (*G 6-30, H cpl 28, J 261*)

ORNATE

1. *Ornate wall painting,* House of M. Lucretius Fronto, Pompeii, before A.D. 50. (*H 272*)
2. *Ornate wall painting,* from a villa at Boscotrecase, early first century A.D. (*G 6-31*)

INTRICATE

1. *Scenes from the Ixion Room,* House of the Vetii, Pompeii, before A.D. 79. (*G 6-32, J 259*)
2. *Still Life with Peaches,* from Herculaneum, c. A.D. 50, 14 in. by 14 in. (*G 6-33, J cpl 18*)
3. *Herakles and Telephos,* Herculaneum, c. 70 A.D., about 7 ft. by 6 ft. (*G 6-35, H cpl 21, J 262*)

MUMMY PORTRAIT

Mummy Portrait from El Faiyum, Egypt, A.D. second century, various examples, various sizes. (*G 6-40, H cpl 32, J cpl 20*)

C. SCULPTURE

As in the other art forms, the Romans synthesized the developments of Greek and Etruscan sculpture, and added elements of their own to produce a unique art style.

PURPOSES: Because of the combination of religion and politics in the Roman state, most of the sculpture served as both religious and state propaganda.

SUBJECT MATTER

1. Introduced during the **Republican Period**:
 a. Portrait busts of ancestors and rulers.
 b. Copies and adaptations of Greek originals.
 c. Wholesale import (and plunder) of Greek originals.

2. Introduced during the **Empire Period**:
 a. Official portraits of rulers:
 (1) The orator and addressing the people.
 (2) The leader on horseback (**equestrian statue**).
 (3) The leader as pontifex maximus (priest) or as god.
 b. Relief sculpture of actual or mythological events on
 (1) Triumphal arches.
 (2) Commemorative columns.
 (3) **Sarcophagi.**

MEDIA AND TECHNIQUES

1. Marble and bronze were used for free-standing and relief sculpture.
2. "Copies" of Greek originals were often adaptations rather than direct copies because
 a. Faces were more realistic.
 b. Poses were more forceful.
 c. Bracing had to be added between body and limbs for added strength when bronze originals were copied in marble, which was weaker.
3. Skill and technique were generally very sophisticated because sculptors had great ability to render textures, surfaces, and details.
4. The Early Empire Period is considered the technical peak of Roman sculpture.
5. The quality of workmanship declined during the Late Empire Period.
 a. Works were mass-produced, quickly executed.
 b. Forms and details were roughed in with gouges and drills, not polished and finished carefully.
6. Between the Fall of Rome in A.D. 476, and the fifteenth century—one thousand years—no large hollow-cast bronzes were produced in Europe.

DESIGN

1. The Republican Period

1. Portraiture emphasized direct, forceful images.
2. Emphasis was on realistic portrayal of individuals, not on idealization of types of faces or figures.
3. **Verism** (extreme realism) of portraits developed from ancestor worship and the keeping of wax images (**imagines**) of the dead.
4. The preference for portrait busts rather than full figures was influenced by
 a. Etruscan prototypes such as canopic urns lids.
 b. Roman **imagines** or wax masks.

2. The Empire Period

1. Public images conveyed the "message" of Rome.
2. Official portraiture was less realistic, more idealistic than Republican Period images.
3. Early Empire sculpture continued Greek proportions.
4. Late Empire sculpture
 a. Figures became shorter, more clumsy in form, unattractive.
 b. "Shorthand" was used to imply figures and settings:
 (1) A head cluster represented a crowd.
 (2) A city gate represented an entire city.
 c. Reliefs concentrated on real events and images, not on religion or myth.

LOCATION, SIZE, AND SCALE

1. Roman sculptures adorned both private and public buildings.
2. Most sculptures were life-size or larger.
3. Roman sculpture is known for extreme monumentality.

EXAMPLES
REPUBLICAN PERIOD

1. *The Orator (Arringatore)*, first century B.C., bronze, 71 in. high. (*H cpl 26, J 236*)
2. *Patrician Carrying two Portrait Heads,* 50 B.C.-A.D. 15, marble, life-size. (*H 245, J 238*)
3. *Pompey the Great,* c. 55 B.C., marble, life-size. (*G 6-15, H 246*)

EMPIRE PERIOD

1. *Augustus of Prima Porta,* c. 20 B.C., marble, 80 in. high. (*G 6-54; H 255; J 239, 240*)
2. *Imperial Procession* and other friezes, Ara Pacis, Rome, 13-9 B.C., marble. (*G 6-55, 56, 57; H 257, 258, 259; J 241, 242, 243, 245*)
3. *Bust of Vespasian,* c. A.D. 75, marble, life-size. (*G 6-66, H 270, J 250*)
4. *Reliefs,* from the Arch of Titus, c. A.D. 81, Rome, 90 in. high. (*G 6-59, 60; H 268, 269; J 246, 247*)
5. *Portrait of a Flavian Lady,* c. A.D. 90, marble, life-size. (*G 6-67, H 271, J 249*)
6. *Reliefs,* Column of Trajan, A.D. 106-113, column 125 ft. high. (*G 6-61, 62; H 277, 278; J 248*)

7. *Equestrian Statue of Marcus Aurelius,* A.D. 161–180, bronze, over life-size. (*G 6-69, H 289, J 252*)
8. *Portrait of Caracalla,* c. A.D. 211–217, marble. (*G 6-70, H 293*)
9. *Portrait of Philip the Arab,* c. A.D. 244, marble. (*G 6-71, H 295, J 253*)
10. *Ludovisi Battle Sarcophagus,* third century A.D., limestone. (*G 7-15, H 296*)
11. *Tetrarchs,* A.D. 305, porphyry, 51 in. high. (*G 6-79, H cpl 33*)
12. *Head of Constantine,* A.D. 330, marble, 8 ft. high. (*G 6-78, H 302, J 255*)
13. *Reliefs* from the Arch of Constantine, second and fourth centuries A.D., marble. (*G 6-81, 82; H 281; J 256, 257*)

D. MINOR ARTS

Roman minor arts included the making of mosaics, jewelry, cameos, and coins. Their technology and imagery profoundly influenced the development of Early Christian and Byzantine art in the succeeding centuries.

Mosaics were especially important:

PURPOSES: Mosaics were used as floor paving in public buildings and houses.

SUBJECT MATTER

1. Geometric and floral pattern.
2. Figural scenes from mythology, history, and everyday life.

MEDIA AND TECHNIQUES

1. **Tesserae** (flat pieces of stone) were laid in a bed of cement.
2. Very small pieces were used during the Republic and the Early Empire.
3. Large pieces were used during the Late Empire.

DESIGN

1. Early mosaics were illusionistic, imitating wall painting.
2. Later images were less detailed and illusionistic. It is the late form of mosaic technology that was adapted by the Early Christians for wall and ceiling decoration in their new churches.
3. Two styles were used by Roman mosaicists throughout their history:
 a. A **silhouette style** using only black and white tesserae.
 b. A **polychrome style** with many different colors.

EXAMPLES OF MINOR ARTS

CAMEO

Gemma Augustea, early first century A.D., onyx cameo, 8 in. by 9 in. (*H cpl 29*)

MOSAIC

1. *The Battle of Alexander* (*Issus*), from the House of the Faun, Pompeii, third-first century B.C., Greco-Roman mosaic, approx. 9 ft. by 17 ft. (*G 6-37, H cpl 20, J cpl 16*)
2. *Wall Mosaic* from the House of Neptune and Amphitrite, Herculaneum, c. A.D. 70. (*G 6-39*)

VOCABULARY

acroterium	cist(ae)	mosaic
antefix(ae)	concrete	nave
apse	encaustic	podium
atmospheric perspective	equestrian	portico
atrium	forum	rustication
axial alignment	groin vault	sarcophagus
barrel vault	herringbone perspective	tablinium
basilica	imagines	tessera(e)
canopic urn	insula(e)	tumulus
chiaroscuro	lost-wax (cire perdue)	verism

7. Early Christian and Byzantine Art

SUMMARY

I. Early Christian Art A.D. 33–500

Architecture: Exclusively religious; basilican plan was most common; some use of central plan for baptistries, martyria, and mausolea; infrequent use of mixed plan. Emphasis was on low, horizontal structures with plain exteriors and elaborate interior decoration.

Painting: During the Persecution Era, catacomb paintings in a sketchy style were most important. After Recognition, fresco and mosaic cycles decorated church interiors. Manuscript illuminations and some panel paintings also expressed religious values. Painting was used to instruct, not to entertain.

Sculpture: Sarcophagi were most significant. Figure sculpture was extremely rare. Early works reflected the influence of Roman classicism and illusionism; later works reflected the increasing interest in symbolic content.

Minor arts: Church furnishings, ivory carvings, and metalwork were more important than sculpture. Style paralleled the changes in painting and sculpture.

II. Byzantine Art A.D. 330–1453

Architecture: Exclusively religious; preference for central and mixed plans with occasional use of basilican plan. Emphasis was on complex, mysterious interior spaces covered with domes and half-domes and rich surface ornamentation. Invention of the pendentive and use of the squinch made it possible to construct round domes over rectangular spaces.

Painting: Fresco and mosaic cycles in a formal, elegant style complemented church design. Panel paintings in tempera (icons) and illuminated manuscripts were produced in great quantities. All forms of painting emphasized other-worldly figures, long and slender proportions, and formal, hierarchic groupings. Symbolic content was more important than naturalism or illusionism.

Sculpture: This was the least important art form in the Byzantine Era.

Minor arts: Ivory carving and metalwork were used to produce book covers, reliquaries, and other church objects.

I. EARLY CHRISTIAN ART c. A.D. 33-500

During the Period of Persecution, the major art form was wall and ceiling paintings in the **catacombs** (underground burial vaults and funeral chapels). After Recognition, art and architecture became more elaborate in the visualization of complex religious ideas.

A. ARCHITECTURE

With the recognition of Christianity, religious architecture became the most important form of building throughout the Christian world. This remained true for more than twelve centuries.

BUILDING TYPES

1. The **modified basilican plan** church was based on the Roman assembly hall. It was also called the "long" plan because of emphasis on longitudinal axis, and was the dominant plan for congregational services.
2. The **central plan** (circular, polygonal, cruciform) was based on the Greco-Roman tholos. It was used for baptistries, funeral chapels, mausolea, martyria.
3. The **mixed plan**, combining elements of basilican and central forms, was used infrequently.

MEDIA AND TECHNIQUES

1. Concrete, stone, and brick were the major materials.
2. Timber was used for open ceilings, roofs, and doors.
3. Plaster and stucco facings "dressed" the wall surfaces.
4. Round arches were used to frame doorways and windows, to separate naves from aisles, naves from apses, etc.
5. Domes and vaults were used to enclose and roof aisles and apses.
6. Building stone and columns were frequently quarried from pagan Roman buildings.

DESIGN: The Early Christian Era was a time of experimentation and formulation of basic architectural prototypes for a new world order. Although the plans and forms of ancient Greek and Roman temples were consciously rejected, many of the formal details were adopted by the Church and redefined.

1. **Basilican plan structures**: (See Figure 7-1a and 7-1b)
 a. The Roman assembly hall was modified as follows:
 (1) An **atrium** was placed in front of the church as a forecourt.

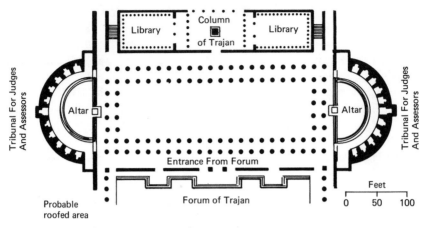

a. Roman basilica (Basilica Ulpia, Rome)

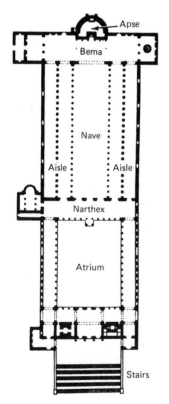

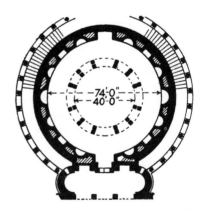

c. Central Plan: Circular (Santa Costanza, Rome)

b. Christian basilica (Old St. Peter's, Rome)

FIGURE 7-1 Early Christian and Byzantine church plans.

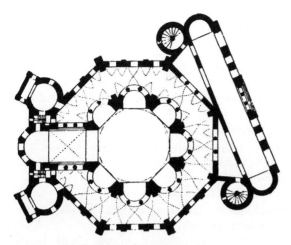

d. Central Plan: Octagonal (San Vitale, Ravenna)

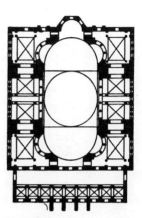

e. Domed Basilica (Hagia Sophia, Istanbul) (after V. Sybel)

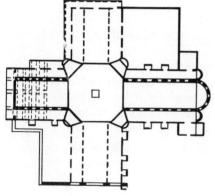

f. Greek Cross (St. Simeon Stylites, Kal'at Siman, Syria)

FIGURE 7-1 *(cont.)*

(2) A **narthex,** or vestibule, was placed between the atrium and the basilica.

(3) **Columns** divided the interior into distinct areas:

　(a) The **nave,** a large, rectangular space.

　(b) The **aisles,** which flanked the nave on both sides.

(4) A **triumphal arch** emphasized the separation of the nave (assembly area) from the sanctuary.

(5) Double Roman apses were reduced to a single **apse** (semicircular niche) usually at the east end.

(6) The **entrance** was moved from the long side wall to the short end wall opposite the apse.

 b. The overall impression was of a long, horizontal path to the **altar** and **sanctuary**.

 c. **Naves** were generally covered with peaked timber roofs. The nave was usually higher than the aisles, and lighted by **clerestory windows** in the upper levels' nave walls.

 d. **Aisles**, lower than the nave, were usually roofed with barrel vaults, and windowless.

 e. **Apses** were covered with hemispherical domes or half-domes.

 f. Occasionally, a **transept** or **bema** (a rectangular space between the nave and the apse) spanned the width of the church or extended beyond the aisles, forming a cross-shaped plan.

2. **Central plan structures**: (See Figure 7-1c)

 a. Central space was domed and surrounded by a circular arcade, double arcade, colonnade, or double colonnade.

 b. An **ambulatory** surrounded the central space and was usually barrel vaulted.

 c. General principles of basilica decoration applied.

3. **Mixed plan structures**: (See Figure 7-1f)

 a. A few structures were designed as combinations of both basilican and central plans.

 b. Most commonly, a central octagonal space was surrounded by four radiating basilicas. Occasionally, a circular or octagonal structure was affixed to the end of a basilica or connected to it by an enclosing wall.

 c. This type of plan did not contribute significantly to the development of Christian architecture in the West.

4. Every element of structure and decoration in any Christian building was a symbolic visualization of the complex theology developed by the Early Church.

5. Exteriors were plain, unarticulated.

6. Interiors were richly decorated with paintings, mosaics, and portable fittings and furnishings.

EXAMPLES

BASILICAN PLAN

1. San Giovanni in Laterno, Rome (Cathedral of Rome), founded 313. (*illustrated elsewhere*)
2. Old St. Peter's, Rome, begun 333. (*G 7-4, 6; H 321, 322; J 267, 268*)
3. San Paolo Fuori le Mura, Rome, 385-400. (*G 7-5, J 266*)
4. Santa Maria Maggiore, Rome, 432-440. (*illustrated elsewhere*)

CENTRAL PLAN

Santa Costanza, Rome, c. 350. (*G 7-7, 8, 9; H 324, 325; J 271, 272, 273*)

MIXED PLAN

1. Church of the Holy Sepulchre, Jerusalem, c. 345. (*illustrated elsewhere*)
2. St. Simeon Stylites, Kal'at Siman, Syria, c. 470. (*H 326*)

NOTE: At the beginning of the sixth century, St. Benedict introduced the Benedictine Order of monasticism. For the next four hundred years, the monasteries were the mainstays of Christian civilization in the West.

B. PAINTING AND MOSAIC

The visual arts of the Early Christian Era were a synthesis of antique (pagan) forms and new symbolic content. Because of the instructional value of the images, **iconography** (the meaning of images) or symbolism, became more important than naturalistic or illusionistic representations.

During the Period of Persecution, catacomb paintings were the major form of art. After Recognition, **wall paintings** and **mosaics** were used inside the churches to emphasize the spirituality of the architecture. **Manuscript illumination** (illustration) was also important in the establishment and perpetuation of Christian teachings and religious symbolism.

FORMS AND SUBJECT MATTER

1. **Catacomb paintings**: Images emphasized hope of salvation and an end to persecution. Major subjects included
 a. **Christ** shown as youthful Good Shepherd or teacher.
 b. **Orants** (praying figures, standing with arms partially extended), generally women; symbols of the soul and the Church.
 c. **Eucharist** (Communion) in commemoration of the Last Supper.
 d. **Old Testament** precursors of Christ.
 e. Figures from the Old Testament who were persecuted for their beliefs.
2. **Wall paintings and mosaics**, after 313.
 a. Emphasis was on ritual and the authority of the Church as well as hope for individual salvation. Christ now shown as bearded ruler.
 b. A program of appropriate subjects to be represented on specific portions of the Church was developed by the end of the fourth century:
 (1) **Theological subjects** were shown on the triumphal arch and in the apse.
 (2) **Old Testament subjects** were represented in **narrative cycles** on nave walls between the arcade and the clerestory.
 (3) **New Testament subjects** and images of the **saints** were paired with Old Testament scenes in the nave, but the New Testament scenes emphasized symbolic content rather than convincing narrative.

3. **Manuscript illumination:**
 a. By the fourth century, the form of books was altered from the **rotulus** (scroll) used in antique eras to the **codex** (book with separate pages bound between covers).
 b. Subjects included
 (1) Pagan literature considered divine such as writings of Plato and Virgil.
 (2) Religious themes and narratives as used for wall paintings and mosaics.

MEDIA AND TECHNIQUES

1. **Catacomb paintings** were done in fresco using cheap pigments applied in thin washes in a sketchy manner. Technique was often weak as many of the painters were not trained artists.
2. **Church paintings** after Recognition were also done in fresco on prepared walls. So little has survived, it is difficult to discuss technique or style.
3. **Mosaics** were no longer made of stone **tesserae** as the Romans had done, but were made of cubes **of colored glass.** The tesserae were set irregularly into damp cement so that each piece of glass caught the light and reflected a sparkling shimmer of color and light. Gold leaf baked into glass was especially popular because of its luminosity.
4. **Manuscript illuminations** were generally made of thinned tempera on pages of **vellum** (calf skin) or **parchment** (lamb skin). Manuscripts for imperial courts were produced on pages dyed purple (a sign of royalty) and illustrated and lettered in gold and silver. Less prestigious manuscripts were painted in ink and colored washes on bleached vellum and parchment.

DESIGN: While there were many variations of design and style during the first five centuries of Christian art, it is possible to describe the general features:

1. Roman interest in illusionism and the sculptural quality of figures lingered for a time, but was eventually replaced by a concern for **symbolic images** without sculptural volume.
2. Many elements of late antique design were adapted to Christian use:
 a. Postures, gestures, and costumes were dependent upon Roman prototypes.
 b. Theatrical exaggeration of gesture and expression was continued and strengthened, producing a kind of pantomime.
 c. Roman "shorthand" devices continued, such as head clusters for crowds, city gates for entire cities, etc.
 d. **Chiaroscuro,** perspective, and cast shadows were attempted intermittently until the fifth century.

3. By the fifth century a unique style had been created:
 a. Illusionism and naturalism had been replaced with flat images of symbolic value.
 b. Poses became stiff and frontal, expressions and gestures became stereotyped, and figures seemed to float on the walls without real substance.
 c. Emphasis on iconography exceeded concern for convincing narratives or beauty.
 d. Backgrounds were increasingly minimized and transformed into shimmering gold surfaces that implied eternal, sacred space rather than physical earthly settings.

EXAMPLES

CATACOMB PAINTINGS

1. *Breaking of Bread* (detail), Catacomb of St. Priscilla, Rome, late second century. (*H 317*)
2. *The Good Shepherd*, Catacomb of SS. Pietro e Marcellino, Rome, fourth century. (*G 7-3, H 318, J 265*)

MOSAICS

1. *Saints Cosmos and Damian*, dome, Hagios Georgios, Salonika, Greece, c. 400. (*H cpl 35, J 274*)
2. *Vault mosaics from Santa Costanza*, Rome, c. 350. (*G 7-9*)
3. *Annunciation, Adoration of the Magi*, and *Parting of Lot and Abraham*, Santa Maria Maggiore, Rome, c. 432-440. (*G 7-12, H 327, J 275*)
4. *Scenes from the Book of Joshua*, nave, Santa Maria Maggiore, Rome, c. 432-400. (*H cpl 36*)
5. *Christ with Saints*, apse, SS. Cosma e Damiano, Rome, c. 530. (*H 332*)

MANUSCRIPT ILLUMINATIONS

1. *Miracle of Ascanius*, from the *Vatican Virgil*, late fourth century. (*H 329*)
2. *Farmer Instructing his Slaves*, from the *Vatican Virgil*, late fourth century. (*G 7-13, J 276*)
3. *Joseph Recognizes his Brothers*, and *Jacob Wrestling the Angel*, *Vienna Genesis*, early sixth century. (*G 7-14, H cpl 41, J cpl 23*)

DURA-EUROPOS

Dura-Europos was a trade city in Syria in the route from Palmyra to the Mediterranean Sea. Between A.D. 200 and 256, both a Christian church and a Jewish synagogue were built within the city walls and were decorated with wall frescoes illustrating Biblical narratives and concepts.

None of the paintings from the church have survived, but the few remaining paintings from the synagogue indicate a blending of Greco-Roman and Near Eastern traditions. Typically, the images display a disregard for perspective and illusionism in favor of a solemn directness of symbolic forms. The figures are shown with rigid frontality, flatness of form without color modulation or shading, and spatial isolation of individual figures hovering in front of indefinite backgrounds. These Jewish frescoes are remarkable because they belong to a rare period in which the Judaic ban against figural images was ignored and, because the figural style suggests one possible source of Byzantine style.

Examples

1. *Consecration of the Tabernacle,* Synagogue, Dura-Europos, c. 250 A.D. (*J cpl 21*)
2. *Haman and Mordecai,* Synagogue, Dura-Europos, c. 250. (*H 319*)
3. *Priests and Attendants,* Temple of the Palmyrene Gods, Dura-Europos, c. 250. (*G 7-21*)

C. SCULPTURE

Large free-standing sculpture declined in importance during the Early Christian Era and architectural sculpture, so important to the Hellenic world, fell into disuse. Sarcophagi were the most important form of sculptural art.

FORMS AND SUBJECT MATTER

1. **Sarcophagi** with Christian meaning were produced as early as the third century. Decoration included
 a. Pagan subjects and scenes redefined.
 b. Portraits of the deceased carved in shells or medallions.
 c. Old and New Testament scenes symbolizing the salvation possible through Faith.
2. **Free-standing sculptures** were not common, but those produced represented officials and emperors in a continuation of the Roman use of statues as symbols of the power of the Empire.

MEDIA AND TECHNIQUES

1. Limestone and marble were the most common materials for sarcophagi and statues.
2. Techniques reflected the degeneration of the late Roman Empire; the polished and refined work of the Classical Ages was generally replaced by crude craftsmanship and simplified technology.

3. Chiseling, gouging, and drilling of reliefs were more characteristic than carving and modeling in depth.

DESIGN

1. The majority of Early Christian sculpture abandoned the Greco-Roman interest in naturalism and illusionism.
2. Forms generally exhibited the following characteristics:
 a. All figures were carved equally deeply, implying their position on the same plane surface.
 b. Forms were flattened, not rounded.
 c. Poses stressed rigid frontality and isolation from other figures.
 d. Forms were defined chiefly by outlines rather than by modulation of form.
 e. Squat proportions and stereotyped poses prevailed.
3. Compositions became abstract with decorative surface arrangements:
 a. Organization stressed ideas not illusionism.
 b. Symmetry of elements replaced naturalistic scenes.
 c. Perspective was "reversed" and "piled up"; figures looked crowded into the extreme foreground; recession into space was misrepresented.
 d. Fear of empty spaces (**horror vacui**) resulted in very crowded surface decoration.
 e. Descriptive realism remained in the details only; the overall composition was given over to surface pattern.

EXAMPLES

1. *Sarcophagus of Junius Bassus,* c. 359, marble, 4 ft. by 9 ft. (*H 330; J 277, 278*)
2. *Good Shepherd Sarcophagus,* Catacomb of Praetextus, Rome, late fourth century, marble. (*G 7-16*)
3. *Colossus of Barletta,* Barletta, Italy, late fifth century, bronze, over life-size. (*H 320*)

D. MINOR ARTS

Portable religious objects, especially church furnishings, were much more important than sculpture during the early Christian Era.

FORMS AND SUBJECT MATTER

1. **Ivory plaques** and **book covers** were decorated with
 a. Christian symbols and narrative scenes.
 b. Imperial images of standing or enthroned officials.

2. **Church furnishings,** including croziers (Bishops' staffs), chalices, candlesticks, and reliquaries, were decorated with religious signs and symbols such as the cross, the **Chi Rho** monogram, and the peacock.

MEDIA AND TECHNIQUES

1. Elephant tusk was used for ivory carvings.
2. Metals such as gold, silver, and bronze were cast and hammered into church furnishings.

DESIGN: See Early Christian Sculpture.

EXAMPLES

1. *Archangel Michael,* fourth century, ivory. (*G 7-18, J 280*)
2. *Priestess of Bacchus,* leaf of a diptych, c. 390 A.D., ivory, about 12 in. by 6 in. (*G 7-17, J 279*)
3. *Three Marys at the Sepulcher* and *The Ascension,* early fifth century, ivory. (*H 331*)
4. *Diptych of Consul Anastasius,* c. 507-517, ivory. (*G 7-19*)

II. BYZANTINE ART c. 330-1453

Just as the political, economic, and cultural fortunes of the West were at their lowest, Byzantine fortunes were on the rise. From the eastern capital at Constantinople spread a new art and architecture that expressed the mysterious, mystical powers of Eastern Christianity.

A. ARCHITECTURE

As in the West, Church architecture was the most important and is the best preserved. The Byzantine Empire developed a preference for complex designs with dark and mysterious interiors transformed by rich ornament and mosaic into spiritualized spaces without apparent weight or mass.

BUILDING TYPES

1. **Simple basilica** with timber roof, infrequently used.
2. **Central plan** (octagonal or circular). (See Figure 7-1d)
3. **Mixed plans** containing elements of both central and basilican plans developed in two directions:
 a. **Domed basilica.** (See Figure 7-1e)
 b. **Greek cross,** often with the four angles filled in. (See Figure 7-1f)

MEDIA AND TECHNIQUES: For a general discussion see Early Christian architecture. Byzantine architects retained a clear understanding of the possibilities of arches, vaults, and domes as used by the Romans. They expanded the technology through the invention of the **pendentive** and the use of the **squinch**, both of which allowed rectangular or square spaces to be joined to round domes and half-domes.

1. **The Pendentive**: (See Figure 7-2a) Pendentives are concave, triangular elements fitted between the rectangular walls and the dome of a structure so that the dome rests on a continuous curved base. Often the four rectangular walls below the pendentives are replaced with arches, so that the dome actually rests on four piers with the pendentives between the pier-sprung arches and the domes.
2. **The Squinch**: (See Figure 7-2b) Squinches are series of arches, corbels, or lintels of increasing size placed diagonally across the corners of rectangular structures to provide an interface with domes. Often, the square or rectangular base is transformed into an octagon by the use of squinches; then the dome rests on the octagonal interface above the walls.

DESIGN

1. The overall impression of a Byzantine church was complex and vertical, especially when compared to simple, horizontal Early Christian buildings.
2. Reliefs decorated church exteriors. Carving, painting, and mosaics decorated the interiors.
3. Byzantine architecture developed an alternative to the use of Greco-Roman orders:
 a. Columns were massive monoliths.
 b. Capitals were cube-shaped, with pierced decorations.
 c. **Impost blocks** (inverted pyramid-shaped blocks of stone) were added between capitals and the arches or vaults they supported. (See Figure 7-2c)
4. Domes were characteristic of Byzantine architecture. The pointed "onion dome" was developed in northern areas where snow would have overloaded the hemispherical dome common in Mediterranean areas.
5. A few simple **basilican-plan** churches were constructed during the Age of Justinian. Most were built in Italy and show the influence of Early Christian forms.
6. **Central plan** (circular and octagonal) buildings were built intermittently throughout the Byzantine Era.
7. **Domed basilicas** were popular only during the Age of Justinian.
8. **Greek cross and modified plans** included a central circular space surrounded by four arms of equal length. Often the angles between the arms were filled in to form a square. This type of building came to be the most typical of mature Byzantine architecture.
9. **Galleries**, generally reserved for women, were second-story spaces over the ambulatory or aisles, overlooking the nave.

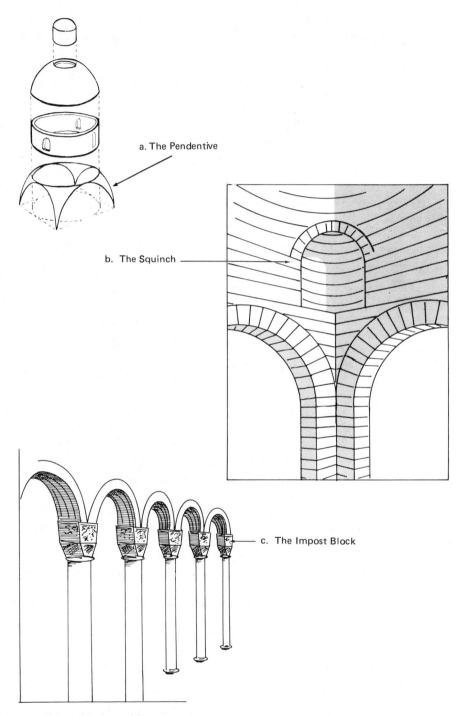

a. The Pendentive

b. The Squinch

c. The Impost Block

FIGURE 7-2 Byzantine construction details.

EXAMPLES
SIMPLE BASILICAN PLAN

1. Sant' Apollinare Nuovo, Ravenna, Italy, after 504. (*G 7-25*)
2. Sant' Apollinare in Classe, near Ravenna, 530-549. (*G 7-27, 28; J 269, 270*)

CENTRAL PLAN

1. Baptistery of the Orthodox, Ravenna, fifth century. (*illustrated elsewhere*)
2. San Vitale, Ravenna, 525-547. (*G 7-29, 30, 31, 32, 33; H 333, 334; J 283, 284, 285*)
3. Saints Sergius and Bacchus, Constantinople, c. 526-527. (*illustrated elsewhere*)

DOMED BASILICAS

1. St. Irene, Constantinople, fifth century. (*illustrated elsewhere*)
2. Hagia Sophia, Constantinople, 532-537. (*G 7-38, 39, 40, 41; H 338, 339, 340, 341; J 287, 288, 289, 290, 291*)

GREEK CROSS AND MODIFIED PLAN

1. Church of the Apostles, Constantinople, fourth century (destroyed).
2. St. John, Ephesus, early fifth century.
3. Mausoleum of Galla Placidia, Ravenna, c. 425. (*G 7-22, 23; H 328*)
4. Katholikon, Monastery of Hosios Loukas, Phocis, Greece, 1020-40. (*G 7-42, 43, 45; H 428, 429; J 292, 293, 294*)
5. San Marco, Venice, Italy, begun 1063. (*G 7-46, 47, 48; H 434, 435, 436; J 296, 297*)
6. Cathedral of St. Demetrius, Vladimir, Russia, 1193-97. (*G 7-49, H 443*)
7. Cathedral of Basil the Blessed, Moscow, Russia, 1554-60. (*H 444, J 298*)

B. PAINTING AND MOSAIC

PURPOSE: Religious.

FORMS AND SUBJECT MATTER

1. **Frescoes and mosaics** in churches
 a. Emphasized theological subjects:
 (1) Christ as Lawgiver, Judge, and the like.
 (2) Saints and other holy figures.
 (3) The Virgin and Child.

b. Gave symbolic content precedence over narrative (story telling).
2. **Icons** (panel paintings)
 a. Usually depicted images of saints or the Virgin and Child.
 b. Were banned from time to time due to the cult of miracles attributed to them, regarded as idolatry by the Church.
3. **Manuscript illuminations**
 a. Included both narrative scenes and symbolic images.
 b. Helped establish a repertoire of acceptable subjects and forms.

MEDIA AND TECHNIQUES

1. Media included fresco and glass mosaic for church decoration; tempera and gold leaf on wood, vellum, and parchment for panels and manuscripts.
2. Quality of workmanship varied greatly.
 a. Many, but not all, icons were produced by amateurs.
 b. Mosaic and fresco programs for important churches were well done and were very sophisticated.

DESIGN

1. During the **Age of Justinian** (A.D. 526–565)
 a. Classical illusionism coexisted with the flat, decorative, symbolic style.
 b. The essential features of the mature Byzantine style were established by the end of Justinian's reign.
2. In the **mature Byzantine style** (mid-sixth century onward)
 a. Figures were frontally posed, elongated, and flat.
 b. Figures were grouped hierarchically, their number was minimized, and emphasis was on isolation rather than interrelated groups.
 c. Eyes were large and staring; facial expressions were either blank or "anxious."
 d. Backgrounds were neutral, usually gold, with little suggestion of architecture or landscape settings.

EXAMPLES
FRESCOES

1. *Dormition of the Virgin,* Church of the Trinity, Sopocani, Serbia (Yugoslavia), 1258-1264. (*H 440*)
2. *Anastasis (Harrowing of Hell or Resurrection),* apse fresco, Kariye Camii (Church of Christ in Chora), Istanbul (formerly Constantinople), Turkey, 1315-1321. (*G 7-55, H cpl 60, J 301*)
3. *Theophanes the Greek, Stylite* (detail), Church of Our Savior of the Transfiguration, Novgorod, Russia, 1378. (*H 445*)
4. *Last Judgment,* west wall of the narthex, Church of St. George, Voronet, Romania, c. 1550. (*H cpl 62*)

MOSAICS

1. *Christ as Good Shepherd,* lunette, Mausoleum of Galla Placidia, Ravenna, 425-450. (*G 7-24, H cpl 37*)
2. *Miracle of the Loaves and the Fishes,* nave wall, Sant' Apollinare Nuovo, Ravenna, 425-450. (*G 7-26*)
3. *Christ Enthroned between Angels and Saints,* apse, San Vitale, Ravenna, 525-547. (*G 7-36, H cpl 38*)
4. *Emperor Justinian and Attendants,* sanctuary, San Vitale, Ravenna, 526-547. (*G 7-29, 34, 37; H 336; J 286*)
5. *Empress Theodora and Attendants,* sanctuary, San Vitale, Ravenna, 526-547. (*G 7-35*)
6. *Apse mosaics,* Sant' Apollinaire in Classe, near Ravenna, c. 533-549. (*G 7-28, H 337, J cpl 22*)
7. *Transfiguration,* Monastery of St. Catherine, Mt. Sinai, c. 549-564. (*H cpl 39*)
8. *Virgin and Child Enthroned* and *Deëis,* Hagia Sophia, Istanbul, before 867. (*H 426, 441; J cpl 25*)
9. *Annunciation, Crucifixion,* and *Pantocrator* mosaics, Church of the Dormition, Daphne, Greece, c. 1100.
10. *Pentacost,* dome, San Marco, Venice, c. 1150. (*H 437*)

PANEL PAINTINGS

1. *Virgin and Child between Saints Theodore and George,* Mt. Sinai, sixth century, 26 in. by 19 in. (*H cpl 40*)
2. *Vladimir Madonna,* fourteenth century, 21 in. by 31 in. (*G 7-57*)
3. Andrei Rublev, *Old Testament Trinity,* c. 1410-1420, 56 in. by 45 in. (*G 7-58, H cpl 62, J cpl 27*)

MANUSCRIPT ILLUMINATIONS

1. *Crucifixion* and *The Women at the Tomb, Rabula Gospels,* c. 586. (*H 342*)
2. *David Composing the Psalms, Paris Psalter,* c. 900, 15 in. by 11 in. (*G 7-56, J cpl 26*)
3. *Joshua Leading the Israelities Toward the Jordan River, Joshua Roll,* late tenth to early eleventh century. (*H 427*)

C. SCULPTURE

Sculpture was the least important of the arts of Byzantium. Free-standing sculpture was generally banned as idolatrous and, except during the Age of Justinian, relief carving was only done on a very small, portable scale.

Sarcophagi of limestone and marble were produced in Ravenna during the fifth to seventh centuries, and they were typically decorated with symbols against flat backgrounds rather than with narrative scenes.

EXAMPLE:

Sarcophagus of Archbishop Theodore, Ravenna, seventh century, marble. (*G 7-20*)

D. MINOR ARTS

As in the Early Christian Era, the minor arts were considerably more significant than sculpture during the Byzantine Era. The portability of the small ivory and metal objects helped to spread the Byzantine style to neighboring areas, including Europe, where they strongly affected the development of Romanesque sculpture.

MEDIA AND FORMS

1. **Ivory** was used for
 a. Book covers.
 b. Hinged relief carvings, called **diptychs** (two panels), **triptychs** (three panels), or **polyptychs** (four or more panels).
 c. Church furnishings.
2. **Metalwork** included
 a. Book covers.
 b. Church furnishings.
 c. **Reliquaries**: containers for bones and other relics of saints and holy persons.

TECHNIQUES

1. Carving, for ivory.
2. Casting and hammering for gold and silver.
3. Enameling on metal:
 a. **Champlevé**: A technique in which depressions are dug out of the background metal, and enamel added.
 b. **Cloissoné**: A technique in which small barriers of metal wire are soldered to the background, creating areas to hold enamel.
4. Artists were highly skilled. The quality of the workmanship and the intrinsic value of the materials made these works very precious.

EXAMPLES

1. *Christ Enthroned Between Saints Peter and Paul,* and *The Virgin Enthroned Between Two Angels,* ivory diptych, mid sixth century (*H 343*)
2. *Harbaville Triptych,* ivory, late tenth or early eleventh century. (*G 7-60, J 304*)
3. *Silver-gilt Book Cover,* from the Treasury of San Marco, Venice, gold filigree and enamel, c. 1020. (*illustrated elsewhere*)

VOCABULARY

aisle	codex	manuscript illumination	reliquary
ambulatory	diptych	martyrium	rotulus
baptistry	gallery	narthex	squinch
bema	horror vacui	nave	transept
catacomb	icon	orant(s)	triptych
champlevé	iconoclasm	parchment	truss
clerestory	iconography	pendentive	vellum
cloisonné	impost block	polyptych	

8. Islamic Art

SUMMARY

Architecture: Building types included mosque, madrasah, tomb, and palace complex. Buildings were primarily of brick, faced with stucco or plaster, with wooden ceilings and roofs. The most innovative features were the pointed arches and vaults used to create elaborate, delicate-looking structures. Decorations included carved, lacy arabesque patterns and inscriptions, brilliant mosaics, and gold-leafed domes.

Painting: Manuscript illumination was the most important form of painting, especially after A.D. 1200. Styles of the illustrations were complex, linear, and elegant. Influences came from Greco-Roman and Chinese art. Calligraphy was important.

Sculpture: Carved stucco and plaster decorations for architecture were the only important forms of sculpture. Three dimensional representations of the human figure or of animals were prohibited by the religion, although a few rare exceptions can be found.

Minor arts: The production of ceramics, carpets, and textiles was emphasized by nomadic Arab artisans. Their work featured strong colors and complex arabesque and geometric patterns. Through trade with the West, many Islamic motifs entered the art of the late Middle Ages in Europe.

Much of the progress of Islamic art and culture is outside the domain of this course in western art, but there are many ways in which Islam affected the West between A.D. 800 and 1600. Algebra, arabic numerals, and great advances in medicine came from the lands of Islam. Many art historians credit Islamic architects with providing the seeds of Gothic architecture. The importation of textiles, carpets, ceramics, and manuscripts also profoundly affected European decorative arts.

A. ARCHITECTURE

The structural and decorative uses of the pointed arch in Islamic architecture are considered important sources for Gothic architecture. The delicate carvings that complemented Islamic buildings also affected western art, particularly in Spain where the influence was felt well into the Renaissance.

BUILDING TYPES

1. **The mosque:** an assembly hall for sermons and prayers.
2. **The madrasah:** a school for religious and legal instruction.
3. **The tomb** and other memorial structures at sacred sites.
4. **The palace complex.**

MEDIA AND TECHNIQUES

1. Brick (mud-brick and fired brick) was used for walls, piers, arches, and vaults.
2. Stucco and plaster were used to cover brick surfaces, and often were carved into elaborate decorative schemes.
3. Wood was used for roof beams and coverings, and coffered ceilings.
4. Marble and other kinds of stone were used occasionally as decorative veneers and sometimes for structure.
5. Post-and-lintel construction was commonly used. Flat roofs were supported by walls, piers, and columns.
6. Arch construction was used for vaults and domes, and for arcades. Arches were also used for decorative enrichment.
7. The pointed arch was used very inventively as early as A.D. 700, and it profoundly influenced late Romanesque and Early Gothic architecture in Europe. Europeans who traveled to Syria, Egypt, and Spain on religious pilgrimages, on the Crusades, and for trade observed Islamic architecture first-hand.

DESIGN

1. **Types of mosque** construction included
 a. The **hypostyle mosque,** derived from Mohammed's house.
 (1) A courtyard, large and square.
 (2) A **zullah** consisting of multiple columns supporting roofs.

 b. The **basilica mosque**, adapted from Christian buildings.

 c. The **central plan** for tomb-mosques and other memorial structures (shrines).

 (1) Plans were circular, polygonal, or square.

 (2) Structures were often roofed with domes.

 d. The **four-iwan plan** for mosques and madrasahs.

 (1) An **iwan** is a vaulted room, open at one end, derived from tent construction. It is uniquely Near Eastern.

 (2) Four iwans open off a central court, forming a cross-shaped plan.

2. **Mosques** generally contained the following elements:

 a. **A courtyard**, rectangular and enclosed.

 b. **A sahn**, the fountain in the center of the courtyard.

 c. **A qibla wall**, the wall of the Mosque which faced Mecca.

 d. **A mihrab**, the niche in the gibla wall.

 e. **A minbar**, the pulpit next to the mihrab where the imam (teacher) recited the *Koran* and gave sermons.

 f. **A minaret**, or tower. Usually one of these was located at each corner of a mosque, and was used by the **muezzin** (crier) to call the faithful to prayer.

3. **Madrasah** complexes included the following:

 a. **A sahn** in the center of an enclosed courtyard.

 b. Four schools constructed on the four sides of the court.

4. **Palace** complexes

 a. Were surrounded by fortified brick walls with towers.

 b. Were fortress-like with forbidding, severe exteriors.

 c. Had lavish interiors, with fountains and gardens.

 d. Used pointed arches, vaults, domes, and half-domes extensively.

 e. Were decorated lavishly with delicate stucco and plaster carvings that made architectural surfaces look like lacework.

5. **Decoration** of Islamic architecture included

 a. Mosaics: glass and tile, brilliantly colored.

 b. Carved designs in stucco, plaster, and wood.

 c. Inscriptions in elegant calligraphy carved above columns and arches.

 d. Arches: pointed, flying (multiple tiers of arches springing from the same pier), multi-lobed, multi-colored, and striped.

 e. Columns and capitals quarried from earlier Roman and Christian buildings.

 f. Textiles and carpets.

EXAMPLES

MOSQUES, MADRASAHS, TOMBS, AND SHRINES HYPOSTYLE

1. The Great Mosque, Samarra, Iraq, 848–852. (*G 7-61, 62; H 354, 355; J 308, 309*)

2. Mosque, Cordoba, Spain, eighth to tenth century. (*G 7-63, 64, 65, 66; H 358, 359, cpl 46; J 310, 311, 312*)

BASILICA

1. The Great Mosque, Damascus, Syria, 705-715. (*H 352, cpl 45*)
2. Mosque of Selim II, Edirne, Turkey, 1569-75. (*G 7-77, 78, 79*)

CENTRAL PLAN

1. Dome of the Rock, Jerusalem, seventh century (shrine). (*H cpl 44*)
2. Mosque of Ahmed I, Istanbul, Turkey, 1609-1617. (*H 363; J 318, 319, 320*)
3. Tomb of Sultan Hasan, Cairo, Egypt, c. 1356-1363. (*G 7-74, 75; H 362; J 316*)
4. Taj Mahal, Agra, India, 1632-1654. (*G 7-76, J 317*)

FOUR-IWAN PLAN

Madrasah of Sultan Hasan, Cairo, Egypt, c. 1356-1363. (*G 7-74, 75; H 360, 361, 362; J 315*)

PALACES

1. Palace at Ukhaydir, Iraq, late eighth century. (*G 7-67, 68*)
2. Palace at Mshatta, Jordan, c. 743. (*G 7-69, 70; H 353; J 307*)
3. Palace of the Alhambra, Granada, Spain, 1234-1492. (*G 7-72, 73; H 364, 365; J 313, 314*)

N.B.: Elaborate non-figural mosaics were important complements to many of these structures.

B. PAINTING

Wall painting was significant only during the Mongol domination of Persia and Iraq. Although the Mongols converted to Islam, they ignored the restrictions against figurative representation, and produced lavish palace decorations. Literary sources describe these works, but none survive.

Manuscript illumination was practiced throughout the Middle East. The Arabian Peninsula was the most active center between 700 and 1200, and Persia was most significant between 1200 and 1800.

PURPOSES AND SUBJECT MATTER: **Early manuscripts** (700-1200) consisted primarily of scientific texts written in Arabic or translated from Greek,

Hebrew, and other languages. The illustrations were often done by foreign artists of various religions.

Later manuscripts (1200–1800) included a much broader range of subjects:

1. **Literary works.** Histories, romances, poems, and the like were especially popular and often were illustrated with landscape paintings based on earlier Chinese Sung Dynasty models and on narrative paintings in which the settings were more important than the action.

2. **Religious themes**, often associated with the life of Mohammed, were important after 1400. The *Koran* was never illustrated, but the production of new copies of the text was extremely significant to the development of diverse calligraphic styles.

MEDIA AND TECHNIQUES

1. Water-soluble pigment was mixed with egg white, egg yolk, or similar substances, and applied in opaque layers.

2. Drawings were done in pen and ink.

3. Illuminations were done on parchment, vellum, or paper. Paper was brought from China by the Mongols. In the thirteenth century, the Arabs introduced paper into Western Europe.

4. Gold leaf was an important addition to later, more lavish works.

DESIGN

1. Many foreign styles influenced early Islamic painting, including Early Christian and Byzantine. Chinese art had the most profound impact on Persian painting. Initially, Moslem artists knew of Chinese works only through trade. With the arrival of the Mongols, direct contact with Chinese art and artists strongly affected Persian manuscript production. Through the dispersion of Persian manuscripts, the Chinese influence made its way to other Islamic countries. **Chinese influences** included
 a. An interest in landscape painting.
 b. Buddhist prototypes for religious images.
 c. Flame-like haloes.
 d. Curly clouds.
 e. Oriental facial types and costumes.

2. All paintings had a linear quality with forms treated as flat, decorative elements.

3. Rhythm and pattern of shapes and lines were expressive and lively.

4. **Calligraphy** (beautiful handwriting) developed as an important art and often was included in illuminations as a necessary element. Frequently, the letter forms were intended to produce a kind of hidden imagery of human and animal forms.

EXAMPLES

1. *Koran page written in Kufic script,* ninth century. (*H 366*)
2. *Erasistratus and an Assistant,* from an Arabic translation of Dioscorides' *De Materia Medica,* 1224. (*J 323*)
3. *Temptation of Adam and Eve,* from the *Chronology of Ancient Peoples,* manuscript of al-Biruni, Tabriz, Iran, 1307. (*H 367*)
4. *Pen drawing in red ink from a Hariri manuscript,* 1323. (*J 324*)
5. *Summer Landscape* from the *Album of the Conquerer,* mid-fourteenth century. (*J cpl 28*)
6. Junaid, *Bihzad in the Garden,* from the poems of Khwaju Kirmani, 1396. (*H cpl 47*)
7. *Two Warriors Fighting in a Landscape,* 1396. (*J 325*)
8. Mirak, *Laila and Majun in Love at School,* from the *Khamasa,* a poem by Nizami, 1524-25. (*G 7-81*)
9. *The Ascension of Mohammed,* 1539-43. (*J cpl 29*)

C. SCULPTURE

Relief sculpture was important for architectural decoration. It consisted of designs and patterns rather than scenes, figures, or symbols, although a few animal images can be found.

Free-standing sculpture was restricted due to the religion's prohibition against the making of graven images. The few animal images that were made are exceptional.

EXAMPLES

1. *Wall Carvings,* Alhambra, Granada, Spain, fourteenth century (inscriptions). (*G 7-73, H 365, J 314*)
2. *Stone frieze,* Palace at Mshatta, Jordan, eighth century (contains animals). (*G 7-69, H 353, J 307*)
3. *Stone Lions,* Court of the Lions, Alhambra, Granada, eleventh or fourteenth century (rare, free-standing animal images). (*illustrated elsewhere*)

D. MINOR ARTS

Because many Moslem artists and artisans were nomads, portable works were important, and many of these were traded to westerners, significantly influencing Medieval European arts.

1. **Textiles and carpets** influenced western design and manufacturing techniques in the late Middle Ages.

2. **Ceramic** production was limited to urban centers, especially in Persia and Iraq. Persian ceramics carried many Chinese elements into the West.

3. **Metalwork** included basins, jewel cases, etc., made of wrought iron, copper, and brass inlaid with silver.

4. Other minor arts included leather craft, enamel on glass, ivory and wood carvings, and book manufacture.

EXAMPLES

1. *Coronation Cloak of the German Emperors,* 1133–34, red silk with gold embroidery, 11 ft. wide. (*J 322*)

2. *Incense Burner in the form of a stylized lion,* from Khurasan, Iran, 1181–82, bronze, 3 ft. high. (*J 321*)

3. *Carpet from the tomb-mosque of Shah Tahmasp at Ardebil,* Iran, 1540, about 34 by 17 ft. (*G 7–80*)

VOCABULARY

arabesque	iwan	minbar
calligraphy	madrasah	mosque
flying arches	mihrab	qibla(h)
imam	minaret	sahn

9. Early Medieval Art

SUMMARY

I. Migration Period A.D. 375–750

Architecture: None.

Painting: No wall painting. Manuscript illumination was significant. The Hiberno-Saxon school is the best-known style: non-illusionistic, dominated by interlace patterns, strongly influenced by metalwork.

Sculpture: Nothing monumental except for stone crosses in some areas.

Minor Arts: Metalwork was the most innovative art form. "Nomad gear," jewelry, and religious objects were made of metal and decorated with enamel and gems.

II. Carolingian Period A.D. 750–900

Architecture: Basilican and central plan churches were most notable. Forms were based on Early Christian models, but buildings were more massive. Westwork and square schematism were introduced.

Painting: Wall painting was done, but none has survived. Manuscript illumination continued with various schools. In general, illusionism was greater than Hiberno-Saxon, but styles were still more abstract than Mediterranean sources.

Sculpture: Some small figure sculptures were created.

Minor Arts: Metalwork was still dominant for book covers and religious objects. Style derived from Migration Era, but more restrained. Figure representations and symbolism were based on Early Christian types.

III. Ottonian Period A.D. 900–1024

Architecture: Churches were mostly basilican plan with westwork. Forms were refined from Carolingian prototypes, with square schematism and geometric clarity perfected.

Painting: A few wall frescoes survive. Manuscript illumination still dominant, with style more disciplined and formalized. Figures dominate narrative compositions. Color used symbolically. Emphasis on mystical expressionism.

Sculpture: Monumental relief with free-standing sculpture were reintroduced for religious works. Linear effects were dependent on illumination styles. Passion and expressionism were emphasized.

Minor Arts: Continued as in the Carolingian era.

During much of the Early Medieval Period, the only central authority in Europe was the Christian Church. Through its monasteries and missionaries, the Church tried to maintain the foundations of western civilization and build a stable economic, political, and social structure in Northern Europe.

I. THE MIGRATION PERIOD c. 375-750

The Goths of Scandinavia and the Huns of Eastern Europe set the migrations in motion. The Goths moved from the Baltic Sea southeastward to the Black Sea between A.D. 150 and 250. In the fourth century, the Huns and Goths began to move westward. This set off a chain reaction of movement along the frontiers of the crumbling Roman Empire. Although the barbarians were Christians, they did not share in the cultural heritage of the Christians of the Mediterranean and Byzantine areas. The art of the Migration Era is a combination of pagan and Christian elements.

A. ARCHITECTURE

Permanent building was not important during this period. It is more accurate to describe this period as destructive of architecture because of the sacking of Roman-built cities throughout Western Europe.

B. PAINTING

Monumental painting was non-existent in Northern Europe during the Migration Period. **Manuscript painting** was very important as an art and a civilizing tool. Monks in Ireland and England made new copies of old manuscripts in order to preserve classical Biblical learning. The illustration of these texts increased their instructive value.

The **Hiberno-Saxon** (Irish-English) **style**, the most innovative of the Migration Period, was spread by Irish and English missionaries to Germany and elsewhere on the Continent.

SUBJECT MATTER

1. **Gospel Books** were the most important form of manuscripts.
2. **Author portraits** appeared at the front of each Gospel Book. This idea originated in pagan times, but was Christianized to represent the Evangelists and scribes rewriting sacred texts. Each of the four Evangelists was represented with his personal symbol. Frequently, the symbol replaced the human image entirely:

a. Matthew (the winged man).
b. Mark (the winged lion).
c. Luke (the winged ox).
d. John (the eagle).

3. **Decorative pages** were included as aids to meditation. These included elaborate crosses or variations of the **Chi Rho** monogram of Christ. Some are called carpet pages because the color and design recall Oriental rugs.

4. **Decorated initials** at the beginning of important words were popular. Subjects included fanciful combinations of human heads, animals and interlace. Sometimes full figures were incorporated into the design.

MEDIA AND TECHNIQUES

1. Manuscripts consisted of individual pages of vellum or parchment bound into books.

2. Text and outlines of illustrations were done in ink with quill pens. Color was added with fine brushes in a variant of the watercolor medium.

3. Gold leaf was added for embellishment.

4. Beautiful book covers of wood, ivory, or gold protected the pages and kept them together.

DESIGN: The manuscript painting styles clearly reflect influences from contemporary metalwork and older manuscript illuminations. The **Hiberno-Saxon style** flourished in the seventh and eighth centuries.

1. Flat pattern prevailed.

2. Human figures were two-dimensional, with anatomy frequently misrepresented. Drapery was merely pattern; it did not reflect the body underneath.

3. Interlace included animals, people, and lines intertwined.

4. Patterns and images were inverted, reversed, and repeated to cover and crowd picture surfaces.

During the late eighth century, a more Mediterranean style was introduced into England, and it gradually replaced the native Hiberno-Saxon style.

EXAMPLES

1. *Decorative Page, Book of Durrow,* late seventh century, 10 by 16 in. (*H 349*)

2. *Ornamental Page, Lindesfarne Gospels,* 698-721, 13 by 10 in. (*G 8-4, H cpl 42, J cpl 31*)

3. *St. Matthew, Lindesfarne Gospels,* c. 698, 11 by 9 in. (*G 8-6*)

4. *Imago Hominis* and *St. Mark, Echternach Gospels,* early eighth century, 10 by 8 in. (*H 350, J cpl 32*)

5. *XPI Page, Book of Kells,* 760-820, 13 by 10 in. (*H cpl 43*)

6. *Scribe Ezra Rewriting the Sacred Records, Codex Amiatinus,* early eighth century, 14 by 10 in. (*G 8-5*)

C. SCULPTURE

Other than **large stone crosses** made in the British Isles, monumental relief and free-standing sculpture were insignificant during the Migration Period. The crosses were used as grave markers and were usually decorated with the same motifs and patterns as contemporary metalwork.

D. MINOR ARTS

During the Migration Period, most art objects were portable **nomads' gear**, such as horse trappings, jewelry, belt buckles, pins (called **fibulae**), weapons, etc. Toward the end of the era, artists began making chalices, reliquaries, and book covers for the Church.

SUBJECT MATTER: Subjects and design motifs included

1. Abstract linear interlace.
2. Animal interlace.
3. Geometric decoration.
4. Human figures intertwined.

MEDIA AND TECHNIQUES

1. Bronze and iron were used for weapons and related articles.
2. Gold, silver, and various alloys were used for jewelry, church furnishings, and book covers. Enamel and gem inlay were often added to the metal pieces.
3. Wood and ivory were used for church furnishings and book covers.
4. Casting, chip-carving, and repoussé techniques were used on metals. Carving was used for wood and ivory.
5. Workmanship and quality are generally considered excellent.

DESIGN

1. Metalwork design was inspired by
 a. The intricate Hiberno-Saxon manuscript style.
 b. Foreign objects acquired through trade:
 (1) Roman coins and belt buckles.
 (2) Luristani and Scythian bronzes from Eurasia and the Steppes.

2. The most typical decoration consists of two-dimensional interlace pattern covering entire surfaces or compartments of metal, wood, and ivory objects.

LOCATION, SIZE, AND SCALE

1. Most pieces have been found in graves, especially in the Nordic **"ship burials."** (The dead chief and his retainers were put on their ship, surrounded with grave goods, food, and drink, and then buried under an earth mound.)
2. Some pieces were buried in treasure hoards to safeguard them from robbers and marauders.
3. Most work is small, lightweight, and portable. Because of the interest in very detailed, intricate designs, the scale of the work is miniature.

EXAMPLES

1. *Frankish Rosette Disk Fibula,* c. 425, silver and cloisonné, 1 in. long. (*G 8-1*)
2. *Animal Head,* Oseberg Ship Burial, c. 825, wood, 5 in. high. (*G 8-3, H 348, J 327*)
3. *Purse Lid,* Sutton Hoo Ship Burial, c. 655, gold and enamel, 7 in. long. (*G 8-2, H 347, J 326*)
4. *Eagle Fibula,* c. 400, gold and enamel, 3 in. long. (*illustrated elsewhere*)

II. CAROLINGIAN PERIOD 750-900

The Carolingian Period takes its name from the political dynasty established by Charles Martel, his son, Pepin the Short, and his grandson, Charlemagne (Charles the Great). On Christmas Day, A.D. 800, the Pope crowned Charlemagne as the first Holy Roman Emperor (at St. Peter's in Rome), thus illustrating the blending of Roman and Christian civilization. Charlemagne attempted to stabilize the lands under his control, transplant classical learning to Northern Europe, and strengthen religious ties to Italy and the Pope.

A. ARCHITECTURE

PURPOSE: Religious architecture was most important. Charlemagne ordered the construction of numerous monasteries and churches. These structures established the basic principles upon which later Medieval architecture would be designed.

BUILDING TYPES

1. Basilican plan churches (long plan).
2. Central plan churches.
3. Monasteries (religious communities).

MEDIA AND TECHNIQUES

1. Stone in massive blocks was used for church walls, foundations, and vaults. Building stones and columns were often confiscated from Roman ruins.
 a. Masons were imported from Italy and Byzantium to work alongside local craftsmen.
 b. Skill was inconsistent. Due to lack of experience with large stone structures, there was much trial and error experimentation.
2. Timber was used for roofs and ceilings.
3. Post-and-lintel and arch construction were combined.

DESIGN

1. **Basilican (long plan) churches** (See Figure 9–1a)
 a. Most were built as abbey churches at monasteries.
 b. Plans were based on the Early Christian basilica, but considerably modified.
 c. The basics of Romanesque and Gothic architecture were established by the following modifications:
 (1) **The bay** (a rectangular space supported by four vertical posts with horizontal bracing) was established as a unit of repeatable interior space (a module).
 (2) **The transept** equalled the nave in width. It was not randomly sized.
 (3) **The crossing square** (intersection of the nave and the transept) was a square bay which served as the module of measurement for the rest of the church. Use of the crossing square as a unit of measurement is called **square schematism**.
 (4) **The westwork** (a "transept" at the west facade or a narthex extended to the width of the transept) became the dominant feature of the front of the church, resulting in equal treatment of east and west ends. (See Figure 9–1a)
 (5) The towers over crossing, westwork, etc., put emphasis on verticality as opposed to the horizontality of Early Christian basilicas.
 (6) Groin vaulting was used occasionally to support roofs.
2. **Central plan churches**
 a. The central plan was always the secondary plan.

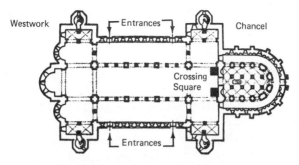

Westwork Entrances Chancel Crossing Square Entrances

a. Long Plan (St. Michael's, Hildesheim)

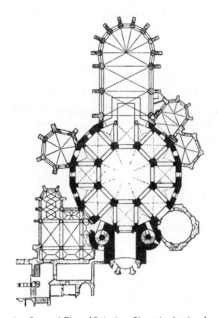

b. Central Plan (Palatine Chapel, Aachen)

FIGURE 9-1 Early Medieval church plans.

 b. Many central plans were simplified interpretations of San Vitale in Ravenna, and of similar Mediterranean octagonal structures.
 c. Some plans were Greek cross variants of Galla Placidia in Ravenna.
 d. Stress was on heavy, blockish forms and geometric clarity.
 e. Exteriors were plain.
 3. **Monasteries** included many types of buildings: churches, living quarters, workshops, storerooms, barns, etc.

4. Completely new styles resulted from misinterpretations of pagan Roman and Early Christian models that were being imitated.

EXAMPLES
BASILICAN PLAN

1. Abbey Church of Centula (St. Riquier), begun 790. (*G 8-15, 16; H 370; J 333, 334*)
2. Abbey Church of Fulda, consecrated 819. (*illustrated elsewhere*)
3. Abbey Church at Corvey, 873-885. (*illustrated elsewhere*)

CENTRAL PLAN

Palatine Chapel, Aachen (Aix-la-Chapelle), Germany, 792-805. (*G 8-12, 13; H 368, 369; J 330, 331, 332*)

MONASTERIES

1. Gateway of the Abbey at Lorsch, Hesse, Germany, 768-774. (*H 372*)
2. Plan for the monastery of St. Gall, Switzerland, c. 819. (*G 8-14; H 371; J 335, 336*)

B. PAINTING

Charlemagne and his heirs helped preserve western civilization by encouraging the production of **manuscripts**. They also encouraged the development of **mural painting** to decorate the interiors of churches, but little has survived.

PURPOSE: religious

SUBJECT MATTER: The subjects for manuscript illumination included

1. **Author portraits** of the Evangelists.
2. **Canon tables** of corresponding verses in the Gospels.
3. **Narrative illustrations**, in the margins, or as full pages.

MEDIA AND TECHNIQUES: For a general discussion, see Migration Era painting.

1. Technique was often more painterly and more illusionistic than in the Hiberno-Saxon school.
2. Skill and technique varied considerably.

DESIGN

1. There was a strong dependence on Italo-Byzantine texts which were brought north and copied.
2. Paintings of the Evangelists were often given painted frames in imitation of Roman (*H 374, J 338*) and Early Christian works.
3. **The Palace School at Aachen** paid close attention to Mediterranean styles. This school helped to spread Helleno-Roman interests in naturalism.
 a. Three-dimensional illusionism was attempted.
 b. Shading and perspective were attempted.
4. **The Reims School** was closer to the Hiberno-Saxon style.
 a. Agitated, linear patterns were more important than illusionism.
 b. Perspective, drapery, and anatomy were often inaccurate.

EXAMPLES

1. *St. Matthew, Gospel Book of Charlemagne,* Aachen, c. 800–810, 7 by 9 in. (*G 8-7, H 373, J 337*)
2. *St. Matthew* and *St. Mark, Gospel Book of Archbishop Ebbo,* Reims, 816, 8 by 10 in. (*G 8-8, H 375, J 339*)
3. Various illustrations, *Utrecht Psalter,* c. 830. (*G 8-9, H 376, J 340*)
4. *Scenes from the Life of St. Paul, Bible of Charles the Bald,* c. 875. (*H cpl 48*)

C. SCULPTURE

Monumental sculpture was insignificant during the Carolingian Era. There were some small reliefs and a few small cast bronze figures (such as an equestrian statue of Charlemagne, c. 870), but the majority of the three-dimensional works belong to the minor arts.

D. MINOR ARTS

FORMS AND MEDIA

1. Book covers were made of ivory, gold, enamel, gems.
2. Reliquaries were of gold and silver, with gems.
3. Church furnishings, such as chalices, crosses, and plates were of gold and silver.

TECHNIQUES AND DESIGN

1. Technology improved on Migration era methods.
2. Subjects and styles consciously imitated Mediterranean prototypes.

EXAMPLES

1. *Book cover, Codex Aureus of Emmeram,* gold, pearls, and gems, c. 870. (*G 8-10*)
2. *Book cover, Lorsch Gospels,* ivory and gold, ninth century. (*H 377*)
3. *Book cover, Lindau Gospels,* gold and gems, c. 870. (*H cpl 49, J cpl 33*)

III. OTTONIAN PERIOD 900-1024

Following the death of Charlemagne in 814, the Empire was divided into several feuding dukedoms. In 919, the Duke of Saxony was elected King Henry I of Germany and Italy. The Ottonian rulers (named for Henry's son, Otto I) restored much of the orderly society begun by Charlemagne, and established Germany as the cultural center of Europe.

A. ARCHITECTURE

The churches of the Ottonian Period relied on Carolingian developments, but refined them into a more coherent system of design.

BUILDING TYPES: churches.

1. The basilican plan with dominant westwork prevailed.
2. The central plan was occasionally used for chapels.

MEDIA AND TECHNIQUES: See Carolingian Period for a general discussion. There was greater confidence in technology and design.

DESIGN

1. **Geometric arrangements** and clarity were emphasized. Buildings were designed as readable series of cubes, cones, etc.
2. **Towers** emphasized verticality of churches.
 a. Square crossing towers had pyramidal roofs.
 b. Twin towers occurred at westwork and apse, with stages combining cubes, octagons, and cylinders. Roofs were conical.
3. **Westwork** and the **east chancel** (choir and apse) were treated as equal in importance, with the naves simply separating the two ends of buildings.
4. **Corbel tables** and **pilaster strips** articulated the exterior surfaces to emphasize the geometry of the parts. (See Figure 9-2)
 a. **Corbel tables** are decorative elements consisting of blind arcades (no opening through the arch) topped with continuous cornices or **string courses.**

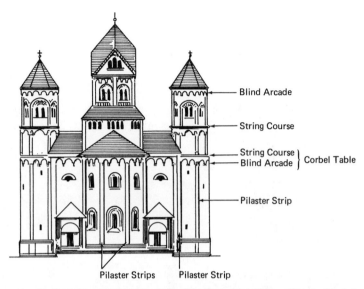

FIGURE 9-2 Early Medieval architectural detailing (based on Abbey Church, Maria Laach).

 b. **Pilaster strips** are very shallow pilasters which project only slightly from the walls to which they are attached.
 5. Solid, thick, massive structures were emphasized.
 6. **Square schematism** dictated interior space and proportions.
 a. **The crossing square** was often emphasized with heavy piers or arches.
 b. **An alternating support system** of columns and piers made square schematism visible along the nave arcade.
 7. The nave wall generally consisted of
 a. An arcade on the ground level.
 b. Blank wall space above the arcade, suitable for fresco painting.
 c. Clerestory windows under the ceiling to admit light.

LOCATION, SIZE, AND SCALE

 1. **Abbey churches** were built at monasteries, while **cathedrals** and **parish churches** were built in towns.
 2. Buildings were larger in all dimensions than Carolingian models.
 3. Scale was massively monumental, and this effect was heightened by the emphasis on verticality.

EXAMPLES

 1. St. Cyriakus, Gernrode, c. 975. (*illustrated elsewhere*)
 2. St. Pantaleon, Cologne, c. 980. (*H 378, J 342*)

3. St. Michael's, Hildesheim, 1001–1033. (*G 8-17, 18, 19; H 379, 380, 381; J 343, 344, 345*)

B. PAINTING

Although a few fragments of wall frescoes survive as murals in churches, **manuscript illumination** remained the dominant form of painting during the Ottonian era.

SUBJECT MATTER

1. **Symbolic images:**
 a. Crucified Christ.
 b. Christ as judge.
 c. Christ as Enthroned Ruler.
2. **Narrative cycles** (sequences or series):
 a. Old Testament stories.
 b. New Testament stories. It was important to emphasize parallelism between the Old and New Testaments and to connect the Fall and the Redemption through paired narratives.

MEDIA AND TECHNIQUES: See Migration and Carolingian Painting.

DESIGN

1. Ottonian painting was disciplined, formalized.
2. Settings and perspective were flat, non-illusionistic.
3. Color was intense, dark; often used symbolically.
4. Shading and highlight were reduced to meaningless pattern.
5. Forms were heavily outlined.
6. Figures' poses and gestures were intense and expressionistic, with an emphasis on mystical reality.
7. Body parts and drapery were stylized into flat patterns reminiscent of Hiberno-Saxon forms.

EXAMPLES

1. *Otto Imperator Augustus,* source uncertain, c. 985. (*H cpl 50*)
2. *Annunciation to the Shepherds, Gospel Lectionary of Henry II,* 1002–1024, 13 by 10 in. (*G 8-22, H 387*)
3. *Otto Enthroned Receiving Homage, Gospel Book of Otto III,* 997–1000, 13 by 10 in. (*G 8-23*)
4. *St. Luke* and *Christ Washing the Feet of St. Peter, Gospel Book of Otto II,* c. 1000. (*J cpl 34*)

C. SCULPTURE

During the Ottonian Period, monumental sculpture in wood and bronze reappeared in Western Europe for the first time since the Fall of Rome.

FORMS AND SUBJECT MATTER

1. **Church doors** and other large surfaces were decorated with narrative scenes from the **Bible** in relief.
2. Life-size **Crucifixes** were hung over altars.
3. **Madonna and Child** figures were portable, and carved in great numbers.

MEDIA AND TECHNIQUES: The most significant changes in technology involved the use of bronze and wood for large sculptures.

1. Bronze was hollow-cast into free-standing forms and reliefs for the first time in 600 years.
2. Wood was carved into Madonna and Child images and Crucifixes which were generally **polychromed** (multi-colored) or gilded.
3. New technology developed very quickly; skill and craftsmanship were generally excellent.

DESIGN

1. **Relief sculpture**
 a. Architecture and landscape were suggested, not detailed.
 b. Figures dominated scenes.
 c. Narratives were emphasized by exaggerated gestures and poses.
 d. Much of the imagery was invented; sources are not known.
2. **Free-standing sculptures:**
 a. Crucifixes and Madonnas introduced grief, suffering, and passion into western Christian imagery.
 b. Poses and gestures were exaggerated, expressionistic.
 c. Surface detailing was patterned, linear.

EXAMPLES

1. *Bronze Doors,* St. Michael's, Hildesheim, 1015–1035, 15 ft. high, each panel 23 by 43 in. (*G 8-20; H 382, 383; J 346*)
2. *Gero Crucifix,* Cologne, 969–976, polychromed oak, 74 in. high. (*H 385, J 341*)
3. *Essen Madonna,* c. 1000, silver gilt over wood, 30 in. high. (*illustrated elsewhere*)
4. *Bishop Bernward's Column,* 1015–1035, bronze, 12 ft. high. (*H 384*)

D. MINOR ARTS

Ivory plaques and book covers continued to be produced using the same basic techniques as in the Carolingian Period. The style reflected contemporary trends in manuscript illumination rather than imitating large-scale sculpture.

EXAMPLE

Doubting Thomas, c. 1000, ivory, 10 by 4 in. (*G 8-21, H 386*)

<div style="border:1px solid black">

VOCABULARY

alternating support system	corbel table	pilaster strip
Animal Style	crossing square	polychrome
bay	fibula(e)	square schematism
blind arcade	Hiberno-Saxon	string course
chancel	interlace	westwork

</div>

10. Romanesque Art

SUMMARY

Architecture: There were several regional styles; design focused on making churches larger, fireproof, well-lighted, and well-organized for interior traffic circulation. In general, all styles resembled each other in the following elements: modified basilican plan, massive and blockish forms, "readable" geometric units, square schematism, arch and vault construction, towers, galleries, and clerestory windows. Major regional styles included

Pilgrimage: barrel vaults, no clerestory, double aisles and ambulatories, radiating chapels, high crossing towers.

Burgundian: pointed barrel vaults with pointed transverse arches, two transepts, clerestory lighting.

Anglo-Norman: three-part division of facade both horizontally and vertically, twin facade towers, ribbed groin vaulting, six- or seven-part vaults, delicate interior walls.

Rhineland: double apses, multi-stage towers, groin vaults without ribs, octagonal dome over crossing, large clerestory windows, austere interiors.

Lombard: atrium in front, ribbed groin vaulting, multi-stage towers, no transept, octagonal dome over last bay.

Tuscan: open timber roofs, classical columns in nave arcade, interior and exterior incrusted marble decoration.

Aquitanian: roofed with multiple domes, no aisles, occasional use of Greek cross plan.

Hall church: no transepts or clerestory, colorfully painted interiors, high aisles, richly sculptured exteriors.

Painting: Manuscript painting continued the formalizing trends of the Ottonian era; many "schools" had unique variations of line, form, color. None were classical-illusionistic. Wall painting was most important in regions with direct contact with Byzantine artists; style was largely dependent on contemporary manuscript design.

Sculpture: Architectural sculpture in southwest France was most innovative. Sculpture was used to decorate the portals and interiors of churches. Style, forms, and subjects derived mainly from manuscript sources. Metal sculpture was significant in Germany.

In the eleventh and twelfth centuries, Europe consisted of numerous feudal states, powerful monasteries, and independent chartered cities. Capitalism, banking, and commerce were beginning to alter the structure of European society just as the arts were on the verge of radical change.

A. ARCHITECTURE

Romanesque ("Roman-like") architecture is considered to be the first mature style of the Middle Ages. Although there were several regional variations, the general development of Romanesque architecture solved many structural problems and led the way to a new aesthetic in the Gothic Period.

PURPOSE: Religious architecture overshadowed secular building. Romanesque church builders attempted to solve problems such as

1. Size. Larger churches were needed to handle the growing congregations and the increasing number of pilgrims.
2. Fire. Stone vaulting eliminated flammable wooden ceilings in most areas.
3. Light. Clerestory lighting brightened church interiors.
4. Traffic. Ambulatories improved circulation patterns.
5. Acoustics.
6. Aesthetically pleasing appearances.

MEDIA AND TECHNIQUES

1. Cut stone and brick were used for foundations, walls, and vaulted ceilings.
2. Timber was still used in some regions (Italy) for ceilings and roofs.
3. Arch construction, with regional variations, was the dominant method. Mortar held the stones together.
4. Concrete was not used.
5. Much of the Romanesque technology was developed through trial and error, since the basics of ancient Roman architectural design were not known.

DESIGN

1. General characteristics applied to most, but not all, Romanesque churches:
 a. Most churches were built on a modified basilican plan. (See Figure 10-1)
 b. Buildings were composed of simple, "readable" geometric units.
 c. The overall appearance was massive, blockish.
 d. Exteriors reflected the interior arrangement of space through the placement of buttresses, windows, and exterior articulation such as
 (1) **Corbel tables.** (See Figure 9-2)

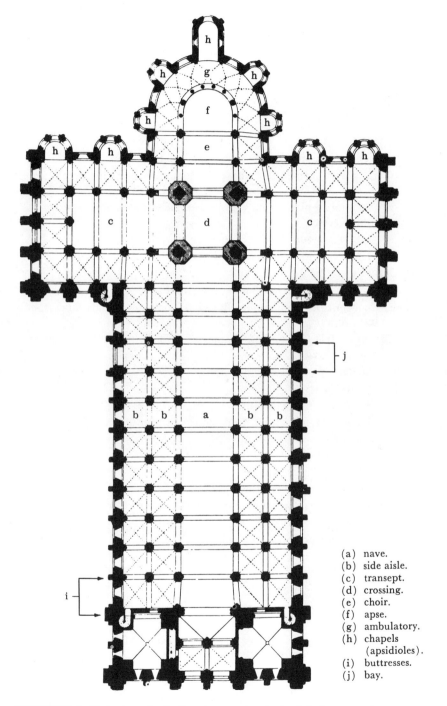

(a) nave.
(b) side aisle.
(c) transept.
(d) crossing.
(e) choir.
(f) apse.
(g) ambulatory.
(h) chapels
 (apsidioles).
(i) buttresses.
(j) bay.

FIGURE 10-1 Basic elements of a Romanesque church plan (pilgrimage type).

 (2) **Blind arcades.** (See Figure 9–2)

 (3) **Colonettes** (thin columns or shafts).

 (4) **Pilaster strips** (See Figure 9–2)

 e. Structural support was provided by

 (1) Arches.

 (2) Barrel vaults.

 (3) Groin vaults with and without ribs.

 f. Towers emphasized the vertical aspects of churches.

 g. Interiors were proportioned according to square schematism.

 h. Interiors were divided into repeated modules or compartments (bays) emphasized by

 (1) **Compound piers** (piers with clusters of engaged columns or colonnettes attached).

 (2) Alternating support systems.

 (3) Transverse, longitudinal, and diagonal arches.

 i. Galleries were built over the aisles to increase usable floor space.

 j. Clerestory windows pierced upper nave walls to admit light.

2. Regional characteristics were extremely varied. Some of the most important styles are listed here:

 a. **Pilgrimage style** (in southern France and northern Spain, en route to Compostela, Spain).

 (1) Large projecting transept.

 (2) Double aisles.

 (3) Ambulatory with radiating chapels.

 (4) Round, barrel-vaulted nave with transverse arches, groin vaults over aisles.

 (5) No clerestory; light only from windows in walls.

 (6) No alternating support system.

 (7) Very high octagonal crossing tower.

 b. **Burgundian style** (Burgundy, in east-central France).

 (1) Pilgrimage plan of ambulatory and chapels.

 (2) Two transepts, both with radiating chapels.

 (3) Pointed barrel vaults with pointed transverse arches; groin vaults over side aisles.

 (4) Clerestory lighting.

 (5) No alternating support system.

 (6) No gallery.

 (7) Two crossing towers, two transept towers, two facade towers.

 c. **Anglo-Norman style** (Normandy, in northern France, and in England). This was the most progressive, and the closest ancestor to the Gothic style.

 (1) Three-part (**tripartite**) division of facade both horizontally and vertically.

(2) Twin towers flanking the facade.

(3) Ribbed groin vaulting.

 Note: A controversy exists on the location of the earliest ribbed vaults: Durham, England, or St. Ambrogio, Milan, Italy.

(4) Transverse arches either pointed (Durham) or depressed (St. Étienne, Caen).

(5) Six-part (Caen) and seven-part (Durham) vaults.

(6) Comparatively delicate interior walls—a forerunner of the Gothic "skeletal" structures.

d. **Rhineland style** (in west-central Germany).

 (1) Apse at each end (Carolingian influence).

 (2) No principal western entrance; small doors at sides.

 (3) Multi-stage towers decorated with blind arcades.

 (4) Octagonal dome over crossing.

 (5) Groin vaults (without ribs).

 (6) Large clerestory.

 (7) Austere interior decor.

e. **Lombard style** (in northern Italy).

 (1) Atrium (Early Christian influence) in front.

 (2) Octagonal dome over last bay; no transept.

 (3) No clerestory.

 (4) Multi-stage towers influenced Rhineland style.

 (5) Ribbed groin vaults. Date of ribs is unknown.

f. **Tuscan style** (in central Italy, Sicily). The most similar to Roman and Early Christian styles.

 (1) Nave arcades with classical columns.

 (2) Open timber roofs.

 (3) Diaphragm arches, rounded or pointed.

 (4) Rich encrustation of two-tone marble on both exteriors and interiors. Emphasis was more on pattern than on structure.

 (5) Large projecting transept.

g. **Aquitanian** (southern France, Italy). Greatly influenced by Byzantine architecture.

 (1) Roofed with multiple domes.

 (2) Greek cross plan sometimes used.

 (3) No aisles.

h. **Hall style** (Poitou, in western central France). Preaching, rather than pilgrimage, was emphasized.

 (1) No transepts.

 (2) No clerestory.

 (3) Aisles nearly the same height as the nave.

(4) Colorfully painted interiors.

(5) Richly sculptured exteriors.

EXAMPLES
PILGRIMAGE

1. St.-Sernin, Toulouse, France, c. 1080-1120. (*G 9-1, 2, 3; H 389, 390, 391; J 347, 348, 349, 350*)
2. Ste. Foy, Conques, France, begun c. 1041. (*illustrated elsewhere*)
3. Santiago de Compostela, Spain, 1060-1130. (*illustrated elsewhere*)

BURGUNDIAN

1. Abbey Church of St.-Pierre, Cluny, France, 1085-1130. (*H 392*)
2. St.-Lazare, Autun, France, 1121-46. (*J 351*)

ANGLO-NORMAN

1. Abbey church of St. Étienne, Caen, France, 1067-1087. (*G 9-11, 12, 13; H 420, 421, 422; J 354, 358*)
2. Durham Cathedral, England, c. 1093-1130. (*G 9-14, 15; H 418, 419; J 355, 356, 357*)

RHINELAND

1. Cathedral of Speyer, Germany, 1030-60. (*G 9-4, 5, 6, 7; H 412; J 362*)
2. Abbey Church of Maria Laach, c. 1156, near Coblenz, Germany. (*H 413, 414*)

LOMBARD

Sant' Ambrogio, Milan, Italy, late eleventh to early twelfth century. (*G 9-8, 9, 10; H 415, 416, 417; J 359, 360, 361*)

TUSCAN

1. San Miniato al Monte, Florence, Italy, 1018-1062. (*G 9-18, 19; H 404*)
2. Cathedral group, Pisa, Italy, 1153-1283. (*G 9-16, 17; H 405, 406; J 364, 365, 366*)
3. Cathedral of Monreale, Sicily, 1174. (*H 407, 408*)

AQUITANIAN

1. St. Pierre, Angoulême, France, twelfth century. (*G 9-20*)
2. St. Front, Perigeáux, France, eleventh century. (*illustrated elsewhere*)

HALL

1. Notre-Dame-la-Grande, Poitiers, France, eleventh century. (*H 402, J 353*)
2. St.-Savin-sur-Gartempe, France, 1060-1115. (*J 352*)

B. PAINTING

FORMS AND SUBJECT MATTER: Both **wall murals** and **manuscript illumi-nations** survive in large enough quantities to be informative. (See Early Medieval Painting for a general discussion.) Certain subjects became especially popular during the Romanesque Period:

1. The Crucifixion.
2. The Last Judgment.
3. Episodes from the Book of Revelations (the Apocalypse).

MEDIA AND TECHNIQUES

1. **Wall paintings** were done in dry fresco with pigments mixed with water or various glue-like substances.
 a. Colors were limited to a few hues.
 b. Colors, once bright, have worn off many church walls, giving a flat, dull effect today.
2. **Manuscript illuminations** were done in ink and watercolor on parchment or vellum, and embellished with gold leaf.
3. Techniques were refined continuations of those of the Early Medieval eras.

DESIGN

1. Painting styles continued the developments of the Carolingian and Ottonian eras.
2. Spain and Italy were influenced by direct contact with Byzantine art and artists.
3. Figures were simplified masses.
 a. Drapery was decoratively "compartmentalized" or "partitioned" and did not suggest underlying anatomy.
 b. Faces were simplified, with large staring eyes and anxious expressions.
 c. Postures and gestures were exaggerated to express emotion.

4. Paintings were linear, flat, stylized.
5. Painting, sculpture, and the minor arts were very similar.

LOCATION, SIZE, AND SCALE

1. **Wall paintings** have been found primarily in Italy, France, and Spain.
2. **Manuscript painting** was done throughout Europe, but the monasteries of England (the Winchester school) and northern France (the Cîteaux school), were the most innovative.
3. Size: wall paintings were large; manuscripts miniature.
4. Scale of both types: miniature.

EXAMPLES
WALL PAINTINGS

1. *Crucifixion,* nave fresco, Sant' Angelo in Formis, Capua, Italy, c. 1080. (*H 423*)
2. *Christ Enthroned with St. Michael Battling the Dragon,* fresco, S. Pietro al Monte, Civate, Italy, late eleventh century. (*H cpl 53*)
3. *Martyrdrom of St. Lawrence,* wall painting, Cluniac Priory Church, Berzé-la-Ville, France, early twelfth century. (*H cpl 54*)
4. *The Building of the Tower of Babel,* nave vault, St.-Savin-sur-Gartempe, France, early twelfth century. (*J 381*)
5. *Christ in Majesty,* fresco from S. Clemente, Tahull, Spain, 1123. (now in Barcelona). (*H 424*)
6. *Adoration of the Magi,* apse fresco from Santa Maria, Tahull, Spain, late twelfth century (now in Barcelona; a copy is in the church apse). (*G 9–28*)

MANUSCRIPT ILLUMINATIONS

1. *The Scribe Eadwine, Eadwine Psalter,* England, c. 1150, (nineteenth century engraving extant). (*G 9–32*)
2. Master Hugo, *Moses Expounding the Law,* frontispiece of the *Book of Deuteronomy* of the *Bury Bible,* Abbey of Bury St. Edmonds, England, early twelfth century. (*G 9–31, H cpl 58*)
3. *Plague of Locusts, Apocalypse,* St.-Sever, France, mid-eleventh century. (*H cpl 56*)
4. *Initial R with St. George and the Dragon, Moralia in Job,* Cîteaux, France, twelfth century. (*G 9–30, H 57*)

C. SCULPTURE

Monumental stone sculpture had all but died out after the Fall of Rome, and its revival was an important Romanesque accomplishment. The developments, partilarly in portal sculpture, greatly influenced Gothic church decoration.

FORMS: Almost all Romanesque sculpture was in relief, related to church architecture. It was used for the decoration of

1. **Entrance portals** (See Figure 10-2), which consisted of
 a. **Splays** (the angled sections flanking the doors).
 b. **Door jambs** (the areas alongside the doors).
 c. **Trumeaux** (singular: trumeau) (the posts between double doors).
 d. **Lintels** (the horizontal beams over doors).
 e. **Tympana** (singular: tympanum) (the semicircular spaces bordered by archivolts and lintels, especially above the center doors of west facades).
2. **Interiors**: capitals, piers, walls, and cloisters.

PURPOSES AND SUBJECT MATTER: Various religious stories, themes, and symbols were represented in an effort to instruct as well as to entertain. Particular subjects were represented on specific parts of the churches:

1. **Tympana**
 a. The Last Judgment (later a favorite subject for Gothic portals), often with symbols of the Evangelists.
 b. The Mission of the Apostles (relating to the Crusades).
 c. Visions from Revelations.

FIGURE 10-2 French Romanesque portal elevation.

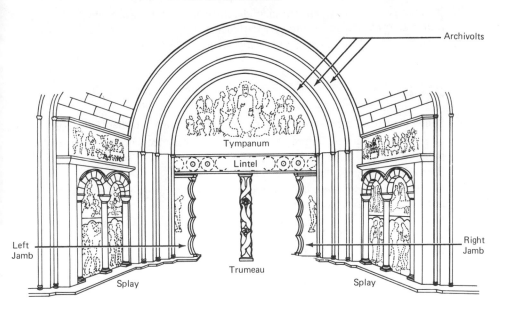

2. **Trumeaux, jambs, and splays**
 a. Christ.
 b. Apostles.
 c. Saints.
3. **Archivolts**
 a. Vices and virtues shown as women in combat.
 b. Signs of the zodiac and labors of the months.
4. **Capitals**
 a. Decorative plants and animals.
 b. **Historiated** (or figured) capitals featured narrative scenes from the *Bible.*

 Note: These capitals could be seen easily because Romanesque columns were relatively short. When taller, more graceful columns came in with the Gothic style, historiated capitals were no longer made since their decorations would have been too far removed from the viewer.
5. **Wall reliefs**
 a. Christ and saints.
 b. *Bible* scenes. (The Descent from the Cross was particularly popular.)

MEDIA AND TECHNIQUES

1. Cut stone, usually limestone or sandstone, was used.
2. Intense colors and gold were added to many pieces of sculpture.
3. In some geographic regions strong undercutting produced figures almost fully round. In other regions forms were flattened.
4. Bronze was used for religious and secular sculpture in Germany.

DESIGN

1. Sources included manuscript illumination and metalwork rather than nature.
2. The same compartmentalized forms found in manuscript painting are evident in sculpture.
3. Hierarchic scaling was used in tympanum sculpture.
4. Expressionism and emotional impact of figures and scenes were emphasized, not scientific observation of reality.
5. Some decorative influences came from the ornamental work on Islamic architecture (Moissac).
6. Elongated figures, serpentine hair, and flattened figures showed Carolingian and Ottonian manuscript influences.
7. The more rounded forms and classical proportions found in southern France (Toulouse and Arles) and in Italy reflect classical influences.

LOCATION, SIZE, AND SCALE

1. Stone sculpture was produced primarily in France and parts of Italy, with some examples in Spain. Sculpture in England was inferior to sculpture on the Continent.
2. The best metalwork was done near Liège (then Germany, now Belgium).
3. Size varied according to function, from ten inches to ten feet. Much of the stone sculpture was monumental in size, but miniature in scale because of crowded compositions and detailed linear style.

EXAMPLES

1. *Portal group,* Priory Church, St.-Gilles-du-Gard, France, c. 1130. (*H 401, J 374*)
2. *Portal group,* St. Trophime, Arles, France, c. 1160. (*G 9-27*)

TYMPANA

1. *Mission of the Apostles,* tympanum, La Madeleine, Vézelay, France, c. 1120-1132. (*G 9-26; H 395; J 372, 373*)
2. *Last Judgment,* tympanum, St. Lazare, Autun, France, c. 1130. (*G 9-25, H 396, J 371*)
3. *Second Coming of Christ (Vision of St. John),* tympanum, St. Pierre, Moissac, France, 1115-1135. (*G 9-22, H 398*)

TRUMEAUX

The Prophet (Isaiah or Jeremiah), trumeau of the south portal of St. Pierre, Moissac, France, 1120. (*G 9-23, H 399, J 369*)

WALL RELIEFS

1. *Christ in Majesty,* ambulatory of St.-Sernin, Toulouse, France, late eleventh century. (*G 9-21*)
2. Benedetto Antelami, *Descent from the Cross,* Cathedral of Parma, Italy, 1178. (*H 327*)
3. Benedetto Antelami, *King David,* facade, Cathedral of Fidenza, Italy (almost free-standing). (*H 411, J 375*)
4. *Apostle,* St.-Sernin, Toulouse, France, c. 1090. (*J 368*)

METAL SCULPTURE

1. Renier of Huy, *Baptismal font,* St. Barthlélémy, Liège (now Belgium), 1107-18, bronze, 25 in. high. (*H 403, J 376*)

2. *Lion Monument,* Cathedral Square, Brunswick, Germany, 1166, bronze, 6 ft. long. (*J 377*)

D. MINOR ARTS

The Meuse Valley produced some of the most innovative **metalwork** of the Romanesque Period. Bronze water ewers were made in the shape of real and imaginary animals and decorated in a style influenced by Persian metalwork brought from the Crusades. Gold and enamel plaques were also important. The work of Nicholas of Verdun is the best known. He used "wet" drapery which revealed the anatomy of the figure beneath it, and inspired a new style of painting in the Gothic Period.

The Bayeux Tapestry, a unique piece of **embroidery**, also dates from the Romanesque Period. This work chronicles the Norman Conquest of England in a style very similar to contemporary manuscript painting.

Ivory carving was generally similar to stone sculpture. However, *the Lewis Chessmen,* probably made in Scandinavia, exhibit a more robust style.

EXAMPLES

1. *Ewer,* Mosan, c. 1130, gilt bronze, 7 in. high. (*J 378*)
2. Nicholas of Verdun, *The Crossing of the Red Sea* and *Sacrifice of Isaac,* a series of altar plaques, Klosterneuberg Abbey, Austria, 1181, enamel and gold, 5 in. high. (*H 485, J 280*)
3. *The Bayeux Tapestry,* 1073–83, wool embroidery on linen, 20 in. high, 230 ft. long. (*J 380*)
4. *The Lewis Chessmen,* found at Uig, Isle of Lewis, Scotland, mid-twelfth century, walrus ivory, 4 in. high. (*illustrated elsewhere*)

VOCABULARY

ambulatory	diaphragm arch	splay
archivolt	historiated capital	trumeau(x)
buttress	jamb	tympanum
colonnette	portal	(pl. tympana)
compound pier	ribbed vault	

11. Gothic Art

SUMMARY

Architecture: Churches with modified basilican plans were especially important. Elegant structures were built with an exoskeletal system of piers and flying buttresses, ribbed vaults, and pointed arches. Walls were reduced in mass and enriched with complex decoration. Castles, fortresses, town houses, and city halls were also important.

French Gothic c. 1140–1500: Gothic originated in France. The general divisions of French Gothic are Early, High, and Late. All were variations of tall, slender structures with deep porches, recessed portals, and unified interiors supported by ribbed vaults with pointed arches.

English Gothic c. 1150–1550: English Gothic combined Anglo-Norman Romanesque with French Gothic. The main styles were Lancet, Decorated, and Perpendicular. English churches tended to be lower than French, had screen facades with multiple tiers of sculpture, and used fan and net vaulting.

German Gothic: One style was inspired by French designs. Hall churches also developed with naves and aisles of equal height integrated by widely-spaced piers. Flying buttresses were not used in hall churches.

Italian Gothic: Only northern Italy adopted Gothic, using it in combination with remnants of classical design. Churches tended to be low and wide. The main Gothic feature was the use of the pointed arch.

Painting: Manuscript illumination was most important. Panel painting began to develop. Works were produced in university and cathedral schools and royal courts. Religious and secular subjects coexisted as the nobility began to patronize the arts. Forms and styles derived from sculpture.

Sculpture: Free-standing and architectural sculpture for church decoration were important. Works were used to communicate Church dogma and to honor the nobility. Tomb effigies were made in France and England. French styles went from stiff, to realistic, to courtly. German and Netherlandish sculpture developed new interest in realism and expressionism.

Minor arts: Stained glass, metalwork, ivory carving, and tapestry weaving were of great importance.

The Gothic Period was the last era of European history in which the Church was the main sponsor of the arts and focus of each community. At the close of the Gothic Period, the Church as institution and the church building itself were no longer the controlling elements in European society and culture. They were displaced by the rising fortunes of kings, bankers, and merchants.

A. ARCHITECTURE

Gothic architecture originated in the design and construction of a new choir for the Abbey Church of St. Denis, near Paris, in 1140-1144. Over the next fifty years, the Gothic style gradually replaced the Romanesque in France as the "modern" style. The **Age of the Great Cathedrals**, c. 1200-1270, saw the perfection of Gothic concepts which spread throughout Europe. By 1400, the Gothic style in France began to decline, emphasizing ornament rather than structural clarity, and by 1500, it had been replaced almost completely by the "classical" forms of Renaissance architecture.

PURPOSES: Gothic architecture was an expression of urban prosperity and civic pride.

BUILDING TYPES

1. **Churches** with modified basilican plans were the most important structures.
 a. Parish churches were built in most large towns.
 b. Cathedrals were built in towns with Bishops' residences.
2. **Secular structures** of importance included
 a. Castles and palaces.
 b. Fortresses and walled cities.
 c. City halls and guild halls.

1. Church construction

MEDIA AND TECHNIQUES

1. Sandstone, limestone, marble (Italy), and brick (northern Germany) were used for foundations, walls, and vaults.
2. Slate, lead, and tile were used for roofing.
3. Timber was used for roofing, and for centering and bracing during construction.
4. Concrete was not used; mortar was used to join stones or bricks.
5. Stained or clear glass was used for windows.
6. The arch principle was the basis of Gothic construction, using ribbed vaults with pointed arches. Pointed arches allowed all the segments of a vault to be

constructed at the same height and provided increased strength for the buildings.

7. The new technology and design were transmitted by members of masonic lodges and craft guilds as they traveled to construction sites throughout Europe.

DESIGN (See Figure 11-1): While there were several regional and chronological differences in Gothic design, **general features** included

1. Ribbed vaults.
2. Pointed arches.
3. Flying buttresses.
4. Modular bay systems.
5. Large windows (except in Italy).
6. Verticality emphasized (except in Italy).
7. **Interiors** featured
 a. Compound piers with clusters of colonnettes running from floor to ceiling.
 b. Tall rather than wide structures.
 c. Slender proportions in all elements.
 d. Less massive walls.
8. **Exteriors** featured
 a. Pier buttresses and flying buttresses.
 (Pier buttress: A pier-shaped stone or brick support attached to a wall to strengthen it against the thrust of a vault.)
 (Flying buttress: An arch transmitting the thrust of a vault to an outer pier or wall.)
 b. Blind arcades and blind arches.
 c. Triangular gables, pointed roofs, spires, and finials.

a. Early Gothic in France c. 1140-1194

The Gothic style originated in the Île de France region around Paris. Its nearest Romanesque ancestor was the Anglo-Norman style, with some influence from Burgundy and southwestern France.

1. **Exterior** features included
 a. Twin-tower facades, based on St. Étienne, Caen.
 b. Division of facades into horizontal and vertical bands.
 c. Porches projecting strongly from recessed triple-portals and covered with complex sculptural programs.
 d. Towers at crossings and transepts.
 e. Rose windows above the central portals.

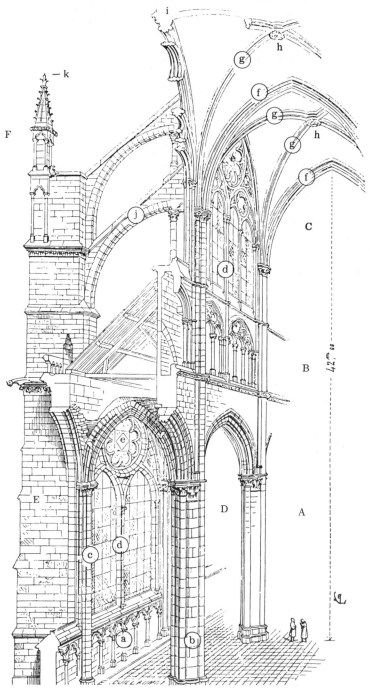

FIGURE 11-1 Perspective section of nave bay of Amiens Cathedral (Viollet-le-Duc: (A) nave arcade; (B) triforium; (C) clerestory; (D) side aisle; (E) buttress; (F) pinnacle; (a) blind arcade; (b) compound pier; (c) respond; (d) mullion; (e) tracery; (f) transverse rib; (g) diagonal rib; (h) boss; (i) molding profile; (j) strut; and (k) finial.

2. **Interior** features included
 a. Vaults with structural ribs. The **in-fill** of the vaults was not structural. In-fill is any material (stone, rubble, and such) used to fill the space between the ribs.
 b. Beginning of an exoskeleton system of ribs and buttresses with screen walls.
 c. Square schematism and alternating support system.
 d. Double aisles and double ambulatories.
 e. Half the length of the church often occupied by the **chevet** (apse, ambulatories, and chapels).
 f. Six-part nave vaulting.
 g. Four-part nave elevation (See Figure 11-2a)
 (1) Nave arcade.
 (2) Gallery (also called **tribune**).
 (3) **Triforium** (a small arcade).
 (4) Clerestory.

FIGURE 11-2 French Gothic nave elevations.

a. Early Gothic (Laon) b. High Gothic (Chartres)

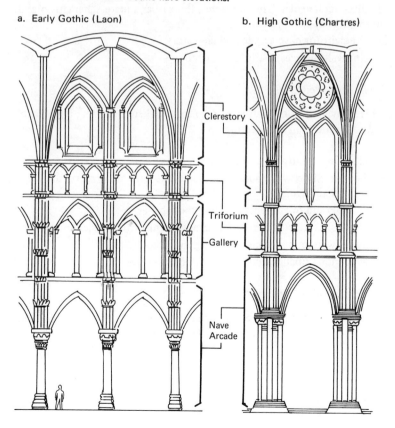

b. High Gothic in France c. 1194–1300

High Gothic is considered to be "classic" Gothic because the ideals of the style were perfected in this era.

1. True exoskeleton construction was used with flying buttresses.
2. **Exterior** features included
 a. More plastic, sculptural facade treatment.
 b. Open tracery towers without real wall surfaces.
 c. Rose windows occasionally replacing stone tympana over portals.
 d. Transepts seldom extending very far beyond the width of the facade.
3. **Interior** features included
 a. Four-part vaults (replacing six-part).
 b. Three-part nave elevation, replacing four-part elevation (See Figure 11–2b)
 (1) Nave arcade.
 (2) Triforium.
 (3) Clerestory.
 c. Identical rectangular bays replacing the earlier square schematism and alternating support system.
 d. Equal height for nave arcade and clerestory.
 e. Interior wall surfaces nearly nonexistent.

c. Late Gothic in France c. 1300–1500

Late Gothic (**Flamboyant Style**) churches in France looked more like large jewel boxes or elegant sculpture than architecture.

1. Ornamental surface treatment was emphasized over structural clarity.
2. The Flamboyant Style was named for flame-like pointed tracery that was attached to every surface.
3. Cavernous portals and open tracery dominated facades.
4. Five-part facades reflected the interior arrangement of four aisles and a nave.
5. Crossing towers were popular; facade towers were not.
6. Buildings were much smaller than High Gothic structures.

d. English Gothic c. 1150–1550

England adopted Gothic architecture earlier than the other regions outside France. General characteristics of the English Gothic style include

1. Park-like settings for churches.
2. **Exterior** features:
 a. Screen-like facades decorated with multiple tiers of arcading not reflected in the interior plan.

 b. Tall steeples over the crossings; dwarf or nonexistent towers on facades.

 c. Small portals not deeply recessed into porches.

 d. Generally low, wide buildings without flying buttresses.

 e. Extremely long buildings.

 f. Preference for double transepts.

 g. Square east end rather than round apse.

3. **Interiors** featured

 a. Three-part elevations separated into distinct horizontal bands rather than joined into vertical units by cluster colonettes.

 b. Preference for linear forms and detailing.

 c. Use of fan and net vaults, which became very decorative rather than structural.

English Gothic church architecture progressed through three distinct styles:

1. **Early English or Lancet** 1150–1250

 a. Clear geometric units.

 b. Simple lancet-shaped windows without sculptural embellishment.

2. **Decorated** 1250–1350

 a. Rich, sculptural foliate decoration on arches, vaults, and other elements.

 b. Crossed lines of tracery in windows.

3. **Perpendicular** 1300–1500

 a. Perpendicular intersections of tracery and lattice work on walls and windows.

 b. Fantastic fan vaults and pendant roof-bosses.

e. *German Gothic c. 1230–1600*

There were two developments in German Gothic design:

1. **French-style churches** based on High Gothic, but with the following variations:

 a. Taller spires and pointed towers.

 b. No radiating chapels or double ambulatories.

2. **Hall churches** based on French and German Romanesque:

 a. Naves and aisles of equal height.

 b. Widely-spaced piers between aisles and nave, emphasizing their connection rather than separation.

 c. Nave arcade all the way to the vaults.

 d. Aisle elevation consisting of two stories of large windows.

 e. No flying buttresses, since aisles braced the nave vaults.

 f. Chancel ending in a trefoil shape.

 g. Conservative, simple exteriors. Exterior sculpture was not important.

f. Italian Gothic c. 1275-1400

Italy never wholeheartedly adopted the Gothic style, although some northern Italian cities did add Gothic elements to their architecture, which was based on the survival of Early Christian forms. Even as Gothic ideals were gaining some acceptance in Italy, the Renaissance style was being developed in Florence.

Differences from French Gothic included:

1. Low, wide churches based on Early Christian basilican form.
2. Broad facades without deeply recessed portals.
3. Fewer windows due to heat and the tradition of opaque interior wall decoration (frescoes, mosaics, and marble).
4. Strips of colored marble decorating exteriors. Exterior sculpture was unimportant.
5. Screen walls on west facades.
6. Absence of flying buttresses and pinnacles.
7. Domes at crossings in some cases.
8. Frequent use of the trefoil chancel.
 Note: Milan Cathedral is more like French Gothic because it was designed by northern architects.

2. Secular architecture

Non-religious architecture became important for the first time since the Fall of Rome. Castles, fortresses, and city halls began to be constructed after 1200. After 1400, town houses for the upper classes became important.

Secular architecture tended to be more massive than religious structures, but depended on church design for their decorative elements. Spatial arrangements were based on monastic buildings and Islamic fortresses and palaces. Typical Gothic features included

1. Pointed arches for doorways, windows, and blind arcades, as well as arcades at street level, and upper balconies.
2. Tracery and trefoil window treatments.
3. Steep pointed towers accenting entrances and corners of structures.
4. **Crenellation**, borrowed from Moslem architecture, on the parapets and roof lines of fortresses and some city halls.

EXAMPLES
CHURCH CONSTRUCTION
FRENCH
EARLY GOTHIC

1. Abbey Church of St. Denis near Paris, choir and ambulatory, c. 1140-1144. (*G 10-1, 2, 3; H 446, 447; J 384, 385*)

2. Sens Cathedral, 1130-1168. (*illustrated elsewhere*)
3. Laon Cathedral, begun 1160, vaults 80 ft. high. (*G 10-5, 6, 7, 8, 18; H 452, 453, 454*)
4. Notre Dame, Paris, 1163-1250, vaults 107 ft. high. (*G 10-9, 10, 11, 12; H 455, 456, 457; J 386, 387, 388, 389*)

HIGH GOTHIC

1. Chartres, 1194-1220, vaults 118 ft. high. (*G 10-13, 15, 16, 17, 18; H 448, 449, 458, 459, 460; J 390, cpl 37*)
2. Reims, 1210-1299, vaults 127 ft. high. (*G 10-30; H 465, 466; J 394*)
3. Amiens, 1220-1236, vaults 144 ft. high. (*G 10-22, 23, 24, 25; H 469, 470, 471, 472, 473; J 391, 392, 393*)
4. Beauvais, 1247-1272, vaults 157 ft. high, collapsed in 1284. (*G 10-28, H 476*)
5. Ste. Chapelle, Paris, c. 1243-48, vaults 68 ft. high. (*G 10-26, 27*)
6. Bourges Cathedral, 1195-1255. (*G 10-19, 20, 21; H 463*)

LATE GOTHIC

St.-Maclou, Rouen, 1434-1514. (*G 10-37; H 477, 478; J 397*)

ENGLISH
EARLY GOTHIC (LANCET)

1. Canterbury Cathedral, 1175-1200 and 1397-1400. (*G 10-38, 39*)
2. Salisbury Cathedral, 1220-1270. (*G 10-40, 41, 42, 43; H 491, 492, 493; J 399, 400, 401*)

DECORATED

1. Lincoln Cathedral, 1192-1233 and 1255-1320. (*illustrated elsewhere*)
2. Wells Cathedral, begun 1338. (*illustrated elsewhere*)

PERPENDICULAR

1. Gloucester Cathedral, begun 1332. (*G 10-44, H 494, J 402*)
2. Chapel of Henry VII, Westminster Abbey, London, 1503-1519. (*G 10-45; H 495; J 403, 404*)

GERMAN
FRENCH-TYPE

Cologne Cathedral, 1248-1322 (modeled on Amiens).

HALL-TYPE

1. St. Elizabeth, Marburg, c. 1257-1283. (*G 10-47, 48, 49; H 484*)
2. Ulm Cathedral, begun 1392. (*illustrated elsewhere*)

ITALIAN GOTHIC

1. Siena Cathedral, 1226-1380. (*H 501*)
2. Santa Croce, Florence, c. 1294. (*H 497; J 408, 409*)
3. Florence Cathedral, begun 1368. (*G 10-53, 54, 55; H 498, 499, 500; J 410, 411, 412*)
4. Milan Cathedral, begun 1386 (northern style). (*G 10-57; H 502, 503, 504; J 414*)
5. Santa Maria Sopra Minerva, Rome, c. 1285 (the only Gothic church built in Rome). (*illustrated elsewhere*)
6. Orvieto Cathedral, begun c. 1310. (*G 10-56, J 413*)

SECULAR CONSTRUCTION

1. Palais Jacques Coeur, Bourges, France, 1443-1451. (*H 479, J 398*)
2. Burg Eltz on the Moselle, Germany, thirteenth–sixteenth century. (*illustrated elsewhere*)
3. Palazzo Vecchio, Florence, Italy, begun 1298. (*H 505, J 415*)
4. Palazzo Pubblico, Siena, Italy, 1298-1348. (*G 10-58*)
5. Doge's Palace, Venice, Italy, 1309-1340 and 1440-1442. (*G 10-59, H 506*)
6. Ca' d'Oro, Venice, 1422-c. 1440. (*H 507, J 416*)
7. Carcassonne, fortified city, southern France, mainly twelfth-thirteenth centuries. (*illustrated elsewhere*)

B. PAINTING

During the late Middle Ages, the cultural differences between Northern Europe and Italy began to increase in painting as well as in architecture and sculpture. Italian painting during this period is discussed in the next chapter.

In Northern Europe, **manuscript illumination** continued as the major form of painting. Toward the end of the era, panel painting began to displace it, and the invention of the printing press in the fifteenth century ended the production of hand-made manuscripts.

PURPOSES AND SUBJECT MATTER: Religious subjects dominated the period with books produced for the nobility and the merchant classes as well as monastic libraries. As the patronage shifted to the upper classes, secular subjects became popular. Romances and histories were written and illustrated. **Drolleries**

(playful designs) were added to the margins and depicted scenes of leap-frog and other amusements as well as images of plants and animals.

MEDIA AND TECHNIQUES

1. Watercolor and ink were used on parchment, vellum, and after 1380, paper.
2. Tempera on wood was used for panel paintings.
3. Techniques continued the earlier interest in linear forms and patterns.
4. Pastel colors, often quite delicate and luminous, replaced the darker, opaque colors of earlier periods.
5. Gold leaf completed the decoration.

DESIGN

1. There were many changes in style over the four hundred years of the Gothic Period. The royal court at Paris was usually the leader in stylistic development.
2. Laymen as well as clergy produced paintings for the universities, cathedrals, and royal courts throughout Europe.
3. Interest in naturalism coexisted with courtly elegance, but the aristocratic forms dominated with
 a. Delicate, elongated figures and faces.
 b. "Sweet" facial expressions and unconvincing poses.
 c. Interest in naturalism usually restricted to careful observation and representation of foliage and animals.

EXAMPLES

1. *God the Father as Architect, Bible Moralisée*, c. 1250. (*H cpl 65*)
2. *Abraham and the Three Angels, Psalter of St. Louis*, c. 1260. (*G 10–35, H cpl 66*)
3. Jean Pucelle, *Belleville Breviary*, c. 1326. (*H 481*)
4. *Wilton Diptych*, tempera on panel, c. 1377–1413. (*H cpl 68*)
5. Master Honoré, *Scenes from the Life of David, The Breviary of Philip the Fair*, c. 1296. (*J 446*)

C. SCULPTURE

Sculpture underwent drastic transformations during the Gothic Period. At the beginning of the era, sculptured figures were flat, stiff, and unconvincing. They were clearly subordinated to the architecture that they decorated. Gradually, they became more fluid until they gained complete independence from their architectural backgrounds. By 1300, sculpture had replaced architecture as the most innovative art in

Northern Europe, and by the close of the Gothic Period, architectural sculpture had gone completely out of style, replaced by free-standing work.

PURPOSES AND SUBJECT MATTER: The primary purpose was religious. Sculptures were produced for churches and for the private chapels of the nobility.

1. **Architectural sculpture** included
 a. **Standing human figures** attached with metal bars to door jambs, trumeaux, and piers of churches. These were most popular in France before 1300.
 b. **Relief carvings** and castings on church facades, choir-screens, pulpits, doors, etc.
2. **Devotional sculpture** included
 a. **Madonna and Child images.**
 b. **Crucifixes.**
 c. **Pietàs** (a **Pietà** is an image of the seated Virgin holding the body of the dead Christ).
 d. Images of Christ as the **Man of Sorrows.**
3. **Tomb effigies** were made for the French and English nobility.
4. **Altarpieces** and shrines were especially popular in Germanic territories.
5. Subjects chosen from the *Bible* and other religious literature, emphasized salvation and mystic bliss rather than torment and damnation as in the Romanesque Period.

MEDIA AND TECHNIQUES

1. Stone was most important until 1300, as the emphasis was on architectural decoration.
2. Wood became important in Germany after 1300.
3. Color was added to sculpture primarily in two ways:
 a. Fresco-type paint was used on stone.
 b. Tempera was used on wood.
4. Craftsmanship was considered to be at its peak in the thirteenth century.

DESIGN: Gothic sculptors throughout Europe shared an increased confidence in their ability to create images without imitating the flat, linear patterns of earlier manuscript painting. In fact, by 1350, painters were trying to imitate the new sculptural images.

1. French Gothic Sculpture

France had revived sculpture as a major art form during the Romanesque Period and continued to pioneer new concepts and designs until about 1300 when the workshops of Germany became more creative. (England generally followed French styles, importing both artists and finished works.)

1. **Early Gothic Sculpture**, 1140-1194, exhibited
 a. Less agitation than Romanesque figures.
 b. Clarification and simplification of images.
 c. Attempts at creation of real faces, not masks.
 d. Rounded bodies.
 e. Convincing drapery that looked like material, not string.
2. **High Gothic Sculpture**, 1194-1300, exhibited
 a. Humanized figures with the following characteristics:
 (1) Individualized and expressive faces.
 (2) Figures turned to each other, expressing relationships.
 (3) Realistic costumes.
 (4) More graceful poses. ("Classical" elements seen in work from the School of Reims.)
 (5) Figures becoming more independent of their settings.
 b. Complex sculptural programs on churches to instruct the illiterate.
3. **Late Gothic Sculpture**, 1300-1500, exhibited
 a. The **"S-curve"** which transformed the classical weight-shift pose into mannered elegance by adjusting anatomy to fit the pattern of the curve. (This is also called "Gothic sway" or the "hip-shot" pose.)
 b. Elongated and delicate faces and bodies.
 c. Courtly style resembling the precious gold work made for the aristrocracy.

2. German Gothic Sculpture 1200-1500

Because the sculptural decoration of church facades was not as important as in France, sculpture became free of architectural restraints sooner in German territories.

1. **Free-standing and portable works**, especially devotional images and altarpieces, became important sooner than elsewhere.
2. Early thirteenth century works were strongly influenced by the "classical" style of the School of Reims, France.
3. Fourteenth century works emphasized extreme realism in faces, poses, and drapery. Expressions of pain and grief were exaggerated in **Pietà** images.
4. Fifteenth century works exhibited the **"soft style"**: a variation on French Late Gothic which emphasized sweet faces, S-curve postures, and soft drapery folds.

3. Italian Sculpture

Late Medieval sculpture in Italy developed largely independent of Gothic influences from Northern Europe. This development is best described as the Proto-Renaissance, and is discussed in the next chapter.

EXAMPLES
FRENCH
EARLY GOTHIC

Jamb figures, Royal Portal, west facade, Chartres Cathedral, 1145-1150. (*G 10-13, 14; H 449, 450; J 417, 418*)

HIGH GOTHIC

1. *Jamb figures,* south transept, Chartres Cathedral, 1215-1220. (*G 10-29, H 461, J 419*)
2. *Annunciation* and *Visitation,* west facade, central portal, Reims Cathedral, 1225-1245. (*G 10-30, 31; H 467, J 421*)
3. *Priest and Knight,* interior west wall, Reims Cathedral, after 1251. (*H 468, J 422*)
4. *La Vierge Dorée,* south transept trumeau, Amiens Cathedral, c. 1258. (*illustrated elsewhere*)
5. *Christ Treading on the Lion and the Basilisk,* central trumeau, Amiens Cathedral, c. 1258. (*H 474*)

LATE GOTHIC

Virgin and Child from St. Aignan (Virgin of Paris), painted limestone, c. 1330. (*G 10-36, H 480, J 423*)

ENGLISH GOTHIC

Tomb of a Knight, Dorchester Abbey, Oxfordshire, c. 1260. (*J 425*)

GERMAN GOTHIC

1. *Death of the Virgin,* south transept tympanum, Strasbourg Cathedral (now France) c. 1230. (*H cpl 67, J 420*)
2. *Angel Pier,* Strasbourg Cathedral c. 1230. (*H 487*)
3. *Bamberg Rider,* Bamberg Cathedral, limestone, 1240-1255. (*G 10-51, H 489*)
4. *Ekkehard and Uta,* Naumburg Cathedral, painted limestone, 1240-1255. (*G 10-50, H 488, J 428*)
5. *Head of a Crucifix,* Santa Maria im Kapitol, Cologne, wood, 1301. (*G 10-52*)
6. *Rottgen Pietà,* c. 1370, wood, 34 in. high. (*J 429*)

D. MINOR ARTS

1. **Stained glass** in clerestory and rose windows
 a. Depicted religious images and stories.
 b. Was made by using lead strips to join pieces of flattened colored glass. Iron bands held the windows in place. Details were added with paint.
2. **Metalwork** was used for devotional images and reliquaries made of gold or silver, with enamel and gem inlay.
3. **Ivory carving** was done for small free-standing figures and relief panels for diptychs, triptychs, and polyptychs.
4. **Tapestry weaving** depicted religious and secular subjects with tall, elegant figures and fanciful animals against extremely detailed backgrounds.

EXAMPLES

STAINED GLASS

1. *Crucifixion window,* St. Remi, Reims, France, c. 1190, 12 ft. high. (*G 10-32*)
2. *Noli Me Tangere* and *Crucifixion* scenes, Chartres Cathedral, twelfth century. (*H 462*)
3. *Rose and lancet windows,* north transept, Chartres Cathedral, thirteenth century, rose 43 ft. in diameter. (*H cpl 63*)
4. *Good Samaritan window,* Chartres Cathedral, early thirteenth century. (*G 10-33*)
5. *Interior of Ste. Chapelle,* Paris, 1243-1248. (*H cpl 64*)

METALWORK (See also Chapter Ten)

1. *Reliquary Bust of Charlemagne,* 1349, silver chased and jeweled, life-size. (*illustrated elsewhere*)
2. *The Charlemagne Shrine,* early thirteenth century, silver gilt, copper gilt, enamel, filigree and gems, 80 by 37 by 22 in. (*illustrated elsewhere*)
3. *Nef of St. Ursula,* late fifteenth century, gold, silver, enamelled copper, 18 by 11 by 6 in. (*illustrated elsewhere*)
4. *Reliquary of Jeanne d'Evreaux,* 1339, silver gilt and enamel, 27 in. high. (*illustrated elsewhere*)

IVORY CARVING

1. *Soissons Diptych,* French, end of thirteenth century, ivory, 12 by 4 in. each panel. (*illustrated elsewhere*)
2. Various Madonna and Child images, Victoria and Albert Museum, London. (*illustrated elsewhere*)

TAPESTRY

Lady with the Unicorn, set of six tapestries from the Chateau of Pierre d'Aubusson at Boussac, France, fifteenth century, approximately 10 by 11 ft. (*illustrated elsewhere*)

VOCABULARY

chevet	fan vault	rose-window
choir	flying buttress	S-curve
crenellations	hall church	tracery
drolleries	pier buttress	tribune
exoskeleton	Pietà	triforium

12. Proto-Renaissance and International Gothic Art

SUMMARY

I. Proto-Renaissance in Italy c. 1250–1350

Architecture: Italian thirteenth and fourteenth century architecture was generally Romanesque, with a few Gothic buildings in Northern Italy.

Painting: Painting was the most innovative art form of this period. Large fresco wall paintings and tempera panel paintings were produced in the Proto-Renaissance style in which depth was implied by the use of light and shade, by overlapping figures in groups, and by an imperfect linear perspective. The human body was defined under its draperies, gestures conveyed emotion, and compositions were simplified. Landscape paintings represented actual places.

Sculpture: Two trends developed in Central Italy during the fourteenth century:

> **The Classicizing style** emphasized elements used in ancient Roman sculpture such as Roman figure and facial types, drapery treatments, and architectural settings.

> **The Gothicizing style** was inspired by the French Gothic style but added more violent representations of action and emotion.

II. International Gothic Art c. 1330–1420

Painting: Manuscript illuminations and tempera panel paintings in the International Gothic style were produced in the Burgundy region of France and portions of north and central Italy. Elements of the Sienese Proto-Renaissance style were combined with French Gothic features to produce a unique style favored by the nobility in France and the Papal court in Avignon. Although the Proto-Renaissance interests in careful modeling of figures and faces and representations of actual places were adopted, the International Gothic style was in most ways the opposite of the Proto-Renaissance because of its emphasis on line rather than volume, crowded compositions with up-tilted backgrounds, very ornate costumes, and lavish use of gold leaf.

Sculpture: The works produced for the Burgundian court are the best examples of International Gothic sculpture. Great strides were made to free sculpture from architectural restraints. Figures were rounded, carefully detailed, and covered by heavy drapery falling in soft folds.

I. PROTO-RENAISSANCE IN ITALY c. 1250-1350

Some authors include the works of this period under "Gothic" to maintain chronological progression. Others treat it separately because of the great stylistic changes that occurred in Italy, particularly in painting. These authors use the term "Proto-Renaissance" to designate a time (late thirteenth and early fourteenth centuries), and a style (depth in representation, classically-inspired, rounded figures) that occurred in a particular place, Tuscany, the area around Florence.

A. ARCHITECTURE

In most of Italy, architecture was still basically Romanesque, influenced by classical forms found in Late Roman and Early Christian buildings. The Gothic style penetrated only the northern part of the country, and even then, Italian Gothic churches were lower, wider, and plainer than their French counterparts.

B. PAINTING

During the Proto-Renaissance, vigorous schools of art grew up in Florence, Siena, Pisa, and elsewhere in Central Italy.

PURPOSES AND SUBJECT MATTER: Painting still was used mostly in the decoration of churches, although there was an increasing interest in painting for civic purposes, such as the decoration of city halls. The rich merchants were the main source of funds and support.

1. **Religious subject matter.** The most important of many sources of artistic subjects included
 a. *The Bible.*
 b. *The Apocrypha:* a group of stories once included in the *Bible,* but later removed as inauthentic.
 c. *The Golden Legend,* written in the thirteenth century by Jacopo de Voragine, Archbishop of Genoa, a collection of folklore describing the lives of the saints, arranged in the sequence of the Catholic calendar of saints' days.
 d. *Mirror of Man's Salvation:* a retelling of Christ's life with Old Testament parallels.
2. **Secular subject matter** (worldly, non-religious).
 a. Political scenes extolling good government were painted in the City Hall of Siena.
 b. An allegorical reference to the Black Death was painted in Pisa.

MEDIA AND TECHNIQUES

1. **Large fresco wall paintings** were the most important:
 a. **Buon fresco** (true fresco) involves painting directly into wet plaster so that the color is absorbed and becomes part of the wall.
 b. **Fresco secco** (dry fresco) is the application of pigments to dry plaster. This method is less permanent because the bond between the paint and the plaster is very weak, but it was necessary to use it at times to add details to buon fresco paintings.
2. **Tempera panel paintings** consisted of large altarpieces done on wood panels that were
 a. Covered with **gesso** and scraped smooth.
 b. Painted with a mixture of pigment and egg yolk called tempera.
 c. Embellished with gold leaf. Gold backgrounds were increasingly replaced by blue sky as painting became more naturalistic.

DESIGN: The Proto-Renaissance style was the result of Italian artists' experimentation with elements quite different from the Byzantine manner that had prevailed until that time in Italy.

1. **New elements** included
 a. **Direct observation of nature.** This had started in the Gothic Period but was greatly developed by Proto-Renaissance artists.
 b. **Modeling with light and shade,** resulting in a new roundness of forms. The light source was not yet specifically indicated (as it would be in the fifteenth century) and light seemed to come from the direction of the viewer.
 c. **Conveyence of emotion** through convincing gestures and facial expressions.
 d. Attempts to indicate depth using an imperfectly developed **linear perspective.**
 Note: Linear perspective is a specific method for representing three-dimensional space on a two-dimensional surface. It will be explained further in the next chapter.
 e. **Overlapping figures** to indicate depth.
 f. Reduction of detail; simplified composition.
 g. **Emphasis on narrative** rather than symbolism.
 h. Representation of **actual places** and use of landscape to express nature rather than fantasy.
 i. Observation of the underlying structure of the human body.
2. Elements carried over **from the Byzantine style** included
 a. Plate-like haloes.
 b. Hierarchic scaling (important people made larger).

EXAMPLES

SIENESE SCHOOL

1. Duccio di Buoninsegna, panels from the back of the *MaestàAltar,* 1308-11, tempera and gold on wood panel, varying sizes. (*G 15-8, 9; H 11, 12, 13; J 448, 449, J cpl 38*)
2. Pietro Lorenzetti, *Birth of the Virgin,* 1342, tempera on wood panel, 6 by 6 ft. (*G 15-21; H 15; J 452*)
3. Ambrogio Lorenzetti, *Good Government frescoes,* Palazzo Pubblico, Siena, 1338-39. (*G 15-22, 23, 24; H 16, cpl 3; J 453, cpl 41*)

ROMAN SCHOOL

Pietro Cavallini, *Seated Apostles,* Santa Cecelia in Trastevere, Rome, c. 1291, fresco. (*G 15-10, H cpl 1*)

FLORENTINE SCHOOL

1. Giovanni Cimabue, *Madonna Enthroned,* 1280-90, panel, 13 by 7 ft. (*G 15-11, H 6, J 447*)
2. Giotto di Bondone, *Madonna Enthroned,* c. 1310, panel, 11 by 7 ft. (*G 15-12, H 7, J 451*)
3. Giotto, Arena Chapel, Padua, frescoes, 1305. (*G 15-14, 17; H 8, 9, cpl 2; J 459, cpl 39*)
4. Giotto, Bardi Chapel, Santa Croce, Florence, frescoes, c. 1320. (*G 15-15*)
5. Taddeo Gaddi, *Annunciation to the Shepherds,* Baroncelli Chapel, Santa Croce, c. 1332-38, fresco. (*H 10*)
6. Taddeo Gaddi, *Meeting of Joachim and Anna,* Baroncelli Chapel, Santa Croce, c. 1338, fresco. (*G 15-18*)
7. Giovanni di Milano, *Pietà,* 1365, panel, 48 by 22 in. (*H 19, J 456*)

PISAN SCHOOL

Francesco Traini, *Triumph of Death,* Campo Santo, Pisa, c. 1350, fresco. (*G 15-25; H 17, 18; J 454, 455*)

C. SCULPTURE

PURPOSES AND SUBJECT MATTER: Proto-Renaissance sculpture consisted mostly of relief carvings used to decorate church pulpits and doors. Subjects were primarily episodes from the *Bible.*

MEDIA AND TECHNIQUES

1. Marble was popular for reliefs and free-standing works since it was plentiful in Italy. It was used in combination with granite, porphyry, and other stone.
2. Bronze was cast and gilded.

DESIGN: Two trends developed in the Proto-Renaissance:

1. **The Classicizing style** depicted
 a. Round arches and other Roman architectural elements.
 b. Roman facial types, draperies, and hair styles.
 c. Closely-packed figure groups.
 d. Calm poses and gestures similar to ancient styles.
2. **The Gothicizing style**, inspired by French art, depicted
 a. Pointed arches and other Gothic architectural elements.
 b. Non-Classical costumes and draperies.
 c. Agitated figures.
 d. Violent action and emotion that went beyond its Gothic inspiration.

NOTE: A combination of both styles is found in the work of Andrea Pisano.

EXAMPLES
CLASSICIZING STYLE

Nicola Pisano, pulpit, Pisa Baptistry, 1259-60, marble. (*G 15-1, 2; H 1, 2; J 432, 433*)

GOTHICIZING STYLE

Giovanni Pisano, pulpit, Sant' Andrea, Pistoia, 1301, marble. (*G* 15-3; *H 3, 4*)

COMBINED STYLES

Andrea Pisano, south door, Baptistry of Florence, 1330-35, gilt bronze. (*G 15-4, 5*)

II. INTERNATIONAL GOTHIC ART c. 1330-1420

Artists working at the Papal Court in Avignon, France, were the first to add Proto-Renaissance naturalism to Gothic interests. From Avignon, this new Inter-

national Gothic style spread to other royal courts in Europe. The Burgundian princes proved to be its most ardent patrons.

A. ARCHITECTURE

The International Gothic style developed only in painting and sculpture.

B. PAINTING

FORMS

1. **Manuscript illuminations.**
2. **Panel paintings**, mostly used as altarpieces.

PURPOSES AND SUBJECT MATTER: Both religious and secular. See Proto-Renaissance.

MEDIA AND TECHNIQUES

1. Opaque and transparent watercolor were used for manuscript illuminations on vellum, parchment, and paper.
2. Tempera over gesso-coated wood panels was used for altarpieces.
3. Fresco was used for occasional wall paintings.
4. Gold leaf was used lavishly on both manuscripts and panel paintings.

DESIGN: The International Gothic style developed as a fusion of the new Proto-Renaissance naturalism with existing French interests.

1. Elements from **French Gothic** painting:
 a. Interest in representations of luxurious living.
 b. Increasing interest in secular subject matter.
 c. Emphasis on line rather than volume.
2. Elements from Sienese **Proto-Renaissance** painting, introduced by Simone Martini:
 a. Modeled forms with deeper shadows.
 b. Expression through posture and gesture.
 c. Interest in narrative.
 d. Humanizing of forms and subject matter.
 e. Real places shown in landscapes.

3. Elements of the resulting **International Gothic** Style:
 a. Magnificent costumes (showing that people depicted were wealthy patrons).
 b. Intricate detail in costume fabrics as well as in surrounding scenery.
 c. Lavish use of gold and bright colors.
 d. Curvilinear line in figures and settings.
 e. Uptilted background planes; serpentine recession into the background.
 f. Modeled forms, particularly faces.

EXAMPLES

SIENESE SCHOOL

1. Simone Martini, *Guidoriccio da Fogliano,* Palazzo Pubblico, Siena, 1328, fresco, 11 by 32 ft. (*G 15-20*)
2. Simone Martini, *Annunciation,* 1333, tempera and gold on panel, approx. 10 by 9 ft. (*G 15-19, H 14*)
3. Simone Martini, *Road to Calvary,* 1340, panel, 10 by 6 in. (*J cpl 40*)

FLORENTINE SCHOOL

Gentile da Fabriano, *Adoration of the Magi,* 1423, panel, approx. 10 by 9 ft. (*G 16-26, H cpl 5, J cpl 45*)

FRANCO-FLEMISH SCHOOL

1. Melchior Broederlam, *Presentation* and *Flight into Egypt,* 1394-99, panel, approx. 64 by 57 in. (*G 18-4, J cpl 43*)
2. The Limbourg Brothers, *Très Riches Heures du Duc de Berry,* 1413, manuscript illuminations, approx. 9 by 5 in. (*G 18-5, 6; H 90; J 459, 460, cpl 44*)

C. SCULPTURE

PURPOSES AND SUBJECT MATTER: Church decoration continued to be important. In addition, Philip the Bold, Duke of Burgundy, (ruled 1364-1404) founded the Chartreuse de Champmol, a monastery whose grounds in Dijon, France, included a family chapel and a tomb for the Burgundian royal family. Artists from throughout Europe were attracted to the area to create sculpture for the Burgundian nobility.

MEDIA AND TECHNIQUES: Carving in limestone, granite, and other stone was popular for both reliefs and nearly free-standing figures.

DESIGN

1. Extreme detail was shown in figures and faces.
2. Skillful rendering of textures and use of shadow enhanced sculptural qualities.
3. Heavy draperies, falling in soft folds, increased monumentality; however, they also concealed underlying forms.
4. Figures were developed that could conceivably stand alone since they were no longer dependent on architectural backgrounds.

EXAMPLES

BURGUNDIAN

1. Claus Sluter, *The Well of Moses,* 1395-1406, stone, height of figures approx. 6 ft. (*G 18-1, 2; H 86, 87; J 431*)
2. Claus Sluter, *Portal of the Chartreuse de Champmol,* Dijon, 1391-97. (*H 85, J 430*)

VOCABULARY

Apocrypha	gesso	tempera
buon fresco	linear perspective	trecento
fresco secco	secular	

13. Fifteenth Century Art

SUMMARY

Architecture: **Italian** church architecture, human in scale, derived its style from Roman Antiquity and from subsequent periods. Secular architecture did the same, but was more massive and fortress-like. In **Northern Europe,** architecture remained Gothic.

Painting: Regional differences were very significant.

Italy: Subjects were primarily religious although portraits and illustrations of pagan myths were also produced. One-point linear perspective and aerial perspective were scientifically developed. The figure-triangle composition was introduced. Directed lighting, careful shading, and proportional scaling of figures developed earlier in Italy than in the North. Fresco wall paintings were the most important form, but tempera was also used for paintings on wood panels or on canvas.

Northern Europe: Religious and secular subjects were important. Three-quarter view portraits developed first in Flanders. Linear perspective was used, along with aerial perspective, but imperfectly. Disguised symbolism was introduced, haloes were eliminated, and light sources were definite. Oil painting was invented in Flanders. Fresco painting was unimportant and manuscript illuminations were only occasionally produced.

Graphics: Expanded manufacture of paper and the invention of the printing press nurtured the development of printmaking. Woodcut developed early in the century and engraving developed later.

Sculpture: Both relief and free-standing sculpture made great advances in the fifteenth century in Italy. Portraits were extremely realistic with attention to correct representation of the underlying skeletal structure. Equestrian figures were popular. Contrapposto reappeared for the first time since the Fall of Rome. Ancient Roman sculpture was an important source of style and subject. Relief sculpture was extremely convincing through the use of linear perspective and sculptors' aerial perspective. Northern sculpture remained Gothic.

1. Italy

Florence led the other commercial centers of northern and central Italy in supporting the arts. While several wealthy families and guilds patronized the arts, it was largely the banking fortunes of the Medici family which made Florence one of the two great cultural centers of Europe, the other being Flanders.

2. Northern Europe

As in Italy, the new commercial towns of Northern Europe were the centers of a new Renaissance style in the arts. The cities of Flanders (Bruges, Ghent, Antwerp, and Brussels) led the way in supporting the new style, but patrons in Paris, London, Augsburg, Nuremburg, and Prague also played important parts.

A. ARCHITECTURE

1. Italy

Renaissance architecture was directly inspired by the antique Roman ruins studied by the architect-sculptor, Filippo Brunelleschi, in the early fifteenth century. He was concerned with a clarity of design achieved through logical, mathematical organization of elements. The new design gave a cool, serene atmosphere to Renaissance buildings. Other architects continued the style and added refinements of their own.

PURPOSES: The Church was no longer the sole patron of architecture. Secular building became increasingly important and was paid for by wealthy families and guilds, and by taxes imposed on the general public.

BUILDING TYPES

1. Churches.
2. Secular buildings such as hospitals, palaces, etc.

a. Church Construction

MEDIA AND TECHNIQUES

1. Stone and brick were used for foundations and walls.
2. Marble was used for wall facings and decoration.
3. Plaster covered the walls of interiors.
4. Glass, stained or clear, was used for windows, smaller in Italy than in the North because of the heat.
5. Tile was used for roofing.
6. Post-and-lintel construction was used in combination with arches and domes.

DESIGN: "Man was the measure of all things" in the Early Renaissance, just as he had been in the Golden Age of Greece. The worshipper in a Renaissance church felt significant as an individual, rather than overwhelmed by the majesty of religion.

Essential to the Renaissance style was the uncluttered look of its church interiors. Renaissance architecture, while borrowing heavily from ancient Roman architecture, also derived many elements from medieval architectural styles.

1. Elements from **Roman** architecture included
 a. Round arches.
 b. Classically proportioned columns.
 c. Classical capitals, primarily Corinthian.
 d. Some flat ceilings; some barrel-vaulted interiors.
 e. Coffered ceilings.
 f. The triumphal arch motif for facades.
 g. The temple front motif for facades.
 h. Domes.
 i. Central plans for some churches.
2. **Early Christian** elements included
 a. Arches springing from columns.
 b. Two-part nave elevations.
 c. Flat entablatures broken by arches.
 d. Latin cross (basilican) plans.
3. **Byzantine** elements included
 a. Domes on pendentives.
 b. Impost blocks above capitals.
4. **Romanesque** elements included
 a. Modular construction based on bays.
 b. Flat patterned facades.
5. **Gothic** elements included Brunelleschi's solution to dome construction used on Florence Cathedral.

"UNFINISHED BUSINESS" FROM THE MIDDLE AGES

1. **Santa Maria Novella,** Florence
 a. A Dominican church, begun in 1278.
 b. Alberti designed a Renaissance facade in 1456.
2. **Santa Croce,** Florence
 a. A Franciscan church, begun in 1294.
 b. Brunelleschi added the Pazzi Chapel in 1440.
 c. The facade was not finished until the nineteenth century.
3. **Florence Cathedral**
 a. Begun in 1296.

 b. The unfinished octagonal crossing square 338 ft. wide required a dome.
 c. Brunelleschi designed a dome using Gothic construction principles, completed in 1436.
 d. The facade was not finished until the nineteenth century.

b. Secular Construction

Secular architecture followed church design in many ways, but private homes were more massive than churches to the extent of being fortress-like in appearance. While the interiors were lavishly decorated, the exteriors were kept austere and forbidding.

MEDIA AND TECHNIQUES

1. Stone was used for palace exteriors, and it was heavily rusticated, especially at the bottom, and less so on the upper stories. (**Rustication** is the beveling of the edges of stone blocks to emphasize the joints between them.)
2. Marble was used for decoration of interiors.
3. Tile was used for roofing. The tile roofs of Florence are typically red.
4. Lavish interior decoration was reserved for the upper floors, since the ground floor was not used as a family dwelling but for offices, storage, servants' quarters, etc.

 DESIGN: As in church architecture, many elements were taken from earlier styles:

1. **The cortile.** Many homes were built around a central courtyard, or cortile, adapted from ancient Roman insulae.
2. **Arcades.** These supported the upper stories and were composed of round arches springing from columns.
3. **String courses.** Facades were divided into three horizontal bands with string courses (stone ridges) between them, also an adaptation from the Antique.
4. **Cornices.** Projecting, ornamental mouldings crowned the tops of buildings.

EXAMPLES
CHURCH CONSTRUCTION

1. Filippo Brunelleschi, dome of Florence Cathedral, 1420-36. (*G 16-16; H 20, 21; J 410*)
2. Filippo Brunelleschi, San Lorenzo, Florence, 1421-69. (*H 23, 24; J 499, 500*)
3. Filippo Brunelleschi, San Spirito, Florence, begun 1428. (*G 16-18, J 505*)
4. Filippo Brunelleschi, Pazzi Chapel, Santa Croce, Florence, begun 1440. (*G 16-20, 21, 22; H 25, 26, 27; J 501, 502, 503, 504*)
5. Leon Battista Alberti, facade of S. M. Novella, Florence, begun c. 1456. (*G 16-40*)

6. Leon Battista Alberti, S. Francesco, Rimini, begun 1450. (*G 16-41; H 32; J 518, 519*)
7. Leon Battista Alberti, S. Andrea, Mantua, designed 1470. (*G 16-42, 43, 44; H 33, 34, 35; J 520, 521*)
8. Giuliano da Sangallo, S. M. delle Carceri, Prato, 1485. (*G 16-45, 46, 47; H 36, 37; J 522, 523, 524*)

SECULAR CONSTRUCTION

1. Filippo Brunelleschi, Foundling Hospital, Florence, 1419-24. (*G 16-17, H 22*)
2. Michelozzo di Bartolommeo, Medici-Riccardi Palace, begun 1444. (*G 16-24, 25; H 28, 29, 30; J 507*)
3. Leon Battista Alberti, Palazzo Rucellai, Florence, 1446-51. (*G 16-39, H 31, J 517*)

2. Northern Europe

Fifteenth century architecture in Northern Europe continued in the Gothic style. See Chapter Eleven for details.

B. PAINTING

1. Italy

PURPOSES AND SUBJECT MATTER: The Medici and other wealthy families commissioned many paintings to decorate churches and other public buildings as well as their homes. Subjects included

1. Religious painting. See Chapter Twelve for sources.
2. Portraiture.
3. Pagan mythology, after mid-century.

MEDIA AND TECHNIQUES

1. **Fresco wall paintings** were of primary importance.
2. **Panel paintings**
 a. Were done in tempera. (Oil painting, in use in the North, did not become popular in Italy until the next century.)
 b. Were large, flat altarpieces with fewer panels than northern examples, and only rarely hinged.
 c. Were occasionally in the form of **tondos** (round paintings) which came in about mid-century, for private homes.

DESIGN: The following elements were found in Italian **quattrocento** paintings:

1. **Correct linear perspective.** Brunelleschi is credited with its invention. In 1435, Alberti wrote the following rules:
 a. No distortion of straight lines.
 b. No distortion of objects parallel to the picture plane.
 c. Orthagonals (diagonal lines) converge in a single vanishing point, depending on the position of the observer's eye. (See Figure 13-1)
 d. Size diminishes relative to distance.
2. **Aerial perspective.** This is the graying of colors as they recede into the distance.
3. Correct representations of anatomy.
4. Correct scale of figures and surroundings; elimination of hierarchic scaling.
5. Landscape backgrounds, some with architecture.
6. Haloes still used.
7. **Sacra conversazione** composition (Madonna and Child conversing with Saints).
8. **Figure-triangle composition.** (See Figure 13-2)
9. Lighting from a definite source outside the picture.
10. Profile portraits followed later by three-quarter views.

2. Flanders

PURPOSES AND SUBJECT MATTER: Paintings were made to suit the tastes of the nobility and rising merchant class, whose money came from the wool trade and banking. Except for a lively interest in portraiture, the subjects of Flemish paintings were largely religious.

MEDIA AND TECHNIQUES

1. By mid-century, manuscript illumination had been replaced by panel painting and printmaking.
2. **Oil painting** on wood panels developed in Flanders early in the fifteenth century while Italy continued to use tempera.
 a. **Transparent glazes** were built up in layers over an underpainting of tempera on gesso-coated panels.
 b. **Alla prima** painting directly over the gesso was practiced by some artists, such as Bosch.
3. **Grisaille** refers to paintings in oil done entirely in shades of gray in imitation of stone carvings.
4. Often multiple panels were hinged together to make large altarpieces.

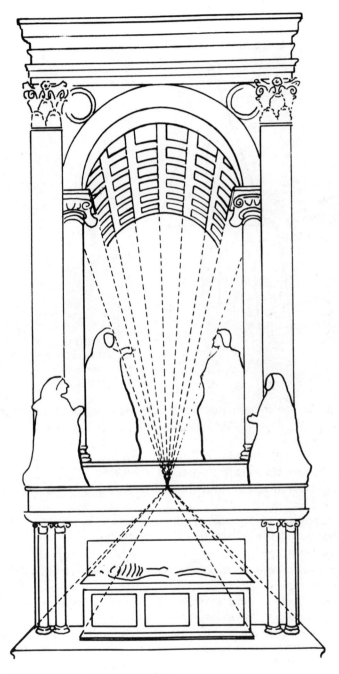

FIGURE 13-1 Linear perspective.

FIGURE 13-2
Figure-triangle
composition

DESIGN: The following elements were found in Flemish fifteenth century painting:

1. **Accurate detail.** This was equated with credibility; the more true to life a painting was, the more its story could be believed.
2. **Heavily draped figures.** This was not surprising since Flanders was a textile center.
3. **Contemporary** settings and costumes. Scenes from the *Bible* were shown as taking place in fifteenth century Flemish settings.
4. **Aerial perspective.**
5. **Linear perspective,** correctly used only in the second half of the fifteenth century.
6. **Incorrect scale** in some instances. Sometimes figures were too large for the implied space, or were hierarchically scaled.
7. **No flattery.** Portraits were very detailed with no idealization. While Flemish portraits were very detailed records of the facial surface, there was little evident concern for the underlying bone structure.
8. **A definite light source,** usually from the side.
9. **No haloes.** Flemish painters eliminated haloes early in the fifteenth century, while Italians retained them until the end of the century.

10. Use of **disguised symbolism**. Ordinary objects, seemingly just decorative, were used to symbolize religious concepts. For example:
 a. Dog—fidelity.
 b. Mousetrap—Christ as bait to catch the Devil.
 c. Enclosed garden—Mary's virginity.
 d. Lilies—purity of the Virgin.
11. **Individual innovations:**
 a. Work by **Bosch** is difficult to classify and subject to various interpretations.
 b. **Geertgen tot Sint Jans** introduced night scenes with the light source within the composition.

3. France

PURPOSES AND SUBJECT MATTER: Since the Hundred Years' War (1337-1453) had deterred the rise of a wealthy merchant class in France, artists worked to please the tastes of royalty and the wealthy nobility. They painted portraits and religious scenes.

MEDIA AND TECHNIQUES: Panel painting was popular, although it did not completely overshadow manuscript illumination as happened elsewhere.

DESIGN: There was no uniform style for French fifteenth century painting. Influenced by both Flanders and Italy, artists had greatly differing individual styles.

1. **Italian influences** included
 a. Portraiture accurately representing the underlying structure.
 b. Classical architectural backgrounds shown in correct perspective.
2. **Flemish influences** included
 a. Strong influence of Van Eyck in poses, drapery, and setting.
 b. Lighting effects similar to Geertgen tot Sint Jans.
3. **Gothic** influence included the use of gold backgrounds.

4. Germany

PURPOSES AND SUBJECT MATTER: Free of warfare, German business prospered, and art was commissioned by wealthy merchants. The subject matter was religious.

MEDIA AND TECHNIQUES: Painting was done on wood panels with both tempera and oil paints.

DESIGN: Germany was divided into small, political units, and like France did not have a unified style. There were many regional styles, among them:

1. The "**soft style**" of Cologne, in the North. This was a combination of
 a. The **International Gothic Style**, with ornate, delicate figures and gold backgrounds.
 b. The influence of **Jan Van Eyck** in facial types, costumes, and voluminous drapery.
2. The "**hard style**" of southern Germany. This was also influenced by Van Eyck, but was much more angular than the style of the North.
3. **Combined** German and Italian Influences.
 a. Medieval characterizations of the Devil.
 b. Italian backgrounds with correct perspective, probably the influence of the north Italian painter, Mantegna.

EXAMPLES

ITALIAN

FLORENTINE SCHOOL

1. Masaccio, *The Tribute Money,* Brancacci Chapel, S.M. del Carmine, Florence, 1427, fresco, 8 by 20 ft. (*G 16-27; H 54, cpl 6; J 510*)
2. Masaccio, *Expulsion from Eden,* same location, 1425, fresco. (*G 16-28, H 55, J 511*)
3. Masaccio, *Holy Trinity,* S.M. Novella, Florence, 1428, fresco, 22 by 11 ft. (*G 16-29; H 57; J 508, 509*)
4. Paolo Uccello, *Battle of San Romano,* c. 1455, panel, 6 by 11 ft. (*G 16-30, H 61, J cpl 54*)
5. Andrea del Castagno, *Last Supper,* Cenacolo di Sant' Apollonia, Florence, 1445-50, fresco. (*G 16-31, H 63, J 516*)
6. Andrea del Castagno, *Pippo Spano,* Sant' Apollonia, Florence, 1448, fresco. (*G 16-32*)
7. Andrea del Castagno, *David,* c. 1448, painted leather, 45 in. high. (*H 64, J cpl 55*)
8. Domenico Veneziano, *St. Lucy Altarpiece,* 1445, panel, 7 by 7 ft. (*G 16-33, H cpl 9, J cpl 52*)
9. Piero della Francesca, *Annunciation,* San Francesco, Arezzo, 1455, fresco. (*G 16-34*)
10. Piero della Francesca, *Battista Sforza,* 1465, panel, 18 by 13 in. (*H cpl 10*)
11. Piero della Francesca, *Federigo da Montefeltro,* 1465, panel, 18 by 13 in. (*H cpl 11*)
12. Fra Angelico, *Annunciation,* San Marco, Florence, 1440-45, fresco. (*G 16-37, J 514*) 1438-45 version (*H 59*)
13. Fra Angelico, *Descent from the Cross,* 1434, fresco. (*H cpl 8*)
14. Fra Lippi, *Madonna and Child with Angels,* c. 1465, panel. (*G 16-38*)
15. Fra Lippi, *Madonna and Child,* c. 1452, tondo panel, 53 in. (*H cpl 8*)
16. Fra Lippi, *Madonna Enthroned,* 1437, panel. (*J 513*)

17. Antonio Pollaiuolo, *Apollo and Daphne,* c. 1475, panel, 12 by 8 in. (*G 16-57*)
18. Antonio Pollaiuolo, *St. Sebastian,* 1475, panel, 10 by 7 ft. (*H 71*)
19. Domenico Ghirlandaio, *Birth of the Virgin,* S.M. Novella, Florence, 1485-90, fresco. (*G 16-58, H 77*)
20. Domenico Ghirlandaio, *Giovanna Tornabuoni,* 1488, panel. (*G 16-59*)
21. Domenico Ghirlandaio, *Old Man and His Grandson,* c. 1480, panel, 24 by 18 in. (*J 537*)
22. Sandro Botticelli, *Birth of Venus,* 1482, tempera on canvas. (*G 16-61, H cpl 12, J cpl 58*)
23. Sandro Botticelli, *Portrait of a Young Man,* late 15th century, panel, 23 by 16 in. (*G 16-60*)
24. Sandro Botticelli, *Primavera,* c. 1478, panel, 7 by 10 ft. (*H 76*)

UMBRIAN SCHOOL

1. Luca Signorelli, *Damned Cast into Hell,* San Brizio Chapel, Orvieto Cathedral, 1499-1504, fresco. (*G 16-62, H 79, J 539*)
2. Pietro Perugino, *Giving of the Keys to St. Peter,* Sistine Chapel, Rome, 1481-83, fresco. (*G 16-63, H 78, J 538*)

NORTH ITALIAN SCHOOL

1. Andrea Mantegna, *St. James Led to Martyrdom,* Ovetari Chapel, Church of the Eremitani, Padua, c. 1455, fresco, destroyed 1944. (*G 16-64, H 80, J 534*)
2. Andrea Mantegna, *Camera degli Sposi frescoes,* Ducal Palace, Mantua, 1474. (*G 16-65, 66; H 81, cpl 13*)
3. Andrea Mantegna, *St. Sebastian,* 1455-60, panel, 27 by 12 in. (*J cpl 56*)
4. Andrea Mantegna, *Dead Christ,* c. 1501, tempera on canvas. (*G 16-68, H 82*)
5. Antonello da Messina, *St. Jerome in His Study,* c. 1450-55, oil on panel, 18 by 14 in. (*H 83*)
6. Antonello da Messina, *St. Sebastian,* c. 1475-77, oil. (*G 16-67*)

FLEMISH

1. Robert Campin, *Nativity,* c. 1425, panel. (*H cpl 16*)
2. Robert Campin, *Merode Altarpiece,* c. 1425-28, panel. (*G 18-7; H 93; J 462 cpl 46*)
3. Jan van Eyck, *Crucifixion, Last Judgment,* 1420-25, panels, each panel 22 by 8 in. (*J cpl 47*)
4. Jan van Eyck, *Ghent Altarpiece,* 1432, panels, 11 by 15 ft. open. (*G 18-8, 9, 10; H 96, 97, 98, 99; J 463, 464, 465*)

5. Jan van Eyck, *Man in a Red Turban,* 1433, panel, 10 by 7 in. (*G 18-11, H 103, J 466*)

6. Jan van Eyck, *Madonna of Chancellor Rolin,* c. 1433-34, panel, 26 by 24 in. (*H 100, cpl 17*)

7. Jan van Eyck, *Arnolfini Wedding,* 1434, panel, 32 by 23 in. (*G 18-13, 14; H 101, 102; J cpl 48*)

8. Jan van Eyck, *Virgin with Canon van der Paele,* 1436, panel, 48 by 62 in. (*G 18-12*)

9. Rogier van der Weyden, *Francisco d'Este,* 1433, panel, 12 by 8 in. (*J 467*)

10. Rogier van der Weyden, *Deposition,* 1435, panel, 7 by 9 ft. (*G 18-5, H cpl 18, J cpl 49*)

11. Rogier van der Weyden, *Last Judgment Altarpiece,* 1444-48. (*H cpl 19*)

12. Petrus Christus, *Legend of Saints Elegius and Godeberta,* 1449, panel, 39 by 34 in. (*G 18-17*)

13. Dirk Bouts, *Last Supper,* 1464-68, panel, 72 by 60 in. (*G 18-18, H 104*)

14. Hugo van der Goes, *Portinari Altarpiece,* c. 1476, oil on panel, center 8 by 10 ft. (*G 18-19, 20; H 105, 106; J 468, 469*)

15. Hans Memling, *Mystic Marriage of St. Catherine,* 1479, panel, 6 by 6 ft. (*G 18-21*)

16. Hans Memling, *Shrine of St. Ursula,* 1489, panel. (*H 107, 107A, B, C*)

17. Geertgen tot Sint Jans, *Nativity,* c. 1490, panel, 13 by 10 in. (*H 108, J 470*)

18. Hieronymous Bosch, *Crowning with Thorns,* c. 1500, panel. (*H 109*)

19. Hieronymous Bosch, *Carrying of the Cross,* c. 1510, panel. (*G 18-22*)

20. Hieronymous Bosch, *Garden of Earthly Delights,* 1505-10, panel, 86 by 77 in. (*G 18-23, 24; H 110, 111, 112, cpl 20; J 471, 472, cpl 50*)

FRENCH
ITALIAN-INFLUENCED PAINTING

1. Jean Fouquet, *Étienne Chevalier and St. Stephen,* c. 1450, panel, 36 by 33 in. (*G 18-25, H 117, J 474*)

2. Jean Fouquet, *Marriage of the Virgin,* c. 1452-56, manuscript illumination, 6 by 5 in. (*H 118*)

FLEMISH-INFLUENCED PAINTING

1. Master of the Annunciation of Aix, *Annunciation of Aix,* c. 1445, panel, 61 by 69 in. (*H 119*)

2. Master René of Anjou, *Amour Gives the King's Heart to Désir,* 1457, manuscript illumination, 11 by 8 in. (*H 120*)

GOTHIC-INFLUENCED PAINTING

1. Enguerrand Quarton, *Coronation of the Virgin,* 1453-54, panel, 72 by 86 in. (*H cpl 21*)

2. Anonymous Master or Enguerrand Quarton, *Avignon Pietà*, 1460, panel, 64 by 86 in. (*G 18-26, H 121, J 476*)

GERMAN

SOFT STYLE

1. Stephan Lochner, *Madonna in a Rose Garden*, 1430-35, panel. (*G 18-27*)
2. Stephan Lochner, *Presentation in the Temple*, 1447, panel. (*H 113*)

HARD STYLE

Conrad Witz, *Miraculous Draught of Fish*, 1444, panel. (*G 18-28, H 118, J 473*)

COMBINATION STYLE, German and Italian

1. Michael Pacher, *St. Wolfgang Forces the Devil to Hold His Prayerbook,* c. 1481, panel, 58 by 37 in. (*G 18-30*)
2. Michael Pacher, *Pope Sixtus Taking Leave of St. Lawrence,* c. 1462-70, panel, 41 by 39 in. (*H 115*)
3. Michael Pacher, *St. Augustine and St. Gregory,* c. 1483, panel, 81 by 77 in. (*J 480*)

C. GRAPHICS

1. Woodcuts

Woodblock printing had been used in Europe since the twelfth century in the textile industry, but it was not until the fourteenth century that woodcuts were used artistically. The late fifteenth century is considered the peak of woodcut design.

MEDIA AND TECHNIQUES

1. **Woodcuts are relief prints**: the artist cuts away the background of a plank-cut board, inks the surface, and prints the raised design by hand or on a mechanical press.
2. Fine detailing requires the use of dense wood such as poplar, pear, or cherry. Gouges of various widths are used for cutting. (See Figure 13-3a)
3. Color was often hand-painted on early woodcuts.

DESIGN

1. Initially, woodcuts were very primitive with simple forms and figures indicated only by outline and a few lines to suggest drapery and other detail.

a. Woodcut technique.

FIGURE 13-3
Printmaking tools and
techniques.

b. Drypoint technique.

2. By the end of the century, cross-hatching and other methods were used to create subtle gradations of tone and to suggest depth.

2. Engravings

Engraving developed as an outgrowth of metalsmithing arts. About 1430, this method of printmaking began to be used both in Northern Europe and in Italy. By the end of the century, it had replaced woodcut prints in most areas.

MEDIA AND TECHNIQUES

1. **Engravings are intaglio prints**: the artist cuts into the surface (usually a metal plate) with a **burin** to produce grooves which are then filled with ink. The surface of the plate is wiped clean, paper is laid over the plate and is forced into the grooves to pick up the ink because of the pressure of the press.
2. Engravings were usually not multi-colored.
3. **Drypoint** is a variation of engraving in which a fine metal needle is used to scratch the image into the plate. Drypoint prints are usually softer and more fluid than engravings, but fewer prints or impressions can be pulled from such plates. (See Figure 13-3b)

DESIGN

1. Even in early use, engravings were much more detailed than woodcuts.
2. **Hatching and stippling** were used to convey texture, volume, and depth. Northern artists preferred form-following hatching; Italian artists preferred parallel hatching.

EXAMPLES
WOODCUTS

1. Anonymous, *St. Dorothy*, c. 1420. (*J 481*)
2. Albrecht Dürer, *Four Horsemen of the Apocalypse*, 1497-98. (*G 18-36, H 196, J 600*)

ENGRAVINGS
ITALIAN

Antonio Pollaiuolo, *Battle of the Ten Naked Men*, 1465-70. (*G 16-56, H 72, J 530*)

GERMAN

Martin Schongauer, *The Temptation of St. Anthony*, c. 1480-90, 12 by 9 in. (*G 18-31, H 116, J 483*)

DRYPOINT

The Hausbuch Master, *Holy Family*, c. 1480-90. (*J 484*)

D. SCULPTURE

Sculpture remained Gothic throughout the fifteenth century in Northern Europe. It was in **Italy** that the great changes were made. Life-size figures were popular, and nude figures appeared for the first time since Antiquity.

PURPOSES AND SUBJECT MATTER

1. Sculpture was commissioned by the guilds and by private patrons to ensure their own remembrance.
2. Portraiture was popular.
3. Life-size figures or relief sculpture, religious in content, were used to decorate churches and other public buildings.
4. Figures depicting subjects from mythology and religion were used in decorating private homes.
5. Great persons were memorialized by equestrian statues and elaborate, classically decorated tombs.

MEDIA AND TECHNIQUES

1. Bronze was hollow cast into life-size figures and equestrian statues, and also used for relief sculpture.

2. Marble and stone were carved.
3. Terracotta was modeled into life-size figures and glazed reliefs.
4. Wood was carved and gilded.

DESIGN: The following elements are found in fifteenth century Italian sculpture:

1. Correct **contrapposto**, for the first time since Antiquity.
2. Drapery which moves with the body and does not obscure it. (To achieve this, artists made nude clay models and draped them with actual cloth dipped in a thin slip of diluted clay.)
3. Well-muscled figures.
4. Figures no longer dependent on architecture. Even if placed in a niche, they could easily be removed from it and stand alone.
5. Action and dynamic composition increasing in the second half of the century.
6. Three-dimensionality achieved in relief sculpture by
 a. Lessening of relief as one moves into the distance, called "**sculptors' aerial perspective.**"
 b. Use of **linear perspective**.
7. **Correct scale** in relief sculpture. Figures are correctly sized with relation to their settings.
8. **Realism** in portrait sculpture. Bone structure is revealed beneath the skin, there is no flattery, and the eyes look straight out at the viewer. (Portrait busts include head and shoulders, without pedestals.)
9. **Psychological insight.** This is new to the Renaissance and not derived from Antiquity or other earlier periods.

EXAMPLES
FREE-STANDING
SINGLE FIGURES

1. Donatello, *St. Mark,* Or San Michele, Florence, 1411-13, marble, approx. 8 ft. high. (*G 16-5, H 38, J 489*)
2. Donatello, *St. George,* Or San Michele, Florence, 1415-17, marble, approx. 7 ft. high. (*G 16-6, H 39, J 490*)
3. Donatello, *Zuccone,* from the campanile of Florence Cathedral, 1423-25, marble, approx. 7 ft. high. (*G 16-8, 9; H 41; J 492*)
4. Donatello, *David,* c. 1430-32, bronze, approx. 5 ft. high. (*G 16-13, H 43, J 497*)
5. Donatello, *Mary Magdalene,* c. 1454-55, wood, approx. 5 ft. high. (*G 16-15, H cpl 4, J cpl 51*)
6. Andrea Verrocchio, *David,* c. 1465, bronze, approx. 4 ft. high. (*G 16-13, H 43*)

GROUPS

1. Nanni di Banco, *Quattro Santi Coronati,* Or San Michele, Florence, c. 1408–14, marble, approx. life-size. (*G 16-4, H 49, J 485*)
2. Andrea Verrocchio, *Doubting of Thomas,* Or San Michele, Florence, 1465–83, bronze, life-size. (*H 74*)
3. Antonio Pollaiuolo, *Herakles and Antaios,* c. 1475, bronze, approx. 18 in. high with base. (*G 16-55, H 73, J 529*)

EQUESTRIAN FIGURES

1. Donatello, *Equestrian statue of Erasmo da Narni,* ("*Gattamelatta*"), c. 1445–50, bronze, approximately 11 by 13 ft. (*G 16-14, H 44, J 498*)
2. Andrea Verrocchio, *Bartolomeo Colleoni,* c. 1483–88, bronze, approx. 13 ft. high. (*G 16-53, 54; H 75; J 533*)

PORTRAITS

1. Antonio Rossellino, *Giovanni Chellini,* 1456, marble, 20 in. high. (*H 69*)
2. Antonio Rossellino, *Matteo Palmieri,* 1468, marble. (*G 16-49*)
3. Desiderio da Settignano, *Bust of a Little Boy,* c. 1455, marble. (*G 16-50*)

TOMBS

1. Antonio Rossellino, *Tomb of the Cardinal of Portugal,* S. Miniato al Monte, Florence, 1460–66, marble. (*H 68*)
2. Bernardo Rossellino, *Tomb of Leonardo Bruni,* Santa Croce, Florence, c. 1445–50, marble, approx. 20 ft. high. (*G 16-48, J 527*)

RELIEFS

1. Filippo Brunelleschi, *The Sacrifice of Isaac,* (competition panel), 1401–2, gilt, 21 by 17 in. (*G 16-1, H 46*)
2. Lorenzo Ghiberti, *The Sacrifice of Isaac,* (competition panel), 1401–2, gilt bronze, 21 by 17 in. (*G 16-2, H 45, J 440*)
3. Jacopo della Quercia, *Creation of Adam,* main portal, S. Petronio, Bologna, 1425–38, marble, 33 by 24 in. (*H 51, J 495*)
4. Luca della Robbia, *Cantoria,* from the Cathedral of Florence, 1431–38, marble, 17 ft. long. (*H 50, J 525*)
5. Luca della Robbia, *Madonna and Child,* Or San Michele, Florence, c. 1455–60, terracotta with polychrome glaze, 6 ft. diameter. (*G 16-52*)
6. Luca della Robbia, *Madonna and Angels,* c. 1460, glazed terracotta, 63 by 87 in., lunette-shaped. (*J 526*)

7. Donatello, *St. George and the Dragon,* Or San Michele, Florence (base of niche), 1415-16, marble, 16 by 47 in. (*H 40*)

8. Donatello, *The Feast of Herod,* c. 1425, gilt bronze, approx. 23 by 23 in. (*G 16-10, H 42, J 493*)

9. Lorenzo Ghiberti, east doors ("*Gates of Paradise*") of the Baptistry of Florence Cathedral, c. 1435, gilt bronze, approx. 17 ft. high. Each panel approx. 31 by 31 in. (*G 16-11, 12; H 47, 48; J 494*)

10. Desiderio da Settignano, *Christ and Saint John the Baptist,* c. 1461, marble. (*H 70*)

VOCABULARY

alla prima	grisaille	rustication
burin	hatching	sacra conversazione
cornice	intaglio	string course
cortile	Neoplatonism	tondo
disguised symbolism	orthagonal	vanishing point
drypoint	perspective	woodcut
engraving	quattrocento	

14. Sixteenth Century Art

SUMMARY

The sixteenth century included three styles: **High Renaissance, Late Renaissance,** and **Mannerism.** High Renaissance ideals in art included order, unity, harmony of proportion, clarity, simplicity, balance, and symmetry. Late Renaissance artists continued these goals and Mannerist artists negated them all.

Architecture: Italy and France produced the most innovative work.

Italy: High and Late Renaissance buildings became somewhat lighter and more graceful than fifteenth century works, while continuing the same basic principles. Central plan churches were considered ideal, but long plans were also built. Three architects had significant influence on later styles: Bramante, Michelangelo, and Palladio. Mannerism parodied Renaissance ideals and used classical elements in unheard of ways for secular buildings.

France: Church construction continued in the Gothic manner. Palaces and chateaux were built in a new French Renaissance style which combined the northern heritage with Italian elements.

Painting: Italian developments inspired artists in other regions.

Italy: High Renaissance artists such as Leonardo, Raphael, and Michelangelo perfected the use of pyramidal compositions, massive monumental figures, harmonious color schemes, simplified groups of calm figures. Portraits projected psychological insight. The Late Renaissance maintained High Renaissance standards. Venice developed a unique style which placed more emphasis on color than on sculptural forms. Mannerist artists reacted against the calm of the High Renaissance. Their disturbing style was achieved through clashing colors, ambiguity, asymmetry, frantic action, contrived poses, and elongated figures.

France: Mannerism had a strong influence on the School of Fontainebleau, especially in the combination of stucco and painting.

Germany, the Netherlands, and England: Italian High Renaissance art significantly affected the styles of these countries. Dürer and Holbein were the most successful at combining the Italian and northern traditions. Engravings and woodcuts continued to be produced throughout Europe. Dürer is the best-known printmaker.

Sculpture: Michelangelo was the century's most outstanding sculptor, moving from a High to a Late Renaissance style which inspired Mannerism. Mannerist sculpture also influenced French and Spanish artists.

A. ARCHITECTURE

1. Italy

Rome was the center of art in Italy, but building also flourished elsewhere, particularly in Venice. In Florence, architecture was less important than in the previous century.

PURPOSES AND BUILDING TYPES

1. **Religious**: Most church building in Rome was commissioned by the Vatican. Private patrons and civic commissions supported church construction elsewhere.
2. **Secular**: Wealthy families built lavish palaces, libraries, offices, etc.

MEDIA AND TECHNIQUES

1. The basic materials and construction methods were the same as in the fifteenth century.
2. In Rome, marble was often "quarried" from ancient Roman structures. Originally imported from various parts of the Empire, the marble came in many colors and patterns.
3. **Rustication** was not used as extensively as it had been in the fifteenth century; sometimes only the corners of buildings were rusticated.

DESIGN

a. *High Renaissance, 1498-1520*

1. **Ideals included** order, clarity, simplicity, harmony, and proportion.
2. The circle, square, and triangle were the preferred organizational elements.
3. **The central plan** was the preferred design for churches.
4. High Renaissance architects, especially **Bramante**, perfected the ideals established in the fifteenth century.
5. **The balustrade**, a series of short posts connected by a railing, was introduced above the entablature.

b. *Late Renaissance, 1520-1600*

1. Design concepts established in the Early and High Renaissance continued to spread throughout Italy.
2. **New architectural elements** were introduced by
 a. **Michelangelo.**
 (1) **The Colossal Order**: The use of columns and pilasters rising through more than one story of a facade. Although originated by Alberti, it was popularized by Michelangelo.

(2) Paired columns, often in colossal orders, were used both decoratively and structurally.

b. **Andrea Palladio.**
 (1) His severely classical style, based on Roman architecture, later influenced building in England and America.
 (2) His use of interlocking temple facades for the front of San Giorgio Maggiore was a unique solution to the problem of exterior church decoration.

c. **Giacomo della Porta**'s facade for Il Gesù, designed in 1568, served as a prototype for Baroque church facades throughout the Catholic world. It consisted of two temple facades, one above the other, united by scroll buttresses.

c. *Mannerism, 1520-1600*

1. Mannerism appeared only in secular architecture.
2. Architects such as Romano and Vasari consciously negated every accepted Renaissance principle and parodied existing structures.
 a. Proportions and scale were ambiguous.
 b. Classical motifs were used illogically:
 (1) Irregular spacing of columns, pilasters, doors, windows, etc.
 (2) Keystones slipping from arches; triglyphs slipping from friezes.
 (3) Arches supported by columns, piers, or both, of varying proportions and number.

2. France

France was the first country north of the Alps to adopt the Renaissance style for secular buildings. Churches continued to be built in the Gothic manner.

PURPOSES AND BUILDING TYPES: Charles VII, King of France, returned from an Italian campaign around 1490, and brought back Italian artists and architects to help transform his previously heavily fortified castles into pleasure palaces in the Italian style. His successor, Francis I, built several large châteaux in the new French Renaissance style.

MEDIA AND TECHNIQUES: A variety of excellent building stone was available in France, along with slate for roofing and decoration.

DESIGN: French Renaissance architecture was a blending of French elements with Italian Renaissance ideas.

1. **Traditional French elements**
 a. Remnants of medieval castles (seen at Chambord):
 (1) Moats (now used for prestige, not defense).

 (2) Round, fortress-like towers.

 (3) Gothic decorations such as pinnacles, towers, and small flying buttresses.

 b. Sloping roofs, to shed snow.

 c. Large windows, suitable for French climate.

 d. Dormers (windows in the roof).

 e. Pavilions jutting from the wall (seen in the Square Court of the Louvre).

 f. Sculptured decoration.

2. **Italian Renaissance elements**

 a. Multi-tiered facades delineated with string courses.

 b. Round arches.

 c. Ground-floor arcades.

 d. Pedimented windows; curved or triangular pediments.

 e. Open staircases.

 f. Lozenge decorations in black slate, imitating marble.

 g. Paired columns.

EXAMPLES

ITALIAN

HIGH RENAISSANCE

1. Donato Bramante, Il Tempietto, Rome, 1502. (*G 17-6, 7; H 139, 140; J 547, 548*)

2. Unknown architect, S.M. della Consolazione, Todi, begun 1508. (*G 17-10, 11*)

LATE RENAISSANCE

1. Antonio da Sangallo the Younger, Farnese Palace, Rome, 1535–50 (completed by Michelangelo). (*G 17-4*)

2. Michelangelo, Capitoline Hill, Rome, designed 1537. (*G 17-31, 32, 33; H 186*)

3. Jacopo Sansovino, Library of St. Mark, Venice 1536–88. (*G 17-53, H 173*)

4. Andrea Palladio, Villa Rotunda, Vicenza, begun 1550. (*G 17-54; H 174; J 591, 592*)

5. Andrea Palladio, San Giorgio Maggiore, Venice, 1565. (*G 17-56; H 175, 176; J 593, 594*)

6. Giacomo della Porta, Il Gesù, Rome, 1575–84. (*G 19-1; H 189; H 595, 596*)

MANNERISM

1. Michelangelo (Proto-Mannerist) Laurentian Library, Florence, begun 1524. (*G 17-30; H 155; J 560, 561*)

2. Giulio Romano, Palazzo del Tè, Mantua, 1525–35. (*G 17-50, 51, 52*)

3. Giorgio Vasari, Uffizi Palace, Florence, 1560-80. (*H 190, J 589*)
4. Bartolommeo Ammanati, Palazzo Pitti courtyard, Florence, 1558-70. (*H 191, J 590*)

FRENCH

1. Château de Chambord, Loire Valley, France, begun 1519. (*G 18-52, 53; H 210; J 613, 614*)
2. Pierre Lescot and Jean Goujon, Square Court of the Louvre, Paris, begun 1546. (*G 18-54, H 211, J 615*)

B. PAINTING

1. Central Italy

a. High Renaissance, 1498-1520

In painting, the High Renaissance revolved around the work of three artists: Leonardo, Michelangelo, and Raphael. It ended with the deaths of Leonardo in 1519, and Raphael in 1520.

PURPOSES AND SUBJECT MATTER

1. **Religious painting** was dominant.
 a. **Raphael** specialized in Madonna and Child depictions.
 b. **Michelangelo** decorated the Sistine Ceiling with a complicated Biblical program. (See Figure 14-1)
2. Themes from mythology increased in importance.
3. Interest in real landscapes and real people increased.
4. Portraits gave a psychological insight into the personality of the sitter.

MEDIA AND TECHNIQUES

1. Tempera continued to be used on wood panels.
2. Oil began to be used, sometimes in combination with tempera on wood panels, or alone on wood or canvas.
3. Fresco remained important.
4. Leonardo experimented unsuccessfully with painting in an oil and tempera emulsion on dry plaster.

DESIGN: The following elements are found in High Renaissance paintings:

1. **Pyramidal** (replacing triangular) **composition.**

FIGURE 14-1 Diagram of the Sistine ceiling fresco cycle.

2. Stately, monumental figures, with a more mature appearance than fifteenth century types.
3. **Modeling with light and dark,** consisting of
 a. **Chiaroscuro** (modeling from dark to light).
 b. **Sfumato** (modeling from dark to light) used only by Leonardo. The effect is a smoky haze.
4. **Two-point** (replacing one-point) **linear perspective.**

b. *Late Renaissance, 1520–1600*

PURPOSES AND SUBJECT MATTER: Michelangelo outlived Leonardo and Raphael, but his work took on a new pessimism after the Sack of Rome in 1527. Other artists carried on the Renaissance ideals, and dealt with both Christianity and mythology in their work.

MEDIA AND TECHNIQUES

1. Oil on canvas increased in use.
2. Tempera and fresco continued in importance.

DESIGN

1. Correggio's **experimental lighting** (*Holy Night*) was similar to that seen earlier in the work of Geertgen tot Sint Jans.
2. Correggio's **illusionistic dome painting** (*Assumption of the Virgin*) is a direct ancestor of subsequent seventeenth century Baroque ceiling paintings.
3. Michelangelo's style (*Last Judgment*) approached the **grotesque.**
4. Otherwise, Renaissance values continued.

c. *Mannerism, 1520–1600*

PURPOSES AND SUBJECT MATTER: In painting, as in architecture, a style developed in reaction to the absolute perfection of the High Renaissance. The subject matter included religious themes and mythology, but the treatment of traditional subjects was often bizarre. Subjects with personal rather than universal symbolism were often represented.

MEDIA AND TECHNIQUES: Oil and tempera paintings on wood or canvas were typical of Mannerist works.

DESIGN: In opposition to the High Renaissance ideals, the Mannerists developed a style of chaos, disunity, discord, obscurity, imbalance, asymmetry, frantic action, exaggeration, spatial ambiguity, and dissonant colors.

1. **Spatial ambiguity**: figures the wrong size for the space they occupy.
2. **Dissonant colors**: acid pinks and greens, clashing with orange. This is completely different from the clear reds and blues of the High Renaissance.
3. **Frantic action**: nervous gestures and expressions.
4. **Exaggeration**: bodily proportions elongated.
5. **Disunity**: figures gazing off in all directions.
6. **Incongruity**: classical elements of architecture used in odd ways, as stage props.

2. Venice

PURPOSES AND SUBJECT MATTER

1. As in the rest of Italy, both religious and mythological subjects were popular.
2. **Giovanni Bellini** specialized in Madonnas.
3. **Titian's** greatest fame came from portraiture, to which he brought great psychological insight.
4. The female nude was introduced into painting by the Venetians, solely to give visual pleasure.

MEDIA AND TECHNIQUES

1. **Oil on canvas**: The introduction of oil painting on canvas proved to be exactly what was needed to encourage painting in the damp Venetian climate in which tempera and fresco could not survive.
2. **Individual techniques**
 a. **Titian** used a quick-setting emulsion of oil and tempera for his underpainting, and then built up his colors with many coats, or glazes, of very thin paint.
 b. **Tintoretto** arranged a stage with wax figures and, using a grid, enlarged them directly onto the canvas. He primed his canvas with dark tones of gray or brown, then painted the light areas over them. He used diluted oils and painted with a wide, square-ended brush.
 c. **Veronese** painted an area of color in a single flat tone, then modeled highlights and shadows with lighter or darker paint of the same hue.

DESIGN

1. **Color** was the most important element in Venetian painting, probably because the "golden light" of Venice is unique.
2. A unique, **relaxed style** developed in Venetian painting; emotional impact was more important than mathematical precision of design.
3. **Mannerism** was not a part of Venetian style, although some artists, such as Tintoretto, occasionally used Mannerist devices.

3. Germany

German painting surpassed that of the Netherlands in the early sixteenth century, and its greatest masters were contemporaries of those of the Italian High Renaissance—Leonardo, Michelangelo, and Raphael. Then, as quickly as it had risen, German painting declined with the deaths of Dürer and Grünewald in 1528.

PURPOSES AND SUBJECT MATTER: The Italian High Renaissance became known to German painters through engravings by such Italian artists as Marcantonio Raimondi, who reproduced the works of the great painters. German artists were intent on assimilating the Italian advances into their own work.

1. **Religious** and **mythological** subject matter continued.
2. **Landscape,** in which man was reduced in size to inconsequential proportions, acknowledged man's smallness in relation to God and Nature.
3. **History painting,** the depiction of real events, gained in importance.
4. **Portraiture** was important.

MEDIA AND TECHNIQUES

1. Painting was most frequently done in **oil on wood panel.**
2. **Engraving** flourished in the work of Dürer. (See fifteenth century Graphics for an explanation of engraving.)
3. **Watercolor,** previously used solely for sketches and "notes," was used as a serious medium by Dürer, who was ahead of his time in doing so.

DESIGN

1. The German painting style was in transition. By heritage, the northern style was linear, but the Italian method of depicting masses and volumes was regarded as ideal. Dürer finally achieved this in his last major work, *Four Apostles.*
2. **Portraiture** was concerned with **psychological insight.**
 a. Dürer and Holbein are the best-known portraitists.
 b. Holbein achieved the monumentality of the Italian Renaissance in his portraits, such as *Christina of Denmark.*
3. **Perspective** was used correctly.
4. **The Danube Style** (*Donaustil*) of landscape painting was based on the immersion of man into the vastness of nature.
5. **Proto-Expressionism** is seen in the detailed depiction of suffering in Grünewald's *Isenheim Altarpiece.*
6. Figure types were typically northern.
7. Symbolism continued to be important, but was not necessarily religious. Dürer's work continually referred to the four humors of man: choleric, melancholic, sanguine, and phlegmatic.

4. The Netherlands

PURPOSES AND SUBJECT MATTER: Due to religious and political strife, Netherlandish painters were interested in developing non-religious subject matter in their painting:

1. **Landscape,** with human figures insignificant in size, followed the German trend.
2. **Still life,** formerly used in other paintings as disguised symbolism, gained an independence of its own.
3. **Genre** painting depicted the life of the peasants and sometimes pointed out moral lessons.

MEDIA AND TECHNIQUES

1. Oil on panel.
2. Oil and tempera on panel.
3. Tempera on canvas.

DESIGN

1. Attempts were made to follow the Italian High Renaissance style, which came second-hand to the Netherlands via Dürer, but the results were northern.
2. Figures were often bundled in bulky clothing.
3. The northern love of detail is still in evidence.

5. France

PURPOSES AND SUBJECT MATTER: Italian masters were brought to France by Francis I to help decorate his castles because there were no French painters of equal stature. Subjects were secular, in the form of

1. Portraiture.
2. Mythological subjects.
3. Historical subjects.

MEDIA AND TECHNIQUES

1. Panels were painted with oil and tempera.
2. **Mixing of media:** Painting, fresco, imitation mosaic, and stucco sculpture were all mixed together in a single composition, a technique that later became a great favorite of the Baroque and Rococo Periods in the seventeenth and eighteenth centuries.

DESIGN

1. The native style was stiff, formal, linear, and flat.
2. Italian Mannerists, Il Rosso Fiorentino, Primaticcio, and others, developed the **First School of Fontainebleau**, the painting of which emphasized the following characteristics:
 a. Abrupt changes in scale and texture.
 b. Elongated figures.
 c. Figures in artificial poses.

6. England

PURPOSES AND SUBJECT MATTER: **Portraiture**, the most important form of painting in the court of Henry VIII, was mostly done by foreign artists. The German, Hans Holbein, set an example for British taste that lasted for several generations.

MEDIA AND TECHNIQUES

1. Panels were painted in oil and tempera.
2. Miniatures were done on parchment.

DESIGN

1. **Holbein** achieved the Italian Renaissance style for which Dürer had spent his life striving. His portraits were solid and monumental.
2. **Hilliard**, a native English painter, was influenced by the Mannerist style, which came to England via Fontainebleau.

EXAMPLES
ITALIAN
HIGH RENAISSANCE

1. Leonardo da Vinci, *Adoration of the Magi,* begun 1481, unfinished panel, 96 by 97 in. (*H 126, J 540*)
2. Leonardo da Vinci, *Madonna of the Rocks,* begun 1483, oil on panel, 78 by 48 in. (*G 17-1, H 127, J 541*)
3. Leonardo da Vinci, *Virgin and Child and St. Anne,* 1501-13, panel, 66 by 51 in. (*G 17-2, H cpl 22*)
4. Leonardo da Vinci, *Last Supper,* S. M. delle Grazie, Milan, 1498, oil and tempera on plaster, 14 by 28 ft. (*G 17-3, H 128, J 542*)
5. Leonardo da Vinci, *Mona Lisa,* 1503-6, oil on panel, 30 by 21 in. (*G 17-4, H 130, J 544*)

6. Michelangelo, *Sistine Ceiling,* Vatican, 1508, fresco. (*G 17-27, 28; H 137, 138, cpl 23; J 557, cpl 60*)
7. Raphael, *Marriage of the Virgin,* 1504, panel, 67 by 46 in. (*G 17-17, H 114*)
8. Raphael, *Madonna of the Meadows,* 1505, panel, 44 by 34 in. (*H 145*)
9. Raphael, *Madonna of the Goldfinch,* 1505-6, panel, 42 by 29 in. (*G 17-18*)
10. Raphael, *School of Athens,* Stanza della Segnatura, Vatican, 1509, fresco. (*G 17-19, H cpl 24, J 570*)
11. Raphael, *Dispùta,* Stanza della Segnatura, Vatican, 1509, fresco. (*H 146*)
12. Raphael, *Expulsion of Heliodorus,* Stanza d'Eliodoro, Vatican, 1512, fresco. (*H 147*)
13. Raphael, *Sistine Madonna,* 1513, oil on canvas, 104 by 77 in. (*H 148*)
14. Raphael, *Galatea,* Villa Farnesina, Rome, 1513, fresco. (*G 17-20, H 150, J 571*)
15. Raphael, *Baldassare Castiglione,* 1514, oil on canvas, 30 by 26 in. (*G 17-21*)
16. Raphael, *Pope Leo X With His Nephews,* 1518, panel, 60 by 47 in. (*H 149, J cpl 61*)
17. Raphael, *Transfiguration,* 1517, panel, 13 by 9 in. (*H 151*)

LATE RENAISSANCE

1. Andrea del Sarto, *Madonna of the Harpies,* 1517, oil on panel, 82 by 70 in. (*G 17-39, H 156*)
2. Correggio, *Assumption of the Virgin,* dome, Parma Cathedral, 1526-30, fresco. (*G 17-40, 41; H 178; J 582*)
3. Correggio, *Holy Night,* 1522, panel, 8 by 6 ft. (*H 177*)
4. Correggio, *Jupiter and Io,* 1532, oil on canvas, 64 by 27 in. (*G 17-42, H 179, J 583*)
5. Michelangelo, *Last Judgment,* Sistine Chapel, Vatican, Rome, 1534-41, 56 by 44 ft. (*G 17-37, 38; H 181, 182; J 556, 558*)

MANNERISM

1. Jacopo Pontormo, *Joseph in Egypt,* 1518, oil on canvas, 38 by 43 in. (*H 157*)
2. Jacopo Pontormo, *Descent from the Cross (Entombment),* 1525-28, panel, 11 by 6 ft. (*G 17-43, H cpl 25*)
3. Il Rosso Fiorentino, *Descent from the Cross,* 1521, panel, 11 by 6½ ft. (*H 158, J cpl 64*)
4. Il Rosso Fiorentino, *Moses Defending the Daughters of Jethro,* 1523, 5 by 4 ft. (*G 17-44*)
5. Parmagianino, *Self-Portrait in a Convex Mirror,* 1524, panel, 9½ in. diameter. (*H 180, J 577*)
6. Parmagianino, *Madonna With the Long Neck,* c. 1535, oil on canvas, 85 by 52 in. (*G 17-45, H cpl 30, J cpl 65*)

7. Bronzino, *Venus, Cupid, Folly, and Time (Exposure of Luxury)*, c. 1546, 61 by 57 in. (*G 17-46, H 192*)
8. Bronzino, *Eleanora of Toledo and her son Giovanni de Medici*, c. 1550, 45 by 38 in. (*J 578*)
9. Bronzino, *Portrait of a Young Man*, c. 1550, oil on wood, 37 by 29 in. (*G 17-47*)

VENETIAN

1. Giovanni Bellini, *St. Francis in Ecstasy*, c. 1485, panel. (*J cpl 57*)
2. Giovanni Bellini, *Transfiguration of Christ*, late 1400s, oil on panel, 45 by 59 in. (*H cpl 14*)
3. Giovanni Bellini, *San Zaccaria Altarpiece*, 1505, oil on canvas, 16½ by 8 ft. (*G 17-59, H 84*)
4. Giovanni Bellini, *Feast of the Gods*, 1514, 67 by 74 in. (*G 17-60*)
5. Giorgione, *Enthroned Madonna*, 1505, panel, 78 by 60 in. (*H 160*)
6. Giorgione, *The Tempest*, 1505-10, oil on canvas, 30 by 29 in. (*H cpl 26, J cpl 62*)
7. Giorgione, *Pastoral Symphony*, 1508, oil on canvas. (*G 17-61*)
8. Titian, *Sacred and Profane Love*, 1515, oil on canvas, 30 by 29 in. (*G 17-62, H cpl 27*)
9. Titian, *Bacchanal*, c. 1520, oil on canvas, 69 by 76 in. (*H 161, J cpl 63*)
10. Titian, *Assumption of the Virgin*, 1516-18, panel, 22 by 12 ft. (*H 162*)
11. Titian, *Madonna of the Pesaro Family*, 1519-26, oil on canvas, 16 by 9 ft. (*G 17-62, H 163, J 572*)
12. Titian, *Man with the Glove*, 1527, oil on canvas, 39 by 35 in. (*G 17-65, H 164, 573*)
13. Titian, *Venus of Urbino*, 1538, oil on canvas, 47 by 65 in. (*G 17-64, H 165*)
14. Titian, *Pope Paul III and his Grandsons*, 1546, oil on canvas, 82 by 68 in. (*H 166, J 574*)
15. Titian, *Rape of Europa*, 1559-62, oil on canvas, 73 by 81 in. (*H 167*)
16. Titian, *Crowning with Thorns*, c. 1570, oil on canvas, 9 by 5 ft. (*G 17-66, H 168, J 575*)
17. Lorenzo Lotto, *Madonna and Child with Saints* (Sacra Conversazione) 1520s, oil on canvas, 45 by 60 in. (*H 169*)
18. Tintoretto, *The Miracle of the Slave*, 1548, oil on canvas, 14 by 12 ft. (*G 17-67, H cpl 28*)
19. Tintoretto, *Finding the Body of St. Mark*, 1562-66, oil on canvas, 14 by 14 ft. (*G 17-68*)
20. Tintoretto, *Crucifixion*, 1565, oil on canvas, 17 by 40 ft. (*H 170*)
21. Tintoretto, *Christ Before Pilate*, 1566-67, 18 by 13 ft. (*J cpl 66*)
22. Tintoretto, *Last Supper*, 1592-94, oil on canvas, 12 by 19 ft. (*H 171, J 579*)

23. Veronese, *Feast in the House of Levi,* 1573, oil on canvas, 18 by 42 ft. (*G 17-69, H cpl 29, J cpl 69*)

24. Veronese, *The Triumph of Venice,* 1585, ceiling, Doge's Palace, Venice, oil on canvas. (*G 17-70, H 172*)

GERMAN (Painting and Graphics)

1. Albrecht Dürer, *Italian Mountains,* c. 1495, watercolor. (*J 599*)
2. Albrecht Dürer, *Self-Portrait,* 1498, panel, 20 by 16 in. (*H 195*)
3. Albrecht Dürer, *Self-Portrait,* c. 1500, panel, 26 by 19. in. (*J 601*)
4. Albrecht Dürer, *Great Piece of Turf,* 1503, watercolor, 16 by 12 in. (*G 18-38*)
5. Albrecht Dürer, *Adam and Eve,* 1504, engraving, 10 by 8 in. (*H 197, J 602*)
6. Albrecht Dürer, *Adoration of the Trinity,* 1511, oil on panel, 53 by 49 in. (*H cpl 31*)
7. Albrecht Dürer, *Knight, Death and the Devil,* 1513, engraving, 10 by 7 in. (*H 198, J 603*)
8. Albrecht Dürer, *Melancholia I,* 1514, engraving, 10 by 8 in. (*H 200*)
9. Albrecht Dürer, *St. Jerome in His Study,* 1514, engraving, 10 by 8 in. (*H 199*)
10. Albrecht Dürer, *Hieronymous Holzschuher,* 1526, panel, 19 by 14 in. (*G 18-39*)
11. Albrecht Dürer, *Four Apostles,* 1526, panel, each 84 by 30 in. (*G 18-41, H 201, J cpl 71*)
12. Matthias Grünewald, *Isenheim Altarpiece,* c. 1515, hinged panels, closed 10 by 11 ft. (*G 18-34, 35; H 202, 203, cpl 32; J 598, cpl 68*)
13. Albrecht Altdorfer, *Battle of Alexander,* 1529, oil on panel, 63 by 48 in. (*G 18-32, H 204*)
14. Lucas Cranach the Elder, *Apollo and Diana,* no date, oil on panel, 18 by 14 in. (*H 205*)
15. Lucas Cranach the Elder, *Judgment of Paris,* 1530, panel, 14 by 9 in. (*G 18-33, J 605*)

NETHERLANDISH

1. Jan Gossaert (Mabuse), *Agony in the Garden,* c. 1503-7, panel, 33 by 25 in. (*H 218*)
2. Jan Gossaert, *Neptune and Amphitrite,* 1516, oil on panel, 74 by 49 in. (*G 18-45*)
3. Joachim Patinir, *Landscape with St. Jerome,* c. 1520, 30 by 36 in. (*G 18-46*)
4. Joachim Patinir, *St. Jerome,* c. 1520, panel, 14 by 14 in. (*H 219*)
5. Pieter Bruegel, *Landscape with the Fall of Icarus,* 1554-55, panel transferred to canvas, 29 by 44 in. (*H cpl 34*)
6. Pieter Bruegel, *Triumph of Death,* 1561, panel, 46 by 64 in. (*H 220*)

7. Pieter Bruegel, *The Peasant Wedding,* 1565, panel, 45 by 64 in. (*J cpl 74*)
8. Pieter Bruegel, *Harvesters,* 1565, oil on panel, 46 by 63 in. (*H 221*)
9. Pieter Bruegel, *Hunters in the Snow,* 1565, oil and tempera on panel, 46 by 64 in. (*G 18-47, H 222, J 610*)
10. Pieter Bruegel, *Peasants' Dance,* c. 1567, 45 by 65 in. (*G 18-48*)
11. Pieter Bruegel, *Parable of the Blind,* 1568, tempera on canvas, 34 by 60 in. (*G 18-49, J 611*)

FRENCH

1. Jean Clouet, *Portrait of Francis I,* 1525-30, tempera and oil on canvas, 38 by 29 in. (*G 18-50, H 208, J 607*)
2. Il Rosso Fiorentino, *Venus Reproving Love,* 1530-40, fresco. (*G 18-51*)
3. Francisco Primaticcio, *Apelles with Alexander and Campaspe,* 1540s, stucco and painting. (*H 209*)

ENGLISH

1. Hans Holbein the Younger, *Erasmus of Rotterdam,* 1523, panel, 16 by 12 in. (*J 606*)
2. Hans Holbein the Younger, *Madonna of Burgomaster Meyer,* 1526, panel, 57 by 40 in. (*H cpl 33*)
3. Hans Holbein the Younger, *The French Ambassadors,* 1533, oil and tempera on wood, 80 by 81 in. (*G 18-42, H 206*)
4. Hans Holbein the Younger, *Christina of Denmark,* 1539, 70 by 32 in. (*G 18-44*)
5. Hans Holbein the Younger, *Henry VIII,* 1539-40, panel, 32 by 29 in. (*H 207*)
6. Nicholas Hilliard, *A Young Man Among Roses,* 1588, parchment miniature, 6 by 3 in. (*J 608*)

C. SCULPTURE

1. Central Italy

a. High Renaissance 1498-1520

PURPOSES AND SUBJECT MATTER: The greatest sculptor of the sixteenth century was Michelangelo. His work was primarily religious because of Papal commissions. and because of his own intense faith.

MEDIA AND TECHNIQUES: Michelangelo felt that every piece of marble had a human figure imprisoned within it, and the artist needed only to carve away the excess to get it out.

DESIGN: Influenced by the rediscovery of the *Laocoön* group in Rome in 1503, Michelangelo's figures were

1. Heavily muscled.
2. Heroic.
3. Monumental.
4. Expressive of pent-up, tightly controlled emotion.

b. Late Renaissance 1520-1600

Michelangelo continued to dominate sculpture.

DESIGN: Since Mannerism grew out of Michelangelo's work, it is not logical to call him a Mannerist. His later style exhibits many of the characteristics used by the Mannerists, among them

1. **Tension**, both in the uncertain balance and spatial relationships of his figures (Medici tombs) and in the anxiety created in the viewer.
2. **Ambiguity**, as seen in the uncertain meanings of many of his works.

c. Mannerism 1520-1600

PURPOSES AND SUBJECT MATTER: Unlike Michelangelo, the Mannerists used mythological subject matter in the majority of their works, which were commissioned by private patrons.

MEDIA AND TECHNIQUES

1. Stone and marble were used.
2. Bronze was cast.
3. Gold was used by Benvenuto Cellini. His small gold works could be listed as Minor Arts.

DESIGN

1. **Influences from Michelangelo**:
 a. **Tension** in figures, and in relationships expressed in groups.
 b. **Ambiguity** of meaning (*The Rape of the Sabines* was not named until later.)
2. Elements also found in Mannerist painting:
 a. Elongated torsos.
 b. Extremely small heads.
 c. Unusual poses.

2. France

PURPOSES AND SUBJECT MATTER: Italian sculptors were invited to the French court by Francis I, who hoped to bring the Italian High Renaissance to France. He got Italian Mannerism instead. As in Italy, secular themes prevailed among the Mannerist sculptors who came to France. Their French counterparts used more religious subjects.

MEDIA AND TECHNIQUES

1. Stone.
2. Bronze.
3. Stucco. The combining of stucco work with painting originated at Fontaine-bleau with Primaticcio.

DESIGN: As in architecture, French sculpture combined the Italian Mannerist style with native French elements.

1. **Italian Mannerist elements:**
 a. Small heads.
 b. Elongated torsos.
 c. Artificial poses.
 d. Sinuous figure contours.
2. **Northern elements:**
 a. Composition in the manner of Van der Weyden.
 b. More sincere emotion than found in Italian painting.

3. Spain

PURPOSES AND SUBJECT MATTER: Pedro and Alonzo Berruguete, father and son, were Spanish artists, credited with bringing the Italian Renaissance and Mannerist styles to Spain. Alonzo spent the years 1504 to 1517 in Italy.

Art was religious in Spain.

MEDIA AND TECHNIQUES

1. Stone.
2. Wood.
3. Alabaster.

DESIGN

1. Elongated figures.
2. Small heads.
3. Otherworldly expressions.
4. Angular poses.

EXAMPLES
ITALIAN
HIGH RENAISSANCE

1. Michelangelo, *Pietà,* marble, 1498-1500, 68 in. high. (*H 132*)
2. Michelangelo, *David,* 1501-4, marble, 14 ft. high. (*G 17-22, H 133, J 552*)
3. Michelangelo, *Moses,* c. 1513-15, marble, 92 in. high. (*G 17-23, H 134, J 553*)
4. Michelangelo, *Dying Slave,* 1513-16, marble, 90 in. high. (*G 17-24, H 135, J 554*)
5. Michelangelo, *Bound (Rebellious) Slave,* 1513-16, marble, 84 in. high. (*G 17-25, H 136, J 555*)

LATE RENAISSANCE

1. Michelangelo, *Medici Tombs* in San Lorenzo, Florence, 1519-34, marble. (*G 17-29; H 152, 153, 154; J 559*)
2. Michelangelo, *Crossed-leg Captive,* 1527-28, marble, 9 ft. high. (*H 131*)
3. Michelangelo, *Rondanini Pietà,* 1554-64, marble, 63 in. high. (*H 197, J 568*)

MANNERIST

1. Benvenuto Cellini, *Perseus,* 1545-54, bronze, 18 ft. high. (*H 193*)
2. Giovanni da Bologna, *Rape of the Sabine Women,* 1583, marble, 13½ ft. high. (*G 17-49; H 194; J 587, 588*)

FRENCH

1. Benvenuto Cellini, *Diana of Fontainebleau,* 1543-44, bronze relief, over life-size. (*G 17-48*)
2. Benvenuto Cellini, *Salt Cellar of Francis I,* 1539-43, gold, 10 by 13 in. (*J cpl 70*)
3. Francisco Primaticcio, *Stucco work at Fontainebleau,* c. 1541-45. (*G 18-51, H 209, J 586*)
4. Francisco Primaticcio, *Tomb of Henry II,* Church of St. Denis, Paris, 1563-70 (with Germain Pilon). (*J 618, 619*)

5. Germain Pilon, *Descent from the Cross,* 1583, bronze relief. (*G 18–56, H 217*)

6. Jean Goujon, *Fountain of the Innocents,* 1548–49, stone reliefs. (*G 18–55; H 212–216; J 616, 617*)

SPANISH

Alonzo Berruguete, *St. John the Baptist,* c. 1540, wood relief, 31 by 19 in. (*J 585*)

VOCABULARY

balustrade	colossal order	pyramid composition
chiaroscuro	Mannerism	sfumato
cinquecento	Palladian style	

15. Seventeenth Century Art

SUMMARY

General characteristics of the Baroque styles included the manipulation of space, light, mass, volume, and texture to express power.

Architecture: Grandeur, elegance, and opulence were expressed in a great variety of national styles.

Italy: Religious architecture served the Counter-Reformation. Complex forms with undulating rhythms and oval motifs were built on a grand scale. Leading architects were Borromini and Guarini. St. Peter's in Rome was completed after 120 years of construction.

France: Secular building was dominant. The style is called "Classical-Baroque" because the classicism of the Renaissance was combined with Baroque grandeur.

England: Throwing off Gothic design, architects such as Jones and Wren created elegant palaces and churches in a style similar to the Renaissance work of Palladio.

Painting: Each country developed unique expressions of the Baroque.

Italy: Illusionistic ceiling paintings, mostly religious, were dynamic, expansive, and emotionally charged. Intense colors, exaggerated poses and gestures, and diagonally arranged compositions were typical. Caravaggio's use of tenebrism influenced artists throughout Europe. The Caracci perpetuated Renaissance values.

Spain: Two styles developed: intense mysticism and detached realism. Tenebrism and illusionism were important to both.

Flanders: Tenebrism, rich brush work, intense colors, and a wide variety of subjects were typical of Rubens' work. Van Dyck is known for stately portraits of the English court. Other artists imitated Rubens and Van Dyck.

Holland: Portraiture, genre, still life, and landscape painting flourished. Only Rembrandt produced religious works. The works of Hals, Vermeer, and the Little Dutch Masters were also important.

France: The Classical-Baroque style of French painting was sponsored by the King and his court. "Grand subjects" such as mythological or historical narratives were preferred, but portraiture, genre, and landscape painting were also popular.

England: The Flemish artist Van Dyck dominated English portraiture and influenced the rise of a native English school.

Sculpture: Bernini, the genius of the age, influenced generations of carvers with his intensely powerful and emotional style.

A. ARCHITECTURE

1. Italy

PURPOSES AND BUILDING TYPES

1. **Churches** and other religious structures (convents, colleges, etc.) were designed to express the power and unity of the Catholic Church.
2. **Palaces** and other secular buildings were designed in a variety of styles.
3. The completion of St. Peter's, Rome, after 120 years of construction epitomizes the progression from Renaissance to Baroque styles.

MEDIA AND TECHNIQUES

1. Traditional building methods and materials were used, but more lavishly.
2. Often simple materials such as brick were plastered and painted to imitate expensive materials such as marble.

DESIGN: Space and light (and illusionistic treatment of both) were the main concerns of architects such as Borromini in Rome and Guarini in Turin.

1. **Space** was treated expansively and volumes were combined to imply movement.
 a. **Undulating facades** juxtaposed convex with concave shapes.
 b. **Dynamic balance** through complex plans and elevations and placement of doors, windows, and ornamentation replaced the static balance and calm of the Renaissance.
 c. Scale and size were **grand**. People were made to feel small within a vast, expanding space.
2. **Light and dark** were manipulated for emotional impact:
 a. **Shadows** and mysterious shapes were created with deep recesses, overhangs, and complex geometric forms.
 b. The changing play of light and color against various surfaces was used to heighten the theatrical/emotional effect.
3. Where Renaissance architects had implied permanence through simple geometric forms (circles, squares, triangles), static balance, and clear, even lighting, **the Baroque implied change** through complex geometric forms (ovals, ellipses, irregular polygonals), multiplicity of forms, dynamic balance, and theatrical lighting.
4. The "classical" language of the Renaissance was perpetuated in the use of Greco-Roman orders and ornamentation.

2. France

PURPOSES AND BUILDING TYPES

1. French seventeenth century architecture was predominantly secular: mostly grandiose palaces (*châteaux*) for the nobles and the king.
2. The Palace of Versailles and the design of the surrounding landscape exemplify the elegance of French Baroque design and the power and wealth of the French monarchy.
3. French palace architecture set the standard for all of Europe between 1660 and 1715.

MEDIA AND TECHNIQUES

1. Stone and marble, often imported at great cost, were used lavishly.
2. Gold leaf, stucco, mirrors, tapestries, and other expensive ornamentation completed the architectural settings.

DESIGN: French seventeenth century style is called "Classical–Baroque" because the calm and restraint of the Italian Renaissance are combined with the elegance and grandeur of the Baroque.

1. **Italian Renaissance (classical) elements**
 a. Symmetry and clarity of volumes and masses.
 b. Classical design elements and decoration used traditionally:
 (1) Classical orders.
 (2) Centrally-located entrances.
 (3) Spherical domes.
 (4) Three-story facades delineated with string courses.
2. **Baroque elements**
 a. Grand scale and enormous structures.
 b. Ostentatious use of materials.
 c. Emphasis on expansive space and theatrical lighting.
3. **Traditional French elements**
 a. Use of the pavilion system.
 b. Grace, elegance, and a lighter feeling than Italian Baroque architecture.

3. England

PURPOSES AND BUILDING TYPES

1. Architecture served the needs of the monarchy, the nobility, and the Anglican church.

2. Churches and palaces were constructed at the beginning and end of the century. Civil war limited construction at mid-century. The Great Fire of London in 1666 stimulated building in the last quarter of the century.

MEDIA AND TECHNIQUES

1. Stone was used for the most important buildings. Brick was used for other structures.
2. Construction methods included Gothic and Italian Renaissance practices.

DESIGN

1. Before the seventeenth century, English architecture had made minor concessions to Italian ideas, but design and building practices were basically Gothic.
2. **Inigo Jones**, who studied in Italy, revolutionized English architecture by introducing Palladian ideas to England. From there they spread to America.
3. **Christopher Wren**, Jones' successor, combined the following styles:
 a. Palladian elements from Jones.
 b. Facades inspired by French Classical-Baroque.
 c. Mass and volume influenced by the dynamism of Italian Baroque.
4. **Renaissance values** dominated design:
 a. Simplicity and clarity of forms.
 b. Symmetry and static balance.
 c. Intellectual appeal; rational, restrained forms.
5. Baroque elements were maintained:
 a. Grand scale and enormous size.
 b. Elegance and opulence.

EXAMPLES
ITALIAN
ROME

1. Giacomo della Porta, Il Gesù, facade, c. 1575-84. (*G 19-1, H 189, J 596*)
2. Carlo Maderna, Santa Susanna, 1597-1603. (*G 19-4, H 233*)
3. Carlo Maderna, St. Peter's, facade, 1606-12. (*G 19-3, 5; H 234; J 623*)
4. Gianlorenzo Bernini, Colonnade of St. Peter's, begun 1656. (*G 19-3, H 243, J 623*)
5. Gianlorenzo Bernini, Scala Regia, The Vatican, 1663-66. (*G 19-7*)
6. Francesco Borromini, S. Carlo alle Quattro Fontane, 1665-67. (*G 19-14; H 244, 245, 246; J 630, 631, 632*)
7. Francesco Borromini, St. Ivo, 1642-60. (*G 19-16; H 247; J 633, 634*)
8. Francesco Boromini, St. Agnese, facade, 1653-66. (*H 249, J 635*)

TURIN

1. Guarino Guarini, Chapel of the Holy Shroud, dome, 1667-94. (*G 19-20; H 256; J 636, 637*)
2. Guarino Guarini, Palazzo Carignano, 1679-92. (*G 19-19, H 255, J 639*)

VENICE

Baldassare Longhena, S.M. della Salute, 1631-87. (*G 19-22, H 253*)

FRENCH

1. François Mansart, Orléans Wing, Château de Blois, 1635-38. (*G 19-68, H 265*)
2. François Mansart, Château de Maisons-Lafitte, vestibule, 1643-50. (*J 679*)
3. Louis le Vau, Château de Vaux-le-Vicomte, 1657-61. (*H 266*)
4. Claude Perrault, East Front of the Louvre, 1667-70. (*G 19-69, H 267, J 680*)
5. Louis le Vau and Jules Hardouin-Mansart, garden facade, Versailles, 1669-85. (*G 19-72, H 268, J 681*)
6. Jules Hardouin-Mansart and Charles le Brun, Hall of Mirrors, Versailles, begun 1678. (*G 19-73, H 270*)
7. Jules Hardouin-Mansart, Charles le Brun, and Antoine Coysevox, Salon de la Guerre, Versailles, begun 1678. (*H 271, J 683*)
8. Jules Hardouin-Mansart, Royal Chapel, Versailles, 1689-1710. (*G 19-74, H 272*)
9. Jules Hardouin-Mansart, Grand Trianon, Versailles, begun 1687. (*H 273*)
10. Jules Hardouin-Mansart, Church of the Invalides, Paris, 1680-91. (*G 19-75, 76; H 274, 275; J 684*)

ENGLISH

1. Inigo Jones, Banqueting Hall, Whitehall Palace, London, 1619-22. (*G 19-80, H 279*)
2. Christopher Wren, St. Paul's Cathedral, London, 1675-1710. (*G 19-81; H 280, 281, 282, 283; J 696, 697, 698*)

B. PAINTING

Dynamic is the best way to describe seventeenth century painting. The manipulation of space, light, mass, volume, and texture to express power and optimism dominated the Baroque Era.

1. Italy

PURPOSES AND SUBJECT MATTER

1. **Church decoration** focused on illusionistic ceiling paintings which gave the observer a "view into Heaven." Religious themes with heightened emotional impact were depicted.
2. **Easel paintings** also represented dynamic religious stories emphasizing salvation and ecstasy.
3. **Palace decoration** emphasized mythological subjects with Christian interpretations. Illusionism was extremely important.
4. **Landscape settings** in various subject paintings began to compete with the figures as the most important images in the compositions.

MEDIA AND TECHNIQUES

1. Fresco was used for ceiling and wall paintings.
2. Oil on canvas was used for easel paintings.
3. "Mixed media," the combination of various materials, was typical of the Baroque. Most often, painting and stucco relief were combined for heightened illusionism.
4. Imitation of other media and other art forms was also common:
 a. Paintings imitated sculpture.
 b. Paintings imitated architecture with their elaborate attempts to "open up" ceilings or create *tromp l'oeil* settings.

DESIGN

1. **General characteristics** of Italian Baroque painting include
 a. Dynamic instead of static balance.
 b. Receding compositions with design elements placed diagonally rather than parallel to the picture plane.
 c. Extreme illusionism in space and lighting often made the wall or ceiling appear transparent: the observer perceived a scene viewed through a window or a roofless building.
 d. Extremely complicated perspective and foreshortening reinforced the illusions.
 e. Emotional response was heightened through the use of intense colors, exaggerated poses and gestures, and daring compositions.
 f. The overall compositional effect was more significant than the careful rendition of specific details.
2. **The Caracci** established the Bolognese Academy to train painters in the Renaissance manner in a style which synthesized the form of Michelangelo, the grace of Raphael, and the color of Titian.

3. **Caravaggio** introduced many basic elements of seventeenth century painting:
 a. **Tenebrism,** a unique shading approach which used extremes of light and dark for dramatic effects.
 b. **Dynamic compositions** which implied energetic, intense activity and emotion.
 c. **Earthy realism** in depicting religious subjects as genre.

2. Spain

PURPOSES AND SUBJECT MATTER

1. **Religious painting** continued to dominate Spanish art.
2. **Portraiture, genre,** landscape, mythology, and other non-religious subjects began to develop under the influence of Velázquez.
3. Velázquez also painted the first female nude in Spanish art, the *Rokeby Venus.*

MEDIA AND TECHNIQUES

1. Oil on canvas was the preferred medium.
2. Techniques included both smooth brushwork and rich impasto.

DESIGN: There were two opposing trends in the Spanish art of the Baroque Era: mysticism and realism.

1. **Mysticism** dominated Spanish religious art and is best illustrated by the work of El Greco. His work is known for
 a. Elongated figures influenced by the Byzantine traditions of his native Greece.
 b. Venetian color and lighting from the work of Titian and Tintoretto.
 c. Mannerist devices of ambigious space and cool colors.
 d. Baroque interest in arousing emotion and expressing a strong sense of movement and energy.
2. **Realism** also appealed to Spanish painters. The work of Velázquez is known for
 a. A broad range of non-religious subjects treated realistically.
 b. An interest in depicting common people sympathetically.
 c. Careful rendition of settings and groups of figures.
 d. Subtle color and gradual tonal changes in his mature work.
 e. Baroque illusionism and expansive compositions.
3. **Caravaggio's work** influenced Spanish painting as artists learned of his use of tenebrism and earthy realism.

3. Flanders

PURPOSES AND SUBJECT MATTER

1. Flemish painters portrayed a variety of subjects for wealthy patrons of many nations.
2. Rubens' favorite subject was the human figure presented in the guise of religious, historical, and mythological subject paintings.
3. Van Dyck, best known as court painter to King Charles I of England, established the basics of English portrait painting.
4. At one time or another most Flemish Baroque painters were students of Rubens and were strongly influenced by his subjects and his style.

MEDIA AND TECHNIQUES

1. Oil on canvas was the preferred medium, but wood panel was also used.
2. Rubens developed rich brushwork which was adopted by his students, and which influenced later artists.
3. **The studio method** of the Renaissance was continued by Rubens. Assistants did the preparatory and preliminary work on paintings of Rubens' design. Many of the artists employed by Rubens became specialists in landscape, genre, still life, and drapery, and were used only for those specialties. Rubens added the finishing touches.

DESIGN

1. **Rubens** was strongly affected by Italian painting, and he completed the blending of Italian and Northern traditions which Dürer had started.
 a. **Early style**, before 1630 is characterized by
 (1) The influence of Michelangelo in its heavy musculature.
 (2) The influence of Tintoretto in its high drama.
 (3) The influence of Caravaggio in its strong lighting contrasts (tenebrism).
 b. **Later style**, after 1630 is characterized by
 (1) The influence of Titian in its light colors.
 (2) The retention of dynamic compositions with the diagonal emphasis that recurred in all of his work.
 (3) Sensuous female figures.
2. **Van Dyck** influenced English art for over a century.
 a. **Early style** is characterized by
 (1) The influence of Rubens, his teacher.
 (2) The elongated figures of Mannerism.
 b. **Later style** is characterized by
 (1) Calm and serene poses and expressions.

(2) Smoother brushwork than Rubens', and more carefully defined forms.

(3) Flattering portraits of English nobility.

(4) Children often included in adult portraits for liveliness.

4. Holland

PURPOSES AND SUBJECT MATTER

1. Holland was Protestant and puritanical.
 a. Religious paintings were not needed for church decoration since church interiors were austere.
 b. Religious easel and panel paintings were few, mostly by Rembrandt, as private patrons were uninterested in such works. (Even Rembrandt's works treat the religious subjects in terms of everyday life.)
 c. Historical and mythological subjects were very rare. They were occasionally dealt with in genre pictures.
2. The Dutch were proud of their newly-won independence, their country, and their fellow citizens.
 a. The principal art customers were the middle class burghers, who wanted paintings to decorate their homes and proclaim their status.
 b. Paintings were bought and sold on the open market. Without the church or the aristocracy to act as patrons, artists were free to starve for the first time, but most survived. Some patronage was provided by civic bodies who wanted group portraits.
 c. **Contemporary Dutch life** was the main subject and was depicted in paintings of:
 (1) Individual and group portraits.
 (2) Everyday life (genre pictures), often showing rowdy behavior.
 (3) Landscapes and seascapes.
 (4) Interior scenes of households and churches.
 (5) Still life (flower arrangements and table settings).
 (6) **Vanitas:** a descendant of disguised symbolism in which still-life objects such as skulls, burnt candles, watches, etc. signify that life is short and earthly pleasures will not last.

MEDIA AND TECHNIQUES

1. Oil was used on wood panels or canvas.
2. Pictures were not usually large. They were intended for private homes, not public buildings.
3. **Individual methods**
 a. **Frans Hals** was one of the first to paint **alla prima**, without underpainting.

 b. **Vermeer** used a *camera obscura* to aid in his composition. This is an arrangement of mirrors and lenses in a box that focuses a scene onto paper.
 c. **Landscape painters** worked in the studio from sketches and memory.
4. **Etching,** a technique that originated with the armorers, was perfected in the seventeenth century for printmaking.
 a. The metal plate (initially iron, later copper) was covered with an acid-resistant wax; then the design was drawn on the waxy surface with a needle, exposing the metal underneath. When the wax-covered plate was immersed in acid, the acid ate into the exposed metal. When the wax was removed the plate was inked and printed in the same way as an engraving. (See Figure 15-1)
 b. As etching advanced, artists used multiple acid baths. After each bath, certain areas would be "stopped out" with acid-resistant varnish. These areas remained shallow, and printed lighter, while the areas that were exposed a number of times deepened, and printed darker.
 c. Etching was often combined with other techniques, such as drypoint and engraving.
 d. Rembrandt is the best known etcher of the seventeenth century.

DESIGN: There were several different schools of art in seventeenth century Holland.

1. **The Utrecht School**
 a. These artists were great admirers of Caravaggio's tenebristic lighting. Gerrit van Honthorst specialized in night scenes using Caravaggesque lighting.
 b. This school was important for transmitting the Baroque style from Italy to Holland, but produced no major artists.
2. **The Haarlem School** (most notably Frans Hals) applied the new lighting methods and color schemes to portraiture.
3. **Landscape and seascape** painters used low horizons, emphasizing the sky and clouds. Figures were small, insignificant, and anonymous.
 a. These paintings usually made no pretense of storytelling or allegory.
 b. One group of painters worked in an Italian manner, painting Dutch scenes with the golden light of Venice.

FIGURE 15-1 Etching technique.

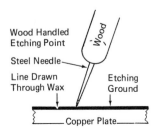

Wood Handled
Etching Point

Steel Needle

Line Drawn
Through Wax

Etching
Ground

Copper Plate

4. **Interior scene painters** used easily distinguished color schemes:
 a. **Pieter de Hooch** painted in warm tones, using reds and yellows. (He was known also for showing views through open doors into adjoining rooms, and for including young children in his scenes.)
 b. **Jan Vermeer** was known for his preference for cool tones.
5. **Dutch genre painters** delighted in animated scenes of boisterousness.
6. **Portrait painters** showed varying amounts of interest in psychological penetration:
 a. **Hals** painted the public image of the sitter.
 b. **Rembrandt** painted the private image.

5. France

In the first half of the century, Poussin, de la Tour, Claude, Le Nain, and others produced very innovative works. With the founding of the Academy of Painting and Sculpture in 1648, and the dominance of Louis XIV over official taste, painting became less spirited. At the end of the century, the Academy split into two antagonistic factions.

PURPOSES AND SUBJECT MATTER: Before 1650, artists worked for a variety of patrons. After mid-century, they served the king and decorated the royal palaces. They produced:

1. Religious painting.
2. Grand subjects from history or mythology.
3. Genre.
4. Landscape.
5. Official portraiture.
6. Palace decorations glorifying the king (especially after 1643).

MEDIA AND TECHNIQUES

1. Oil on canvas was preferred.
2. Individual methods
 a. **Poussin** worked from a miniature stage which he arranged with small, draped wax models to try out compositions and lighting.
 b. **Claude** painted his own landscapes and had assistants paint in the figures. In this way, the paintings sold better than pure landscapes without narrative interest.
 c. **Rigaud** painted only the heads of his portraits, gluing them into place after his assistants had rendered backgrounds, architecture, costumes, and other details.

DESIGN: French seventeenth century painting is called "Classical-Baroque." The second half of the century conserved the work of the innovators of the first fifty years.

1. **Classical-Baroque** characteristics include
 a. Calm, serene compositions in the manner of the High Renaissance.
 b. Harmonious color schemes reminiscent of Raphael, Correggio, and Titian.
 c. A preference for "grand subjects," often with a moralistic tone, taken from historical or mythological narrative.

2. **Innovators** before 1650 included
 a. **Georges de la Tour**, best-known French Caravaggiste; noted for his austere, somewhat simplified compositions, and strong tenebrism.
 b. **Louis le Nain** and family, known for genre paintings which gave dignity to peasants and contrasted rustic virtue with courtly artifice.
 c. **Claude Lorrain** (called Claude), known for landscape paintings which borrowed heavily from Italian (Venetian) Renaissance coloring and composition, but minimized the importance of figures. He is often considered the "father" of Romantic landscape painting.
 d. **Nicolas Poussin**, known for his very formal, classical approach to historical, mythological, and religious subjects. Like Claude, he spent most of his life in Italy and was strongly influenced by the Italian Renaissance masters.

3. **The French Academy**
 a. Was founded in 1648 by Charles le Brun, Court Painter to Louis XIV, to train artists in the techniques and styles approved by the directors.
 b. Taught an extremely rigid curriculum that perpetuated Poussin's ideas and manner.
 c. Most Academy-trained painters produced works for the king and his court.

4. **"Poussinistes" versus "Rubenistes":**
 a. At the end of the century, the Academy and most other artists split into two factions. One group declared Poussin the greatest artist, the other revered Rubens.
 (1) **Poussinistes** stressed form, structure, and grand subjects. Classical, intellectual, calm response was their goal.
 (2) **Rubenistes** revelled in color, dynamic compositions, energetic brushwork, and emotional impact.

EXAMPLES

ITALIAN

BOLOGNESE ACADEMY PAINTERS IN ROME

1. Annibale Caracci, *Venus and Anchises,* and *Polyphemos,* Palazzo Farnese, 1579–1600, ceiling frescoes. (*G 19–24, 25; H cpl 36; J 620*)

2. Annibale Caracci, *Landscape with Flight Into Egypt,* 1603, oil on canvas, 48 by 98 in. (*J 622*)
3. Guido Reni, *Aurora,* Casino Rospigliosi, 1613-14, ceiling fresco. (*G 19-26, J 621*)
4. Domenichino, *Hunt of Diana,* 1615, oil on canvas, 7 by 10 ft. (*H 229*)
5. Domenichino, *Last Communion of St. Jerome,* 1614, 14 by 8 ft. (*G 19-29*)
6. Guercino, *Aurora,* Villa Ludovisi, 1621-23, fresco. (*G 19-27, H 230, J cpl 76*)

CARAVAGGIO

1. *Calling of St. Matthew,* 1600, oil on canvas, 11 by 11 ft. (*H 231, J cpl 75*)
2. *Conversion of St. Paul,* 1601, oil on canvas, 90 by 69 in. (*G 19-32, H 232*)
3. *David with the Head of Goliath,* 1605-6, oil on canvas, 36 by 46 in. (*H cpl 37*)

CEILING PAINTERS INFLUENCED BY GUERCINO

1. Pietro da Cortona, *Glorification of the Reign of Urban VIII,* Palazzo Barberini, Rome, 1633-39, fresco. (*J cpl 77*)
2. Giovanni Battista Gaulli, *Triumph of the Name of Jesus,* Il Gesù, Rome, 1672-85, fresco. (*H 38, J 629*)
3. Fra Andrea Pozzo, *Glorification of St. Ignatius,* nave of Sant' Ignazio, Rome, 1691-94, fresco. (*G 19-34, H 252*)

SPANISH

1. Sanchez Cotán, *Still Life,* 1602-5, 25 by 33 in. (*J 668*)
2. José de Ribera, *The Martyrdom of St. Bartholomew,* 1639, 72 by 78 in. (*G 19-35, H 314*)
3. Francisco de Zurbarán, *St. Francis in Meditation,* c. 1639, 60 by 39 in. (*G 19-36*)
4. Francisco de Zurbarán, *Vision of St. Peter Nolasco,* 1629, 70 by 88 in. (*H 315*)
5. El Greco, *The Burial of Count Orgaz,* 1586, 16 by 12 ft. (*G 18-62, 63; H 223; J 580, cpl 67*)
6. El Greco, *Grand Inquisitor Don Fernando Niño de Guevero,* c. 1600, 67 by 42 in. (*H 224*)
7. El Greco, *View of Toledo,* 1600-1610, 48 by 43 in. (*H 225*)
8. El Greco, *The Resurrection,* 1597-1604, 9 by 4 ft. (*H cpl 35*)
9. El Greco, *Fray Felix Hortensio Paravacino,* c. 1605, 44 by 34 in. (*G 18-63, J 581*)
10. Diego Velázquez, *Water Carrier of Seville,* c. 1619, 42 by 32 in. (*J 670*)
11. Diego Velázquez, *Los Borrachos (The Drunkards),* 1628, 66 by 90 in. (*G 19-37, H 316*)

12. Diego Velázquez, *Garden of the Villa Medici Rome*, 1649-51, 18 by 15 in. (*H 317*)
13. Diego Velázquez, *Pope Innocent X*, 1650, 55 by 45 in. (*J 671*)
14. Diego Velázquez, *Las Meniñas*, 1656, 10 by 9 ft. (*G 19-39, H cpl 44, J 672, cpl 83*)

FLEMISH

1. Peter Paul Rubens, *Elevation of the Cross*, 1610, panel, 15 by 11 ft. (*G 19-41, H 284, J 648*)
2. Peter Paul Rubens, *Fall of the Damned*, 1614-18, oil on panel, 9 by 7 ft. (*H 286*)
3. Peter Paul Rubens, *Rape of the Daughters of Leucippus*, 1616-17, 87 by 82 in. (*G 19-40, H 285*)
4. Peter Paul Rubens, *The Lion Hunt*, 1617-18, 8 by 12 ft. (*G 19-42*)
5. Peter Paul Rubens, *Henry IV Receiving the Portrait of Marie de'Medici*, 1621-25, 13 by 10 ft. (*H cpl 41*)
6. Peter Paul Rubens, *Garden of Love*, 1638, 6 by 9 ft. (*H 287, J cpl 79*)
7. Peter Paul Rubens, *Landscape with Château of Steen*, 1616, panel, 53 by 93 in. (*J 650*)
8. Anthony van Dyck, *Madonna of the Rosary*, 1624-28. (*H 288*)
9. Anthony Van Dyck, *Charles I in Hunting Dress*, 1635, 9 by 7 ft. (*G 19-45, H 289, J 651*)

DUTCH
THE UTRECHT SCHOOL

1. Gerrit van Honthorst, *The Supper Party*, 1620, 84 by 56 in. (*G 19-46*)
2. Gerrit van Honthorst, *Adoration of the Shepherds*, 1621, 51 by 38 in. (*H 290*)
3. Hendrick Terbruggen, *The Calling of St. Matthew*, 1621, 40 by 54 in. (*J 652*)
4. Hendrick Terbruggen, *Incredulity of St. Thomas*, 1623, 42 by 54 in. (*H 291*)

THE HAARLEM SCHOOL

1. Frans Hals, *Balthasar Coymans*, 1645, 30 by 25 in. (*G 19-47*)
2. Frans Hals, *The Jolly Toper*, 1627, 32 by 26 in. (*J cpl 80*)
3. Frans Hals, *Banquet of the Officers of the St. George Guard Company*, 1616, 9 by 10 ft. (*H 301*)
4. Frans Hals, *The Laughing Cavalier*, 1624, 34 by 27 in. (*H 302*)
5. Frans Hals, *Officers of the Civic Guard of St. Adrian*, 1633, 7 by 11 ft. (*G 19-49*)
6. Frans Hals, *Malle Babbe*, c. 1650, 30 by 25 in. (*G 19-48, H 303, J 653*)

7. Frans Hals, *Women Regents of the Old Men's Almhouse,* 1664, 68 by 99 in. (*H 304, J 654*)

LANDSCAPES

1. Jan Van Goyen, *Fort on a River,* 1644, panel, 17 by 30 in. (*H 662*)
2. Jan Van Goyen, *River Scene,* 1656, 14 by 25 in. (*H 292*)
3. Jacob Van Ruisdael, *The Jewish Graveyard,* c. 1655, 32 by 38 in. (*J 663*)
4. Jacob Van Ruisdael, *View of Haarlem,* 1670, 22 by 25 in. (*G 19-60, H 293*)
5. Meyndert Hobbema, *Avenue at Middelharnis,* 1689, 41 by 56 in. (*H 294*)

ITALIANATE LANDSCAPES

Aelbert Cuyp, *Landscape with Cattle and Figures,* c. 1650, 15 by 20 in. (*H 295*)

INTERIOR SCENES

1. Jan Vermeer, *Kitchen Maid,* 1658, 18 by 16 in. (*H 312*)
2. Jan Vermeer, *Young Woman with a Water Jug,* 1665, 18 by 16 in. (*G 19-57, 58*)
3. Jan Vermeer, *Artist in his Studio (Allegory of the Art of Painting),* 1665. (*H cpl 43*)
4. Jan Vermeer, *The Letter,* 1666, 17 by 15 in. (*J cpl 82*)
5. Pieter de Hooch, *The Linen Cupboard,* 1663, 29 by 30 in. (*H 296*)

GENRE SCENES

1. Adrien Brouwer, *Boors Drinking,* 1620s, oil on panel, 11 by 9 in. (*H 298*)
2. Jan Steen, *The World Upside Down,* 1663, 41 by 57 in. (*H 297*)
3. Jan Steen, *Eve of St. Nicholas,* 1660-65, 32 by 28 in. (*J 667*)

STILL LIFE

1. Willem Claesz Heda, *Still Life,* 1634, panel, 17 by 22 in. (*J 665*)
2. Willem Claesz Heda, *Still Life,* 1648, panel, 35 by 28. (*H 299*)
3. Willem Kalf, *Still Life,* 1659, 20 by 17 in. (*G 19-59*)
4. Jan Davidz. de Heem, *Flower Still Life,* c. 1665, 21 by 16 in. (*J 666*)

CHURCH INTERIORS

1. Pieter Saenredam, *St. Cunera Church,* 1655, panel, 20 by 27 in. (*J 664*)
2. Pieter Saenredam, *Church of St. Bavo,* panel, 28 by 22 in. (*H 300*)

REMBRANDT: RELIGIOUS PAINTINGS

1. *Tobit and Anna with the Kid,* 1626, panel, 15 by 12 in. (*J 655*)
2. *Supper at Emmaus,* 1628-30, 15 by 16 in. (*G 19-50*)
3. *Blinding of Samson,* 1636, 8 by 10 ft. (*J 656*)
4. *Angel Leaving Tobit and Tobias,* 1637, panel, 27 by 20 in. (*H 306*)
5. *Supper at Emmaus,* 1648 (2nd version), 27 by 26 in. (*G 19-51, H 308*)
6. *Jacob Blessing the Sons of Joseph,* 1656, 6 by 7 ft. (*J cpl 81*)
7. *The Return of the Prodigal Son,* 1665, 9 by 7 ft. (*G 19-52, H 310, J 660*)

REMBRANDT: GROUP PORTRAITS

1. *Anatomy Lesson of Dr. Tulp,* 1632, 67 by 85 in. (*H 305*)
2. *The Night Watch,* 1642, 11 by 14 ft. (*H 307, J 657*)
3. *Syndics of the Cloth Guild,* 1662, 6 by 9 ft. (*G 19-55*)

REMBRANDT: SELF-PORTRAITS: many examples, various dates. (*G 19-53, 54; H 311; J 659*)

REMBRANDT: OTHER

The Polish Rider, 1655, 46 by 53 in. (*H cpl 42, J 658*)

REMBRANDT: GRAPHICS

1. *Christ Preaching,* c. 1652, etching. (*J 661*)
2. *The Three Crosses,* 1660-61, fourth-state etching with burin and drypoint, 15 by 18 in. (*G 19-56*)

FRENCH

1. Georges de la Tour, *Newborn,* 1630, 30 by 36 in. (*H 257*)
2. Georges de la Tour, *Lamentation over St. Sebastian,* 1630s, 5 by 4 ft. (*G 19-61*)
3. Georges de la Tour, *Joseph the Carpenter,* 1645, 39 by 26 in. (*J 673*)
4. Louis le Nain, *Peasant Family,* c. 1640, 44 by 62 in. (*G 19-62, J 674*)
5. Louis le Nain, *The Cart,* 1641, 22 by 29 in. (*H 258*)
6. Nicolas Poussin, *Inspiration of the Poet,* 1628-29, 72 by 84 in. (*H 259*)
7. Nicolas Poussin, *Cephalus and Aurora,* c. 1630, 38 by 51 in. (*J 675*)
8. Nicolas Poussin, *Et in Arcadia Ego,* 1630, 40 by 32 in. (*G 19-64*)
9. Nicolas Poussin, *Rape of the Sabine Women,* 1636-37, 61 by 83 in. (*H cpl 39, J cpl 84*)
10. Nicolas Poussin, *Et in Arcadia Ego,* 1640 (2nd version), 34 by 48. (*G 19-65*)

11. Nicolas Poussin, *Holy Family on the Steps,* 1648, 27 by 39 in. (*H 260*)
12. Nicolas Poussin, *Landscape with the Burial of Phocion,* 1648, 47 by 71 in. (*G 19-66, J 676*)
13. Claude Lorrain, *Embarkation of Saint Ursula,* 1641, 44 by 58 in. (*H cpl 40*)
14. Claude Lorrain, *Marriage of Isaac and Rebecca,* 1648, 59 by 78 in. (*G 19-67, H 261*)
15. Claude Lorrain, *On the Slopes of the Janiculum,* no date, pen and ink, 9 by 12 in. (*H 262*)
16. Claude Lorrain, *View of the Campagna,* c. 1650, wash drawing. (*J 677*)
17. Philippe de Champaigne, *Unknown Man,* 1650, 36 by 29 in. (*H 263*)
18. Hyacinthe Rigaud, *Portrait of Louis XIV,* 1701, 9 by 8 ft. (*H 264*)

C. SCULPTURE

Sculpture was significant only in Italy and France during the seventeenth century. The major influence on the style in both countries was the work of Gianlorenzo Bernini.

1. Italy

PURPOSES AND SUBJECT MATTER

1. Sculpture was primarily religious, commissioned by the Catholic Church to counteract the Protestant Reformation.
2. A few of Bernini's subjects were taken from mythology.

MEDIA AND TECHNIQUES

1. Combining materials was typical of Baroque sculpture. Bernini's *Ecstasy of St. Theresa* combines marble with gilt bronze rods to simulate rays of light, and paint to simulate a view into Heaven.
2. As in previous centuries, building and sculptural materials continued to be stripped from ancient Roman monuments. For instance, the bronze for the *Baldocchino* in St. Peter's was taken from the Pantheon.

DESIGN: Baroque design elements include

1. A sense of psychological intrusion into the viewer's space.
2. Violent energy and emotion.
3. Realistic detail.
4. Twisting poses, meant to be observed from all angles, not only the front.
5. The portrayal of on-going motion or action as opposed to Renaissance works which show repose before or after an action.

2. France

PURPOSES AND SUBJECT MATTER: Sculpture, like the other seventeenth century art forms in France, was primarily secular, and served the purpose of glorifying the king and high officials. Subject matter was mainly

1. Portraiture.
2. Mythology.

MEDIA AND TECHNIQUES

1. Marble and terracotta were the preferred media.
2. Stucco was used for preliminary sketches. Ironically, in the case of Coysevox's *Louis XIV on Horseback* for the Salon de la Guerre, the king preferred the stucco (plaster-of-Paris) version over the finished marble, and had it installed on the wall. (The marble is near the Chapel at Versailles.)

DESIGN: The officially-approved style was much more restrained than Italian Baroque, but there were individual variations.

1. **Coysevox**'s portrait style was quite close to Bernini's when he was not restrained by official taste.
2. **Puget**'s emotional realism ran counter to the mainstream of official taste, and he lost court patronage.
3. **Girardon**'s work was very close to Hellenistic examples, and he was highly praised by the French Academy, which considered ancient art to be supreme.

EXAMPLES
ITALIAN

1. Gianlorenzo Bernini, *Apollo and Daphne,* 1622-24, marble, 96 in. high. (*H 237*)
2. Gianlorenzo Bernini, *David,* 1623, marble, lifesize. (*G 19-11, H 236, J 625*)
3. Gianlorenzo Bernini, *Baldocchino,* St. Peter's, Rome, 1624-33, gilt bronze. (*G 19-9, H 238, J 624*)
4. Gianlorenzo Bernini, *Ecstasy of Sta. Theresa,* 1645-52, marble, gilt bronze, paint, lifesize figures. (*G 19-13; H 239; J 626, 627*)
5. Gianlorenzo Bernini, *Fountain of Four Rivers,* 1648-51, travertine and marble. (*H 241*)
6. Gianlorenzo Bernini, *Cathedra Petri,* 1657, marble, gilt bronze, stucco, and stained glass. (*G 19-10, H 242, J 628*)
7. Gianlorenzo Bernini, *Model for the Equestrian Statue of Louis XIV,* 1670, terracotta, 30 in. high. (*J 686*)

FRENCH

1. Pierre Puget, *Milo of Crotona,* 1671-83, marble, 9 ft. high. (*G 19-78, H 278, J 689*)
2. Antoine Coysevox, *Charles le Brun,* 1676, terracotta, 26 in. high. (*H 276, J 688*)
3. Antoine Coysevox, *Bust of Colbert,* 1677, marble, (*H 276*)
4. Antoine Coysevox, *Louis XIV on Horseback,* 1683-85, stucco. (*H 271*)
5. François Girardon, *Apollo Attended by Nymphs,* 1666-72. (*G 19-79*)
6. François Girardon, *Tomb of Richelieu,* 1675-77, marble. (*H 277*)
7. François Girardon, *Model for the Equestrian Statue of Louis XIV,* 1687, wax, 30 in. high. (*J 687*)

VOCABULARY

baldocchino	etching	naturalism
Baroque	foreshortening	tenebrism
camera obscura	illusionism	undulating facade
dynamic balance	impasto	

16. Eighteenth Century Art

SUMMARY

Architecture:

Italy: The best examples are in Turin, where works were more classical than in southern Italy. Juvarra borrowed elements from Michelangelo and Borromini, but with a lighter effect.

France: Domestic exteriors remained classical; interiors became more delicate and intimate, mostly gold and white with pastel colors. The new, asymmetrical, curved and counter-curved style is called **Rococo.** Public buildings became more severely classical.

Germany: Many new churches were built as the country recovered from the Thirty Years' War. The style was influenced by French Rococo, with Neo-Classicism coming in at the end of the century.

Austria: The design of churches, monasteries, and palaces was inspired by French Rococo combined with Baroque and classical elements.

England: Four trends co-existed: Continental, Palladian, Neo-Classical Revival, and Gothic Revival.

Painting:

Italy: Venetian artists produced masterful paintings in a light style quite different from the previous heavy Baroque. Tiepolo spread the Venetian style to Spain, Germany, and Austria.

France: "Fêtes galantes" were popularized by Watteau and his followers, who ushered the Rococo style into France. This light and frivolous style was modified and perpetuated by Boucher and Fragonard. Chardin portrayed interiors and genre subjects in a more serious style, while Greuze painted sentimental subjects with a moralistic tone.

England: For the first time, a native school of English painting developed and flourished. Hogarth dealt with social commentary, while Gainsborough and Reynolds continued the Van Dyck tradition in portraiture. Fuseli and others introduced Romanticism late in the century.

U.S.A.: Unable to develop in their own country, both West and Copley pursued their careers in England.

Sculpture: The outstanding sculptor was Houdon in France, known for his portrait figures rendered with extreme precision of detail.

Minor arts: Porcelain, tapestry weaving, furniture making, and metalwork were of utmost importance in the eighteenth century.

A. ARCHITECTURE

1. Italy

During the eighteenth century, Italy became more of a living museum than an innovative art center. Consequently, there are very few examples of good eighteenth century Italian architecture.

a. *Turin*

PURPOSES AND BUILDING TYPES: Filippo Juvarra was the outstanding architect of the period, constructing many royal palaces, town residences, and churches in the Turin area.

MEDIA AND DESIGN

1. White stone was preferred.
2. Northern Italian architecture remained closer to classical design, less Baroque than that of southern Italy.
 a. Superga monastery church
 (1) Dome based on St. Peter's, Rome.
 (2) Classical portico with Renaissance balustrade.
 (3) Towers derived from Borromini.
 (4) Plan turned around to place dome and apse at the front.
 b. Royal Hunting Lodge at Stupinigi
 (1) Innovative X-shaped plan.
 (2) Many decorative elements borrowed from the design of Versailles.

b. *Rome*

PURPOSES AND BUILDING TYPES

1. **Church construction**: A few facades were added to earlier churches such as Santa Maria Maggiore and San Giovanni in Laterano, both originally Early Christian structures.
2. **Secular construction**: Public monuments included
 a. The Spanish Steps.
 b. The Trevi Fountain.

DESIGN: Baroque styles and practices continued.

2. France

PURPOSES AND BUILDING TYPES

1. **Domestic architecture:** After the death of Louis XIV, courtiers fled Versailles and went to Paris where they built comfortable town houses (called hôtels in French), and enjoyed Parisian social life.
2. **Public building** continued as in the seventeenth century.

MEDIA AND TECHNIQUES

1. Exteriors were of stone.
2. Domestic interiors were of plaster, paint, gold, and glass. Color schemes favored white and pastels, rather than the darker, stronger colors of the Baroque.

DESIGN

1. **Domestic architecture**
 a. Exteriors retained seventeenth-century styles.
 b. Interiors were transformed into a new, lighter style called **Rococo:**
 (1) Anti-symmetrical designs replaced Renaissance and Baroque symmetry.
 (2) Designs were based on curves and counter-curves.
 (3) Scale was more intimate.
 (4) Atmosphere was less formal, more feminine than in the Baroque style.
2. **Public buildings:** Classicism became more severe.

3. Germany

PURPOSES AND BUILDING TYPES: A great revival of building activity began in Germany after the country recovered from the Thirty Years' War.

1. **Church construction:**
 a. New pilgrimage churches.
 b. Enlargement of monasteries.
2. **Secular construction:** Princes began to rebuild their palaces.

MEDIA AND TECHNIQUES

1. Exteriors were of stone and painted stucco.
2. Interiors were of marble, stucco, wood, paint, and gold leaf. A great deal of white was used.

DESIGN

1. French Rococo inspired both church and secular architecture. The best examples are in southern Germany.
2. A Greek revival began, which would grow stronger in the next century.
 a. The Doric order was preferred.
 b. Inspired by the writings of J.J. Winklemann, architects bypassed the Roman style as well as the Renaissance in order to revive purely Greek forms.

4. Austria

PURPOSES AND BUILDING TYPES: Austrian eighteenth century architecture falls into three categories, each with its own specializing architect:

1. **Public buildings and churches** are represented by Johann Bernard Fischer von Erlach.
2. **Palaces** are represented by Lucas von Hildebrandt.
3. **Monasteries** are represented by Jakob Prandtauer.

MEDIA AND TECHNIQUES

1. Stone exteriors.
2. Marble, gold leaf, wood, stucco, and paint for interiors.
3. Colors were muted.

DESIGN

1. Inspired by both Roman Antiquity and Italian Baroque was Fischer von Erlach's Karlskirche in Vienna.
 a. Portico based on the Pantheon, Rome.
 b. Columns similar to those of Trajan and Marcus Aurelius in Rome.
 c. Facade based on Borromini's Sant' Agnese.
2. Inspired primarily by Italian Baroque was Prandtauer's Benedictine Monastery at Melk.
3. Inspired by French Rococo was Hildebrandt's Upper Belvedere Palace in Vienna.

5. England

PURPOSES AND BUILDING TYPES

1. In England, the architecture of the eighteenth and early nineteenth centuries is called "Georgian," after the kings George I-IV.

2. Residential architecture was most important at this time. Palaces, mansions, and country homes were built. In the case of Blenheim Palace, it was built to reward the Duke of Marlborough for his victories against Louis XIV of France.

MEDIA AND TECHNIQUES

1. Stone, brick, and wood were used for exteriors.
2. Marble, wood, stucco, and paint were used for interiors.

DESIGN: Four styles co-existed:

1. Continental influence as exemplified by Blenheim Palace, a combination of St. Peter's and Versailles.
2. Palladian style as exemplified by Chiswick House, based on the Villa Rotunda, Vicenza.
3. Classical Revival:
 a. Roman style, influenced by the excavations at Pompeii and exemplified by Syon House.
 b. Pure Greek style, influenced by the explorations and writings of Stuart and Revett and exemplified by Doric Portico, Hagley Park.
4. Gothic Revival (Pseudo-Gothic) as exemplified by Strawberry Hill.

EXAMPLES
ITALIAN

1. Filippo Juvarra, Superga Monastery Church, near Turin, 1715-31. (*G 20-3, H 318*)
2. Filippo Juvarra, Royal Hunting Palace, Stupinigi, near Turin, 1729-33. (*H 319*)
3. Francesco de Sanctis, The Spanish Steps, Rome, 1723-25. (*illustrated elsewhere*)
4. Niccolo Salvi, The Trevi Fountain, Rome, 1732-62. (*illustrated elsewhere*)

FRENCH

1. Germain Bouffrand, Salon de la Princess, Hôtel de Soubise, Paris, 1732. (*G 20-6, H 323, J 691*)
2. Germain Soufflot, The Pantheon, Paris, 1757-90. (*G 20-25, H 324, J 708*)
3. Ange-Jacques Gabriel, Place de la Concorde, Paris, 1763. (*H 326*)
4. Ange-Jacques Gabriel, Petit Trianon, Versailles, 1762-68. (*H 327, 328*)

GERMAN

1. Mathaes Daniel Pöppelmann, Der Zwinger, Dresden, 1711-22. (*H 342*)
2. Balthasar Neumann, Residenz, Würzburg, 1719-50. (*H 339, cpl 48*)
3. Balthasar Neumann, Vierzehnheiligen, near Bamberg, 1743-72. (*G 20-9, 10; H 340*)
4. Dominikus Zimmermann, Die Wies, near Munich, 1745-54. (*J 646, 647*)

AUSTRIAN

1. Jakob Prandtauer, Benedictine Abbey, Melk, 1702. (*H 336, 367; J 643, 644*)
2. Johann Bernhard Fischer von Erlach, Karlskirche, Vienna, 1716-37. (*H 335, J 641, 642*)
3. Johann Lucas von Hildebrandt, Upper Belvedere Palace, Vienna, 1721-22. (*H 338*)

ENGLISH

1. Sir John Vanbrugh, Blenheim Palace, Oxfordshire, 1705-24. (*G 20-4, H 344*)
2. Lord Burlington, Chiswick House, Middlesex, 1724-29. (*G 20-5, H 347, J 705*)
3. James Gibb, Radcliffe Library, Oxford, 1739-49. (*H 346*)
4. Henry Flitcroft and Henry Hoare, Temple of Apollo, Stourhead, 1744-65. (*H 707*)
5. Sanderson Miller, Sham Gothic Ruins, Hagley Park, 1747. (*G 20-21, H 351*)
6. Horace Walpole, Strawberry Hill, Twickenham, Middlesex, 1748-77. (*G 20-20, H 349, J 714*)
7. James Stuart, Doric Portico, Hagley Park, 1758. (*G 20-22, H 352*)
8. Robert Adam, Etruscan Room, Osterly Park House, Middlesex, 1761. (*G 20-23, H 348*)
9. Robert Adam, Syon House, Middlesex, 1762. (*H 348*)
10. Robert Adam, Home House, London, 1772-73. (*J 710*)

B. PAINTING

1. Italy

PURPOSES AND SUBJECT MATTER: Only the Venetian school produced great painters in the eighteenth century. Tiepolo, the most outstanding, painted ceiling frescoes for patrons in Austria, Germany, and Spain as well as Italy. His work depicted scenes from mythology, history, and religion.

Veduta paintings by such artists as Guardi and Canaletto were views of identifiable places such as Venice.

MEDIA AND TECHNIQUES

1. Most artists used oil on canvas attached to walls and ceilings, since the Venetian climate was hostile to true fresco.
2. Tiepolo used a "**secco su fresco**" method handed down from Byzantine times that involved mixing pigment with egg, oil, or wax, rather than water, and painting onto damp plaster. The paint formed a very hard skin, and allowed for rapid painting over large areas.

DESIGN

1. **Tiepolo's work** featured lightness, elegance, and grace.
 a. Pastel colors were favored over the darker Baroque tones.
 b. Foreshortening of figures was particularly dramatic.
 c. Illusionistic architecture was continued.
2. **The veduta painters** emphasized accuracy in representation.
 a. Guardi's paintings featured soft, modulated lights and darks.
 b. Canaletto's line was hard and dry.

2. France

PURPOSES AND SUBJECT MATTER: Small easel paintings replaced large public works.

1. Created for the nobility were
 a. "**Fêtes galantes**," the pastoral gatherings of lovers in which Watteau specialized.
 b. Scenes of erotic frivolity, nudes, and the use of themes from mythology as an excuse to paint flesh.
 c. Portraits by Quentin de la Tour.
2. Created for the middle class were
 a. Still-life and interior scenes done with honesty and sympathy by Chardin.
 b. Scenes of moralistic sentimentality by Greuze.

MEDIA AND TECHNIQUES

1. **Watteau** used a pearly white underpaint, with areas of pink and blue. Over this ground he put washes of blue, green, and brown. Details were added in impasto, using rose, blue, yellow, and white. Then over the entire surface he applied glazes in the manner of Titian.
2. **Boucher** used carefully enameled rich pinks and blues without glazes.
3. **Fragonard** painted with energetic brushwork, the opposite of Boucher's painstaking method.

4. Most artists used oil on canvas, but Quentin de la Tour used pastel for his portraits.

DESIGN: The eighteenth-century painters resolved the controversy of the previous century between the "Poussinistes" and the "Rubenistes" in favor of Rubens. Color was very important, although they tended to use a lighter, more subtle palette.

1. Watteau's figures were delicate, and based on triangular shapes. He kept a notebook of figure sketches, and many of the same figures appear several times in his paintings.
2. Chardin's figures were similar to Watteau's in lightness and grace, but were used to depict household activities rather than leisure and frivolity.
3. Boucher's and Fragonard's figures were slightly more solid, but not heavy.
4. Greuze's figures were solid. He used stock poses and arranged his figures on a narrow "stage."
5. Aristocratic paintings often portrayed idyllic country settings, while the middle-class works favored simple interiors.

3. England

The first native English school of painting began in the eighteenth century. Previously, England's major painters (such as Holbein and Van Dyck) came from other countries.

PURPOSES AND SUBJECT MATTER: Paintings were done for royalty, the aristocracy, and the middle class.

1. Genre painting included the caustic, witty satires of Hogarth.
2. Landscape was Gainsborough's preferred subject, although he earned his living as a portraitist.
3. Portraiture included animals as well as people. George Stubbs earned his living painting portraits of horses.
4. Mystical, fantastic subjects were seen in the work of Fuseli.

MEDIA AND TECHNIQUES

1. Gainsborough built miniature landscapes with twigs, bark, and pebbles, and painted from them in his studio. He diluted his oils with turpentine to the consistency of watercolor. His paintings have held up extremely well compared to those of his arch-rival Reynolds.
2. Reynolds employed many assistants and turned out an enormous body of work, but due to faulty technical procedures, some of his paintings are cracked and in poor condition. The faces in his portraits often look pale and sickly because the carmine pigment has faded.

3. Prints, especially social commentaries and satires, were produced mostly in etching and aquatint. (**Aquatint**: a method of etching in which the plate is dusted with powdered resin, warmed to fuse the resin to the plate, and then bathed in acid that etches marks around the resin. Repeated stopping-out and "biting" of the image produces delicate gradations of tone resembling watercolor. This method is usually combined with engraving, drypoint, or line etching.)

DESIGN

1. Hogarth's cluttered canvases are reminiscent of Jan Steen's, with Rococo influence in the detailing.
2. Gainsborough's early portraits are somewhat stiff, but his later works are naturalistic.
3. Having traveled in Italy, Reynolds was impressed with classicism, and used classical poses and props in his paintings. Sometimes he used classical costumes (disparaged by others as "nightgowns") as well, to avoid having his paintings become dated by current fashions.
4. The Romantic painters, Fuseli and Blake, leaned heavily on Mannerism for elements of their styles.
5. Cozens tried "creating chance effects on purpose" with ink blot compositions, a method not understood by his contemporaries, but having momentous implications for twentieth century art.

4. Colonial America

Both of America's outstanding eighteenth century painters, West and Copley, moved to England to develop their talents.

PURPOSES AND SUBJECT MATTER

1. Portraits by John Singleton Copley.
2. History painting by Benjamin West and Copley.

MEDIA AND TECHNIQUES

1. Oil on canvas.
2. Technique was generally considered the equal of their European contemporaries.

DESIGN

1. John Singleton Copley produced unpretentious early works resembling Dutch portraits. His later works were elaborate history paintings which abandoned this provincial virtue.

2. Benjamin West participated in the English Neo-Classical Revival. However, he broke with that style in *The Death of General Wolfe,* which portrayed an episode in the French and Indian War, by showing the figures in the dress of the time rather than in Roman togas.

EXAMPLES

ITALIAN

1. Giovanni Battista Tiepolo, *The Banquet of Anthony and Cleopatra,* Palazzo Labia, Venice, before 1750, fresco. (*H 321*)
2. Giovanni Battista Tiepolo, *Investiture of Bishop Harold,* Kaisersaal, Residenz, Würzburg, Germany, 1750-53, fresco. (*H cpl 45, J 645, cpl 78*)
3. Giovanni Battista Tiepolo, *Apotheosis of the Pisani Family,* Villa Pisani, Stra, 1761-62, fresco. (*G 20-12*)
4. Francesco Guardi, *Piazetta San Marco, Venice,* date unknown, oil on canvas. (*H 322*)

FRENCH

1. Jean-Antoine Watteau, *L'Indifferent,* c. 1716, 10 by 7 in. (*G 20-2*)
2. Jean-Antoine Watteau, *Pilgrimage to Cythera,* 1717, 51 by 76 in. (*G 20-14, H 329, J cpl 85*)
3. Jean-Antoine Watteau, *Signboard of Gersaint,* c. 1721, 5 by 10 ft. (*H cpl 46*)
4. Jean-Baptiste Simeon Chardin, *Kitchen Still Life,* 1730-35, 12 by 14 in. (*J 694*)
5. Jean-Baptiste Simeon Chardin, *Copper Cistern,* 1733, 11 by 9 in. (*H 331*)
6. Jean-Baptiste Simeon Chardin, *Back from the Market,* 1739, 18 by 15 in. (*J cpl 87*)
7. Jean-Baptiste Simeon Chardin, *Grace at Table,* 1740, 19 by 15 in. (*G 20-18*)
8. Jean-Baptiste Simeon Chardin, *House of Cards,* 1741, 32 by 26 in. (*H 332*)
9. François Boucher, *The Triumph of Venus,* 1740, 51 by 64 in. (*H 330*)
10. François Boucher, *Cupid a Captive,* 1754, 66 by 34 in. (*G 20-16*)
11. Quentin de la Tour, *Self-Portrait,* c. 1751, pastel, 25 by 21 in. (*G 20-17*)
12. Jean Honoré Fragonard, *Bathers,* 1765, 25 by 31 in. (*H cpl 47, J cpl 86*)
13. Jean Honoré Fragonard, *The Swing,* 1766, 32 by 35 in. (*G 20-15*)
14. Jean Baptiste Greuze, *Return of the Prodigal Son,* 1777-78, 51 by 65 in. (*G 20-36, H 333*)
15. Jean Baptiste Greuze, *The Village Bride,* 1761. (*J 735*)

ENGLISH

1. William Hogarth, *Marriage à la Mode* series, 1743-45, 28 by 36 in. (*G 20-19, H 353*)
2. Thomas Gainsborough, *Robert Andrews and his Wife,* 1748-50. (*J cpl 88*)

3. Thomas Gainsborough, *Mary, Countess Howe,* mid-1760s, 96 by 60 in. (*H cpl 49*)
4. Thomas Gainsborough, *The Honorable Mrs. Graham,* 1775, 93 by 61 in. (*G 20-31*)
5. Thomas Gainsborough, *The Market Cart,* 1787, 72 by 60 in. (*H 354*)
6. Thomas Gainsborough, *Mrs. Siddons,* 1785, 49 by 39 in. (*J 702*)
7. Thomas Gainsborough, *Mrs. Richard Brinsley Sheridan,* c. 1785, 60 by 86 in. (*G 20-32*)
8. Sir Joshua Reynolds, *Lady Sarah Bunbury Sacrificing to the Graces,* 1765, 94 by 60 in. (*H 355*)
9. Sir Joshua Reynolds, *Mrs. Siddons as the Tragic Muse,* 1784, 93 by 57 in. (*J 703*)
10. Sir Joshua Reynolds, *Lord Heathfield,* 1787, 56 by 45. in. (*G 20-34*)
11. George Stubbs, *Lion Attacking a Horse,* 1770. (*J cpl 89*)
12. John Henry Fuseli, *The Nightmare,* 1785-90. (*G 20-41, J 728*)
13. William Blake, *The Ancient of Days,* frontispiece of *Europe, A Prophesy,* 1794, metal relief etching, hand colored. (*J 729*)
14. William Blake, *The Circle of the Lustful,* illustration for Dante's *Inferno,* 1824-27, ink and watercolor, 15 by 21 in. (*H 391*)
15. Alexander Cozens, *Landscape,* 1784, aquatint. (*J 731*)

AMERICAN

1. John Singleton Copley, *Paul Revere,* 1768-70, 35 by 28 in. (*H 356*)
2. John Singleton Copley, *Mrs. Thomas Boylston,* 1766, 50 by 40 in. *(J 726)*
3. John Singleton Copley, *Watson and the Shark,* 1778, 72 by 90 in. (*J 727*)
4. Benjamin West, *The Death of General Wolfe,* c. 1770, 60 by 84 in. (*G 20-35, H 357*)

C. SCULPTURE

1. France

PURPOSES AND SUBJECT MATTER

1. Playful, mythological subjects.
2. Portraits and monuments.

MEDIA AND TECHNIQUES

1. Clodion used terracotta clay to make his small, sensual sculptures look like flesh.
2. Houdon carved in marble with scientific precision.

3. Falconet used bronze for his equestrian monument of Peter the Great.

DESIGN: Styles depended on individual artists:

1. Clodion's figures were playful and frivolous.
2. Some of Houdon's poses were in the Neo-Classical style, but tempered with realism in his careful attention to detail.
3. Falconet's monument recalls the Baroque in its dramatic, dynamic pose.

2. Germany

The outstanding work of eighteenth century German sculpture comes from the hands of the Asam brothers, Egid Quirin Asam and Cosmas Damian Asam, who built and decorated the Church of St. Johannes Nepomuk, in Munich. Their carved and gilded wooden altarpiece, combined with painting, is elaborate in the extreme. Its flamboyance and careful detailing pushed the Rococo style to its limits.

3. England

The best example of English eighteenth century sculpture is a statue of the composer Handel created by the French-born sculptor, Louis-François Roubiliac. Carved for Vauxhall gardens where Handel's music was often played, this life-size work shows Handel as Apollo playing a lyre, with a putto at his feet, but dressed in contemporary attire.

EXAMPLES
FRENCH

1. Clodion, *Satyr and Bacchante,* terracotta, 1775, 23 in. high. (*G 20-28, H 334, J 692*)
2. Jean Antoine Houdon, *Voltaire,* 1778, marble. (*H 372*)
3. Jean Antoine Houdon, *Count Cagliostro,* 1771-89, marble. (*G 20-30*)
4. Jean Antoine Houdon, *Voltaire,* 1781, terracotta. (*J 754*)
5. Jean Antoine Houdon, *George Washington,* 1788-92, marble. (*H 373, J 755*)
6. Étienne Maurice Falconet, *Equestrian Monument of Peter the Great,* Leningrad, 1766, bronze. (*J 693*)

GERMAN

Cosmas Damian Asam and Egid Quirin Asam, *Holy Trinity,* 1733-46, polychromed wood. (*H 343*)

Louis-François Roubiliac (French-born), *George Frederick Handel,* 1738, marble, life-size. (*J 704*)

D. MINOR ARTS

1. *Porcelain*

Soft-paste porcelain, made of clay and glass, had been manufactured in Europe for many years. In France, the Sèvres factory, under the patronage of Madame Pompadour, produced especially beautiful works. However, true porcelain, or "hard paste" was imported from China so profitably that it was called "white gold."

After years of investigation, the hard-paste formula, a mixture of kaolin and feldspar, was discovered in Germany, enabling the Meissen factory to produce Europe's first true porcelain. In England, the Spode factory added bone ash to the hard paste to produce chip-resistant bone china.

The decorations on the imported Chinese porcelain, and literary descriptions of China, inspired a mania in Europe for "**Chinoiserie**," or Chinese-style decorations on domestic porcelain, tapestries, and furniture.

2. *Tapestries*

Tapestry weaving became "painting with wool" in the eighteenth century as weavers endeavored to copy the paintings of the great masters. The "mille fleurs" backgrounds of earlier tapestries were replaced by realistic landscapes, architecture, or Chinoiserie fantasies, while the broad borders so popular in the seventeenth century were replaced by narrow borders in imitation of picture frames.

The leading tapestry factory, Gobelins in France, operated under the directorship of the painter Jean Baptiste Oudry, and later under Boucher, the favorite painter of Madame Pompadour. After the eighteenth century, tapestry weaving lost its popularity and all but died out due to the new enthusiasm for wallpaper.

3. *Furniture*

In France, the heavy styles of Louis XIV were replaced by lighter ones in the eighteenth century. Louis XV style featured the curves and counter curves of the Rococo in furniture inlaid with intricate designs (often Chinoiserie), and decorated with gilt bronze known as **ormolu.**

In mid-century, the discoveries of Pompeii and Herculaneum led to a renewed interest in classicism, resulting in the development of the style curiously named Louis XVI even though it preceded his reign. Straight legs and lines replaced the curves of the Rococo. French styles influenced the rest of Europe.

4. Metalwork

Silver, gold, and gilt bronze were wrought into incredibly intricate and beautiful shapes to produce dishes, candlesticks, decorations for furniture, and decorative mounts for some imported Chinese porcelains whose simple forms were not ornate enough for European collectors.

VOCABULARY

aquatint	Greek Revival	secco su fresco
fêtes galantes	hôtel	veduta
Gothic Revival	Rococo	

17. Nineteenth Century Art

SUMMARY

Architecture: Several revivals flourished beside pioneering efforts of modern architecture. Churches and palaces became less important than public buildings such as large halls and office buildings.

Neo-Classicism flourished especially in the United States and France. Both Greek and Roman sources were carefully imitated.

Gothic Revival was most popular in England and included elements from several non-western or anti-classical sources.

Neo-Baroque was the most flamboyant revival, used mostly for theaters and opera houses.

Metal architecture dominated the second half of the century, first in cast iron and glass, later in steel. Metal "skeletons" provided structural support; "curtain walls" provided enclosure. The skyscraper was invented. Art Nouveau and American Commercial Building were the two most dynamic styles.

Painting: France continued to be the cultural center of Europe.

Neo-Classicism was an austere style dominated by David and Ingres and the French Academy. Line and form were more important than color, and subjects were chosen for their political value.

Romanticism was inspired by literary developments and stressed emotion, action, and color. Goya, Géricault, Delacroix, Constable, and Turner were the masters.

Realism emphasized objective views of nature and people. Often, works were critical of the status quo. Corot, Millet, Daumier, and Courbet led the school in France while Eakins and Homer were active in the United States.

Impressionism disregarded traditional subjects and recorded sensory perceptions and visual impressions. Manet, Monet, Renoir, Degas, and Pissarro were among the masters.

Post-Impressionism is the term used to describe a variety of personal styles in the last two decades of the century. Artists such as Cézanne, Van Gogh, Gauguin, and Rousseau had very strong influence on the early decades of twentieth-century art.

Graphics: Etching continued to be popular, the woodcut was revived, and lithography was introduced. Goya, Toulouse-Lautrec, and Gauguin are known for their graphic works.

Sculpture: Neo-Classicism, Romanticism, and Realism had the strongest influences on sculpture. Canova, Greenough, Rude, Carpeaux, and Barye produced important works, but the genius of the age was Rodin. Rodin's personal style produced expressive, powerful figures.

A. ARCHITECTURE

Early nineteenth century architecture consisted mainly of revival styles whose elements derived from classical (Greek, Roman, Renaissance) or Gothic sources. Around mid-century, cast iron and steel began to be used for more than utilitarian industrial structures. The new metal architecture developed its own structural system and decorative language and laid the foundations for modern architecture.

PURPOSES AND BUILDING TYPES: The Industrial Revolution fostered the development of new building types while weakening the interest in traditional types.

1. **Traditional types**: churches, palaces, etc. These were usually designed in one of the Revival styles.
2. **Modern types** (usually built with metal technology):
 a. Large halls for exhibitions, stores, factories, etc.
 b. Monuments, including museums and universities.
 c. Office buildings.

MEDIA AND TECHNIQUES

1. The various revival styles usually relied on traditional methods and materials, but there were exceptions such as
 a. Thomas Jefferson's Monticello. Instead of marble or limestone, the house was built of brick with wood trim. The columns were of plastered and painted brick.
 b. John Nash's Royal Pavilion at Brighton had metal elements cast to look like masonry.
2. Neo-Baroque styles used very expensive materials ostentatiously.
3. Metal architecture began with cast-iron and glass, then progressed to steel after development of the Bessemer process in 1855.
 a. The structural use of metal for bridge, railway, and industrial engineering led to architectural use of the materials after mid-century.
 b. Structural elements were standardized and prefabricated for assembly at the building site.
 c. Cast iron was abandoned because its low melting point made it disastrously vulnerable to fire. After several fires in the 1870's, building codes specified that metal structures had to be sheathed in masonry.
4. Concrete and metal were used together at the end of the century in some Art Nouveau buildings.

DESIGN: Various styles were used in the nineteenth century:

1. **Neo-Classicism** (including Greek Revival and Roman Revival)
 a. Originated in the early eighteenth century, but flourished at the turn of the nineteenth century.

 b. Was especially popular in the United States and in France under Napoleon.

 (1) The Greek and Roman (Republican) roots of this style suited the political climate.

 (2) Jefferson and Latrobe worked to make this the official American style for public architecture.

 c. Imitated Greek and Roman sources more faithfully than earlier classicisms due to the careful study of recent archeological excavations.

 d. Was most popular for public buildings and churches.

2. Gothic Revival

 a. Flourished from 1800 to 1860.

 b. Was most popular in England for all building types and was considered England's "natural" style. It was used elsewhere, especially in France, for churches.

 c. Included a melange of elements from other styles. For example

 (1) Nash's Royal Pavilion, Brighton, included Chinese, Islamic, and other anticlassical elements.

 (2) Barry and Pugin's Houses of Parliament appear to be Gothic, but utilized Renaissance space concepts.

3. Neo-Baroque

 a. Was the most flamboyant of the revivals, but had the most limited appeal.

 b. Was popularized by Garnier's Paris Opera House and came to be preferred for opera houses and theaters throughout Europe.

 c. Was the favorite style in France under Louis Philippe and Napoleon III. Its ostentation appealed to the *nouveaux riches*.

4. Metal architecture

 a. Was the most innovative approach in the late nineteenth century and was most often used for the two new building types of the era:

 (1) **The exhibition hall**, seen as an endless horizontal repetition of identical units.

 (2) **The office building**, seen as an endless vertical repetition of identical units.

 b. Relied on the tensile strength of iron or steel for construction of skeletal structures in which the metal frame supported the structure. Traditional load-bearing walls gave way to "**curtain walls**" of glass and other materials. The walls provided enclosure, not support. Paxton in England and Le Baron Jenny in the United States were pioneers in skeletal design.

 c. **Art Nouveau** was one expression of the new metal design.

 (1) The style originated in Brussels, spread to Paris and other cities and continued to about 1917.

 (2) Architects such as Horta and Guimard applied curvilinear, organic, and humanizing form and design to buildings of the machine age.

d. **American Commercial Building** from 1880–1917 established American architects as leaders and founders of modern architecture.

 (1) Le Baron Jenny, Richardson, and Sullivan developed "**sky-scrapers,**" tall vertical commercial buildings. (Originally, any building with more than five stories was called a skyscraper; the "giants" had eight.)

 (2) The development of a cheap and reliable source of steel in 1855 and the introduction of the elevator in 1868 made it practical to build skyscrapers.

EXAMPLES
NEO-CLASSICISM

1. Thomas Jefferson, Monticello, Charlottesville, Va., 1770–84, rebuilt 1796–1800. (*G 20-26; H 358; J 711, 712*)
2. Thomas Jefferson, Virginia State Capitol, Richmond, 1785–89. (*G 20-27*)
3. Thomas Jefferson, University of Virginia, Charlottesville, 1817–25. (*H 359*)
4. Benjamin Latrobe, Catholic Cathedral, Baltimore, begun 1805. (*H 360, 361; J 717, 718, 719*)
5. Pierre Vignon, Church of the Madeleine, Paris, 1806–43. (*G 21-1, H 363*)
6. John Nash, Park Crescent, Regents' Park, London, 1812–22. (*H 365*)
7. Karl Langhans, The Brandenburg Gate, Berlin, 1788–91. (*H 364, J 713*)

GOTHIC REVIVAL

1. Sir Charles Barry and A. Welby Pugin, Houses of Parliament, London, begun 1836. (*G 21-2, H 396, J 720*)
2. John Nash, Royal Pavilion, Brighton, 1815–18. (*G 21-3, H 395, J 716*)
3. Eduard Reidel, Schloss Neuschwanstein, Bavaria, begun 1868. (*illustrated elsewhere*)

NEO-BAROQUE

1. Charles Garnier, Opera House, Paris, 1861–74. (*G 21-4; H 397, 398, 399; J 721, 722, 723*)
2. Guiseppe Sacconi and others, Victor Emanuel II Monument, Rome, 1885–1911. (*illustrated elsewhere*)

METAL ARCHITECTURE
CAST-IRON

1. Henri Labrouste, Reading Room, Bibliothèque Ste. Geneviève, Paris, 1843–50. (*G 21-93, H 409, J 724*)
2. Sir Joseph Paxton, Crystal Palace, London, 1850–51. (*G 21-94, H 410, J 859*)

STRUCTURAL STEEL

1. Henry Hobson Richardson, Marshall Field Wholesale Store, Chicago, 1885-87. (*G 21-96, H 508, J 863*)
2. Gustave Eiffel, Eiffel Tower, Paris, 1889. (*illustrated elsewhere*)
3. Galerie des Machines, Paris International Exposition, 1889. (*G 21-95*)
4. Louis Sullivan, Wainwright Building, St. Louis, 1890-91. (*H 509, J 864*)
5. Louis Sullivan, Prudential Building, Buffalo, New York, 1894-95. (*G 21-97*)
6. Louis Sullivan, Carson Pirie Scott Store, Chicago, 1899-1901. (*G 21-98, H 510, J 865*)
7. Victor Laloux, Gare d'Orsay, Paris, 1898-1900. (*illustrated elsewhere*)

ART NOUVEAU

1. Victor Horta, Salon, Van Eetvelde House, Brussels, 1895. (*G 22-59, H 514*)
2. Hector Guimard, Métro Stations, Paris, c. 1900. (*illustrated elsewhere*)
3. Antonio Gaudi, Church of the Sagrada Familia, Barcelona, 1883-1926. (*H 511*)
4. Antonio Gaudi, Casa Milá, Barcelona, 1905-07. (*H 512, 513; J 867, 868*)

B. PAINTING

The five major movements in nineteenth-century painting include:

1. Neo-Classicism, c. 1770-1820.
2. Romanticism, c. 1800-1850.
3. Realism, c. 1850-1880.
4. Impressionism, c. 1870-1888.
5. Post-Impressionism, c. 1880-1905.

1. Neo-Classicism

PURPOSES: Neo-Classicism began late in the eighteenth century as a reaction against the frivolity of the Rococo. It endeavored to raise morals, inspire patriotism, and further the cause of the American and French Revolutions. Its prime proponents were Jacques-Louis David, Jean-Auguste Dominique Ingres, and the French Academy.

SUBJECT MATTER

1. Subjects emphasizing patriotism or self-sacrifice or promoting austerity and morality were selected from
 a. History (especially Republican Rome).

 b. Mythology of Greece and Rome.

 c. Current events.

2. Portraits of civic and cultural heroes were also popular.

MEDIA AND TECHNIQUES

1. Oil on canvas was predominant.
2. Precise draftsmanship and smooth surfaces without the distraction of visible brushstrokes were considered the marks of good technique.

DESIGN

1. **The style of David and Ingres**
 a. Draftsmanship and line were considered more important than color in defining form.
 b. Solid, statuesque figures were presented in rigid, formal poses.
 c. Figures were lined up in a very shallow space and were usually placed parallel to the picture plane.
 d. Lighting was sharply focused, crisp, often harsh.
 e. Cool colors were preferred for their intellectual detachment.
2. **The French Academy style**
 a. Tried to perpetuate the style of David and Ingres, but produced a generation of imitators rather than innovators.
 b. Attempted to set up a universal standard of "good art," considered Romanticism "bad art," and encouraged a rigid public attitude against innovation.
 c. Seems dated and amusing today, with its contrived poses and exaggerated facial expressions.

2. Romanticism

PURPOSES

1. Intensely emotional expression of romantic ideas.
2. In France, Romanticists and Neo-Classicists shared in the idealization and propagandizing of the Revolution and Napoleon.

SUBJECT MATTER

1. Themes from literature, history, or current events.
2. Themes of man struggling against the elements.
3. Hopeless love.
4. Patriotism and heroism (in France, Gros, Géricault, Delacroix).

5. The horrors of war and the stupidity of mankind (in Spain, Goya).
6. Landscape (in England, Constable and Turner; in Germany, Friedrich).

MEDIA AND TECHNIQUES

1. Oil on canvas, applied with clearly visible, broad brushstrokes producing a thick, rough texture.
2. Watercolor and pen and ink were also used for finished works.

DESIGN

1. Color was considered more important than line or draftsmanship.
2. **England**:
 a. **John Constable** painted landscapes in bright, sparkling, naturalistic colors, in rebellion against the brown tones of the Old Masters. His free brushwork and **broken color** (the juxtaposition of colors to produce vibrant effects) influenced Delacroix.
 b. **J.M.W. Turner** used white priming rather than the traditional buff to give further glow to his heightened colors. For him, the romantic effect of color was more important than fidelity to nature, and this liberation influenced the Impressionists.
 c. **William Blake** continued to illustrate literary works in a style which featured distorted anatomy, abstracted forms, and non-naturalistic color.
3. **France**:
 a. **Girodet, Gros, Géricault, and Delacroix** all emphasized
 (1) Violent action.
 (2) Diagonally-arranged compositions.
 (3) Intensified, Caravaggio-like lighting contrasts.
 b. **Delacroix**, impressed with Constable's color effects, put his hues side by side (unmixed) on the canvas and observed their effects on each other, thus pointing the way for the Impressionists.
4. **Spain**: **Goya** had the following three styles:
 a. Early: bright, happy tapestry designs depicting youthful figures at play.
 b. Mid-career: masterful use of color with contrasting light and dark in portraits and scenes of political upheaval.
 c. Late: tormented, "dark" style, predominantly black tones and somber, depressing subjects.
5. **Germany**: **Friedrich**
 a. Used an almost Neo-Classical, hard-edged style.
 b. Depicted romantic themes of melancholy, alienation, death, and man's defeat by nature.
 c. Has been called a Pre-Surrealist by some scholars.

3. Realism

PURPOSES: Realist painters, rebelling against both Neo-Classicism and Romanticism, tried to portray their subjects true to life and free from idealization of any sort.

SUBJECT MATTER

1. Realists were against
 a. History and mythology.
 b. The Renaissance, Catholicism, and all convention.
 c. Depiction of any subject or event not personally experienced by the artist.
2. Realists favored
 a. Landscape.
 b. Genre.
 c. Depiction of an artist's direct experiences.

MEDIA AND TECHNIQUES

1. Oil and watercolor were used.
2. Corot and the members of the Barbizon School painted outdoors on the site, rather than in the studio. (The Barbizon School was a group of painters working together in the small town of Barbizon, southeast of Paris.)
3. Courbet worked with a palette knife, simplifying his planes. He added finishing touches with a brush.

DESIGN

1. Realists rejected the heightened color of the Romanticists, and used colors true to their subject, either bright or drab. Their colors were often muted and "earthy."
2. **Jean Baptiste Camille Corot** had two styles of landscape painting.
 a. Cubic style: He constructed his forms in terms of tonal values rather than in terms of either drawing (Neo-Classical) or color (Romantic).
 b. Popular style: After 1850, he painted dreamy, fuzzy landscapes in shades of silvery green and grey, each with a touch of red. These often were done from memory, were closer in spirit to Romanticism, and were very popular with the general public.
3. **Jean François Millet** combined landscape and genre as he asserted the nobility of the peasants, portraying them at work, solid and monumental against the sky. He was a member of the Barbizon School, along with Theodore Rousseau and Narcisse Diaz.

4. **Honoré Daumier** produced works with a rough, sketchy quality.
 a. His forms were suggested rather than detailed.
 b. His compositions featured accidental, uncentered views, suggesting the influence of photography.
 c. His work was factual; he did not interpret.
5. **Gustave Courbet**, as a leader of the Realist movement, believed in showing only what he saw or experienced, never what he heard about or imagined.
 a. He specialized in depicting simple life and death.
 b. He often glorified himself in his works.
 c. He used strong contrasts of light and dark, particularly in his early works; later his palette lightened.
6. In America, **Winslow Homer and Thomas Eakins**, both of whom visited France in the 1860s, brought back the influences of Corot and Courbet. Their work in turn influenced the Hudson River School of landscape painting.

4. Impressionism

PURPOSES

1. To record nature impersonally, without interpretation.
2. To oppose the Romanticist idea of art conveying emotion.
3. To capture visual impressions, not permanent aspects of scenes or objects.
4. To oppose the stifling training of the art schools and the French Academy.

SUBJECT MATTER: Impressionist painting did **not** include social commentary, emotional drama, allegories, moral lessons, the ugly or the vulgar. Its subject matter was

1. **Color**, as it changes according to time of day and surrounding environment.
2. **Light** and the transformations it causes on surfaces and spaces.

MEDIA AND TECHNIQUES

1. Oil on canvas, pastel, and watercolor were used.
2. New chemical pigments gave a wider range of colors.
3. Priming canvasses with white gave greater color brilliance.
4. Black was eliminated from the palette.
5. Brushstrokes were short and choppy.
6. Unmixed pigments were juxtaposed.
7. Painting was done outdoors much of the time.

DESIGN

1. **Impressionists followed new color principles:**
 a. The color of an object is modified by
 (1) The quality of the light in which it is seen.
 (2) Reflections from other objects.
 (3) Effects produced by juxtaposed colors.
 b. Complementary colors
 (1) Intensify each other if placed side by side.
 (2) Neutralize each other if mixed beforehand.
 c. Juxtaposition of any two colors for the eye to blend from a distance produces a more intense hue than the mixing of the same colors on the palette.
2. **Outside influences on Impressionism included**
 a. Photography, which resulted in accidental views of people and places, often with asymmetrical compositions and no central focus.
 b. Japanese woodblock prints influenced the interest in flat color areas, unusual spatial organization, and intimate scenes of daily life.
3. **Individual painters included**
 a. **Édouard Manet,** who was trained in the studio of Thomas Couture, an Academic painter, but who quickly developed a unique "flat" style. By 1870, he was fully involved with Impressionism. His early work was influenced by his study of Velázquez, Hals, and Goya. His rejection of strong modeling, perspective, and fluid gradation of lighting, colors, and distances reduced his canvasses to flat surfaces, destroying the "window" illusion established during the Renaissance.
 b. **Claude Monet,** who was the leading Impressionist and adhered most closely to its principles of observation without emotion. He often painted works in series, showing the same subject in changing light.
 c. **Edgar Degas,** who specialized in depicting women, often as ballet dancers and in unflattering poses. He is also known for his lithographs and small sculptures.
 d. **Pierre Auguste Renoir,** who also specialized in painting women, but with a more affectionate, sensual approach than Degas.
 e. **Camille Pissaro,** who is best known for painting street scenes of Paris.
 f. **James Abbott McNeill Whistler,** an American who lived and worked in London, and painted "arrangements" of various objects (including people) having related colors. His compositions were strongly influenced by Japanese prints.

5. **Post-Impressionism**

PURPOSES: Post-Impressionism was not a cohesive movement. It is merely the term used to describe various artists working at the end of the century who were influenced by Impressionism but felt that the Impressionist style was too

limiting. Two main interests developed in opposition to Impressionism from which spring much of twentieth century art:

1. **A desire for permanence of form**, as seen in the work of Cézanne and Seurat. This influenced many twentieth century styles including Cubism, De Stijl, Abstraction, and Hard-Edge.
2. **A desire to use color, line, and pattern expressively** and symbolically, as seen in the work of Van Gogh and Gauguin. This influenced twentieth century styles such as Fauvism, Expressionism, and Surrealism.

MEDIA AND TECHNIQUES

1. Oil on canvas was preferred. Toulouse-Lautrec sometimes painted with oil on cardboard.
2. Moreau and Redon sometimes worked in pastels.
3. Watercolor was used by Toulouse-Lautrec.
4. Aubrey Beardsley worked in pen and ink, and with chalk on paper.
5. Speed varied greatly. Seurat took over a year to complete one canvas; Van Gogh sometimes turned out a canvas a day.
6. Van Gogh often squeezed paint directly from the tube onto the canvas.

DESIGN: Styles were individual:

1. **Paul Cézanne**
 a. Regarded form as all-important.
 (1) He classified all forms into three basic categories: the cone, the cylinder, and the sphere.
 (2) He constructed his forms using color alone. He relied on the psychological effect of warm colors (which appear to come forward) and cool colors (which appear to recede).
 (3) He retained the Impressionist palette and the technique of applying "**color patches**," but used them to construct rather than dissolve forms.
 b. Considered subject matter to be secondary to form. His subjects included
 (1) Still life.
 (2) Landscapes of his native Aix-en-Provence.
 (3) Human forms, often portraits.
2. **Georges Seurat**
 a. Utilitized the scientific color theories of Delacroix, Chevreuil, Helmholtz, and others.
 b. Reduced the color patches of the Impressionists to tiny dots of pure color laid side by side (to be mixed by the observer's eye). The technique has been called Optical Painting, Neo-Impressionism, Divisionism, and Pointilism. Seurat preferred the term **Divisionism**.

 c. Indicated three-dimensional space by the size and placement of objects and by diagonal groupings.

 d. Painted holiday scenes and festive Impressionist subjects with monumental figures reminiscent of Piero della Francesca.

3. **Vincent Van Gogh**

 a. Wanted to express emotion through his art.

 (1) He attached symbolic meanings to his colors.

 (2) He used arbitrary color, not locally-true color, for emotional effect.

 b. Changed his palette from dark to light.

 (1) His earliest works were done primarily in grays, greens, browns, and black.

 (2) His later works, under the influence of Impressionism and Japanese prints, were done in brighter colors.

 c. Changed his style according to his mental state.

 (1) When stable he used clear colors, correct perspective, strong, straight strokes.

 (2) When disturbed he used acid colors, distorted perspective, violent, swirling strokes.

4. **Paul Gauguin**

 a. Rebelled against European civilization, wished to renew western art with elements derived from primitive art.

 (1) He chose to depict life in "backward" areas such as Brittany and Tahiti.

 (2) His style was influenced by Oriental and Primitive art, and by Medieval European stained glass.

 (a) His exaggerated color was used decoratively and to express emotion.

 (b) His forms were flat with masses simplified into patterns without perspective or chiaroscuro.

 (c) His line was rhythmic, decorative, and distorted for expressive purposes.

 (d) His composition was influenced by photography, with cut-off views and accidental poses.

5. **Henri de Toulouse-Lautrec**

 a. Depicted the **demi-monde** (fringes of society) where he found acceptance. His subjects included scenes of night clubs, theaters, cafes, restaurants, brothels, etc.

 b. Was influenced by Degas and Gauguin, Japanese prints, and photography.

 (1) His compositions were asymmetrical, oblique, with cut-off views.

 (2) He used strong line and flat color areas.

 (3) His observations were totally objective, detached.

6. **The Symbolists**
 a. Gustave Moreau and Odilon Redon, rebelling against the objectivity of Impressionism and Realism, wanted to penetrate beyond the visible and "to clothe the idea in sensuous form."
 b. Moreau painted dream-like scenes; Redon painted fantastic creatures or objects.
 c. Their style involved glowing color and blurred outlines.

7. **Henri Rousseau**
 a. Painted imaginary scenes combining fact and fantasy.
 b. His style was uniquely his own: flat, decorative, and unintentionally sophisticated.

8. **Art Nouveau** (more predominant in architecture and the decorative arts than in painting):
 a. Aubrey Beardsley (English) produced literary illustrations featuring highly erotic figure groups.
 b. The style is recognized by its flowing, whiplash line (sharp curves), and flat pattern.

9. **James Ensor**, a Belgian
 a. Endeavored to shock the public by satirizing society and organized religion.
 b. Was influenced by Bosch, Breugel, Goya, and Daumier.
 (1) His works depict grotesque figures, skeletons, and carnival masks.
 (2) These images symbolize the evil, indifference, and stupidity of modern civilization.
 c. Influenced twentieth century German Expressionists.
 (1) Strong, bright color.
 (2) Abundant details.
 (3) Crowded figures in groups.

10. **Edvard Munch**, a Norwegian
 a. Expressed emotion, anxiety, fear, and hysteria in his work, using subjects that showed his preoccupation with sex, death, and loneliness.
 b. Was influenced by Van Gogh, Gauguin, and Toulouse-Lautrec.
 (1) He used color arbitrarily for emotional expression.
 (2) Strong color and pattern characterize his work.
 c. Influenced twentieth century German Expressionists.

EXAMPLES (all works are oil on canvas unless otherwise noted)

NEO-CLASSICISM

1. Jacques-Louis David, *Oath of the Horatii,* 1784, 14 by 11 ft. (*G 20–37, H 366*)
2. Jacques-Louis David, *Death of Socrates,* 1787, 59 by 78 in. (*J 736*)

3. Jacques-Louis David, *Death of Marat*, 1793, 5 by 4 ft. (*G 20-38, H 367, J 737*)

4. Jacques-Louis David, *View of Luxembourg Gardens*, 1794, 21 by 30 in. (*J 738*)

5. Jacques-Louis David, *The Coronation of Napoleon and Josephine*, 1805-07, 20 by 30 ft. (*H 368*)

6. Jean-Auguste Dominique Ingres, *François Marius Granet*, 1807, 28 by 24 in. (*G 21-25*)

7. J.A.D. Ingres, *Oedipus and the Sphinx*, 1808, 74 by 56 in. (*G 21-23*)

8. J.A.D. Ingres, *Valpinçon Bather*, 1808, 57 by 38 in. (*H 369*)

9. J.A.D. Ingres, *Grande Odalisque*, 1814, 35 by 63 in. (*G 21-24, J cpl 91*)

10. J.A.D. Ingres, *Louis Bertin*, 1832, pencil sketch and oil painting. (*J 740, 741*)

11. J.A.D. Ingres, *The Apotheosis of Homer*, 1827, 13 by 17 ft. (*H 370*)

12. J.A.D. Ingres, *Comtesse d'Haussonville*, 1845, 53 by 36 in. (*H cpl 50*)

ACADEMIC PAINTERS

1. Thomas Couture, *Romans of the Decadence*, 1847, 15 by 25 in. (*G 21-29*)

2. Jean-Léon Gérôme, *Thumbs Down!*, 1858, 69 by 40 in. (*G 21-31*)

ROMANTICISM

1. Francisco Goya, *The Parasol*, 1777, design for tapestry, 41 by 59 in. (*illustrated elsewhere*)

2. Francisco Goya, *The Family of Charles IV*, 1800, 9 by 11 ft. (*G 21-9, H 376, J 742*)

3. Francisco Goya, *Maja Desnuda*, 1800, 37 by 75 in. (*H cpl 51*)

4. Francisco Goya, *Third of May 1808*, 1814, 9 by 11 ft. (*G 21-10, H 377, J cpl 92*)

5. Francisco Goya, *Saturn Devouring His Children*, 1819-23, detached fresco on canvas, 5 by 3 ft. (*G 21-12, H 380*)

6. Anne-Louis Girodet, *Burial of Atala*, 1808, 7 by 9 ft. (*G 21-13*)

7. Antoine Jean Gros, *The Pest House at Jaffa*, 1804, 17 by 24 ft. (*G 21-14*)

8. Antoine Jean Gros, *Napoleon at Eylau*, 1808, 18 by 26 ft. (*H 381*)

9. Théodore Géricault, *Mounted Officer of the Imperial Guard*, 1812, 10 by 6 ft. (*G 21-16, H 382, J cpl 93*)

10. Théodore Géricault, *The Raft of the Medusa*, 1818-19, 16 by 23 ft. (*G 21-15, H 383, J 744*)

11. Théodore Géricault, *Madwoman*, 1822-23, 28 by 21 in. (*G 21-17, H 384*)

12. Eugène Delacroix, *The Bark of Dante*, 1822, 74 by 97 in. (*H 385*)

13. Eugène Delacroix, *The Massacre at Chios*, 1822-24, 14 by 12 ft. (*H cpl 52, J 746*)

14. Eugène Delacroix, *Greece Expiring on the Ruins of Missolonghi*, 1826, 7 by 8 ft. (*J cpl 94*)
15. Eugène Delacroix, *The Death of Sardanapolis*, 1826, 12 by 16 ft. (*G 21-18, H 386*)
16. Eugène Delacroix, *Liberty Leading the People*, 1830, 11 by 8 ft. (*G 21-20*)
17. Eugène Delacroix, *Paganini*, 1832, oil on cardboard, 17 by 12 in. (*G 21-27*)
18. Eugène Delacroix, *Women of Algiers*, 1834, 71 by 90 in. (*H 387*)
19. Eugène Delacroix, *Medea*, 1838, 30 by 65 in. (*G 21-19*)
20. Eugène Delacroix, *Frédéric Chopin*, 1838, 18 by 15 in. (*J 748*)
21. William Blake, *Circle of the Lustful*, illustration for Dante's *Inferno*, 1824-27, watercolor, 15 by 20 in. (*H 391*)
22. John Constable, *The Hay Wain*, 1821, 50 by 30 in. (*G 21-34, H 392*)
23. John Constable, *Salisbury Cathedral from the Bishop's Garden*, c. 1826, 35 by 44 in. (*illustrated elsewhere*)
24. John Constable, *Stoke-by-Nayland*, 1836, 50 by 66 in. (*H cpl 53, J 733*)
25. J.M.W. Turner, *The Slave Ship*, c. 1839, 35 by 48 in. (*G 21-33, H 393, J cpl 95*)
26. J.M.W. Turner, *The Fighting Téméraire*, 1838-39, 36 by 48 in. (*illustrated elsewhere*)
27. J.M.W. Turner, *Rain, Steam, and Speed*, 1844, 35 by 48 in. (*H cpl 54*)
28. Caspar David Friedrich, *Cloister Graveyard in the Snow*, 1819, 47 by 70 in. (*G 21-38, H 394*)
29. Caspar David Friedrich, *The Polar Sea*, 1824, 38 by 50 in. (*J 734*)

REALISM

1. Jean Baptiste Camille Corot, *Papigno*, 1826, 13 by 16 in. (*J 753*)
2. Jean Baptiste Camille Corot, *Chartres Cathedral*, 1830, 25 by 19 in. (*H 401*)
3. Jean Baptiste Camille Corot, *The Harbor of La Rochelle*, 1851, 20 by 28 in. (*G 21-39*)
4. Jean Baptiste Camille Corot, *Ville d'Avray*, 1870, 22 by 31 in. (*H 402*)
5. Jean François Millet, *The Sower*, 1850, 40 by 32 in. (*H 403, J 754*)
6. Jean François Millet, *The Gleaners*, 1857, 33 by 44 in. (*G 21-40*)
7. Honoré Daumier, *The Uprising*, c. 1860, 33 by 43 in. (*H 405*)
8. Honoré Daumier, *Third Class Carriage*, 1862, 25 by 35 in. (*G 21-42, H 406, J 750*)
9. Gustave Courbet, *The Stone Breakers*, 1849, 5 by 7 ft. (*G 21-43, H 407, J 764*)
10. Gustave Courbet, *Burial at Ornans*, 1849, 10 by 22 ft. (*G 21-44, H cpl 55*)
11. Gustave Courbet, *The Artist in his Studio*, 1854-55, 12 by 19 ft. (*H 408, J 765*)
12. Winslow Homer, *The Croquet Game*, 1866, 16 by 26 in. (*H 411*)

13. Winslow Homer, *The Morning Bell*, c. 1866, 24 by 38 in. (*J 777*)
14. Thomas Eakins, *The Gross Clinic*, 1875, 96 by 78 in. (*G 21-48, H 412, J 778*)

MANET: FLAT STYLE

1. *Déjeuner sur l'Herbe (Luncheon on the Grass)*, 1863, 7 by 9 ft. (*G 21-45, 46; H 414*)
2. *Olympia*, 1863, 51 by 75 in. (*illustrated elsewhere*)
3. *The Fifer*, 1866, 63 by 38 in. (*J cpl 96*)
4. *The Execution of Emperor Maximilian*, 1867, 8 by 12 ft. (*H 415*)

IMPRESSIONISM

1. Édouard Manet, *The Bar at the Folies-Bergère*, 1882, 37 by 51 in. (*G 21-47, H 419, J 766*)
2. Claude Monet, *Women in the Garden*, 1866-67, 8 by 7 ft. (*H 416*)
3. Claude Monet, *The River*, 1868, 32 by 40 in. (*J cpl 97*)
4. Claude Monet, *Impression: Sunrise, Le Havre*, 1872, 19 by 25 in. (*H 413*)
5. Claude Monet, *Rouen Cathedral*, series, 1894. (*G 21-64, H cpl 56*)
6. Claude Monet, *Water Lilies*, series, 1907-20. (*H 418, J 722*)
7. Camille Pissarro, *Place du Théâtre Français*, 1895, 38 by 36 in. (*G 21-65*)
8. Pierre Auguste Renoir, *La Moulin de la Galette*, 1876, 51 by 69 in. (*G 21-66, H cpl 57, J 767*)
9. Edgar Degas, *Viscount Lepic and His Daughters*, 1873, 32 by 48 in. (*G 21-69*)
10. Edgar Degas, *The Ballet Rehearsal (Adagio)*, 1876, 26 by 32 in. (*G 21-67, H 422*)
11. Edgar Degas, *The Glass of Absinthe*, 1876, 36 by 26 in. (*H 423, J 768*)
12. Edgar Degas, *Two Laundresses*, 1884, 29 by 32 in. (*H 424*)
13. Edgar Degas, *After the Bath*, 1889-90, pastel, 29 by 22 in. (*H 425*)
14. James Abbott McNeill Whistler, *Arrangement in Black and Gray: The Artist's Mother*, 1871, 57 by 64 in. (*J 776*)
15. James Abbott McNeill Whistler, *Portrait of Thomas Carlyle: Arrangement in Gray and Black No. 2*, 1872, 68 by 56 in. (*H 426*)
16. James Abbott McNeill Whistler, *Nocturne in Black and Gold, Falling Rocket*, 1874, oil on panel, 24 by 18 in. (*H 427, J cpl 99*)

POST-IMPRESSIONISM

1. Paul Cézanne, *Self-Portrait*, 1879, 14 by 11 in. (*J cpl 100*)
2. Paul Cézanne, *Mont Ste. Victoire*, 1886-88, and 1898-1900, 26 by 35 in. (*G 21-74, H 433, J 787*)
3. Paul Cézanne, *The Card Players*, 1890-92, 53 by 71 in. (*H 435*)
4. Paul Cézanne, *Boy in a Red Vest*, 1893-95, 35 by 28 in. (*G 21-75*)

5. Paul Cézanne, *Still Life with Apples and Oranges,* 1895-1900, 28 by 36 in. (*H 434*)
6. Paul Cézanne, *Woman with a Coffeepot,* 1895, 51 by 38 in. (*H cpl 58*)
7. Paul Cézanne, *Bathers,* 1898-1905, 82 by 98 in. (*H 436*)
8. Georges Seurat, *Sunday Afternoon on the Island of La Grande Jatte,* 1884-86, 7 by 10 ft. (*G 21-72, H cpl 59*)
9. Georges Seurat, *Bathers,* 1884-85, 79 by 118 in. (*H 437, J 788*)
10. Georges Seurat, *The Side Show,* 1887-88, 40 by 60 in. (*J cpl 101*)
11. Vincent Van Gogh, *The Potato Eaters,* 1885, 32 by 45 in. (*J 789*)
12. Vincent Van Gogh, *The Night Café,* 1888, 28 by 36 in. (*G 21-76, H 441*)
13. Vincent Van Gogh, *View of La Crau,* 1888, 28 by 36 in. (*H 440*)
14. Vincent Van Gogh, *Wheat Field and Cypress Trees,* 1889, 39 by 36 in. (*J cpl 102*)
15. Vincent Van Gogh, *Self-Portrait,* 1889, 22 by 17 in. (*H 442, J 790*)
16. Vincent Van Gogh, *The Starry Night,* 1889, 28 by 36 in. (*G 21-77, H cpl 61*)
17. Paul Gauguin, *Vision After the Sermon (Jacob Wrestling with the Angel),* 1888, 28 by 36 in. (*H 439, J cpl 103*)
18. Paul Gauguin, *The Spirit of the Dead Watching,* 1892, 39 by 36 in. (*G 21-78*)
19. Paul Gauguin, *The Day of the God,* 1894, 27 by 35 in. (*H cpl 60*)
20. Henri de Toulouse-Lautrec, *At the Moulin Rouge,* 1892, 49 by 55 in. (*G 21-79, H 438, J cpl 104*)
21. Gustave Moreau, *The Apparition (Dance of Salome),* 1876, 21 by 17 in. (*J 792*)
22. Odilon Redon, *Orpheus,* 1903, pastel, 27 by 22 in. (*H 443*)
23. Henri Rousseau, *The Sleeping Gypsy,* 1897, 51 by 79 in. (*H cpl 62*)
24. Henri Rousseau, *The Dream,* 1910, 7 by 10 ft. (*G 21-85, J cpl 105*)
25. Aubrey Beardsley, *John the Baptist and Salome,* c. 1894, pen and brush, black ink and chalk on paper, 9 by 6 in. (*H 447, J 794*)
26. James Ensor, *The Entry of Christ into Brussels,* 1888, 8 by 14 ft. (*G 21-83, H 445*)
27. Edvard Munch, *The Scream,* 1893, 36 by 29 in. (*G 21-84, H 447, J 797*)

C. GRAPHICS

PURPOSES AND SUBJECT MATTER: Prints were often used for social and political commentary as well as for purely artistic purposes. Subjects paralleled those portrayed in painting.

MEDIA AND TECHNIQUES

1. **Etching,** combined with aquatint, continued to be the most popular technique. Artists such as Goya were able to create striking prints with rich tonal gradations.

2. **Woodcut** was revived late in the century. Its unpredictability, which caused its decline in the sixteenth century, was the very source of its appeal to artists such as Gauguin and Munch.

3. **Lithography** was invented in Germany in 1798 and became very popular in the nineteenth century for both commercial and artistic printing. The process involves drawing with a greasy crayon on a specially prepared smooth limestone block. After wetting the block with water, the stone is inked with a roller and printed. The ink adheres only to the areas drawn on with the crayon and the rest of the stone prints blank. Goya, Géricault, Daumier, Toulouse-Lautrec, and Munch are known for their lithographs. The process has continued to be important in the twentieth century.

DESIGN: As in earlier centuries, printmaking generally followed the stylistic trends in painting.

EXAMPLES

ETCHING

1. Francisco Goya, *The Sleep of Reason Produces Monsters,* from *Los Caprichos,* 1796-98, 7 by 5 in. (*G 20-44, H 378*)
2. Francisco Goya, *Unbridled Folly,* from *Los Disparates,* 1813-19, 8 by 12 in. (*H 379*)

LITHOGRAPH

1. Honoré Daumier, *Rue Transnonain,* 1834, 12 by 18 in. (*G 21-41, H 404*)
2. Odilon Redon, *The Balloon Eye,* from the series *À Edgar Poe,* 1882. (*H 793*)
3. Henri de Toulouse-Lautrec, *La Goulue at the Moulin Rouge,* poster, 1891, 65 by 46 in. (*illustrated elsewhere*)

WOODCUT

1. Paul Gauguin, *Offerings of Gratitude,* 1891-93. (*J 791*)
2. Edvard Munch, *Anxiety,* 1896. (*illustrated elsewhere*)

D. SCULPTURE

In the first half of the century, sculpture consisted mostly of monuments to recent events or heroes and was not as innovative as either painting or architecture. At the end of the century, Auguste Rodin made sculpture once again the equal of the other arts.

1. Neo-Classicism

PURPOSES AND SUBJECT MATTER: The depiction of public figures as heroes or deities.

MEDIA AND TECHNIQUES: Marble was often over-polished. The extremely smooth finish destroyed the stone's natural translucency.

DESIGN: The style was somewhat **stiff and cold.**

1. Idealization of contemporary figures as Greek or Roman gods was often unmoving or unconvincing.
2. The faces lacked expression and even looked vacant. (This was due in part to the practice of leaving the irises and pupils of the eyes uncarved in imitation of Greek sculpture. The Greeks, however, remedied this vacancy by painting in the details.)

2. Romanticism

PURPOSES AND SUBJECT MATTER: Used for memorials and architectural embellishment, the works depicted allegorical and real figures in emotional or dramatic poses.

MEDIA AND TECHNIQUES

1. Stone and bronze were used.
2. Forms were deeply undercut for dramatic lighting contrasts.

DESIGN

1. Figures were often shown in classical undress, but with the effect of appearing naked, not nude.
2. Poses and expressions were exaggerated and theatrical in the manner of Hellenistic or Baroque works.

3. Auguste Rodin

The first sculptor of genius since Bernini, Rodin laid the foundations of modern sculpture with his exploration of new concepts of form and design although his style was too personal to produce direct followers.

PURPOSES AND SUBJECT MATTER

1. Rodin used the human figure to personify various emotions and ideas.

2. He pioneered the use of the fragment or partial figure as a legitimate sculptural form.

MEDIA AND TECHNIQUES

1. Rodin preferred to model his forms in clay or wax and cast them later in bronze or have them carved in marble by a stonecutter. Many of the bronzes were cast after his death. Frequently, multiple castings were poured, all considered originals.
2. His forms usually combined smooth and rough textures, complete and unfinished sections (probably due to the influence of Michelangelo's *Slaves* and *Rondanini Pietà*).
3. His marble figures were only lightly polished to retain the natural luminosity of the stone.

DESIGN: Rodin's style was a personal mixture of Impressionistic and Expressionistic interests as well as influences from Michelangelo's work.

1. **From Michelangelo's work**
 a. He learned technique as well as design concepts.
 b. He derived many powerful subjects (such as *The Gates of Hell*).
 c. He created figures that seemed to emerge from the material and to express themselves.
2. **Like the Impressionists**
 a. Rodin portrayed figures in "accidental" postures rather than in contrived poses.
 b. He tried to portray the changing effects of light on form.
 c. He did not idealize his figures.
 d. He often suggested parts of figures with shadow and texture, rather than showing them explicitly.
3. **Like the Expressionists**
 a. He emphasized emotional impact.
 b. He expressed personal rather than public or universal beliefs.

EXAMPLES
NEO-CLASSICISM

1. Antonio Canova, *Pauline Borghese as Venus,* 1808, marble. (*G 21-5, H 374, J 756*)
2. Horatio Greenough, *George Washington,* 1832–41, marble. (*G 21-6*)
3. Jean Pierre Cortot, *Apotheosis of Napoleon,* left relief of the Arch of Triumph, Paris, 1838. (*illustrated elsewhere*)

ROMANTICISM

1. François Rude, *La Marseillaise,* right relief of the Arch of Triumph, Paris, 1833-36. (*G 21-7, H 389, J 760*)
2. Gustave Doré, *D'Artagnan,* Monument of Alexandre Dumas, 1832. (*G 21-87*)
3. Antoine-Louis Barye, *Jaguar Devouring a Hare,* 1850-51. (*G 21-8, J 762*)
4. Jean Baptiste Carpeaux, *The Dance,* 1867-69. (*H 390, J 763*)

AUGUSTE RODIN

1. *The Man with the Broken Nose,* 1864, bronze. (*J 779*)
2. *The Age of Bronze,* 1876, bronze. (*H 428*)
3. *The Burghers of Calais,* 1884-86, bronze. (*G 21-90, H 431*)
4. *The Kiss,* 1886-98, marble. (*G 21-91, H 429, J 782*)
5. *Balzac,* 1895-97, bronze. (*G 21-92, H 432, J 783*)
6. *The Gates of Hell,* 1880-1917, bronze, 18 by 12 ft. (*H 430*)

VOCABULARY

Art Nouveau	curtain wall	lithography
broken color	Divisionism/Pointilism	

18. Twentieth Century Art

SUMMARY

Architecture: Individual and group styles have developed.

> **Pioneers** of the late nineteenth century stimulated early twentieth century structural developments and decorative changes.
>
> **Expressionism** had limited initial success, but influenced later design concepts and practices.
>
> **Frank Lloyd Wright** developed open and cross-axial plans. His ideas on aesthetics had major international impact.
>
> **Le Corbusier** introduced pilotis, beton brut concrete, and brise-soleils. His ideas also had international significance.
>
> **International Style** variations emphasized unrelieved rectangular units grouped asymmetrically, steel-and-glass construction, and austere design. This style is often considered the most influential of the century, especially affecting the skyscraper.
>
> **Post-World War II** design reacted against the International Style. Several individual styles have been very sculptural.

Painting: Early styles were directly affected by Post-Impressionism. Since 1940, artists in the United States have provided artistic leadership.

> **Fauvism** (Matisse, Derain) liberated color for expressive use.
>
> **Expressionism** included various individuals and groups in Europe who emphasized emotional content over form.
>
> **Cubism** and its offshoots broke natural objects into component geometric shapes and planes. Orphism, Futurism, De Stijl, and Suprematism-Constructivism were based directly on Cubism.
>
> **Fantasy, Dada, and Surrealism** demanded the liberation of art from reason, focusing on the imagination and the subconscious.
>
> **American Modernists** from 1900–1940 tried to catch up with Europe.
>
> **Abstract Expressionism** was the first major style developed in the United States. The artists focused on the act of painting. Many styles have developed from the work of Pollock, de Kooning, etc.
>
> **Realism, Social Realism, and Photorealism** retained an interest in representational subjects portrayed naturalistically.
>
> **Pop, Op,** and related styles have dominated the years since 1960.

Sculpture: Early twentieth century sculptors responded to Rodin, either reacting against him or following his expressive lead. Cubism stimulated the interest in abstract geometric form. Most of the sculpture styles have paralleled painting styles. Recently, the use of mixed media has blurred the line between painting and sculpture.

A. ARCHITECTURE

Twentieth century architects in America and Europe have been most innovative in the design of private homes and public buildings such as banks, museums, stadiums, and commercial and industrial structures. The evolution of new materials such as reinforced and pre-stressed concrete and new structures such as skyscrapers has been especially dramatic. There have been several stylistic changes stimulated by the theories and work of Frank Lloyd Wright, Le Corbusier, Walter Gropius, Ludwig Mies van der Rohe, Philip Johnson, and many others.

1. Pioneers of Modern Architecture

Nineteenth century work by Paxton, Labrouste, Le Baron Jenny, Richardson, Sullivan, Horta, Guimard, and Gaudi provided the stimulus for early twentieth century architects and established many of the fundamental principles and practices of modern architecture. (See the previous chapter for details.)

1. **Cast-iron and glass exhibition halls** led to the development of
 a. Prefabricated construction elements.
 b. Open interiors supported by external "skeletons" and uninterrupted by interior vertical supports.
 c. Glass "skins" or curtain walls for enclosure rather than structural support.
2. **Steel and masonry commercial building** in the United States led to the development of
 a. The skyscraper concept of potentially limitless vertical space.
 b. The integration of architecture and structural engineering, as expressed by Sullivan's slogan "Form follows function."

NOTE: Architects continued to clothe their modern structures with masonry and traditional decorative detailing in Neo-Classical and Gothic Revival styles well into the twentieth century.

3. **Art Nouveau** (which continued until World War I) developed
 a. Humanization of forms. The use of random shapes, curves, and organic motifs in asymmetrical designs softened the effects of the new industrial materials (metal, glass, concrete) and modern building types.
 b. Emphasis on individual experimentation and expression. Standardization was contrary to the ethic of Art Nouveau, and architects designed unique doors, window frames, furniture, and fixtures for each new building. As architects tired of the creative demands, the lack of standardization led to faddish vulgarization.

2. Expressionist Architecture

BUILDING TYPES: Primarily secular, public buildings and monuments.

MEDIA AND TECHNIQUES

1. Reinforced concrete was used in daring shapes. (**Reinforced concrete** has steel bars embedded in the concrete, combining the compressive strength of concrete with the tensile strength of steel. This material is free from the danger of rupture by fire because the expansion rates of concrete and steel are the same.)
2. Due to shortages after World War I, some buildings which were designed for poured reinforced concrete were executed in other materials, such as the Einstein Tower in Potsdam, Germany which was built with brick and covered with stucco.

DESIGN: Influenced by German Expressionist painting and by Art Nouveau, Expressionist architects such as Berg and Mendelsohn were primarily concerned with experimentation and individual expression.

3. Frank Lloyd Wright

Frank Lloyd Wright was one of the century's most influential architects. His concepts have affected architecture throughout the industrialized world as well as in his native America.

BUILDING TYPES: Wright designed private homes, churches, industrial buildings, offices, stores, and museums. His early period is best known for his "prairie houses."

MEDIA AND TECHNIQUES

1. Wright used natural materials: rough-cut stone, marble, brick, wood.
2. He also used industrial materials: steel, glass, and reinforced concrete.
3. He designed new lighting and heating methods for his buildings.

DESIGN

1. Space rather than mass was one of his main concerns.
2. Interlocking geometric forms were used to provide fluid relationships of rooms and spaces, avoiding boxlike rooms. The cross-axial (L, T, X) plan was his specialty.
3. Site accommodation was a primary concern: his designs were intended to harmonize or blend with the landscape and generally emphasized horizontality.

4. Furniture was often designed by Wright to complement his office and house projects (an influence from Art Nouveau's philosophy that the architect had total design control).
5. Asymmetrical balance and the "open plan" were significant.
6. The cantilever was used extensively and innovatively.

4. International Style

The International Style developed between the first and second world wars as a synthesis of ideas and practices of several individuals and countries. Most scholars consider it the most influential style of the century.

PURPOSES AND BUILDING TYPES

1. The goal of International Style architects was to produce functional and aesthetically pleasing buildings using the new methods, materials, and philosophies of the "machine age" rather than drawing from the past.
2. Houses, apartments, industrial buildings, and skyscrapers were built in this style in the United States and Europe.

MEDIA AND TECHNIQUES

1. New industrial materials such as reinforced concrete, steel beams, and expanses of glass were used.
2. Natural materials were usually shunned as inappropriate to the spirit of the technological age.
3. Surfaces were given smooth finishes and textures. Color was usually white. Sometimes accents of primary colors were added.

DESIGN: Sources for the style include

1. The rationalist writings of Viollet-le-Duc. This nineteenth century architect specialized in the restoration of Medieval buildings. His writings explained the logic, structure, and building practices of Gothic design and advocated the modern use of Gothic principles of exposed structure and economy of design in which every element used was essential.
2. The functionalist writing and work of Louis Sullivan, Otto Wagner, and Adolf Loos. Sullivan (American): "Form follows function." Wagner (Austrian): "Form derives from structure and materials." Loos (Austrian): "Ornamentation is equated to crime."
3. The writing and work of Frank Lloyd Wright. In 1910, a book about Wright's work was published in Berlin. His ideas on space, form, and unity of design influenced European architects years before they affected American design. His use of the cantilever, cross-axial and open plans, sweeping planes and overhanging roofs had enormous impact.

4. Industrial design, structural engineering, and the idealization of the machine and technology.

EXPRESSIONS OF THE INTERNATIONAL STYLE (also called Functionalism) include

1. **De Stijl ("The Style") in Holland:**
 a. This style was based on Cubism and the ideas of Wright.
 b. **Basic elements include**
 (1) Emphasis on white (walls), black (window frames, beams), and primary colors (accents) also seen in De Stijl painting (Mondrian).
 (2) Forms composed of intersecting planes and simple geometric units.
 (3) Austerity of design with very little ornament. Large graphics (letters) were used as design elements in some projects.
2. **Le Corbusier's work in France:**
 a. His remark that a house is a "machine for living" illustrates his generation's idealization of technology.
 b. **Basic elements include**
 (1) Buildings contrasting with the landscape (contrary to Wright's belief in harmony of site and building); emphasis on verticality.
 (2) Free, open plans, ambiguity of interior and exterior space.
 (3) Flat roofs, usable as living spaces, decks, gardens.
 (4) Continuous bands of windows.
 (5) Development of **"pilotis"** or poles as structural supports for upper stories. This allowed ground floor space to be open.
 (6) Free facades, independent of the structure.
3. **The Bauhaus in Germany:**
 a. This school of design was founded in Weimar in 1906, by Henri Van de Velde, reorganized in 1919 by Walter Gropius, relocated to Dessau in 1925, and closed down by the Nazis in 1933. The curriculum was designed to unify the arts, architecture, and industrial design and to encourage collaboration or group design.
 b. The Bauhaus complex in Dessau is often considered the first articulate expression of the International Style. Its designer, Gropius, and his successor, Ludwig Mies van der Rohe, led in development of the style.
 c. **Basic elements include**
 (1) Precision, simplicity, and clarity of design as expressed by Mies van der Rohe's statement "Less is more."
 (2) Structure clearly revealed in the use of unrelieved cubic, angular units of glass and steel.
 (3) Open, asymmetrical plans without interior load-bearing walls; movable interior partitions were used.

(4) Overall impression of "transparent structures" of steel and glass, white plastered walls (where there are any walls), and lack of sculptural ornamentation. (Graphic designs and lettering were used for visual interest.)

d. Because of the rise of Hitler and the coming of World War II, many designs from the 1920s and 1930s were not realized until much later. Many of the teachers and students of the Bauhaus fled to America and other countries.

5. Skyscrapers

The skyscraper originated in the United States at the end of the nineteenth century with work by Le Baron Jenny, Richardson, and Sullivan. To many, it has become the symbol of the twentieth century.

PURPOSES: Skyscrapers have been used primarily as office or apartment buildings.

MEDIA AND TECHNIQUES: Skyscrapers were made possible by the development of:

1. Structural steel and reinforced concrete.
2. The elevator, and complex mechanical systems for lighting, heating, cooling, and plumbing.
3. Standardization of parts and mass-production of materials.

DESIGN

1. Before the 1930s, ornament and decoration were based on historical styles, especially in the United States.
2. The International Style deeply affected the development of skyscrapers after 1920. Hood and Howell's New York Daily News Building was the first International Style skyscraper and the first to discard all reference to the past.
3. The first totally glass and steel skyscraper was Lever House in New York, built in 1952. (Mies van der Rohe had designed a glass and steel skyscraper in 1920, but it was never built.)
4. "Set-back" regulations and allowances have affected the shape of skyscrapers.
 a. In the thirties and forties, upper stories were stepped back or recessed to conform to set-back laws and to provide air and light for the lower stories.
 b. Following World War II, many of the set-back laws were changed and skyscrapers became vertical "slabs" such as the United Nations Secretariat Building in New York (1947–50) and the Lake Shore Drive Apartments in Chicago (1950).
 c. Since 1970, many variations in shape have been produced, including the I.D.S. Center in Minneapolis with vertical rather than horizontal set-backs, resulting in a curved surface and semi-elliptical ground plan.

6. Countercurrents after World War II

Even as the International Style has continued and evolved, several other trends and styles have developed since 1945.

BUILDING TYPES: A proliferation of stadiums, airport terminals, and museums has occurred along with the continuation of apartment buildings, private houses, office buildings, churches, banks, etc.

MEDIA AND TECHNIQUES

1. New treatment of raw concrete. Le Corbusier pioneered the practice of leaving concrete just as it came from its wooden molds, retaining its natural gray color and mold markings. In French, this is called "**beton brut.**" It has led to a style called "Brutalism."
2. Precasting of units to be assembled on the site (called **tilt-wall construction**) as used by Moshe Safdie in Habitat for Montreal's EXPO in 1967.
3. **Pre-stressed and post-stressed concrete,** often used in fluid, daring shapes. (Pre-stressed and post-stressed concrete differ from reinforced concrete in that the reinforcing bars are fastened at both ends and kept under constant tension. They differ from each other in the application of the tension either before or after the concrete is poured.)

DESIGN

1. **Innovations**
 a. **The brise-soleil** (sun-break) was introduced by Le Corbusier as a reaction against smooth, slab walls. This resulted in a setting-back of windows and created an egg-crate effect on building facades. Its purpose was to reduce glare and heat build-up in sunny areas.
 b. **New, unprecedented shapes,** often blurring the distinction between roof and walls, were made possible by pre- and post-stressed concrete.
 c. **Adaptation to the site.** Whereas International Style buildings tended to dominate their sites, some new styles blend with the site. The Oakland Art Museum in California combines site accommodation with Le Corbusier's roof garden ideas. The Modern Wing of the National Gallery in Washington, D.C., is wedge-shaped to make maximum use of its site.
 d. **The geodesic dome.** Spherical buildings built of identical geometric units that are mutually supporting can be made of any opaque or transparent material at low cost. The American Pavilion at EXPO '67 by R. Buckminster Fuller is an example.
2. **Styles**
 a. **Brutalism**
 (1) Objective: a ruthlessly straightforward architecture opposed to the clean machine finish, the simple cube and the thin-shelled enclosure of the International Style, but favoring economy and comfort.

 (2) Design: all services (such as pipes and elevators) exposed, rough concrete; large-scale, dramatic buildings.

 b. **Formalism**

 (1) Objective: buildings that are attractive to look at. Formalists are opposed to the "sameness" and austerity of the International Style and in favor of decorative embellishment.

 (2) Design: perforated grillwork facades; showy, flashy buildings; embellishment influenced by Neo-Classicism.

 c. **Sculptural-Expressive**

 (1) Objective: new forms. Developed from Ronchamp.

 (2) Design: individually expressive buildings.

3. **Individual innovators**

 a. **Louis I. Kahn:** Inspired by the forms of the Medieval town of San Gimignano, Italy, the architect designed high, brick towers into which he put service elements such as elevators, stairs, and heating ducts for the Richards Medical Research Building in Philadelphia. With a special interest in lighting effects, he illuminated the Kimbell Art Museum in Fort Worth with skylights, and he added baffles to soften the glare.

 b. **Robert Venturi:** A student of Kahn, he advocates a return to the decorative language of the past. Reacting against the austerity of Mies van der Rohe, he states, "Less is a bore."

 c. **Rogers and Piano:** Taking the concept of exposed structure to its limit, they have created one of the most controversial buildings in many years. In their Centre Pompidou, primarily a gigantic steel and glass structure, not only are the service elements exposed, they are colored-coded: red for traffic elements (elevators and moving stairs), yellow for wiring, green for water pipes, and blue for air ducts.

EXAMPLES

PIONEERS OF MODERN ARCHITECTURE: See Chapter Seventeen for cast iron, USA Commercial building, and early examples of Art Nouveau.

ART NOUVEAU

1. Charles Rennie Mackintosh, Glasgow School of Art, 1896–1910. (*J 869, 870*)
2. Antonio Gaudi, Casa Milá, Barcelona, 1905–07. (*G 22-60; H 512, 513; J 867*)
3. Henry van de Velde, Theater, Werkbund Exhibition of 1914, Cologne. (*J 871*)
4. Bruno Taut, Staircase of the "Glass House," Werkbund Exhibition of 1914, Cologne. (*J 873*)

EXPRESSIONISM

1. Max Berg, Centenary Hall, Wroclaw, Poland, 1912–13. (*H 515*)
2. Erich Mendelsohn, Einstein Tower, Potsdam, Germany, 1920. (*H 516*)

FRANK LLOYD WRIGHT

1. Robie House, Chicago, 1909. (*G 22-61, 62; H 517, 518; J 874, 875*)
2. Kaufmann House ("Falling Water"), Bear Run, Pa., 1936. (*G 22-66, H 519*)
3. Johnson's Wax Building, Racine, Wisconsin, 1936-39. (*H 520, 521*)

INTERNATIONAL STYLE

1. Gerrit Rietveld, Schroeder House, Utrecht, Holland, 1924, (De Stijl). (*G 22-64; H 522, 523; J 876*)
2. Walter Gropius, The Bauhaus, Dessau, Germany, 1925. (*G 22-67, H 524, J 878*)
3. Le Corbusier, Villa Savoye, Poissy, France, 1928-30. (*G 22-65; H 525, 526; J 881, 882*)
4. Ludwig Mies van der Rohe, The German Pavilion, Barcelona International Exhibition, 1929. (*G 22-68, H 527*)
5. Richard Neutra, Kaufmann House, Palm Springs, California, 1947. (*H 528*)

SKYSCRAPERS

1. Raymond Hood and John Mead Howells, Daily News Building, New York, 1930. (*H 529*)
2. George Howe and William Lescaze, Philadelphia Savings Fund Society Building, 1931-32. (*G 22-69, H 530, J 883*)
3. Shreve, Lamb, and Harmons, Empire State Building, New York, 1930-32. (*illustrated elsewhere*)
4. Various architects, Rockefeller Center, New York, 1931-39. (*illustrated elsewhere*)
5. Wallace K. Harrison and consultants, United Nations Secretariat Building, New York, 1947-50. (*H 531, J 880*)
6. Ludwig Mies van der Rohe, Lake Shore Drive Apartments, Chicago, 1950-52. (*H 532, J 884*)
7. Gordon Bunshaft and Skidmore, Owings, and Merrill, Lever House, New York, 1952. (*H 533*)
8. Ludwig Mies van der Rohe and Philip Johnson, Seagram Building, New York, 1956-58. (*G 22-71*)
9. Philip Johnson and John Burgee, I.D.S. Center, Minneapolis, 1972. (*H 534*)
10. Minoru Yamasaki, World Trade Center, New York, 1975, twin towers, 1300 ft. high. (*illustrated elsewhere*)

COUNTERCURRENTS

1. Le Corbusier, Unité d'Habitation, apartment house, Marseilles, 1947-52. (*G 22-103, H 535, J 885*)

2. Le Corbusier, Notre-Dame-du-Haut, Ronchamp, France, 1950-55. (*G 22-104; H 536; J 886, 887; cpl 142*)
3. Pier Luigi Nervi, Exhibition Hall, Turin, Italy, 1948-49. (*H 537*)
4. Marcel Breuer, Whitney Museum of American Art, New York, 1966. (*H 541, 542*)
5. R. Buckminster Fuller, American Pavilion, EXPO '67, Montreal, 1967. (*H 547*)
6. Moshe Safdie et al., Habitat, EXPO '67, Montreal, 1967-68. (*G 22-111; H 545; J 888, 889, 890*)
7. Kevin Roche and John Dinkeloo, Oakland Art Museum, Oakland, California, 1969. (*G 22-112*)
8. I.M. Pei, East Building (Modern Wing), National Gallery of Art, Washington, D.C., 1977-78. (*G 22-113, 114, 115; H 544*)

BRUTALISM

1. Paul Rudolph, Art and Architecture Building, Yale University, New Haven, Connecticut, 1959-63. (*illustrated elsewhere*)
2. Stirling and Gowan, Engineering Laboratories, Leicester University, England, completed 1964. (*illustrated elsewhere*)
3. Mario Ciampi, Berkeley Art Museum, Berkeley, California, 1965-70. (*illustrated elsewhere*)

FORMALISM

1. Edward Durrell Stone, Huntington Hartford Museum, Columbus Circle, New York, 1958-59. (*illustrated elsewhere*)
2. Philip Johnson, New York State Theater, Lincoln Center for the Performing Arts, New York, 1962-64. (*illustrated elsewhere*)

SCULPTURAL-EXPRESSIVE

1. Frank Lloyd Wright, Solomon Guggenheim Museum, New York, 1943-59. (*G 22-106, 107*)
2. Pier Luigi Nervi, Palazzetto dello Sport, Rome, 1958. (*G 22-108*)
3. Eero Saarinen, Terminal, Dulles Airport, Washington, D.C. 1961-62. (*G 22-118, H 540*)
4. Eero Saarinen, TWA Terminal, Kennedy Airport, New York, 1962. (*H 539*)
5. Joern Utzon, Sydney Opera House, Sydney, Australia, 1957-70. (*illustrated elsewhere*)
6. Frei Otto, Olympic Stadium, Munich, 1972. (*G 22-109*)

INDIVIDUAL INNOVATORS

1. Louis I. Kahn, Richards Medical Research Building, University of Pennsylvania, Philadelphia, 1967–61. (*H 538*)
2. Louis I. Kahn, Kimbell Art Museum, Fort Worth, Texas, 1972. (*H 543*)
3. Robert Venturi, Brant-Johnson House, Vail, Colorado, 1977. (*G 22-120, 121*)
4. Rogers and Piano, Centre Pompidou, Paris, 1974–78. (*G 22-116*)

B. PAINTING

Post-Impressionism had an enormous impact on the early directions taken by twentieth-century painters. Two main trends developed and ran concurrently. One followed Cézanne's lead in emphasizing **form**, often reduced to simple geometric components. The other, following Van Gogh, Gauguin, and the Symbolists, emphasized **expression** and concentrated on color and pattern. After the Second World War, leadership in painting shifted from Europe (Paris) to the United States (New York, Washington, D.C., California).

1. Fauvism

Fauvism originated in Paris in 1905. Its leading painters were Henri Matisse, André Derain, and Maurice de Vlaminck.

PURPOSES: Fauvist painters desired expression through the final liberation of color from all past restrictions.

SUBJECT MATTER: Subjects were cheerful, never depressing.

1. Human figures.
2. Landscapes.
3. Interior scenes.
4. Still life.

MEDIA AND TECHNIQUES: Oil paint was applied thickly to canvas with rough brushstrokes.

DESIGN

1. Totally liberated color. Freedom with color was carried further than ever before. Even faces could be painted blue or green, trees red, water yellow.
2. Clashing colors at full intensity were juxtaposed.

3. Natural appearances were distorted.
4. Drawing and perspective were distorted.
5. Images were flat, decorative.

2. Expressionism

a. *France*

Difficult to classify, Georges Rouault exhibited with the Fauves, but his subjects, style, and use of colors were quite different.

PURPOSES

1. Emotional expression.
2. Moralizing social commentary.

SUBJECT MATTER

1. Secular subjects: Aging prostitutes, hardened criminals, judges, sad clowns.
2. Religious subjects: Crucifixions, Old Testament scenes.

MEDIA AND TECHNIQUES

1. Oil on canvas or cardboard.
2. Gouache.
3. Watercolor.

DESIGN

1. Black outlines around forms, inspired by stained glass.
2. Somber colors by comparison with the Fauves.
3. Simplified forms.

b. *Germany: Die Brücke and Der Blaue Reiter*

Influenced by such nineteenth-century forerunners as Ensor and Munch, two groups of German Expressionists were established:

1. **Die Brücke** ("The Bridge"), in Dresden, in 1905 was an all-German group including Ernst Ludwig Kirchner, Erich Heckel, Karl Schmidt-Rottluff, Otto Müller, Emil Nolde, and others.
2. **Der Blaue Reiter** ("The Blue Rider"), in Munich, in 1911 was an international group including Wassily Kandinsky and Alexei von Jawlensky (Russian), Franz Marc and August Macke (German), Paul Klee (Swiss), and others.

PURPOSES

1. **Die Brücke**: Violent expression of human emotions.
2. **Der Blaue Reiter**: More imaginative, less violent expression than Die Brücke.

SUBJECT MATTER

1. **Die Brücke**: Subjects varied with individual artists. In the work of Emil Nolde, the most outstanding member of the group, subjects from Christianity were rendered grotesquely.
2. **Der Blaue Reiter**: Subjects varied with individual artists.
 a. Franz Marc specialized in animal forms.
 b. Wassily Kandinsky produced the first **nonrepresentational** painting (work with no natural object, idea, or emotion as its inspiration) in 1910.

MEDIA AND TECHNIQUES

1. Oil on canvas was preferred.
2. Paint was more roughly applied by Die Brücke painters.

DESIGN

1. **Die Brücke**:
 a. Violently clashing bright colors.
 b. Expressive line.
 c. Simplified forms.
 d. Nolde used grossly distorted faces and figures.
2. **Der Blaue Reiter**:
 a. Franz Marc had his own color symbolism:
 (1) Blue signified the masculine, robust, and spiritual.
 (2) Yellow signified the feminine, gentle, serene, and sensual.
 (3) Red signified matter, brutal and heavy.
 b. Wassily Kandinsky painted with bright colors and assorted shapes, some recognizable (either abstract or representational), some not.

c. *Germany: Independent Expressionists*

1. **Oscar Kokoschka**: In his most outstanding work, *Bride of the Wind,* lovers are shown with forms indicated by broad slashes of light color on a dark background in a circular, flowing composition.

2. **Max Beckmann**: Expressing his revulsion at the brutalities of war, he painted scenes of torture, maimings, and death with distorted forms in brilliant color, outlined by hard black lines.
3. **George Grosz**: Primarily a graphic artist, he also used watercolor in his depictions of social satire and war horrors. His colors were bright; his compositions crowded.
4. **Käthe Kollwitz**: She used simplified, emotionally charged forms, and strong contrasts in woodcut representations of subjects evoking compassion in the viewer.

d. *Expressionism outside Germany*

1. **Chaim Soutine**: A Russian working in Paris, he painted dead chickens and sides of beef symbolizing death with violent colors and excessive distortions of form. He depicted human forms in the same manner.
2. **Francis Bacon**: An English artist working in the fifties, Bacon expressed emotion and social commentary by distorting human figures and deliberately smearing the faces. His backgrounds were simplified, his figures sketchy.

3. Cubism

Cubism was developed in Paris by Pablo Picasso and Georges Braque, beginning in 1908.

PURPOSES

1. To liberate form from natural appearances.
2. To reduce forms to their essential planes.
3. To represent many simultaneous views of any given form.

SUBJECT MATTER

1. Human figures and heads.
2. Still life.
3. Subjects pertaining to café life: musical instruments, performers, sheet music, bottles, and furniture.

MEDIA AND TECHNIQUES

1. Oil on canvas.
2. Charcoal, ink, and gouache on paper.
3. **Collage** (the gluing of bits of paper to canvas, paper, and panel). Invented by Picasso in 1910.

DESIGN

1. **Proto-Cubism (1902–8):**
 a. Picasso and Braque were independently influenced by Cézanne, Matisse, and primitive art.
 b. The simplification of form was especially important.
2. **Analytic Cubism (1908–11):**
 a. Picasso and Braque jointly developed a style in which natural objects were "shattered" into geometric planes.
 b. Multiple viewpoints were combined into single images.
 c. Form was most important. Color tended to be monochromatic tans or grays.
3. **Collage (1910–12):** Still life compositions were emphasized.
4. **Synthetic Cubism (1912–30):**
 a. Unbroken color areas became larger, and recognizable objects reappeared.
 b. Brighter colors were used, especially by Picasso.

4. Followers of Cubism

Several styles, many of them regional, developed out of Cubism.

1. **Orphism (France):** Delaunay and others produced series of paintings in which abstract forms (usually circles) were combined with recognizable objects.
2. **Futurism (Italy):** Futurists wanted museums torn down. Their paintings glorified industrialization, the machine, speed, and war in vibrant colors using Divisionist techniques and shattered forms from Cubism. Boccioni and Carrà were the major Italian painters; Joseph Stella (American) was also influenced by this style.
3. **Suprematism-Constructivism (Russia):** Malevich invented Suprematism in 1913 as a purely geometric, abstract style. El Lissitsky and others developed Constructivism from Collage. Constructivism was primarily a sculptural and architectural style, but some paintings were produced in a formal, geometric hard-edged style. Originally the Russian Revolution encouraged the Suprematists and Constructivists because of their opposition to traditional Czarist art, but the government banned the style in 1920 when the artists refused to paint propagandist works.
4. **De Stijl "The Style" (Holland):** Mondrian reduced all formal elements to rectangles bounded by thick, straight, black lines. De Stijl colors were limited to the primary colors, plus white, gray, and black.
5. **Individuals related to Cubism:**
 a. **Fernand Léger** (France) combined Cubism and Futurism and produced industrial images with sharp precision.

 b. **Marcel Duchamp** (France) worked in many styles. In his Cubist phase, his shattered forms simulated motion.

5. Fantasy Art

PURPOSES: Exploration of the imagination and inner life.

SUBJECT MATTER

1. **Marc Chagall** used personal, autobiographical subjects.
2. **Giorgio de Chirico** painted barren, eerie cityscapes.
3. **Paul Klee** painted witty images, inspired by primitive art and the art of small children.

MEDIA AND TECHNIQUES

1. Chagall and de Chirico used oil on canvas primarily.
2. Klee also made drawings and watercolors on paper, burlap, etc.

DESIGN

1. Chagall's early style was influenced by Cubism, but his later style became more expressive, free, and open.
2. De Chirico used flat color areas, long shadows, and strange perspectives to convey ominous moods.
3. Klee's style emphasized simple, primitive shapes and bright colors.

6. Dadaism

Dada began in Zurich in 1915 and spread to New York, Cologne, Paris, and elsewhere.

PURPOSES

1. To protest against World War I and the society that produced it.
2. To make meaningless art to reflect the lack of meaning in modern society.
3. To be against everything, including Dada. (Even the true meaning of the word "Dada" is uncertain.)

SUBJECT MATTER: None (or so the artists often claimed).

MEDIA AND TECHNIQUES

1. Oil on canvas.

2. Collages combining unrelated objects of all kinds with paint on canvas or glass, or on waste paper.

DESIGN

1. **Jean (Hans) Arp** made amoeba-like forms and cut-outs, often difficult to classify as painting or sculpture.
2. **Marcel Duchamp** assembled junk and glass collages, anticipating Pop Art of the 1960s.
3. **Kurt Schwitters** made delicate collages of waste paper and string nonsensically called "Merz" pictures.
4. **Max Ernst** made oil paintings and collages on canvas of biomorphic forms with elements of machinery. He also worked with the Surrealist group.

7. Surrealism

PURPOSES

1. To explore the unconscious.
2. To liberate art from reason.
3. To depict the imagery of dreams.

SUBJECT MATTER: Dream images, the absurd, the incongruous.

MEDIA AND TECHNIQUES

1. Oil on canvas, wood, etc.
2. **Frottage**, developed by Max Ernst, involved laying a piece of paper over a rough surface and rubbing it with a pencil. The resulting image was incorporated into a painting.
3. **Automatic painting** involved allowing the brush to move without direction from the conscious mind. Joan Miró experimented with this process.

DESIGN

1. **Max Ernst** created eerie landscapes with frottage, and amorphous shapes and human forms in many styles.
2. **Joan Miró** made flat images of fanciful shapes in bright colors on various backgrounds.
3. **Salvador Dali** filled barren landscapes with absurd objects, such as limp watches or ghastly human fragments, rendered with virtuoso precision.
4. **René Magritte** rendered his witty images of the absurd realistically.
5. **Matta (Echaurren)** placed colorful opaque, translucent, or transparent objects in swirling space.

8. American Modernists

In the early years of the twentieth century American painters were provincial and academic, except for a few "daring" artists who rebelled against the norm by working in the Realist and Impressionist styles, already passé in Europe. However, three factors propelled American painters toward modernism:

1. **Travel** in France and Germany by young American artists.
2. Alfred Stieglitz' **"291 Gallery"** established in 1905 at 291 Fifth Avenue, New York. There he showed the work of European pioneers and encouraged American experimentation in painting.
3. **The Armory Show** in 1913 in New York, which created a sensation and caused a new American awareness of modern art.

PURPOSE: To break out of the academic tradition in American art.

SUBJECTS: Varied with the artists.

ARTISTS

1. **Marsden Hartley** discovered Der Blaue Reiter group while traveling through Germany in 1912. His resulting series of paintings based on German military symbols were the first American abstract paintings.
2. **John Marin** was influenced by the work of Cézanne, the Cubists, and Delaunay while visiting France between 1905 and 1911. His bright watercolor cityscapes of New York express the vitality and energy of the city.
3. **Arthur G. Dove** traveled in Europe between 1907 and 1909, and painted abstracted landscape forms.
4. **Georgia O'Keeffe**, trained totally in the United States, received her inspiration from objects around her. In her early work she depicted flowers and other natural objects in sinuous forms and sensuous colors. Since 1929, her work has dealt with the images near her home in New Mexico such as bleached animal skulls, driftwood, desert landscapes. These are rendered with great precision in close-up views. She was married to Alfred Stieglitz and her work shows the influence of his photographic pioneering.
5. **Edward Hopper** developed his own new forms of Realism untouched by European art, despite three trips abroad. His paintings have a ghostly atmosphere reminiscent of de Chirico, but without surrealistic distortions, and express the loneliness prevalent in much of American life.
6. **Stuart Davis** declared the Armory Show the single greatest influence on his work. His abstract paintings depict urban life—the signs, the lights, and the noise—in a style derived from Fauvist and Cubist traditions and often have witty and amusing titles.

9. Social Realism

PURPOSES AND SUBJECT MATTER: During the 1930s, artists in the United States and Mexico were caught up in the political and philosophical conflicts of the time. Socialist and Communist ideas often affected their work.

1. **Mexican artists** such as Rivera, Orozco, and Siqueiros worked at home and in the United States depicting the spirit of Revolution and social change.
2. **American artists,** such as Ben Shahn, used a more restrained style in depicting the tragedies and injustices of political and social events, and the loneliness and emptiness of modern times.

MEDIA AND TECHNIQUES

1. The Mexican painters specialized in mural painting, using fresco on plaster or concrete surfaces. Some of the artists in the United States also produced murals, especially as part of the W.P.A. (Works Progress Administration) projects sponsored by the government during the Great Depression.
2. A variety of other media were also used such as tempera, Duco, or oil on wood or canvas.
3. Some of the artists, such as Shahn, also produced prints.

DESIGN

1. The Mexican artists filled their picture surfaces with a profusion of images. Rivera's work was carefully rendered and included very powerful figures. Orozco worked in a more sketchy style. Bright colors and strong contrasts of light and dark added to the emotional expressiveness of works by Orozco and Siqueiros.
2. The American Social Realists preferred uncrowded compositions with carefully delineated forms. Ben Shahn's unique, personal style bordered on caricature.

10. Abstract Expressionism

The devastation of Europe during World War II caused the center of western art to shift to America as many important European artists settled there. Abstract Expressionism began in the 1940s and was considered the first major painting style started in America.

PURPOSES

1. To express the artist's pent-up emotions through the free application of paint.

2. To assert individual nonconformist personalities that our mechanized culture tends to stifle.

SUBJECT MATTER

1. The act of painting is the subject.
2. Most Abstract Expressionist paintings are nonrepresentational except for some barely recognizable, distorted human figures or other images.

MEDIA AND TECHNIQUES

1. **Proliferation of media.** Artists continued to use oil on canvas, but also used enamels, house paint, casein, and metallic paint.
2. **Liberation of canvas.** Instead of the customary stretchers and easels, artists often tacked the canvas to the wall (Franz Kline) or rolled it out on the floor (Jackson Pollock).
3. **Spontaneous application.** Thick paint was applied vigorously, without modification of strokes or splashes (Hans Hofmann).
4. **Action Painting.** Paint was dripped, spilled, or thrown onto canvas instead of being brushed (Pollock).
5. **Cumulative repainting.** Paint was built up and scraped off until the surface acquired a sculptural quality (de Kooning).

DESIGN

1. **Jackson Pollock** pioneered Action Painting (see Media). His violently expressive canvasses usually were densely covered with lines, spills, and splashes of paint.
2. **Arshile Gorky** (Armenian-born) painted random shapes, often reminiscent of Kandinsky's work, in strong colors. His forms were delicately rendered.
3. **Willem de Kooning** (Dutch-born) produced thick-surfaced, crowded canvasses, some nonrepresentational and others showing grossly distorted women with smeared faces and figures.
4. **Hans Hofmann** (German-born) experimented with drip painting in the 1940s, but is best known for his overlapping rectangular forms, intense colors, and serene compositions.
5. **Franz Kline** enlarged sections of his black and white sketches into huge black and white paintings of broad lines slashing across the canvas.
6. **Clyfford Still** produced large, smooth-surfaced paintings with large-scale areas of color which seem to flow and spread.
7. **Mark Rothko** (Russian-born) painted large, fuzzy-edged blocks of color in luminous tones.
8. **Richard Diebenkorn** produced abstract works until 1955, then became more representational. His work has been important for its influence on art on the West Coast.

11.　American Realism

PURPOSES AND SUBJECT MATTER

1. Abstraction was not universally accepted; some artists preferred to paint representational works in naturalistic or realistic styles.
2. Realism was part of a tradition which began with Courbet. In the United States, Realism was continued in the 1930s by the Social Realists (see above) and by the American Regionalists (Thomas Hart Benton, Grant Wood, Charles Burchfield). Andrew Wyeth has been most closely involved with American Realism since World War II.
3. In the 1930s, mid-western rural life provided the subject matter. In Wyeth's work, rural Pennsylvania is most often depicted.

MEDIA AND TECHNIQUES

1. Oil, tempera, and watercolor were used on canvas, wood, or paper. Wyeth is best known for his reintroduction of egg tempera.
2. Paint was usually applied meticulously.

DESIGN

1. Muted colors and earth tones were preferred.
2. People were not flattered or idealized.
3. Wyeth's work is known for
 a. Psychological implications of his subjects.
 b. A sense of isolation, often implied by scenes without people, or images of solitary figures.
 c. The widespread popularity of his work (in contrast to the more "radical" styles of the century).

12.　Pop Art

Pop Art began in England in the mid-1950s and was quickly taken up by painters in the United States, where it flourished in the 1960s.

PURPOSES

1. To reflect our indifference to the familiar objects of everyday life and popular culture.
2. To depict these objects with cool acceptance, not satire. (However, Pop sculpture often has a satirical edge.)

SUBJECT MATTER

1. Everyday objects and images from the advertising media, such as soup and beer cans.

2. Public figures, movie stars, cultural heroes.
3. Incongruous or absurd combinations of familiar objects.

MEDIA AND TECHNIQUES

1. **"Combines"** were developed by Robert Rauschenberg. Combines are paintings with newsprint, photographs, and other objects attached to the canvas.
2. **Mixed-media** works combine various types of pigment and materials.
3. Painting and sculpture are often combined; most notably by Jasper Johns and Rauschenberg.
4. **Serigraphy** was developed (and often combined with painting on canvas). Andy Warhol and Robert Rauschenberg are well known for their serigraphs. (**Serigraphy**, also called silkscreen printing, involves the printing of silkscreen stencils onto paper or canvas. Because the artist uses paint films rather than printer's inks, serigraphy is often considered a painting medium.)
5. **Acrylic paints** were used by many artists instead of oils. The Mexican Social Realists of the 1930s experimented with the use of industrial polymer-based paints for their murals, but widespread use did not occur until the early 1960s.
 (**Acrylic colors** are synthetic paints known for their bright colors, rapid drying, and non-yellowing properties. "Magna colors" is a trade name for these paints sold in tubes.)
6. **Encaustic** was revived by Jasper Johns.
7. **Ben-day dots**, as used for newspaper photograph and comic strip reproduction, were enlarged and projected onto canvas by Roy Lichtenstein for his comic strip-inspired paintings.

DESIGN

1. **Serial-imagery** (multiple images intended to be viewed as series) was developed by Warhol, Johns, and others.
2. Precise technique, inspired by commercial illustration, characterizes the work of Lichtenstein, Warhol, and James Rosenquist.
3. Thick impasto, smeary brushwork and imprecise technique characterize the work of Johns, Rauschenberg, and Larry Rivers.

13. Op Art

PURPOSES

1. To explore the principles of optical illusion.
2. To produce effects of changing mass, surface, space.
3. To involve the viewer's sight processes in a dynamic way.

SUBJECT MATTER: Nonrepresentational.

MEDIA AND TECHNIQUES

1. Synthetic materials, including acrylics, are popular.
2. Precise technique is required.
3. The artists often design an original plan to be executed by assistants or technicians using mechanical processes.

DESIGN

1. **Victor Vasarely** is the acknowledged leader of the Op Art movement. He has been working in this style since the 1950s, and his work has progressed from black and white optical creations to vivid color configurations. Theories of color perception, the writings of Mondrian and Kandinsky, and mathematics were important in the development of this style. Using paint, glass, or plastic, Vasarely creates complex illusionistic perspectives.
2. **Richard Anuszkiewicz** is the leading American Op artist. He creates works in which the spatial illusions change from convex to concave, and the colors vibrate with extreme intensity, disturbing the viewer's equilibrium.
3. **Identical patterns,** repeated edge to edge, are typical of Op Art works. (Vasarely does not like to call them paintings.)

14. Color-Field and Hard-Edge Painting

PURPOSE: To assert the importance of the canvas itself and to deny illusionism and expressionism.

SUBJECT MATTER: Color and shape and canvas.

MEDIA AND TECHNIQUES

1. Oils, acrylics, metallic and fluorescent paint are used.
2. Paint is applied to both unprimed and primed canvas.
3. **Shaped canvasses** (not rectangular) are used by some artists.
4. **Stain painting** involves thinned paints, poured onto unprimed canvas and allowed to spread and saturate the surface like watercolor.
5. Hard-edge painters separate their colors with precise edges, often with a machine-like perfection.

DESIGN

1. **Color-Field Painting** was developed in the 1950s by Barnett Newman, Morris Louis, and Ellsworth Kelly.

a. **Newman** used only a few colors, usually muted, to define color fields or areas of color. Fuzzy-edged narrow stripes separated the color areas.

b. **Louis** poured bright colors onto unprimed canvas. His works usually consisted of uncentered groups of broad stripes.

c. **Kelly** initially produced brightly colored canvasses with amorphous shapes, and later painted colors in large rectangles.

d. **Noland** has always painted bright bands of color, but has modified the shape, moving from concentric circles to chevrons and horizontal stripes on very long canvasses.

2. **Stain Painting** was developed by Helen Frankenthaler, Morris Louis, and Paul Jenkins. Stylistically, it is often considered a variant of Color-Field Painting. The canvasses often have the appearance of delicate watercolors with their transparent veils of paint.

3. **Hard-Edge Painting** is a term used to describe the later works of Kelly and Noland, but is most closely associated with Frank Stella. Stella produces absolutely parallel stripes separated by narrow white lines and lets the shape of the stripes determine the shape of the canvas.

15. Photorealism

Photorealism began in California in the late 1960s and early 1970s and has become a strong movement on the East Coast as well.

PURPOSE: Reaction against abstraction.

SUBJECT MATTER

1. Everyday scenes, often as banal as possible.
2. Automobiles and other industrially fashioned consumer objects associated with contemporary American life.

MEDIA AND TECHNIQUES

1. Photographs are the preparatory "sketches." Slides are usually projected directly onto the canvasses and determine the placement of the paint.
2. Paint is often applied with an **airbrush** (a compressed-air device for spraying paint) to produce precise forms and smooth surfaces. The influence of commercial art is very strong in the choice of media and techniques.

DESIGN

1. The paintings simulate enormous photographs.
2. Images are generally hard-edged, precisely portrayed.
3. In many ways, this style continues the interests of earlier American painters who combined photography and painting, such as Charles Sheeler.

16. Other Styles

Styles become outdated very quickly in every facet of modern life, including art. Artists struggle to stay current and also to compete with television and other forms of popular culture for an audience. It is not surprising that new styles and new artists are constantly emerging. Art magazines and gallery exhibitions are the best places to experience and learn about the current art scene.

EXAMPLES (All works are oil on canvas unless otherwise specified.)

FAUVISM

1. Henri Matisse, *The Green Stripe (Mme. Matisse)*, 1905, 16 by 13 in. (*H cpl 63*)
2. Henri Matisse, *Joie de Vivre (Joy of Life)*, 1905-06, 68 by 93 in. (*H 448, J 803*)
3. Henry Matisse, *Le Luxe*, 1907-08, 82 by 55 in. (*G 22-3*)
4. Henri Matisse, *Red Room (Harmony in Red)*, 1908-09, 71 by 97 in. (*G 22-4, J cpl 106*)
5. Henri Matisse, *Red Studio*, 1911, 71 by 86 in. (*H cpl 64*)
6. Henri Matisse, *Decorative Figure Against an Ornamental Background*, 1925, 52 by 39 in. (*H 449*)
7. André Derain, *London Bridge*, 1906, 26 by 39 in. (*G 27-2*)

CONTINUATION OF ART NOUVEAU

Gustav Klimt, *Death of Life*, 1908 and 1911, 70 by 78 in. (*illustrated elsewhere*)

EXPRESSIONISM
FRENCH

1. Georges Rouault, *Prostitute at Her Mirror*, watercolor on cardboard, 1906, 27 by 21 in. (*H 452*)
2. Georges Rouault, *The Old King*, 1916-37, 30 by 21 in. (*G 22-5, H cpl 65, J cpl 107*)

GERMAN: DIE BRÜCKE

1. Emil Nolde, *The Last Supper*, 1909, 32 by 41 in. (*J cpl 110*)
2. Emil Nolde, *Doubting Thomas*, 1912, 40 by 34 in. (*H 453*)
3. Emil Nolde, *St. Mary of Egypt Among the Sinners*, 1912, 34 by 39 in. (*G 22-7*)
4. Ernst Ludwig Kirchner, *Street*, 1907, 59 by 80 in. (*J 805*)

GERMAN: DER BLAUE REITER

1. Franz Marc, *Deer in the Wood, No. 1*, 1913, 40 by 41 in. (*H 454*)
2. Wassily Kandinsky, *Improvisation 28*, 1912, 44 by 64 in. (*G 22-10*)
3. Wassily Kandinsky, *Improvisation 30 (Cannon)*, 1913, 43 by 43 in. (*H cpl 66*)
4. Wassily Kandinsky, *Composition 238: Bright Circle*, 1921, 55 by 71 in. (*H 455*)

GERMAN: INDEPENDENT EXPRESSIONISTS

1. Oscar Kokoschka, *Self-Portrait*, 1913, 32 by 20 in. (*H 456, J 806*)
2. Oscar Kokoschka, *Bride of the Wind*, 1914, 71 by 87 in. (*G 22-6, H cpl 67*)
3. Max Beckmann, *The Night*, 1918-19, 52 by 60 in. (*H 457*)
4. Max Beckmann, *The Departure*, 1932-35, triptych. (*G 22-8, J cpl 111*)
5. Max Beckmann, *Blindman's Buff*, 1945, triptych. (*H 458*)
6. George Grosz, *Germany: A Winter's Tale*, 1918. (*J 817*)
7. George Grosz, *Punishment*, 1934, watercolor, 27 by 20 in. (*G 22-9*)
8. Käthe Kollwitz, *Memorial to Karl Liebknecht*, 1919, woodcut. (*G 22-11*)

EXPRESSIONISTS OUTSIDE GERMANY

1. Chaim Soutine, *Dead Fowl*, c. 1926, 38 by 24 in. (*J cpl 108*)
2. Francis Bacon, *Number VII from Eight Studies for a Portrait*, 1953, 60 by 48 in. (*G 22-72*)
3. Francis Bacon, *Figure with Meat*, 1953, 60 by 48 in. (*J cpl 109*)

CUBISM
PICASSO BEFORE CUBISM

1. *Absinthe Drinker*, 1902, 31 by 24 in. (*H 462*)
2. *Portrait of Gertrude Stein*, 1906, 40 by 32 in. (*G 22-12*)
3. *Demoiselles d' Avignon*, 1907, 96 by 92 in. (*G 22-13, H 464, J 809*)

ANALYTIC CUBISM

1. Pablo Picasso, *Seated Woman (Femme Assise)*, 1909, 32 by 26 in. (*H cpl 68*)
2. Pablo Picasso, *Ambrose Vollard*, 1910-11, 36 by 25 in. (*J 810*)
3. Pablo Picasso, *The Accordianist*, 1911, 51 by 34 in. (*G 22-14, H 466*)
4. Georges Braque, *The Portuguese*, 1911, 46 by 32 in. (*H 465*)

COLLAGES

1. Pablo Picasso, *Still Life With Chair Caning,* 1911-12, 11 by 14 in. (*G 22-15, J 811*)
2. Georges Braque, *Le Courier,* 1913, 20 by 22 in. (*J 812*)

SYNTHETIC CUBISM

1. Pablo Picasso, *Three Musicians,* 1921, 80 by 74 in. (*G 22-16, H 468, J 813*)
2. Pablo Picasso, *Three Women at the Spring,* 1921, 80 by 68 in. (*H 469*)
3. Pablo Picasso, *Three Dancers,* 1925, 84 by 56 in. (*J cpl 113*)
4. Georges Braque, *The Table,* 1928, 70 by 28 in. (*G 22-18*)

LATER PICASSO

Guernica, 1937, 11 by 25 ft. (*G 22-17, H 470, J 815*)

FOLLOWERS OF CUBISM
ORPHISM

Robert Delaunay, *Homage to Blériot,* 1914, tempera. (*H 472*)

FUTURISM

1. Umberto Boccioni, *The City Rises,* 1910-11, 6 by 10 ft. (*H cpl 69*)
2. Carlo Carrá, *The Funeral of the Anarchist Galli,* 1910-11, 6 by 8 ft. (*H 482*)
3. Joseph Stella, *Brooklyn Bridge,* 1917-18, oil on bedsheeting, 84 by 76 in. (*H 484, J cpl 114*)

SUPREMATISM-CONSTRUCTIVISM

1. Kasimir Malevich, *The Knife Grinder,* 1912, 31 by 31 in. (*H 485*)
2. Kasimir Malevich. *Suprematist Composition: White on White,* c. 1918, 31 by 31 in. (*G 22-23, H 486*)
3. El Lissitsky, *Proun 99,* 1924-25, 50 by 39 in. (*H 490*)

DE STIJL

1. Piet Mondrian, *Red Tree,* 1908, 28 by 39 in. (*H 491*)
2. Piet Mondrian, *Composition in Line and Color,* 1913, 35 by 45 in. (*H 492*)
3. Piet Mondrian, *Composition with Red, Yellow, and Blue,* 1921, 32 by 20 in. (*H cpl 70*)
4. Piet Mondrian, *Composition in Blue, Yellow, and Black,* 1936, 17 by 13 in. (*G 22-21*)

INDIVIDUALS RELATED TO CUBISM

1. Marcel Duchamp, *Nude Descending a Staircase No. 2,* 1912, 58 by 35 in. (*G 22-20, H 473, J 820*)
2. Fernand Léger, *The City,* 1919, 8 by 10 ft. (*G 22-19, J cpl 115*)
3. Fernand Léger, *Disks,* 1918, 94 by 71 in. (*H 471*)

FANTASY ART

1. Marc Chagall, *I and the Village,* 1911, 75 by 59 in. (*J cpl 118*)
2. Marc Chagall, *Self-Portrait with Seven Fingers,* 1912, 50 by 42 in. (*H 417*)
3. Marc Chagall, *The Crucifixion,* 1943, 55 by 40 in. (*G 22-30*)
4. Giorgio de Chirico, *The Delights of a Poet,* 1913, 28 by 34 in. (*G 22-26*)
5. Giorgio de Chirico, *The Nostalgia of the Infinite,* c. 1913-14, 53 by 25 in. (*H 495*)
6. Giorgio de Chirico, *Mystery and Melancholy of a Street,* 1914, 33 by 27 in. (*J cpl 117*)
7. Paul Klee, *Twittering Machine,* 1922, pen and ink, 16 by 12 in. (*G 22-31, J 818*)
8. Paul Klee, *Dance Monster to My Soft Song!,* 1922, mixed media on gauze, mounted on paper, 18 by 13 in. (*H 496*)
9. Paul Klee, *Ad Parnassum,* 1932, casein and oil on canvas, 40 by 50 in. (*H 497*)
10. Paul Klee, *Park Near L(ucerne),* 1938, 39 by 27 in. (*J cpl 119*)
11. Paul Klee, *Death and Fire,* 1940, oil and gouache on burlap, mounted on linen, 18 by 18 in. (*G 22-35, H cpl 71*)

DADAISM

1. Jean (Hans) Arp, *Mountain Table Anchors Navel,* 1925, oil on cardboard with cutouts, 30 by 23 in. (*H 498*)
2. Marcel Duchamp, *The Bride Stripped Bare by her Bachelors, Even,* 1915-25, oil, lead, foil, and quicksilver on glass, 9 by 6 ft. (*H 500*)
3. Marcel Duchamp, *Tu m',* 1918, oil and graphite on canvas, with bottle brush, safety pins, nut and bolt, c. 2 by 10 ft. (*H 501, J 824*)
4. Marcel Duchamp, *To Be Looked At (From the Other Side of the Glass), with One Eye, Close to, For Almost an Hour,* 1918, oil, paper, lens, double glass panel, 20 by 16 in. (*G 22-25*)
5. Kurt Schwitters, *Picture with Light Center,* 1919, collage of paper with oil on cardboard, 33 by 26 in. (*H 503*)
6. Kurt Schwitters, *Merz Picture 19,* 1920, collage, 7 by 6 in. (*G 22-24*)
7. Max Ernst, *The Elephant of the Celebes,* 1921, 51 by 43 in. (*H 502*)
8. Max Ernst, *1 Copper Plate, 1 Zinc Plate, 1 Rubber Cloth, 2 Calipers, 1 Drainpipe Telescope, 1 Piping Man,* 1920, collage of cutouts from pictures of machinery, 12 by 9 in. (*J 822*)

SURREALISM

1. Max Ernst, *Two Children are Threatened by a Nightingale*, 1924, foil with wood construction, 27 by 22 by 5 in. (*G 22-27*)
2. Max Ernst, *Europe After the Rain*, 1940-42, 21 by 59 in. (*H 504*)
3. Joan Miró, *Harlequin's Carnival*, 1925-25, 26 by 36 in. (*H 505*)
4. Joan Miró, *Painting 1933*, 1933, 68 by 77 in. (*G 22-28, H cpl 72*)
5. Joan Miró, *Composition 1933*, 51 by 63 in. (*J cpl 120*)
6. René Magritte, *Delusions of Grandeur*, 1961, 39 by 32 in. (*H 507*)
7. Salvador Dali, *The Persistence of Memory*, 1931, 9 by 13 in. (*G 22-29, H 506*)
8. Salvador Dali, *Soft Construction with Boiled Beans: Premonitions of Civil War*, 1936, 39 by 39 in. (*H cpl 73*)
9. Matta, *Listen to Living (Écoutez Vivre)*, 1941, 29 by 37 in. (*H cpl 74*)

AMERICAN MODERNISTS

1. Marsden Hartley, *Iron Cross*, 1914, 40 by 32 in. (*H 548*)
2. John Marin, *Lower Manhattan (Composition Derived from the Top of the Woolworth Building)*, 1922, watercolor and charcoal with paper cutout attached with thread, 22 by 27 in. (*H 549*)
3. Arthur G. Dove, *That Red One*, 1944, 27 by 36 in. (*H 550*)
4. Georgia O'Keeffe, *Blue and Green Music*, 1919, 23 by 19 in. (*H cpl 75*)
5. Edward Hopper, *Automat*, 1927, 28 by 36 in. (*H 551*)
6. Edward Hopper, *Early Sunday Morning*, 1930, 35 by 60 in. (*J cpl 129*)
7. Stuart Davis, *House and Street*, 1931, 26 by 42 in. (*H 552*)
8. Stuart Davis, *Owh! In San Pāo*, 1951, 52 by 42 in. (*H cpl 76*)
9. Stuart Davis, *Colonial Cubism*, 1954, 45 by 60 in. (*G 22-81*)

SOCIAL REALISM

1. Diego Rivera, Rockefeller Center Murals, 1930s, now destroyed. (*illustrated elsewhere*)
2. José Clemente Orozco, *The Departure of Quetzalcoatl*, 1932-34, fresco, Baker Library, Dartmouth College. (*H 533*)
3. José Clemente Orozco, *Victims*, detail of a mural, 1936. (*J 808*)
4. David Alfaro Siqueiros, *Echo of a Scream*, 1937, Duco enamel on wood, 48 by 36 in. (*G 22-32*)
5. David Alfaro Siqueiros, *Portrait of the Bourgeoisie*, 1939, mural, pyroxylin on cement, 1000 square ft., Mexico City. (*H 554*)
6. Ben Shahn, *The Passion of Sacco and Vanzetti*, 1931-32, tempera on canvas, 84 by 48 in. (*illustrated elsewhere*)
7. Ben Shahn, *Handball*, 1939, tempera on paper mounted on composition board, 23 by 31 in. (*G 22-34*)

ABSTRACT EXPRESSIONISM

1. Jackson Pollock, *Lucifer,* 1947, oil and aluminum paint on canvas, 41 by 81 in. (*G 22-75*)
2. Jackson Pollock, *One No. 31,* 1950, 9 by 18 ft. (*J 828, cpl 122*)
3. Jackson Pollock, *Blue Poles,* 1953, oil and Duco enamel on canvas, 7 by 16 ft. (*H cpl 78*)
4. Arshile Gorky, *The Liver is the Cock's Comb,* 1944, 72 by 98 in. (*J cpl 121*)
5. Arshile Gorky, *Golden Brown Painting,* 1947, 43 by 56 in. (*H cpl 77*)
6. Willem de Kooning, *Excavation,* 1950, oil and enamel on canvas, 80 by 100 in. (*H 555*)
7. Willem de Kooning, *Woman I,* 1950-52, 76 by 58 in. (*G 22-77*)
8. Willem de Kooning, *Woman II,* 1952, 59 by 43 in. (*J cpl 123*)
9. Willem de Kooning, *The Time of the Fire,* 1956, oil and enamel on canvas, 59 by 79 in. (*H cpl 79*)
10. Hans Hofmann, *Effervescence,* 1944, oil, India ink, casein, and enamel on plywood, 54 by 36 in. (*G 22-74*)
11. Hans Hofman, *The Gate,* 1960, 75 by 48 in. (*H cpl 80*)
12. Franz Kline, *Painting 1952,* 1955-56, 6 by 8 ft. (*G 22-76*)
13. Franz Kline, *Mahoning,* 1956, 80 by 100 in. (*H 556*)
14. Clyfford Still, *Painting,* 1951, 93 by 76 in. (*H 557*)
15. Clyfford Still, *Painting, 1951,* 1951, 93 by 75 in. (*H 557*)
16. Mark Rothko, *White and Greens in Blue,* 1957, 100 by 82 in. (*H cpl 81*)
17. Mark Rothko, *Four Darks on Red,* 1958, 102 by 116 in. (*G 22-78*)
18. Mark Rothko, *Earth and Green,* 1955, 90 by 73 in. (*J cpl 124*)
19. Richard Diebenkorn, *Ocean Park No. 40,* 1971, 93 by 81 in. (*H 558*)

AMERICAN REALISM

1. Grant Wood, *American Gothic,* 1930. (*illustrated elsewhere*)
2. Andrew Wyeth, *Christina's World,* 1948, tempera on gesso panel, 32 by 48 in. (*G 22-79*)

POP ART

1. Jasper Johns, *Target with Four Faces,* 1955, encaustic and newspaper on canvas with plaster casts, 30 by 26 in. (*H 560*)
2. Jasper Johns, *Three Flags,* encaustic on canvas, 1958, 31 by 45 in. (*J 131*)
3. Larry Rivers, *Europe II,* 1956, 54 by 48 in. (*J cpl 130*)
4. Andy Warhol, *Marilyn Monroe,* 1962, oil, acrylic, and silkscreen enamel on canvas, 20 by 16 in. (*H 564*)
5. Roy Lichtenstein, *Blam!,* 1962, 60 by 80 in. (*G 22-97*)

6. Roy Lichtenstein, *Whaam,* 1963, two panels, Magna on canvas, 6 by 13 ft. total. (*H 561*)
7. Roy Lichtenstein, *Girl at the Piano,* 1963, Magna on canvas, 64 by 48 in. (*J 834, cpl 133*)
8. Robert Rauschenberg, *Trapeze,* 1964, oil on canvas with silkscreen, 10 by 4 ft. (*H 559*)
9. James Rosenquist, *F-111,* 1965, oil on canvas with aluminum, 10 by 86 ft. (*H 562*)

OP ART

1. Victor Vasarely, *Vega,* 1957, 77 by 51 in. (*J 837*)
2. Victor Vasarely, *Arcturus II,* 1966, 63 by 63 in. (*H cpl 82*)
3. Richard Anuszkiewicz, *Trinity,* 1970, acrylic, 48 by 72 in. (*H cpl 83*)
4. Richard Anuszkiewicz, *Entrance to Green,* 1970, acrylic, 48 by 72 in. (*J cpl 138*)
5. Bridget Riley, *Current,* 1964, synthetic resin paint on Composition Board, 53 by 59 in. (*G 22-84*)

COLOR-FIELD AND HARD-EDGE PAINTING

1. Barnett Newman, *Stations of the Cross: Twelfth Station,* 1965, acrylic, 78 by 60 in. (*H 569*)
2. Morris Louis, *Beth Feh,* 1958, acrylic, 8 by 10 ft. (*J cpl 126*)
3. Morris Louis, *Pillar of Hope,* 1961, acrylic, 85 by 48 in. (*H 570*)
4. Ellsworth Kelly, *Red White,* 1961, 63 by 85 in. (*H cpl 85*)
5. Ellsworth Kelly, *Red, Blue, Green,* 1963, 7 by 11 ft. (*G 22-83*)
6. Kenneth Noland, *Bridge,* 1964, acrylic, 89 by 98 in. (*H cpl 84*)
7. Yves Klein, *Fire Painting,* 1961–62, painted and burned asbestos, 43 by 30 in. (*H cpl 86*)
8. Helen Frankenthaler, *Interior Landscape,* 1954, acrylic, 9 by 8 ft. (*illustrated elsewhere*)
9. Paul Jenkins, *Phenomena Astral Signal,* 1964, acrylic, 9 by 6 ft. (*J cpl 127*)
10. Frank Stella, *Ophir,* 1960–61, copper paint on canvas, 90 by 84 in. (*H 571*)
11. Frank Stella, *Tahkt-I-Sulayman I,* 1967, polymer and acrylic paint on canvas, 10 by 20 ft. (*H 572*)

PHOTOREALISM

1. Richard Estes, *Escalator, Bus Terminal,* 1969, 42 by 60 in. (*H 584*)
2. Richard Estes, *Nedick's,* 1969–70, 48 by 66 in. (*G 22-101*)
3. Don Eddy, *New Shoes for H,* 1973, acrylic, 6 by 6 ft. (*J cpl 137*)

C. SCULPTURE

Influenced by the work of Auguste Rodin, early twentieth-century sculptors had two choices: they could react against him or follow his lead. As in painting, the artistic leadership in sculpture shifted to the United States after World War II, and has continued in various directions.

1. Formalism

PURPOSE AND SUBJECT MATTER: As a reaction against the emotionalism of Rodin, artists such as Maillol returned to an interest in the formal qualities of the human figure.

MEDIA AND TECHNIQUES

1. Bronze and marble were used.
2. Surfaces were kept fairly smooth and unbroken.

DESIGN: The human figure was shown in classic repose, expressing restraint and balance.

2. Expressionism

PURPOSE AND SUBJECT MATTER: Like Rodin, Expressionist sculptors before World War I used the human figure to convey emotion.

MEDIA AND TECHNIQUES

1. Bronze, marble, wood, and **cast stone** (cast concrete resembling stone) were used.
2. Surfaces were smooth.

DESIGN

1. Human proportions were distorted for emotional effect.
 a. Gaston Lachaise produced exaggerated female forms.
 b. Wilhelm Lehmbruck produced greatly elongated figures.
2. Restrained gestures and subtle but intense facial expressions were used for emotional effect by Barlach.

3. Cubism

Cubist sculpture was influenced by Cubist painting and by African and Iberian sculpture.

PURPOSE: The reduction of natural forms to basic geometric shapes.

SUBJECT MATTER

1. Human figures, alone or in groups.
2. Still life compositions.
3. Animals.

MEDIA AND TECHNIQUES

1. Bronze and stone were used.
2. Both free-standing and relief works were made.

DESIGN

1. Shapes were stylized geometrically.
2. All extraneous details were eliminated.
3. Forms progressed from fairly representational to abstract.
4. **Piercing of the mass** (cutouts and holes in the sculpture) was pioneered by Archipenko. Reversing the traditional concept of a solid form surrounded by space, it asserted the importance of **negative space**.

4. Followers of Cubism

As in painting, Cubism influenced several other styles in sculpture.

1. **Futurism** (Italy) produced only the sculptures of Boccioni. His bronze figures were abstract. The motion of the figures and the space around them were represented as solids.
2. **De Stijl** (Holland) was more important for its architecture and paintings, but the sculptural work of Vantongerloo was also important. His work was totally abstract, with precise geometric forms based on complex mathematical relationships.
3. **Constructivism** (Russia) was an internationally influential sculptural style because of the use of new materials such as glass, cardboard, and plastic and its combination of art and industrial engineering. Tatlin, Gabo, and Pevsner often asserted the importance of **sculptural space** rather than **sculptural mass**.

5. Early Abstraction: Constantin Brancusi

PURPOSES AND SUBJECT MATTER: Brancusi used both human forms and purely nonrepresentational forms to express the beauty of form itself.

MEDIA AND TECHNIQUES

1. Marble, wood, and metal were used.
2. Brancusi carved his own works rather than turn them over to a professional carver. The finishes on his works are exquisitely smoothed and polished.
3. **"Truth to the material"** was crucial to Brancusi. He felt that the unique qualities of each material had to be used and respected.

DESIGN

1. Brancusi preferred to design ovoid, sensual forms.
2. His works generally utilized only one or two shapes.
3. Form was used to express ideas or sensations rather than to replicate nature. For instance, *Bird in Space* expresses the idea of flight, not the form of the bird.

6. Dadaism

The Dada movement included sculpture as well as painting. Zurich, New York, Cologne, Berlin, and Paris had groups of Dadaist artists working between 1916 and 1923.

PURPOSES AND SUBJECT MATTER

1. Nonsense art was produced to satirize the meaninglessness of life.
2. Anti-art was produced to negate the traditions of art.

MEDIA AND TECHNIQUES

1. Wood and other natural materials were used by Arp to create biomorphic forms.
2. **The found object** was developed as a new form. A found object is a natural object selected and exhibited by the artist for its aesthetic quality (or lack of aesthetic quality). When the artist modified the natural object in any way it was called a **found object interpreted**. The **ready-made** and the **ready-made interpreted** were made from manufactured items.

DESIGN

1. **Jean (Hans) Arp** was a founder of Zurich Dada and produced layered wooden reliefs and marble sculptures using abstract organic forms and shapes he called **biomorphs**. Brancusi's work strongly influenced Arp. He in turn influenced Miró and Calder.
2. **Marcel Duchamp** abandoned painting about the time he invented the **found object** and the **ready-made**. Some of his ready-mades gained him notoriety,

such as *Fountain,* a urinal turned sideways. Most of his objects had humorous associations.

3. **Man Ray** was associated with Duchamp in the development of New York Dada. Some of his works were "wrappings," considered ancestors to Christo's recent work.

4. **Pablo Picasso's** long career included the production of humorous sculptures which are best associated with Dada. In these works, art comes full circle: Picasso influenced Duchamp who influenced Picasso.

7. Fantasy and Related Styles

Cubism, Abstraction, Expressionism, and Dada, seemingly at odds with each other, contributed equally to the development of various individual styles classified as Fantasy.

PURPOSE AND SUBJECT MATTER

1. The human figure is usually Giocometti's and Moore's preferred subject. These figures may or may not have meaning beyond their mere representation.

2. Natural objects and abstract forms are also depicted, especially by Calder.

MEDIA AND TECHNIQUES

1. Wood, metal, and stone are used, often together.

2. **The mobile,** a carefully balanced suspended arrangement of rods, wires, strings, and objects, and moves freely in the air was invented by Calder. Duchamp may have provided some proto-types.

3. **The stabile,** a rigid arrangement of interlocking shapes resembling a mobile fused together. (This was also invented by Calder.)

DESIGN

1. Cubism influenced the strong interest in simplified geometric forms, "piercing of the mass," and the use of negative space.

2. Abstraction, as practiced by Brancusi, affected the choice of shapes and inspired an interest in truth in materials.

3. Expressionism most clearly affected the elongated, expressive forms of Giocometti.

4. Dada influenced the choice of shapes (Arp's biomorphs) and added a touch of humor.

8. Assemblage: Louise Nevelson

PURPOSES AND SUBJECT MATTER: Fragments of objects and new materials are combined in the work of Louise Nevelson to create monumental statements.

MEDIA AND TECHNIQUE

1. Wood is most often used and generally is salvaged from old furniture or houses, sawed up, nailed or glued together.
2. White, black, or gold paint is sprayed evenly over the assemblage, to unify the work and create the illusion of refined materials.

DESIGN

1. Dada has inspired the use of discarded materials and junk.
2. Constructivism has affected the manner in which the pieces are assembled.

9. Formalism-Structuralism: David Smith

The work of David Smith and other artists who worked in the 1960s is given various classifications. There is no doubt that the strong forms of Smith's work influenced the young artists of the 1960s, and 1970s, especially the Minimal and Primary Art sculptors.

PURPOSES AND SUBJECT MATTER: Smith made monumental abstract forms.

MEDIA AND TECHNIQUE

1. His finished works were welded steel.
2. Trained in an automobile factory, Smith assembled and welded his own pieces.
3. Using motorized polishing and buffing tools, Smith gave his works calligraphic surface patterns.

DESIGN

1. Cubism and Constructivism are usually cited as the strongest influences on Smith's work.
2. The monumental size and scale are important design elements, not mere incidentals or accidents of construction. Their very size contrasts with most earlier sculpture of the century.

10. Minimal-Primary Art—ABC Art

PURPOSE AND SUBJECT MATTER: Production of simple geometric solids with a minimum of artistic involvement or association.

MEDIA AND TECHNIQUES

1. Wood, fiberglass, metal are used.
2. The artist designs the structure and leaves its fabrication to skilled industrial workers.

DESIGN

1. Monumental geometric solids are fabricated and displayed without reference to emotional content or traditional meanings.
2. The works, usually quite large, are often displayed indoors, with startling effect.

11. Pop Art

PURPOSE AND SUBJECT MATTER: See Pop Art Painting for a summary.

MEDIA AND TECHNIQUES

1. Metal, plexiglass, fiberglass, vinyl, kapok are used.
2. **Found objects** and **ready-mades** are used in some works.

DESIGN

1. More than in painting, Pop Art sculptural works often convey a biting denunciation of and dissatisfaction with modern mass culture.
2. The acquisitive consumer is most often the target of Pop sculpture.
3. Several individuals have created unique expressions of Pop Art:
 a. **Jasper Johns and Andy Warhol** make consumer goods (ale cans, Brillo boxes) into art.
 b. **Claes Oldenberg** makes industrial fixtures and machines (fans, ice bags, sinks) into soft sculptures.
 c. **Christo** wraps buildings and coastlines as packages.
 d. **George Segal** makes life-size plaster mannequins.
 e. **Duane Hanson** makes startling life-like fiberglass and painted polyester figures.
 f. **Edward Kienholz** makes figural displays or tableaux with bizarre and shocking expressive qualities.

12. Kinetic Art

Kinetic sculpture was pioneered between 1915 and 1940 by Marcel Duchamp, Naum Gabo, Lazlo Moholy-Nagy, and others. Since World War II, several artists in Europe, including Pol Bury, have developed the style.

PURPOSE AND SUBJECT MATTER: Motion is used to express time.

MEDIA AND TECHNIQUES: Various constructions are motor-driven.

DESIGN

1. Time, the fourth dimension, is expressed through motion.
2. The motion of the sculpture is mechanized and controlled (in contrast with the random motion of unmechanized works such as mobiles).
3. Some of the constructions, especially those by Jean Tinguely, have humorous, Neo-Dada forms. Most are abstract-geometric.

13. Light Sculpture (Luminary Art)

PURPOSE AND SUBJECT MATTER: Light is manipulated.

MEDIA AND TECHNIQUES

1. Light-reflecting works use plexiglass, polished metal, etc.
2. Light-producing works use neon tubing and electric current.

DESIGN

1. **Richard Lippold** makes abstract, light-reflecting works.
2. **Chryssa** and others make light-producing and light-conducting works which turn on and off, and change color.

14. Earthworks

In the early 1970s, some artists made sculptural statements out of nature itself.

PURPOSE AND SUBJECT MATTER: To unify sculpture and site, art and nature.

MEDIA AND TECHNIQUES: Earth-moving equipment rearranged nature.

DESIGN

1. Works were often intentionally temporary.
2. Most Earthworks were so large they were best seen from the air.
3. Movies and still photographs of the process of creation became art works too.

15. Other Styles

Process and Conceptual Art, Happenings, Environments, and several other terms have been used to describe some of the other directions which sculptors have explored since the 1960s. Some scholars consider these to be merely "phenomena" or sociological developments, and not art. As in the case of recent and contemporary architecture and painting, only the passage of time will test the significance of these innovations.

EXAMPLES
FORMALISM

Aristide Maillol, *Mediterranean (Crouching Woman),* c. 1901, bronze, 41 in. high. (*G 22-37, H 459, J 799*)

EXPRESSIONISM

1. Wilhelm Lehmbruck, *Kneeling Woman,* 1911, cast stone, 70 in. high. (*H 460*)
2. Wilhelm Lehmbruck, *Standing Youth,* 1913, cast stone, 92 in. high. (*G 22-38, H 461, J 802*)
3. Gaston Lachaise, *Standing Woman,* 1912-27, bronze, 70 in. high. (*G 22-39*)
4. Ernst Barlach, *Man Drawing a Sword,* 1911, wood, 30 in. high. (*J 800*)
5. Ernst Barlach, *War Monument,* Güstrow Cathedral, 1927, bronze. *(G 22-40, 41*)

CUBISM
FREE-STANDING

1. Raymond Duchamp-Villon, *Horse,* 1914, bronze, 39 by 24 in. (*H 477, J 845*)
2. Alexander Archipenko, *Walking Woman,* 1912, bronze, 26 in. high. (*H 478*)
3. Alexander Archipenko, *Woman Combing Her Hair,* 1915, bronze, 14 in. high. (*G 22-43*)
4. Jacques Lipchitz, *Man with Mandolin,* 1917, stone, 30 in. high. (*G 22-44*)
5. Jacques Lipchitz, *Figure,* 1926-30, bronze, 85 in. high. (*H 480*)
6. Julio Gonzalez, *Woman Combing Her Hair,* c. 1930-33, iron, 57 in. high. (*G 22-48*)

RELIEF

1. Henri Matisse, *Back I,* c. 1909, bronze, 74 by 46 by 7 in. (*G 22-42*)
2. Henri Matisse, *Back IV,* c. 1929, bronze, 74 by 44 by 6 in. (*G 22-43*)

3. Jacques Lipchitz, *Still-Life with Musical Instruments,* 1918, stone relief, 23 by 28 in. (*H 479*)

FOLLOWERS OF CUBISM
FUTURISM

Umberto Boccioni, *Unique Forms of Continuity in Space,* 1913, bronze, 43 in. high. (*G 22-46, H 483, J, 844*)

DE STIJL

Georges Vantongerloo, *Raumplastik* $y = ax^3 - bx^2 + cx,$ 1935, nickel silver, 15 in. high. (*G 22-49*)

CONSTRUCTIVISM

1. Vladimir Tatlin, *Model for Monument to the Third International,* 1919-20, wood, iron, glass. Tower intended to be 1300 ft. high. (*G 22-50, H 487*)
2. Naum Gabo, *Kinetic Sculpture: Standing Wave,* 1920, wood and metal, motorized, 24 by 9 by 7 in. (*G 22-52*)
3. Naum Gabo, *Space Construction C,* c. 1922, plastic, 39 by 40 in. (*H 488*)
4. Naum Gabo, *Linear Construction,* 1950, plastic and nylon thread. (*G 22-51*)
5. Anton Pevsner, *Portrait of Marcel Duchamp,* 1926, celluloid on copper, 37 by 26 in. (*H 489*)

EARLY ABSTRACTION: CONSTANTIN BRANCUSI

1. *The Kiss,* 1909-25, multiple versions in stone. (*J 839*)
2. *Mlle. Pogany,* 1912-33, multiple versions in marble and bronze. (*H 474*)
3. *Bird in Space,* 1919-29, bronze, multiple versions. (*G 22-47, H 475, J 843*)

DADAISM

1. Jean (Hans) Arp, *Mountain Table Anchors Navel,* 1925, oil on cardboard with cutouts (also listed as painting). (*H 498*)
2. Jean (Hans) Arp, *Torso,* 1953, white marble on black stone base, 5 by 12 by 12 in. base, 37 in. high figure. (*H 499*)
3. Marcel Duchamp, *Bicycle Wheel,* original 1913, third version, 1951, metal wheel attached to painted wood stool, 50 by 25 by 16 in. (Sometimes considered the first kinetic sculpture). (*G 22-54*)
4. Marcel Duchamp, *Fountain,* signed R. Mutt, 1917, industrial urinal placed sideways (ready-made). (*illustrated elsewhere*)
5. Man Ray, *Gift,* original 1921, copy 1958, painted flatiron with metal tacks, 6 by 3 by 4 in. (*G 22-56*)
6. Pablo Picasso, *Bull's Head,* 1943, bicycle seat and handlebars. (*G 22-55*)

FANTASY AND RELATED STYLES

1. Henry Moore, *Two Forms*, 1936, 42 in. high. (*J 841*)
2. Henry Moore, *Reclining Figure*, 1939, elmwood, 81 in long. (*G 22-57*)
3. Alberto Giocometti, *The Palace at 4 a.m.*, 1932-33, wood, glass, wire, string, 25 in. high. (*J 847*)
4. Alberto Giocometti, *City Square (The Place)*, 1948, bronze, 8 by 25 in. (*G 22-58*)
5. Alexander Calder, *Lobster Trap and Fish Tail*, 1939, steel wire and sheet aluminum (mobile), c. 9 by 10 ft. (*J cpl 140*)
6. Alexander Calder, *Horizontal Spines*, 1942, steel wire and sheet aluminum, 54 in. high. (*G 22-53*)

ASSEMBLAGE: LOUISE NEVELSON

An American Tribute to the British People, 1960-65, wood painted gold, 10 by 14 ft. (*G 22-87, H 573*)

FORMALISM-STRUCTURALISM: DAVID SMITH

1. *Cubi VIII*, 1964, stainless steel, 9 ft. high. (*H 574*)
2. *Cubi XVIII*, 1964, stainless steel, 10 ft. high. (*G 22-86, J 855*)
3. *Cubi XIX*, 1964, stainless steel, 9 ft. high. (*H 574, J 855*)

MINIMAL ART-PRIMARY-ABC ART

1. Mathias Goeritz, *Steel Structure*, 1952-53, steel, 15 ft. high. (*J 852*)
2. Donald Judd, *Untitled*, 1965, galvanized iron, seven boxes, each 9 by 49 by 31 in., arranged vertically. (*H 575*)
3. Ronald Bladen, *X*, 1967, painted wood intended for steel fabrication, 22 by 26 by 14 ft. (*G 22-89, J 853*)

POP ART (Also refer to Pop Art Painting for mixed media works)

1. Jasper Johns, *Painted Bronze*, 1960, 5 by 8 by 4 in., simulated ale cans. (*G 22-96*)
2. Andy Warhol, *Brillo Boxes*, painted cardboard. (*illustrated elsewhere*)
3. Robert Rauschenberg, *Odalisk*, 1955-58, 81 by 25 by 25 in. (*J cpl 134*)
4. Robert Rauschenberg, *Monogram*, 1959, stuffed goat and auto tire, 48 by 72 by 72. (*G 22-95*)
5. Eduardo Paolozzi, *Medea*, 1964, welded aluminum, 81 by 72 by 45 in. (*G 22-85*)
6. Robert Indiana, *LOVE*, 1966, aluminum, 12 by 12 by 6 in. (*H 565, J 833*)
7. Claes Oldenberg, *Soft Typewriter*, 1963, vinyl, kapok, cloth, and plexiglass, 27 by 26 by 9 in. (*H 563*)
8. Claes Oldenberg, *Soft Toilet*, 1966, vinyl, kapok, and plexiglass, 55 by 28 by 33 in. (*G 22-98*)

9. Claes Oldenberg, *Giant Ice Bag,* 1969-70, plastic and metal with motor, 15 ft. high. (*J 856*)

10. George Segal, *Cinema,* 1963, plaster, metal, plexiglass, fluorescent lights, 10 by 8 by 3 ft. (*J cpl 135*)

11. George Segal, *The Bus Riders,* 1964, plaster, metal, and vinyl, 69 by 40 by 76 in. (*H 566*)

12. Duane Hanson, *Tourists,* 1970, fiber glass and painted polyester, 64 by 65 by 47 in. (*H 585*)

13. Edward Kienholz, *The Birthday,* 1964, mixed media, 7 by 10 by 15 ft., tableau. (*G 22-99*)

14. Edward Kienholz, *State Hospital,* 1966, mixed media. (*J cpl 136*)

15. Christo, *Wrapped Coast, Little Bay, Australia,* 1969, rope, and plastic sheets, surface area 1,000,000 square ft. (*H 567*)

16. Christo, *Running Fence,* 1976, 20 ft. high by 24 miles long. (*G 22-102*)

KINETIC ART

1. Naum Gabo, *Kinetic Sculpture: Standing Wave,* 1920, wood and metal, motorized, 24 by 9 by 7 in. (*G 22-52*)

2. Jean Tinguely, *Homage to New York,* 1960, photo prior to self-destruction. (*G 22-93*)

3. Pol Bury, *Broad Flatheads,* 1964, wood and nails, 40 by 40 in. (*G 22-92*)

LIGHT SCULPTURE (LUMINARY ART)

1. Richard Lippold, *Variation Within a Sphere No. 10: The Sun,* 1953-56, gold-filled wire, 10 by 22 by 5 in. (*H 576*)

2. Chryssa, *Automat,* 1971, neon and plexiglass, 68 by 68 by 20 in. (*H 578*)

EARTHWORKS

1. Robert Smithson, *Spiral Jetty,* 1970, Great Salt Lake, Utah, coil 1500 ft. long and 15 ft. wide. (*G 22-90, H 580, J 854*)

VOCABULARY

acrylic paint	collage	pre-stressed concrete
action painting	"combines"	reinforced concrete
automatic painting	found object	serial imagery
beton brut	frottage	serigraphy
brise soleil	mobile/stabile	stain painting

Bibliography

I. GENERAL TEXTS

BAUMGART, FRITZ. *A History of Architectural Styles.* New York: Praeger, 1970.

de la CROIX, HORST, and TANSEY, RICHARD G. *Gardner's Art Through the Ages.* 7th ed. New York: Harcourt, Brace, Jovanovich, 1980.

HARTT, FREDERICK. *Art: A History of Painting, Sculpture, Architecture.* Englewood Cliffs: Prentice-Hall, Inc./Abrams, 1976.

JANSON, H.W. *History of Art.* 2nd ed. Englewood Cliffs: Prentice-Hall, Inc./ Abrams, 1977.

NORBURG-SCHULZ, CHRISTIAN. *Meaning in Western Architecture.* New York: Praeger, 1975.

II. DICTIONARIES OF ART

FLEMING, JOHN. *The Penguin Dictionary of Architecture.* Baltimore: Penguin Books, 1972.

HAGGAR, REGINALD G. *A Dictionary of Art Terms.* New York: Hawthorne Books, Inc., 1962.

KALTENBACH, G.D. *Dictionary of Pronunciation of Artists' Names.* Chicago: Art Institute, Chicago, 1965.

MAYER, RALPH. *A Dictionary of Art Terms and Techniques.* New York: Thomas Y. Crowell Co., 1975.

MURRAY, LINDA, and PETER MURRAY. *Dictionary of Art and Artists.* New York: Praeger, 1965.

PIERCE, JAMES SMITH. *From Abacus to Zeus.* Englewood Cliffs: Prentice-Hall, Inc., 1977.

III. OTHER REFERENCES

BERNEN, ROBERT, and SATIA BERNEN. *Myth and Religion in European Painting, 1270–1700.* New York: George Braziller, Inc., 1973.

FERGUSON, GEORGE. *Signs and Symbols in Christian Art.* New York: Oxford University Press, 1966.

OSBORNE, HAROLD. *The Oxford Companion to Art.* London: Oxford University Press, 1975.

RICHARDS, J.M. *Who's Who in Architecture from 1400 to the Present.* New York: Holt, Reinhart and Winston, 1977.

TODD, A.L., and WEISBORD, DOROTHY B. *Favorite Subjects in Western Art.* New York: E. P. Dutton and Co., Inc., 1968.

For your convenience, corresponding material in the three most widely accepted textbooks on western art is listed on the inside front and back covers of this study guide.

SUBJECT	MASTERS AND SMITH	GARDNER[a]
Introduction to Art	1–8	2–17
1. Prehistoric Art	9–18	22–33
2. Egyptian Art	19–31	62–87
3. Ancient Near Eastern Art	32–38	34–61
4. Aegean Art	39–48	88–105
5. Greek Art	49–68	106–155
6. Etruscan and Roman Art	69–87	156–209
7. Early Christian and Byzantine Art	88–105	210–54
8. Islamic Art	106–12	254–67
9. Early Medieval Art	113–26	272–91
10. Romanesque Art	127–38	292–313
11. Gothic Art	139–54	314–51
12. Proto-Renaissance and International Gothic Art	155–62	458–77 494–99 580–86
13. Fifteenth Century Art	163–80	478–523 581–604
14. Sixteenth Century Art	181–99	524–77 604–27
15. Seventeenth Century Art	200–218	628–85
16. Eighteenth Century Art	219–32	686–717
17. Nineteenth Century Art	233–53	722–803
18. Twentieth Century Art	254–95	804–89

[a] de la Croix, Horst, and Tansey, Richard G., *Gardner's Art through the Ages* (7th ed.). New York: Harcourt, Brace, Jovanovich, 1980, in two volumes, paperback, or one volume, hardbound.

Note: Illustrations of examples cited in this study guide which can be found in the major texts are written in italics at the end of the study guide example listings. (*G* = *Gardner's Art through the Ages; H* = Hartt, *Art: A History of Painting, Sculpture, Architecture; J* = Janson, *History of Art.*)